2002
CyberArts

Hannes Leopoldseder – Christine Schöpf

PRIXARS ELECTRONICA
2002 CyberArts

International Compendium Prix Ars Electronica – Net Vision / Net Excellence, Interactive Art,
Computer Animation / Visual Effects, Digital Musics, cybergeneration – u19-Freestyle Computing

CONTENTS

CONTENTS

INTERACTIVE ART

COMPUTER ANIMATION / VISUAL EFFECTS

DIGITIAL MUSICS

CYBERGENERATION – U19 FREESTYLE COMPUTING

PRIX ARS ELECTRONICA 2002

The Fantasy of Reality
Fantasie der Realität

Hannes Leopoldseder

Mondlandung, Kennedy-Mord, das Attentat auf das World Trade Center – drei unterschiedliche Ereignisse, aber ein gemeinsames Merkmal: die stigmahafte Einprägung in die Köpfe der Menschen.

Jeder, der von Medien umgeben war, erinnert sich an die individuelle Örtlichkeit, an der er sich zum Zeitpunkt der jeweiligen Ereignisse aufgehalten hat. Auch Jahrzehnte später ist dieses Bild in der Imagination nicht verblasst, sondern hautnah und lebendig.

11. September 2001, 8.46 Uhr in New York, 14.46 MEZ. Der Nordturm des World Trade Center wird von der American-Airlines-Maschine Flug 11 gerammt, der Südturm um 9.02 vom United Airlines Flug 175. Beide Flugzeuge sind vom Typ Boeing 767-200.

Ich telefoniere gerade im Büro eines Mitarbeiters, da in meinem Büro Techniker die Klimaanlage überprüfen. Der Chefredakteur der Fernsehinformation des ORF – ich war zu diesem Zeitpunkt Informationsintendant des ORF und daher u. a. für die gesamte aktuelle TV-Information verantwortlich – informiert mich über die Breaking News von CNN, über das in der medialen Welt bis dahin zwar als Fiktion denkbare, aber in der realen Welt undenkbare Ereignis. Was als Newsflash begann, hielt die Welt in Atem. Für den ORF wie für andere TV-Sender begann die längste Informationssendung – der ORF war von diesen Minuten an 45 Stunden live auf Sendung, eine Premiere in der Geschichte des Senders.

Es wurde daraus ein Ereignis, von dem Monate später der französische Philosoph Jean Baudrillard in seiner heftig umstrittenen Wortmeldung sagte: „Das ist der vierte Weltkrieg" (*Der Spiegel,* 3/2002), mit der Zielrichtung auf die Globalisierung, die, so Baudrillard, mehr Opfer als Nutznießer schaffe und insbesondere jede Singularität, jede andere Kultur, aufhebe.

Ein Jahr danach. Der Jahrestag fällt in die Festivalwoche der Ars Electronica 2002, in die Woche jenes Festivals, das sich seit mehr als 20 Jahren erfolgreich zum Ziel gesetzt hat, den Wechselwirkungen zwischen Kunst, Technologie und Gesellschaft nachzuspüren und das sich innerhalb von zwei Jahrzehnten einen Ruf als

The moon landing, Kennedy's assassination, the attacks on the World Trade Center—three different events but all with a feature in common: the indelible impression they have left on people's minds. Everyone who had media around them remembers their particular location at the exact moment of each of these events. Even decades later, their imagery has not faded from our minds but is still immediate and vivid.

September 11, 2001 at 8:46 a.m. in New York, 2:46 p.m. CET. The North Tower of the World Trade Center is rammed by an American Airlines plane, Flight 11; the South Tower at 9:02 a.m. by United Airlines Flight 175. Both planes are Boeing 767-200s.

I was just making a call from a colleague's office, because technicians were checking the air conditioning in mine. The editor-in-chief of the information department at Austrian Broadcasting Corporation (ORF)—I was at the time ORF information director and so responsible, among other things, for all incoming television news – suddenly informed me of breaking news on CNN, news about an event which for the media world had been hitherto conceivable in fiction, but inconceivable in the real world. What began as a news flash went on to hold the world in suspense. For ORF, as for other television stations, began the longest news broadcast ever—from these very first minutes on, ORF broadcasted live for 45 hours straight, a situation unprecedented in the station's history.

It turned into an event which the French philosopher Jean Baudrillard commented on a few months later in a fiercely controversial statement: "It is indeed a World War, not the third one, but the fourth." (*Le Monde* 2/11/2001), and it aims at a globalization, according to Baudrillard, that creates more victims than beneficiaries and, moreover, levels all singularity and other culture.

Hannes Leopoldseder

Now, a year later, the first anniversary of this event falls during Ars Electronica 2002, that festival which for more than 20 years has successfully striven to trace interactions between art, technology and society. And over these two decades, the festival has established a reputation as a reliable barometer of developments in the field of digital media.

"Unplugged—Art as the Scene of Global Conflicts"—under this title, Ars Electronica 2002 is attempting to uncover traces of globalization in the heads and hearts of artists. In a certain sense, Ars Electronica 2002 touches not only on a pillar of what has been a constant triad in the festival program, the triad of art, technology and society, but on all three in one. For September 11 has deeply jarred all these realms.

Ars Electronica's program includes certain formats that have become constants—a symposium on the festival's central theme, performances, the electrolobby environment and showroom, installations. This year the festival also includes a special section focusing on Africa as it moves toward the information society.

This year, exemplary developments in the field of digital media are to be found reflected to an extraordinary degree in the Prix Ars Electronica. Held by the Austrian Broadcasting Corporation (ORF), Upper Austrian Regional Studio, in collaboration with the Ars Electronica Center and the O.K Center for Contemporary Art, the competition constitutes an essential part of the festival. With this initiative, ORF, as a state-owned broadcasting company, has consciously aspired over the past sixteen years to fulfill its cultural mission to the public. In particular it wants to contribute to presenting Austria as a future-oriented land of culture beyond all clichés. In addition to the awards themselves, the Prix Ars Electronica offers cash prizes to underscore the growing relevance of media art in the zuverlässiger Indikator von Entwicklungen im digitalen Medienbereich erworben hat.

„Unplugged – Kunst als Schauplatz globaler Konflikte" – unter diesem Titel will Ars Electronica 2002 Spuren verfolgen, die die Globalisierung hinterlässt – in den Köpfen und Herzen der KünstlerInnen. In bestimmtem Sinn berührt Ars Electronica 2002 nicht nur einen Pfeiler im konstanten programmatischen Festivaldreiklang von Kunst, Technologie und Gesellschaft, sondern alle drei in einem. Der 11. September hat in allen Bereichen einen Riss hinterlassen.

Das Programm der Ars Electronica beinhaltet die konstanten Bereiche – Symposium zum Thema, Performances, die Electrolobby, Installationen und als programmatischen Schwerpunkt Afrika auf dem Weg in die Informationsgesellschaft.

Die exemplarische Entwicklung im digitalen Medienbereich spiegelt sich auch in diesem Jahr in besonderem Maße im Prix Ars Electronica des Österreichischen Rundfunks (ORF), Landesstudio Oberösterreich, wider, der in Zusammenarbeit mit dem Ars Electronica Center und dem O.K Centrum für Gegenwartskunst als wesentlicher Bestandteil des Festivals veranstaltet wird.

Der ORF als öffentlich-rechtliches Rundfunkunternehmen will mit dieser Initiative seit 16 Jahren bewusst einen Beitrag zu seinem öffentlich- rechtlichen Kulturauftrag leisten, der insbesondere auch dazu beitragen soll, Österreich als zukunftsorientiertes Kulturland abseits aller Klischees zu präsentieren.

Der Prix Ars Electronica ist zusätzlich zu den Auszeichnungen auch mit Geldpreisen verbunden, um die wachsende Relevanz der Medienkunst im zeitgenössischen Kunstgeschehen zu unterstreichen. Die Preisgelder in der Höhe von 109.000 Euro stammen auch in diesem Jahr nicht vom Österreichischen Rundfunk, denn aus den Gebühren der Radio- und Fernsehkunden wäre dies gar nicht möglich, sondern von Sponsoren: Es sind dies Telekom Austria, voestalpine und BAWAG / P.S.K. Den Sponsoren gilt auch in diesem Jahr der besondere Dank der Teilnehmer am Prix Ars Electronica und des Veranstalters.

Das Festival Ars Electronica gilt damit nicht nur als Ort der Präsentation zeitgenössischer Entwicklungen in der Kunst, sondern ebenso als Ort der Bewertung.

Der Prix Ars Electronica liefert Jahr für Jahr den Beweis für den stetigen, aber unaufhaltsamen Vormarsch der digitalen Medien in den Mainstream des zeitgenössischen Kunstgeschehens. Gerade die Kontinuität über eineinhalb Jahrzehnte bestätigt den Prix Ars Electronica in seiner Bewertungsfunktion.

Die Entwicklung der Computeranimation im Film kann Schritt für Schritt historisch durch die Prämierungen beim Prix Ars Electronica nachvollzogen werden. War es bei der Premiere des Prix Ars Electronica 1987 das Spüren einer emotionalen Komponente bei *Luxo Jr.* von John Lasseter – einem Werk, das ihm die Goldene Nica beim Prix Ars Electronica und die erste Oscarnominierung für Computeranimation einbrachte –, so überzeugt 15 Jahre später *Monsters Inc.* von Pete Docter (ebenfalls Pixar Animation Studios) abermals die Jury mit einem emotionalen Moment, das in dieser Gestaltung nach Ansicht der Jury in der Computeranimation bisher nicht zum Ausdruck gekommen ist. An diesem Beispiel zeigt sich zweierlei: dass sich die Computeranimation zwar kontinuierlich fortentwickelt, allerdings nicht in der Geschwindigkeit, die in den 80iger-Jahren vorausgesagt wurde. Die Konstanz aber bedeutet, dass sich das quantitative Volumen der vollkommen computeranimierten Filmproduktion ausweitet und in durchaus absehbarer Zeit den Großteil des Gesamtvolumens ausmachen kann.

Ebenso einen Meilenstein in der Entwicklung des zeitgenössischen Films stellt *Panic Room* von BUF mit seinen bisher nie gesehenen Bildwelten dar, was von der Jury ebenfalls als wegweisend ausgezeichnet worden ist.

In der Interaktiven Kunst liefert der Prix Ars Electronica mehr und mehr den Beweis für das radikale Vordringen multimedialer Installationen im zeitgenössischen Ausstellungsgeschehen, aber auch in Open-Air-Projekten wie *Body Movies* von Rafael Lozano-Hemmer.

contemporary art scene. As in the past, these prizes, totalling 109,000 euros, do not come directly from the Austrian Broadcasting Corporation – the station cannot afford to sponsor such sums from the fees paid by radio listeners and television viewers. Instead the cash prizes have been donated by Telekom Austria, voestalpine and BAWAG/P.S.K. Bank. And once again, the participants and organizers of this year's Prix Ars Electronica would like to express their gratitude to these sponsors.

Yet Ars Electronica Festival is not just a place for presenting current developments in art but also a place for evaluating them. Year after year, the Prix Ars Electronica provides concrete evidence of the steady and inexorable advance of digital media into the mainstream of contemporary art. Moreover, the Prix Ars Electronica's continuity over one and a half decades bears testimony to its evaluating function.

The development of computer animation in film can be historically traced step by step in the prizes awarded at the Prix Ars Electronica. At the first competition in 1987, the sense of an emotional component brought *Luxo Jr.* by John Lasseter the Golden Nica at Prix Ars Electronica and the very first Oscar nomination for a computer animation. Fifteen years later, *Monsters Inc.* by Pete Docter (also Pixar Animation Studios) has also convinced the jury with an emotional component, such as, the jury believes, has never before been expressed in a computer animation. Two conclusions can be drawn from this example: that computer animation has indeed continued to develop, though not at the speed predicted in the eighties. Nevertheless, this constancy means that the quantity of completely computer-animated film productions is rising and that it may, in the very foreseeable future, account for a major portion of the total volume.

Hannes Leopoldseder

With its previously non-existent visual worlds, *Panic Room* by BUF also represents a milestone in the development of contemporary film. The jury gave it an Award of Distinction for its pioneering visual effects.

In the category Interactive Art, the Prix Ars Electronica once again provides proof of the ground being gained by multimedia installations at contemporary exhibitions, as well as by open-air projects like Rafael Lozano-Hemmer's *Body Movies*. Logically enough, the nearly unimaginable proliferation of the Internet makes Prix Ars Electronica's "Net Vision" and "Net Excellence" sections appear to be *the* categories of the future. By introducing an Internet category in 1995, Ars Electronica once again confirmed its role as a festival that backs new developments early on and by doing so lives up to its reputation as trendsetter.

The prize-winners in the Internet category vividly illustrate the entire spectrum of this media – for instance, in the socially critical orientation of *They Rule* (Josh On, Futurefarmers, USA), an excellent project that reveals the network of connections between influential corporate executives; or in *Carnivore* by RSG, a collective of artists (USA), which shows us what data flows look like. Nevertheless, even though the Internet category clearly has an almost unlimited potential for development, the bonanza spirit has vanished and made way for realistic market assessments and expectations.

One year after September 11, the new economy and the digital media's progress in the field of creative design are far from a state of euphoria. September 11 changed our world and our thinking more than we may at present realize. While writing these lines, I saw on the news ticker that the US Secretary of Defense had announced that terrorists' plans to make a so-called dirty radioactive bomb had been discovered in time. As a festival and with this year's central theme,

Der bisher kaum vorstellbare Wachstumsschub des Internets lässt dementsprechend „Net Vision" und „Net Excellence" des Prix Ars Electronica konsequenterweise als die Zukunftskategorien erscheinen. Mit der Einführung der Internetkategorie 1995 liefert Ars Electronica neuerlich als Festival die Bestätigung dafür, dass es jeweils zu einem frühen Zeitpunkt erfolgreich auf neue Entwicklungen gesetzt hat und damit dem Ruf als Trendsetter gerecht wird.

Die Preisträger in der Internetkategorie zeigen deutlich das gesamte Spektrum dieses Mediums – wie die gesellschaftskritische Ausrichtung von *They Rule* (Josh On, Futurefarmers, USA), ein beispielhaftes Projekt, das das Beziehungsgeflecht zwischen den einflussreichen wirtschaftlichen Führungskräften zeigt, während *Carnivore* der Künstlergruppe RSG (USA) den Datenfluss veranschaulicht. Die Internetkategorie hat zweifellos ein nahezu grenzenloses Entwicklungspotenzial, allerdings ist die Goldgräberstimmung längst verflogen und macht einer realistischen Markt- und Erwartungseinschätzung Platz.

Sowohl die New Economy als auch das Vordringen der digitalen Medien in die kreative Gestaltung sind ein Jahr nach dem 11. September entfernt von jeder Euphorie, denn der 11. September hat unsere Welt und unser Denken mehr verändert, als uns im Augenblick bewusst sein mag.

Während ich diese Zeilen schreibe, lese ich im NewsTicker, dass der amerikanische Verteidigungsminister mitteilte, eine von Attentätern präparierte so genannte schmutzige Atombombe sei rechtzeitig entdeckt worden. Ars Electronica 2002 will als Festival mit seinem Thema vonseiten der Kunst Schauplätze globaler Konflikte aufzeigen, beispielhaft in einer Zeit, in der das Unerwartete, aber auch das bisher Undenkbare in den Raum der Wirklichkeit gerückt ist. Dies kann nicht umfassend geschehen, aber an Nahtstellen und Bruchlinien, an denen die Zeichen einer beunruhigenden Zeitepoche klarer in Umrissen erkennbar werden.

Jules Verne sagte einmal: „ Alles, was ein Mensch sich vorstellen kann, werden andere Menschen verwirklichen." An diesen Satz habe ich mich am 11. September erinnert: Der bekannte Thriller-Autor Tom Clancy publizierte bereits 1996 einen Roman mit dem Titel *Executive Order*, in dem er nicht nur eine Boeing 707 in das Capitol rasen und fast alle Spitzenpolitiker umkommen lässt, sondern auch Anschläge mit Anthrax und Ebola-Virus als Folge beschreibt.

Wenn sich die Geschwindigkeit der technischen und der gesellschaftlichen Transformation weiter radikalisiert, werden wir auch mehr und mehr mit der Vorstellung leben, dass Undenkbares sich in Denkbares wandelt, dass Fantasie Schritt um Schritt Realität wird.

Ars Electronica 2002 wants to present the scenes of global conflict from the standpoint of art—exemplary in a time when the unexpected and hitherto unthinkable have shifted to the realm of reality. Such a presentation cannot cover everything, but concentrates on the seams and sites of fracture where signs of a disquieting epoch are becoming more clearly discernible.

Jules Verne once said: "Whatever one man is capable of conceiving, other men will be able to achieve." This sentence came to my mind on September 11. And the famous thriller author Tom Clancy published a novel entitled *Executive Order* in 1996, in which he not only had a Boeing 707 crash straight into the Capitol and kill top politicians, but also described the attacks with Anthrax and the Ebola virus that followed.

If the speed of technological and societal transformation continues to accelerate so radically, we will increasingly have to live with the idea of the unthinkable becoming the thinkable and of fantasy turning bit by bit into reality.

Hannes Leopoldseder

CyberArts 2002
Christine Schöpf

Five juries of international experts met in April 2002 at ORF's Upper Austrian Regional Studio in Linz to choose the best works from the cyberarts competition Prix Ars Electronica 2002. Eighteen cash prizes, totalling 109,900 euros, were awarded. They went to the USA, Japan, France, Sweden, Great Britain, Australia, Canada, India and Austria.

1,373 artists from 80 countries entered 2,356 works in this year's 16th edition of the most important competition for cyberarts worldwide and one rich in tradition. The results of the six competition categories give a representative view of the current state of art and design in the field of digital media. Moreover, the Prix Ars Electronica's results once again illustrate how greatly the cyberarts have emancipated themselves from traditional art. Elaborate, original concepts, professionally implemented, characterize digital media art of our times. In this sense, the Prix Ars Electronica is a serious platform for established artists as well as for young new talents.

For the state-owned Austrian Broadcasting Corporation (ORF), Upper Austrian Regional Studio, the Prix Ars Electronica not only represents a task which has to be fulfilled but also one of its central cultural activities. The international response this competition attracts each year makes the profound change induced by digital media evident on all fronts. From all over the world the most recent creative achievements in the arts, accomplished in conjunction with scientific research, find a common platform at the Prix Ars Electronica, making this competition an annual trend barometer.

The Prix Ars Electronica attaches just as much importance to the works of young people from Austria as it does to international projects. With the category "u19 freestyle computing", first introduced in 1998, the Prix Ars Electronica

Fünf international besetzte Fachjuries haben im April 2002 im ORF Oberösterreich in Linz getagt, um die besten Werke des Cyberkunst-Wettbewerbes Prix Ars Electronica 2002 zu küren. 18 Geldpreise von insgesamt Euro 109.000 wurden ermittelt. Die Preise des Prix Ars Electronica 2002 gehen in die USA, nach Japan, Frankreich, Schweden, Großbritannien, Australien, Kanada, Indien und Österreich.

1.373 Künstler aus 80 Ländern haben sich mit 2.356 Werken bei der diesjährigen 16. Ausgabe des weltweit wichtigsten und traditionsreichsten Cyberkunst-Wettbewerbes beworben. In der Gesamtschau bieten die Ergebnisse aus den insgesamt sechs Wettbewerbskategorien einen repräsentativen Überblick über den aktuellen Stand von Kunst und Gestaltung im Bereich digitaler Medien. Der Prix Ars Electronica verdeutlicht in seinen Ergebnissen einmal mehr die vollzogene Emanzipation der Cyberkunst vom traditionellen Kunstgeschehen. Elaborierte eigenständige Konzepte in professioneller Umsetzung kennzeichnen die digitale Medienkunst unserer Tage. In diesem Sinn ist der Prix Ars Electronica seriöse Plattform für etablierte Künstlerpersönlichkeiten ebenso wie für neue, junge Talente.

Für den öffentlich-rechtlichen Österreichischen Rundfunk (ORF), Landesstudio Oberösterreich, ist der Prix Ars Electronica nicht nur Auftrag, sondern eine der kulturellen Hauptaktivitäten. Die internationale Resonanz, die dieser Wettbewerb alljährlich erzielt, verdeutlicht den radikalen Wandel, den die digitalen Medien auf allen Linien hervorgerufen haben. Aktuelle kreative Leistungen aus aller Welt im Bereich Kunst in Verbindung mit Wissenschaft und Forschung finden im Prix Ars Electronica eine gemeinsame Plattform und machen diesen Bewerb zum jährlichen Trendbarometer.

Ein ebenso hoher Stellenwert wie den internationalen Projekten wird im Prix Ars Electronica aber auch den Arbeiten junger Menschen in Österreich beigemessen. Mit der 1998 eingeführten Kategorie „cybergeneration – u19 freestyle computing" bietet der Prix Ars

Electronica Jugendlichen die Möglichkeit, ihre Arbeiten einer breiteren Öffentlichkeit vorzustellen und sich der internationalen Konkurrenz zu stellen.

Mit 925 Werken, die heuer in der Kategorie cybergeneration – u19 freestyle computing" eingereicht wurden, konnte sich auch heuer der Erfolg dieser Kategorie des Prix Ars Electronica fortsetzen. Der Bewerb fand heuer bereits zum fünften Mal statt und soll Jugendlichen die Möglichkeit bieten, ihr Können, ihre Kreativität und ihren Einfallsreichtum im Umgang mit dem Computer unter Beweis zu stellen.

Das vorliegende Buch CyberArts 2002 bietet anhand der hier dargestellten Ergebnisse einen einzigartigen Einblick in die Medienkunst am Beginn des 21. Jahrhunderts. Das reichhaltige Adressmaterial macht diese Dokumentation des Prix Ars Electronica zum unverzichtbaren Nachschlagswerk für neugierige Kunstinteressierte. Ergänzt wird dieses Buch durch weitere Dokumentationsmedien wie Video, DVD und CD.

Förderung durch Wirtschaft und öffentliche Hand

Ermöglicht wird die Durchführung des Prix Ars Electronica mit Unterstützung von Sponsoren aus der Wirtschaft und Förderungen seitens der öffentlichen Hand.

Stifter des Prix Ars Electronica ist Telekom Austria, weiterer Sponsor ist die voestalpine. Der Bewerb „cybergeneration – u19 freestyle computing" wird von der BAWAG / P.S.K. unterstützt. Darüber hinaus wird der Prix Ars Electronica von Stadt Linz und Land Oberösterreich gefördert.

offers young people the possibility to present their works to large sections of the population and to see where they stand internationally. With 925 works submitted this category has once again been able to continue its successful course at the Prix Ars Electronica. The competition for those under 19 was held for the fifth time and aspires to offer young people the chance to demonstrate their skills, creativity and ingenuity in dealing with computers.

The book CyberArts 2002—and the results published in it—permits a unique look at media art in the early 21st century. The extensive list of addresses makes this documentation of the Prix Ars Electronica an indispensable work of reference for those interested in and curious about art. This book is supplemented by additional documentary media such as video, DVD and CD.

Sponsored by commercial enterprises and public funds

The Prix Ars Electronica 2002 has been made possible by support from commercial sponsors and subsidies from the government.

Sponsors of the Prix Ars Electronica are Telekom Austria and voestalpine. The competition category "cybergeneration—u19 freestyle computing" has been supported by the BAWAG / P.S.K. Bank. The Prix Ars Electronica is also funded by the City of Linz and the Federal Province of Upper Austria.

Christine Schöpf

Inspired, Educated and Entertained
Inspirierend, bildend und unterhaltsam

Pete Barr-Watson

Last year the Jury statement for these categories opened with the statement:

"And so it has come to this: the bubble burst, dotcoms drying up, lost in a haze of burn rate, the very Internet itself returning to a quaint network of chums and we can at last happily return to the old order ... Uh Uh, WRONG SCRIPT! In fact, quite the opposite ..."

Well, in the twelve months since then, one could've been forgiven for thinking that maybe the sentiment expressed above was a little premature. After all, since then, creative companies whose work is predominantly Web-oriented have still continued to fall by the wayside. But was it premature? Your opinion on this will very much depend on your own involvement in the whole affair, good or bad. But the situation has created an unusual and unique situation in some respects, and that's purely down to the creative sparks that were ignited by all the possibilities the dotcom years offered.

A lot of people found work in those years and at those companies. Later on of course, a lot of people at those companies found there was no more work left. But in the intervening period a good majority of them found new skills and new ways to release their creative energies and when they found they had time on their hands they started on a journey to "beautify" the Web. Personal sites have become the new Web art. Their numbers increase every day and offer us, the viewer, an insight into the minds of the creators. Something that probably just wouldn't have been possible a very short while ago. The opportunity to create, innovate and push back the boundaries that have sprung up around the Internet has proven to be an inspirational force to be reckoned with. Ask any personal site owner why they do what they do and you'll more often than

Letztes Jahr begann das Statement der Jury für diese Kategorie mit folgenden Worten:

„Es ist also so weit: Mit der Dotcom-Bubble ist auch gleich das ganze Internet geplatzt, und endlich können wir getrost zur alten Ordnung zurück kehren ... STOP, WRONG SCRIPT! Das Gegenteil ist natürlich der Fall ..."

Nun ja, es wäre wohl verzeihlich, wenn man in den zwölf Monaten seither das obige Statement für etwas verfrüht angesehen hätte. Denn immerhin sind seither weiterhin etliche Unternehmen, deren Arbeit vorwiegend Web-orientiert war, auf der Strecke geblieben. Aber war es wirklich verfrüht? Es hängt wohl stark davon ab, wie stark man selbst in die Sache involviert ist, welche Meinung man dazu hat, egal ob sie gut oder schlecht ist. Aber die Situation hat sich in mancherlei Hinsicht auf ungewöhnliche und einzigartige Weise entwickelt, und dies verdanken wir jenen kreativen Funken, die von all den Möglichkeiten ausgegangen sind, die uns die Dotcom-Jahre geboten haben.

Viele Leute haben in diesen Jahren bei solchen Unternehmen Arbeit gefunden. Natürlich stellte sich später für etliche heraus, dass keine Arbeit für sie mehr übrig war. Aber in der dazwischen liegenden Zeit erwarb der Groß-teil von ihnen auch neue Fertigkeiten und entdeckte neue Wege, ihre kreative Energie freizusetzen, und als sie dann dastanden mit nichts in der Hand außer jeder Menge Zeit, da machten sie sich dran, das Web zu „verschönern". Persönliche Sites sind die Träger der neuen Web-Kunst geworden. Ihre Zahl wächst täglich, und sie bieten uns – den Betrachtern – einen Einblick in die Gedankenwelt ihrer Schöpfer, etwas, das vor gar nicht allzu langer Zeit so nicht möglich gewesen wäre. Die Möglichkeiten, etwas zu schaffen, zu erneuern und die Grenzen zu verschieben, die rund ums Internet entstanden sind, haben sich als inspirierende Kraft erwiesen, mit der man zu rechnen hat. Man frage einen beliebigen Inhaber einer persönlichen Website, warum er das tut, was er tut. In den meisten Fällen wird die Antwort sein: „Um

etwas anderes zu machen, um zu zeigen, was möglich ist." Das Phänomen der persönlichen Sites hat Bücher, Artikel und Präsentationen auf der ganzen Welt inspiriert; es bleibt weiterhin eine der am leichtesten zugänglichen Möglichkeiten, sich selbst und seine Fähigkeiten und Kreativität zu präsentieren und zu vermarkten. Man sehe sich nur einige der umfangreicheren Sites an wie Matt Owens *Volume_One (www.volumeone.com),* Niko Stumpo's *Abnormal Behavior Child (www.abnormalbehaviorchild.com)* oder Daniel Achilles' *Precinct (www. precinct. net)*, und man wird einige der beeindruckendsten Formen von Website-Design im ganzen Netz sehen. Aber selbst die sind noch nicht das letzte Wort in Sachen Design persönlicher Sites. Es ist ein bisschen zum Klischee geworden zu behaupten, das Netz erlaube jedem alles zu veröffentlichen, aber im Grundsatz ist dies noch immer richtig. Was auch immer dein gestalterischer Geschmack sein mag, hier findest du eine Arena für deine Experimente, deine Kreativität, einen Bereich, in dem Tausende von Menschen auf der ganzen Welt deine Arbeit sehen können.

Und so ist gewissermaßen das Web den Leuten zurückgegeben worden. E-Commerce ist nicht mehr der Heilige Gral der Internet-Entwicklung. Sicherlich sind Firmensites noch immer genauso wichtig, wie sie waren, aber sie werden nicht mehr als der einzig wahre Grund für die Existenz des Internet angesehen. Mehr und mehr praktische Anwendungen für das Internet tauchen auf, bei immer mehr Dingen macht einem das Netz das Leben tatsächlich leichter. Alles in allem wird das Internet als Raum, in dem man lebt und den man erforscht, immer interessanterer.

So gingen denn die Mitglieder der Kategorie Net Vision / Net Excellence heuer mit großen Erwartungen in die Jurysitzung. Wir hofften auf viele Einreichungen von hohem Niveau und erwarteten, dass es schwer werden würde, die besten unter den guten herauszufinden. Und diese Erwartungen wurden auch von einigen der eingereichten Projekte erfüllt – eine Wahl zu treffen war tatsächlich schwer. Aber insgesamt blieb doch das Gefühl zurück, dass bei den nächstjährigen Einreichungen

not hear the words, "to do something different, to show what can be done." The personal site phenomenon has inspired books, articles and showcases around the world and continues to be one of the more accessible methods of promoting yourself, your skills and your creativity. Take a look around at some of the more prolific sites like Matt Owen's *Volume_One (www.volumeone.com),* Niko Stumpo's *Abnormal Behavior Child (www.abnormalbehaviorchild.com)* or Daniel Achilles' *Precinct (www.precinct.net)* and you'll see some of the most amazing designs on the Web today. However, these are by no means the final word in personal site design. It's become a bit of a cliché to say that the Web enables anyone to publish anything, but the sentiment is invariably true. Whatever your taste in design, there's an arena for you to experiment and create. An arena where thousands of people around the globe can see your work.

So in a sense, the Web has been handed back to the people. e-Commerce is no longer the "Holy Grail' of Internet development. It exists, for sure, but it isn't the be-all and end-all of the Internet any longer. Corporate websites are as important now as they ever were, but they aren't considered to be the only reason why there should actually be an Internet these days. More and more practical uses for the Web are springing up. There are a lot more things you can do today to help make your life easier by using the Web. Mapping sites for instance. No, all things considered the Internet is becoming a much more interesting place to reside and explore.

So the selected jury members of the Net Vision / Net Excellence all entered the Jury session this year with high expectations. We had high hopes for the level of entry and we were expecting a difficult time in choosing our selections. And, those high hopes were met by a number of the projects entered, and our choices were difficult

to reach. Heated discussion about the individual merits of projects dominated our meeting days. But, overall we felt that there is serious room for the diversification of next year's entries. There were many projects that followed similar themes— predominantly data visualization—and we feel that there is much more out there that deserves consideration as well. This category is split into two separate sections which are aptly named. Net Vision and Net Excellence cover a vast arena of online creativity and innovation, next year we hope that this is better reflected in the scope of the entries. So, tell all your friends, acquaintances and colleagues, the gauntlet has been thrown down and awaits the challenge.

This year's prize winners and runners-up are, without fail, the cream of the crop. The quality of these projects is easy to see, and the creativity is hard to match. The wide variance of technologies used shows that the Internet is an ever-changing place and open to new innovation all the time. From the social comments made by *They Rule* to the excellent use of currently available technologies by *BotFighters* it's easy to see why they were chosen. Please review the list of winners and runners-up, and look at the projects in turn— online if possible. Be inspired, educated and entertained—just as we were.

Radical Software Group, RSG (USA): *Carnivore*

Carnivore is a project that "perverts" an existing technology. Derived from a snooping application that monitors and reports back on all network traffic, *Carnivore* fulfills an almost identical role. The monitoring of network traffic using *Carnivore* however, provides an interesting new viewpoint on all things "connected'. Data transfer is a fact of life and is one of those things that's normally quite invisible to the user, but using this software you can change that. And it provides for some interesting viewing.

Carnivore is in actual fact an application that resides on your server. It's freely downloadable from the project's site and can be installed on your own machine in very little time. The graphical interface (Client) can be developed using other technologies such as Macromedia Flash, which is widely available. This allows for almost anyone with an interest to develop a *Carnivore* client of their own. This is a very interesting project using complex technology, but the way it's been developed allows for many people to engage with it in a non-exclusive way.

The mental concept of data traffic is one which will have different connotations for many people.

noch viel Raum für eine Diversifikation da ist. Es gab viele Projekte, die ähnlichen Themen folgten, vor allem im Bereich der Visualisierung von Daten, und wir glauben, dass da draußen noch viel mehr ist, was ebenfalls in Betracht zu ziehen wäre. Diese Kategorie ist ja in zwei getrennte Bereiche geteilt, die auch recht passende Namen tragen: „Net Vision" und „Net Excellence" decken ein breites Feld von Online-Kreativität und -Innovation ab, allerdings hoffen wir, dass diese Breite sich nächstes Jahr auch in der Breite der Einreichungen besser widerspiegelt. Deshalb – sagt euren Freunden, Bekannten und Kollegen, der Handschuh ist geworfen und die Herausforderer werden erwartet!

Die diesjährigen Preisträger und Ausgezeichneten sind zweifellos die Crème de la crème. Die Qualität ihrer Projekte ist offensichtlich und ihre Kreativität nicht leicht nachzuahmen. Die breite Vielfalt der eingesetzten Technologien zeigt, dass das Internet ein sich ständig verändernder Raum ist und jederzeit offen für Innovation. Vom sozialkritischen Kommentar in *They Rule* bis zum hervorragenden Einsatz der derzeit verfügbaren Techniken in *BotFighters* ist bei allen offensichtlich, warum sie ausgewählt wurden. Sehen Sie sich die Liste der Preisträger und Auszeichnungen an und betrachten Sie die Projekte – am besten online. Lassen Sie sich inspirieren, bilden und unterhalten – genauso, wie wir das getan haben.

Radical Software Group, RSG (USA): *Carnivore*

Carnivore ist ein Projekt, das eine existierende Technologie „umdreht". Es leitet sich von einer Schnüffel-Anwendung ab, die den gesamten Netzwerkverkehr überwacht und rückmeldet, und spielt praktisch die gleiche Rolle. Die Überwachung des Netzwerkverkehrs durch Carnivore bietet allerdings einen interessanten neuen Blickpunkt auf all die „verbundenen" Dinge. Datentransfer ist ein Faktor des Lebens und eines jener Dinge, die normalerweise für den Benutzer unsichtbar bleiben, aber mit dieser Software lässt sich das ändern. Und sie bietet auch einige interessante Betrachtungsmöglichkeiten.

Carnivore ist eine Anwendung, die auf Ihrem eigenen Server residiert. Es ist kostenlos von der Projektsite herunterladbar und kann in kürzester Zeit installiert werden. Das grafische Client-Interface kann mit unterschiedlichen Techniken gestaltet werden, etwa mit dem allgemein erhältlichen Macromedia Flash. So kann fast jeder Interessierte seinen *Carnivore*-Client nach eigenem Geschmack entwickeln. Dies ist ein sehr interessantes Projekt, das komplexe Technologie verwendet, aber die Form, in der es entwickelt wurde, gibt auch Raum für viele, sich in nicht-exklusiver Weise damit auseinanderzusetzen.

Das Konzept von Datenverkehr hat für unterschiedliche Leute auch unterschiedliche Aspekte. Die breite und

vielgestaltige Palette von möglichen Clients wird auch interessante Einblicke in die jeweilige Wahrnehmung einer „verbundenen Welt" geben, in der – wenn man so will – die visuelle Währung Daten sind. Eins und Null. Eine schwarz-weiße, binäre Welt, die durch die Darstellung visueller Elemente, die sich vor den Augen des Betrachters verändern und verformen, zum Leben erweckt. Uns gefiel, wie hier eine Technologie absorbiert, umgeschrieben und zu etwas anderem umgeschmiedet wurde. Das Projekt zeigt, dass im Netz wie in der realen Welt auch eine Wiederverwertung und Umnutzung zu guten Zwecken möglich ist, auch wenn der ursprüngliche Zweck ein ganz anderer war. Erfindungskraft und Um-die-Ecke-Denken haben dieses Projekt Wirklichkeit werden lassen, und dafür verdient es Applaus.

The wide and varied number of Clients that can be developed will make for some interesting insights into people's perception of the "connected world" where the visual currency, if you like, is data. Ones and zeros. A black and white, binary world brought to life by representing it with visual elements that morph and change before your very eyes. We liked the way in which technology had been absorbed, re-written and recycled into something else. It shows that just as in the real world, things can be re-used by someone else to good effect, even if they were originally destined for an altogether different use. Ingenuity and lateral thinking have made this project a reality and it is to be applauded for that.

Josh On, Futurefarmers (USA): *They Rule*

Dieses Projekt, das ebenfalls die heuer so stark vertretene Datenvisualisierung behandelt, stach uns sofort ins Auge. Kapitalismus und Globalisierung sind gerade derzeit recht sensible Themen, und dieses Projekt greift sie auf eine interessante und recht raffinierte Weise auf. Das Internet erleichtert der breiten Öffentlichkeit zweifellos den Zugang zu diesen Daten, und man kann sich nur schwer eine andere Form von Medium vorstellen, das die in *They Rule* dargestellte Information auf solche Weise präsentieren könnte.

Das Projekt stellt eindrucksvoll dar, wie die amerikanischen Wirtschaftsunternehmen durch zahlreiche Führungskräfte verbunden und verflochten sind, die in mehreren Vorständen oder Aufsichtsräten gleichzeitig sitzen. Manchmal sind die Links geradezu erstaunlich, und die Art, wie die Visualisierung gehandhabt wird, ergibt eine recht intuitive Navigationsmethode. Je „fetter" zum Beispiel die Online-Darstellung einer Person ist, desto mehr Funktionen hat sie inne.

Der User kann die Datenbank abfragen und eigene visuelle Darstellungen bilden, die nach Belieben abgespeichert und abgerufen werden können. Dies macht die Erfahrung mit der Website noch fesselnder und die Erforschung der Verknüpfungen zu einer Person auch bei mehr als einem Besuch lohnend. Und wenn man sich nicht selbst auf die Suche einlassen will, so können jederzeit die von anderen gespeicherten Kriterien und Abbildungen verwendet werden, was ebenfalls so manche die Augen öffnende Tatsache ans Licht fördert. Dieser Art von Daten hätte nur zu leicht allzu sehr dramatisiert und auf sensationslüsterne Weise verwendet werden können – Anhänger von Verschwörungstheorien würden sich freuen! Aber genau das wird bei *They Rule* vermieden: Hier konzentriert man sich auf Tatsachen und erlaubt den Nutzern, diese dem eigenen Tempo entsprechend zu sichten. Die Handhabung ist bestens durchdacht, ein weiterer Faktor, der dem Reichtum der von dieser Site angebotenen Erfahrung zugute kommt.

Josh On, Futurefarmers (USA): *They Rule*

Following on from the data visualization theme that was so prominent this year, *They Rule* is a project that immediately got our attention. Capitalism and globalization are sensitive subjects right now and this project captures that in an interesting yet sophisticated way.

The Internet certainly has allowed this kind of information to be more readily available to the masses. It's hard to imagine another form of media that would present the information contained in *They Rule* in such a manner.

The project successfully attempts to demonstrate the way in which corporate America is so closely intertwined, with many examples of executives sitting on many different boards. Sometimes the links can be quite astonishing. The way in which the visualization is handled also makes for a very intuitive navigation method. For instance, the "fatter" the person's online representative is, the more boards they are connected with.

The user is able to interrogate the database and form visual maps of their own. They can then save that map for future use if they so choose. This makes the experience much more engaging and makes the research of these people an interesting proposition on more than one visit. Alternatively, if the research isn't your thing, then you can view the previously saved searches and maps at will, again providing some eye-opening facts.

This kind of data could easily have been overly dramatized and used in a sensationalist manner. Conspiracy theorists would've had a field day. But, *They Rule* manages to completely avoid that, focusing instead on the facts and allowing the user to investigate them at their own pace. The usability of the project has been very well thought out and this just serves to add to the rich experience the site offers.

Inspired, Educated and Entertained

It's Alive! (S): *BotFighters*

It's a common sight in the technology magazines—amazing new ways to use technology that doesn't yet exist! Ideas and whole articles devoted to what you will be able to do in the future! Well, the reason that *BotFighters* was chosen to receive an Award of Distinction is because what they promise is here today, and it uses technology that the majority of people already have access to mobile telephone handsets.

Engaging mobile gaming is something of a Holy Grail at the moment. Using the handsets that are widely available very much limits what can be done with them. A 3.5 cm x 3 cm greyscale screen isn't very inspiring and it's difficult to entice the user to interact with it too. Well, the producers of *BotFighters* didn't worry about that! They just went ahead and built a game for those very platforms, and didn't concern themselves with the limitations.

Bringing together a unique combination of reality, online elements and mobile technology, *BotFighters* is a multiplayer gaming community that is thriving in many nations.

In order to successfully attack your opponent, you must be within a set distance of each other in the real world. You then can proceed to play the game using SMS messages to control your "Bot".

All in all a brilliant combination of technologies that's here today and available to many people now.

Innovation in the mobile arena is a rare thing it seems. The technology is there and is commonly used but *BotFighters* has taken it to the next step just by looking at the mobile networks with different eyes and not just settling for second best. This is a brave attempt to break out of the mould and make fresh tracks. And it does it well. Mobile gaming will (should) never be the same again.

Maia Gusberti, Michael Aschauer, Nik Thönen, Sepp Deinhofer (A): *./logicaland*

It is rare to come across good online projects that can be used in an educative environment. *./Logicaland* is one such tool. It enables you to visualize and alter the course of a country's development by altering the way it invests its money over a period of time. As in the real world, an individual can't make much of an overall difference, but as a group you can. This opens up a major link to the real world education of school children who would be able to have

It's Alive! (S): *BotFighters*

In den Technologie-Zeitschriften ist es ein gewohnter Anblick – erstaunliche neue Anwendungen für eine Technologie, die noch gar nicht existiert! Gedanken und ganze Artikel werden dem gewidmet, was man irgendwann zukünftig tun können *wird*. *BotFighters* hingegen wurde eine Auszeichnung zuerkannt, weil das, was es uns verspricht, tatsächlich schon existiert und noch dazu eine Technologie verwendet, zu der die Mehrheit der Menschen bereits Zugang hat – das Handy.

Mitreißende mobile Spiele sind im Moment der letzte Schrei. Die Verwendung der weit verbreiteten Display-Handies schränkt allerdings die verfügbaren Möglichkeiten stark ein: Ein Graustufenbild von 3,5 x 3 cm ist nicht gerade inspirierend und macht es auch nicht leicht, den Anwender zur Interaktion zu animieren. Nun, *BotFighters* zerbricht sich darüber nicht den Kopf. Hier wurde einfach ein Spiel für genau diese Plattform entwickelt, ohne dass man sich wegen der Einschränkungen graue Haare hätte wachsen lassen.

In seiner einzigartigen Kombination aus Realität, Online-Elementen und mobiler Technologie ist *BotFighters* eine Multiplayer-Spiele-Community, die in vielen Ländern prosperiert.

Um seinen Gegner erfolgreich attackieren zu können, muss man sich in der realen Welt innerhalb eines vorgegebenen Abstandes zu ihm befinden. Dann kann man das Spiel spielen, indem man seinen „Bot" mit SMS-Nachrichten steuert.

Alles in allem eine brillante Kombination von Technologien, die hier und heute für viele Menschen zur Verfügung stehen.

Innovation im Mobilbereich scheint noch etwas eher Selteneres zu sein. Zwar sind die technischen Voraussetzungen da und werden auch genützt, aber *BotFighters* hat sie einfach dadurch auf eine neue Stufe gehoben, dass man die mobilen Netzwerke mit anderen Augen betrachtet und sich nicht mit dem Zweitbesten zufrieden gegeben hat. Ein mutiger Versuch, ausgetretene Wege zu verlassen und eine neue Spur zu legen – und er ist damit sehr erfolgreich. Die Welt der mobilen Spiele wird (oder sollte) nie mehr so sein wie früher.

Maia Gusberti, Michael Aschauer, Nik Thönen, Sepp Deinhofer (A): *./logicaland*

Man trifft selten auf gute Online-Projekte, die sich auch in einer Bildungsumgebung einsetzen lassen. *./logicaland* ist so ein Werkzeug. Man kann die Entwicklung eines Landes durch Abänderung seiner finanziellen Investitionsstruktur über einen gewissen Zeitraum visualisieren und verändern. Wie im wahren Leben kann ein Individuum allein keine großen Veränderungen auslösen, aber als Gruppe ist es möglich. Dies stellt auch die Verbindung zum Erziehungsbereich her – Schulkinder, die darüber

diskutieren und debattieren könnten, wie ein Land sich entwickeln sollte, und dann die Umsetzung mittels *./logicaland* ausprobieren. Der beschleunigte Zeitmaßstab der Site erlaubt die Beobachtung der Veränderung, die man ausgelöst hat, und damit auch der Art, wie man sein eigenes Land entwickelt.

Es sollte besonders herausgestrichen werden, dass dieses Projekt einen Bezug zwischen Online-Interaktion und Diskussion in der realen Welt herstellt. Es hat das Potenzial, Zusammenhänge im Bereich der sozio-ökonomischen Entwicklung aufzudecken und ist deswegen besonders wertvoll.

Online-Lehrhilfen haben es nicht leicht, bis ins Klassenzimmer vorzudringen. Heutzutage sind die Lehrer einem enormen Druck ausgesetzt, aus jeder Unterrichtsminute möglichst viel herauszuholen. Außerdem sind die Kinder viel weiter entwickelt und verlangen nach mehr Aufmerksamkeit. Wegen diesen Zwängen und Einschränkungen können die bisherigen Lehrbehelfe nur unter hohem Aufwand abgelöst werden. Aber dies wird sich ändern, wie sich ja früher oder später alles ändert, und das vorliegende Projekt ist ein feines Beispiel dieser schönen neuen Welt. Eine gruppenorientierte Lernanwendung in Echtzeit, die zu Diskussion und Debatte anregt, kann einfach nicht ignoriert werden.

schoenerwissen (D): *Minitasking*

Gnutella ist das berühmte File-Sharing-Protokoll, das vom breiten Publikum zum – eben! – Filesharen verwendet wird. Normalerweise lädt man sich dazu eine Client-Anwendung herunter (etwa *Limewire*, aber es gibt auch viele andere) und gibt einen Suchbegriff für jene Datei ein, nach der man sucht. Das kann alles sein: von einer Musikdatei über ein Video bis hin zu einem elektronischen Buch. Natürlich kann man auch die eigenen Files mit anderen Usern teilen und so das Netzwerk erweitern. Alles ziemlich normale Alltagspraxis ...

Minitasking ist eine Anwendung, die das *Gnutella*-Netzwerk zu einem anderen Zweck verwendet: Es überwacht die Suchbegriffe der Rechner anderer Leute und zeigt die gesammelten Daten als schöne visuelle Elemente an, die sich bewegen und ständig visuelles Feed-back liefern. Dieses Projekt legt beim Betrachter der verschiedenen auftauchenden Suchbegriffe die voyeuristischen Tendenzen frei – fast ein Blick in die Köpfe anderer Leute. Eine brillante Anwendung weit verbreiteter Technologie im Internet.

Alexandra Jugovic, Florian Schmitt; Hi-Res! (UK): *Donnie Darko*

Donnie Darko ist ein Glückstreffer in einer Zeit der überkommerzialisierten Online-Werbeflut, die einem ins Gesicht springt. Es ist nicht leicht zu erklären, was

discussions and debates over the way a country should develop and then put it into practice using *./Logicaland*. Its accelerated timescale allows you to see the changes you're affecting and therefore the way you are developing your nation.

We saw a link between online interaction and real world discussion with this project and this is worthy of note. It has real potential to instruct in the ways of socioeconomic development and has major value because of this.

Online teaching aids must have a hard time being adopted in the classroom. In this day and age there are tremendous pressures put onto teachers to make the best of every minute of classroom time. Children are more sophisticated and demand more attention as well. It'd take a lot to change the usual teaching aids more commonly used because of all of these constraints and pressures. But, that'll change, just as everything eventually does and this project is a fine example of this brave new world. A real-time group oriented study application that inspires conversation and debate can't be ignored.

schoenerwissen (D): *Minitasking*

Gnutella is the famous file sharing protocol that is widely used by the general public for, well, sharing files! The usual course of action involves downloading a client application (such as Limewire, although there are many others) and entering a search string for the file you're looking for. This could be anything from a music file to video to electronic book. Of course, you also share your own files with the other users, thereby extending the network. Pretty normal computer activity today ...

Minitasking is an application that utilizes the Gnutella network for another reason. It monitors the search strings from other people's computers and displays the data it gathers as beautiful visual elements that move and constantly provide visual feedback. This project will bring out the voyeuristic tendencies in anyone as you watch the search strings appear. Almost a view into people's minds.

This is a brilliant use of common technology on the Internet.

Alexandra Jugovic, Florian Schmitt; Hi-Res! (UK): *Donnie Darko*

Donnie Darko is a rare find in these days of over commercialized, in your face, online advertising campaigns. There's no easy way to reveal what's

in this site. It acts like an interactive novel and in doing so enhances the impact of the film greatly. You're invited to take a journey of discovery, to reveal the secrets of the story and further your progress through the brilliantly created virtual world described by sometimes haunting imagery. This is not a website that shouts at you to go and see the film. Indeed, using the website (whether you have seen the film or not) is an experience to be relished.

"I can do anything... And so can you". This is the first thing you'll see on entering the actual site. It is a feast of visual and audio design.

Passwords to enter the next stages of the site are gathered along the way and these allow return visits to the site to continue the journey where you left off. Another reason why the metaphor of the site being an interactive novel is so apt. Even without a film this website would be a masterpiece of design and interaction. Superb.

Jonathan Gay (USA): *Macromedia Flash*

Flash was awarded an honourable mention for the way in which it's transformed the Web and many people's lives. This sounds like a grand statement, and really it is. But no apologies for this are due.

Gaming, interactivity, music and video are all things that *Flash* has made available to the Internet viewing public. And more, it's inspired vast communities of people who develop *Flash* content and applications to talk to each other and share knowledge. Last year one of these communities, Ultrashock, itself received an honourable mention.

The versatility of the program allows for the creation of truly multimedia applications such as games, puzzles and cartoons etc. Also, there are future developments planned for *Flash* that will affect many more people and aid communication through the Internet greatly. It's the vast untouched playing field that *Flash* offers to anyone who wants to develop with it that makes it deserve the award. The possibilities are truly unimaginable. Love it or hate it, there is no denying that there is a place for it on the Internet today.

Alexandra Jugovic, Florian Schmitt / Hi-Res! (UK): *The Third Place*

This is a project that was built for Sony Entertainment by Hi-Res! It's a collection of different interactive artists who've come together to offer their interpretation of the "Third Place".

diese Site eigentlich alles bietet. Sie verhält sich wie ein interaktiver Film und verstärkt dabei den Effekt des Films, zu dem sie entwickelt wurde, ganz enorm.

Man wird eingeladen, eine Entdeckungsreise zu unternehmen, die Geheimnisse der Story zu enthüllen und sich durch eine brillant gestaltete virtuelle Welt zu bewegen, die von bisweilen spukhaften Bildern beschrieben wird. Das ist keine Website, die einem zuschreit: „Geh hin und schau den Film an!"; vielmehr ist der Besuch dieser Site – egal, ob man den Film gesehen hat oder nicht – eine Erfahrung, die man genießen sollte.

„Ich kann alles tun ... und Sie können das auch!" ist das Erste, was einem entgegenspringt, wenn man die eigentliche Site betritt. Ein wahres Fest des visuellen und Audio-Designs.

Passwörter zum Fortschreiten zur nächsten Ebene werden unterwegs aufgesammelt und erlauben auch bei wiederholten Besuchen, dort fortzusetzen, wo man zuletzt aufgehört hat – ein weiterer Grund, warum die Metapher des Online-Romans so gut auf die Site paßt. Selbst ohne Film wäre diese Website ein Meisterwerk an Design und Interaktion. Einfach großartig.

Jonathan Gay (USA): *Macromedia Flash*

Flash erhielt eine Anerkennung dafür, wie es das Web und das Leben vieler Menschen verändert hat. Diese Aussage klingt gewagt, und sie ist es vielleicht auch. Aber es gibt nichts, wofür man sich damit entschuldigen müsste.

Spiele, Interaktivität, Musik und Video – all das hat *Flash* dem Internetpublikum zugänglich gemacht. Und darüber hinaus hat es zahlreiche Gemeinschaften von Leuten inspiriert, die *Flash*-Content und Anwendungen entwickeln, um miteinander zu reden und Wissen zu teilen. Eine dieser Gemeinschaften, Ultrashock, hat letztes Jahr selbst eine Anerkennung erhalten.

Die Vielseitigkeit des Programms erlaubt die Schaffung echter multimedialer Anwendungen wie Spiele, Puzzles, Cartoons usw. Weiters sind zukünftige Entwicklungsstufen für *Flash* geplant, die noch mehr Leute involvieren und die Kommunikation im Internet weiterbringen werden. Es ist jene große unberührte Spielweise, die *Flash* jedem bietet, der damit entwickeln will, die diesen Preis verdient hat. Die Möglichkeiten sind wahrhaftig unvorstellbar. Egal ob man es mag oder nicht, es lässt sich nicht leugnen, dass für *Flash* Platz im Internet ist.

Alexandra Jugovic, Florian Schmitt / Hi-Res! (UK): *The Third Place*

Dieses Projekt wurde von Hi-Res! für Sony Entertainment gestaltet. Hi-Res! ist ein Sammelbecken verschiedener interaktiver Künstler, die sich zusammengetan haben, um ihre eigene Interpretation eines „Dritten Ortes" zu präsentieren.

Der „Dritte Ort" ist jener metaphorische Raum, in dem sich – glaubt man Sony – dein Geist aufhält, wenn du Videospiele spielt. Das ist ein interessantes Konzept, und die einzelnen Stücke sind von hoher Qualität, was die Erfahrung selbst recht fesselnd gestaltet.

Wie immer der eigene Geschmack in Designfragen sein mag – hier findet jeder etwas. Man wird sogar möglicherweise mehr Zeit hier verbringen als beabsichtigt, denn das Spielen mit den visuell reagierenden Klangstücken kann einen ganz schön in den Bann ziehen, und die optisch wunderschön animierten Stücke können einen in die Zeitlosigkeit fallen lassen. Aber vielleicht war das auch die Absicht der Designer? Schließlich hat man ja schon davon gehört, dass sich Video-Spieler im Spiel verirrt haben, oder?

Sony ist in der Welt des interaktiven Design als Innovator und zukunftsorientierter Auftraggeber für Medienprojekte wohl bekannt – *The Third Place* enttäuscht die Erwartungen nicht.

Harper Reed: *Audreyhacking.com – Hacking the Audrey*

Der, die oder das „Audrey" wurde von 3Com produziert. Es stellt eigentlich eine dedizierte Internet-Applikation dar, wurde aber von einer großen Community von Leuten adoptiert, gehackt und für zahlreiche sonstige Zwecke verwendet, für die es eigentlich gar nicht gedacht war. Irgendwo zwischen einem Palmtop und einem Desktop-Rechner angesiedelt, gibt es viele verschiedene Möglichkeiten, das Gerät umzufunktionieren, etwa in einen MP3-Player, einen Nachrichten-Client oder sogar in einen Webserver!

Das Internet ist der ideale Treffpunkt für Leute, die durch physische oder mentale Grenzen getrennt sind, und das *Audreyhacking*-Projekt ist ein hervorragendes Beispiel für eine solche Gemeinschaft. Das simple Konzept, dieses Gerät als Basis für Experimente und gemeinsames Wissen zu verwenden, ist an sich schon brillant, wenn aber das Web Menschen auf diese Weise zusammenbringen kann, umso besser.

Kenneth Tin-Kin Hung (USA): *60X1.COM*

Dieses Projekt stach aus den heurigen Einreichungen wegen seiner Einzigartigkeit heraus. Es ist ein überraschendes Beispiel innovativen Designs und zeigt, dass in ihm jede Menge Denkarbeit steckt.

Die lebhaften Farben der Site werden in den bunten Meldungen wieder aufgenommen, die einem von der Seite beinahe entgegen geschrieen werden. Und die Navigation durch die Website ist genauso ungewöhnlich wie die Seiten selbst – in jedem Fall originell in Design und Konzept.

Das ist eine Website, in der man sich verirren kann, wenn man den ständig auftauchenden Links folgt, eine

The "Third Place" is the metaphorical space where Sony says your mind is when playing video games. It's an interesting concept and the individual pieces are of high quality, making the experience itself an engaging one.

Whatever your taste in design, there'll be something here for you. You may find that you spend more time here than you realize as playing with the visually responsive sound pieces can be quite engrossing. Watching the visually beautiful animated pieces can also grab your attention in a time warp sort of way. Or, maybe this was the intention of the designers? Video games players have been known to lose themselves in the game before, haven't they?

Sony is well known in the interactive design world as an innovator and forward-thinking commissioner of media projects and *The Third Place* does not disappoint.

Harper Reed: *Audreyhacking.com—Hacking the Audrey*

The Audrey is a device that was manufactured by 3Com. It's an Internet appliance that's been adopted by a large community of people who "hack" the device and use it to perform tasks that it wasn't originally designed to do. Lying somewhere between a Palm Pilot and a desktop computer, there are many different ways to hack the device such as making it into an MP3 player, an instant messenger client or even a Web server!

The Internet is the ideal meeting ground for people who are separated by physical or mental divides and the *Audreyhacking* project is a prime example of this kind of community. Taking such a simple concept as this device and using it as the basis to experiment and share knowledge is brilliant. As long as the Web can bring people together in this way the better.

Kenneth Tin-Kin Hung (USA): *60X1.COM*

This project was quite unique among the entries this year. It's an amazing example of innovative design and has obviously had a large amount of thought put into it!

The vibrant colour of the site is reflected in the colourful statements that almost shout at you from the page. And the navigation through the site is as unusual as the pages themselves. A totally original site in both design and concept. This is a site that you become lost in, forever following the links that appear, a journey that's been devised for you in the mind of Hung. There

is a slightly black humour to the site, that only serves to enhance the experience and promote it's message more effectively. Excellent work.

Peter Kuthan, Sabine Bitter, Helmut Weber, Thomas Schneider; Arge Zimbabwe Freundschaft (A): *Tonga.Online*

The plight of some of the less advantaged African nations is, thankfully, becoming more public. Projects like *Tonga.Online* are partly to thank for this. This is a website that uses the Internet to facilitate communication amongst a group of people dedicated to aiding others.
One of the main problems that face rural and isolated communities and villages is the lack of a reliable communication channel. So *Tonga.Online* provides people in the Tonga area with resources to communicate and present themselves to the outside world.
This website was chosen because of the way the Internet is being used to aid the people of Tonga by the distribution of information. It's often said that information is the most valuable commodity in the modern world, and so sharing it with people who may normally be excluded has got to be the way forward, for many, many reasons.

Francis Lam (HK): *db-db OUR.DESIGN.PLAYGROUND*

"A fantastically designed interactive space on the Internet" is a good way to describe *db-db*. Seamless methods of interacting with the website and other people make the *db-db* experience what it is, and that's excellent.
Games, chat, personal experiences and photos all go to make up a content-rich website that's very enjoyable to visit.
This is a prime example of the personal site referred to in the introduction to this category. Lam has developed a space that is literally bursting with content and entertainment.
It's an unusual site, with avatar characters representing you online, allowing you to interact with other visitors to the site. This in itself is quite unusual, but very entertaining.
Take the time to explore the different sections and gain an insight to this exceptional designer's mind.

Reise, für uns erdacht im Kopf von Kenneth Hung. Die Site hat einen Anflug von schwarzem Humor, der nur zur Vertiefung der Erfahrung dient – und zur effizienteren Verbreitung ihrer Botschaft. Ausgezeichnete Arbeit.

Peter Kuthan, Sabine Bitter, Helmut Weber, Thomas Schneider; Arge Zimbabwe Freundschaft (A): *Tonga.Online*

Die schlechte Lage einiger weniger glücklichen afrikanischen Nationen rückt zum Glück etwas weiter in den Blickpunkt der Öffentlichkeit, und zum Teil ist dies Projekten wie *Tonga.Online* zu verdanken. Es ist eine Website, die das Internet dazu nützt, um die Kommunikation innerhalb einer Personengruppe zu erleichtern, die sich der Unterstützung anderer widmet.
Eines der Hauptprobleme ländlicher, isolierter Gemeinden und Dörfer ist, dass ein zuverlässiger Kommunikationskanal fehlt. *Tonga.Online* bietet den Menschen im Gebiet der Tongas Ressourcen zur Kommunikation und Selbstdarstellung in der Außenwelt. Diese Website wurde wegen der speziellen Art und Weise, auf die hier das Internet als Hilfsmittel zur Verbreitung von Information im Volk der Tonga verwendet wird, ausgewählt. Oft genug wird darauf hingewiesen, dass Information zu den wichtigsten Gütern der modernen Welt gehört – sie mit Menschen zu teilen, die normalerweise davon ausgeschlossen sind, ist der richtige Weg, aus vielen, vielen Gründen.

Francis Lam (HK): *db-db OUR.DESIGN.PLAYGROUND*

Ein fantastisch gestalteter Raum im Internet ist wohl die beste Beschreibung für *db-db*. Nahtlose Interaktion mit der Website und anderen Menschen machen die *db-db*-Erfahrung zu dem, was sie ist – und sie ist ausgezeichnet.
Spiele, Chats, persönliche Erfahrungen und Fotos wirken zusammen, um eine Website voller Inhalt zu bieten, die zu besuchen eine Freude ist.
db-db ist ein hervorragendes Beispiel für jene persönlichen Websites, die in der Einleitung angesprochen wurden. Lam hat einen Raum gestaltet, der im wahrsten Sinn des Wortes überquillt vor Inhalt und Unterhaltung.
Es ist eine ungewöhnliche Site, mit Avataren, die die Besucher online repräsentieren und ihnen erlauben, mit anderen auf der Site zu kommunizieren. Dies ist schon für sich genommen recht unüblich, und zudem macht es auch noch Spaß.
Nehmen Sie sich die Zeit, die verschiedenen Abteilungen zu erforschen und einen Einblick in die Gedankenwelt dieses außergewöhnlichen Designers zu bekommen.

Elan Lee (USA): *Cloudmakers – the „A.I." Web Game*

Dieses Spiel war Teil der Promotion für den Film *A. I.*, das von Stanley Kubrick unvollendet hinterlassene Projekt, das von Steven Spielberg für DreamWorks gedreht wurde. Warner Bros. hat den Film in den USA am 29. Juni 2001 in die Kinos gebracht.

Das Online-Spiel war recht erfindungsreich; es bestand aus vielen verschiedenen über das ganze Internet verstreuten Websites, die alle die Besucher zu jenen Hinweisen führten, die zur Lösung des Rätsels nötig waren.

Inzwischen ist das Rätsel gelöst und das Spiel vorbei. Dennoch ist die *Cloudmakers*-Site weiterhin ein riesiges Archiv an Informationen über das Spiel und bietet interessante Lektüre.

Auch für diese Idee war die Verwendung des Internets unabdingbar. In keinem anderen Medium hätte eine Campagne wie diese durchgeführt werden können. Und selbst wenn das Spiel inzwischen beendet ist, bleibt mit dieser Site ein Archiv jenes Inhalts, der zur Spielzeit aktiv war. Es schwindelt einen, wenn man an den ganzen organisatorischen Aufwand denkt, den das erfordert haben muss – auch hierfür vollste Anerkennung!

Elan Lee (USA): *Cloudmakers—the A.I. Web Game*

The game was a promotion for A.I. The film was Stanley Kubrick's unfinished project, and was directed by Steven Spielberg for DreamWorks. Warner Bros. released the film in the US on June 29, 2001.

The online game was quite ingenious, being comprised of many different websites spread across the Internet all leading the user to clues to help solve the mystery.

Now the mystery has been solved and the game is over. However the *Cloudmakers* site is a huge depository of information about the game and makes for very interesting reading.

Again, the use of the Internet was crucial to this idea. No other media could have sustained a campaign like this. Even though the game is now over, the site is an archive of the content that was active at the time of the game. The mind boggles at the organization this must have taken, full credit is due!

Carnivore
Radical Software Group (RSG)

In today's high-tech world, data saturates our daily life. While much of this data is ever-present to our eyes and ears—from ringing cell phones to glowing video screens—the data itself is often hidden. Thus the question becomes more and more important: What does data look like? This is the central question answered by *Carnivore*, a new installation artwork for data networks.

Inspired by the FBI software of the same name, *Carnivore* performs an electronic wiretap at its installation locale. The wiretap creates a steady cascade of raw data containing all the email, web, and other traffic being generated at that physical location. The resulting data is fed to a series of artist-made interfaces for visualization and animation.

Since no two data networks are alike, each installation of *Carnivore* takes on the personality of its site. In an office building, *Carnivore* responds like a living organism to the motions of each employee as they work; in a cybercafe, *Carnivore* follows the movements of each patron as they surf the web and check email.

Viewers experience *Carnivore* via video projections and computer kiosks. Each projection or kiosk features a different "window" into the data stream. Internet users may also follow along with the aid of special web-accessible Java applets and Flash movies.

Do hackers read your email? Are your personal demographics being bought and sold on the Net? *Carnivore* tackles these questions head-on, and tests our understanding of both the public and private spheres. More than a simple parody of its FBI predecessor, *Carnivore* breaks new ground by exposing data normally hidden to the public. *Carnivore* inverts the conventional wisdom on data privacy by taking the most dramatic step possible—full surveillance—creating a new form of public art for the Net.

In der heutigen, hoch technisierten Welt ist unser Alltagsleben von Daten übersättigt. Wenn auch viele dieser Informationen stets vor unser aller Augen und Ohren stehen – von läutenden Handys bis zu leuchtenden Videoschirmen –, so bleiben doch die eigentlichen Daten dahinter häufig verborgen. Deswegen wird auch eine Frage immer wichtiger: Wie sehen Daten eigentlich aus? Die Antwort darauf gibt Carnivore, eine neue Installationsarbeit für Datennetze.

Inspiriert vom gleichnamigen FBI-Programm, zapft *Carnivore* elektronisch die Leitungen am Installationsort an. Aus den angezapften Leitungen quillt ein Strom von Rohdaten, der alle Emails, Web- und andere Aktivitäten des jeweiligen physischen Ortes enthält. Dieser Datenstrom wird in eine Serie von künstlerisch gestalteten Interfaces zwecks Visualisierung und Animation eingespeist. Nachdem keine zwei Datennetze gleich sind, bildet *Carnivore* die „Persönlichkeit" des jeweiligen Installationsortes ab. In einem Bürogebäude etwa reagiert *Carnivore* wie ein lebender Organismus auf die Handlungen eines jeden Mitarbeiters bei der Arbeit, in einem Cybercafé verfolgt *Carnivore* die Bewegungen eines jeden Kunden beim Surfen im Netz und beim Abrufen der Emails. Die Zuseher erleben *Carnivore* über Videoprojektion und in Computer-Kiosken mit. Jede Projektion bzw. jeder Kiosk eröffnet ein anderes „Fenster" auf den Datenstrom. Internet-User können den Fluss der Daten auch mithilfe spezieller Java-Applets und Flash-Movies über das Netz verfolgen.

Lesen Hacker Ihre Email? Werden Ihre persönlichen demografischen Daten im Netz angeboten und verkauft? *Carnivore* geht schnurstracks auf diese Anliegen los und testet Ihr Verständnis von öffentlicher und privater Sphäre. *Carnivore* ist mehr als nur eine Parodie seines FBI-Vorgängers: *Carnivore* betritt Neuland, indem es Daten öffentlich macht, die bisher dem Publikum verborgen waren. *Carnivore* kehrt das konventionelle Wissen über Datenschutz um, indem der extremste unter den möglichen Ansätzen – vollständige Überwachung – zur Schaffung einer neuen Form von öffentlicher Kunst im Netz gewählt wird.

"TRIGGER WORDS"
A Carnivore Client
Installation: 315 Mercer Street,
3rd Floor, New York
Start time: Jul 30, 2001 20:11:04
End time: Jul 30, 2001 21:34:22

= my trigger words =

The Radical Software Group (RSG) forms the heart of the *Carnivore* production team. Founded in 2000 by Alexander R. Galloway, the RSG is an all-star collective of computer artists, hand-selected from cities around the world. Continually in flux, RSG membership expands and contracts to accommodate the task at hand. Collaborators are selected according to their unique area of expertise such that advanced production in several genres of contemporary computer art is possible, including network environments and interface design. **Die Radical Software Group (RSG)** stellt das Herzstück des *Carnivore*-Produktionsteams dar. Die im Jahr 2000 von Alexander R. Galloway gegründete RSG ist ein All-Star-Kollektiv von handverlesenen Computerkünstlern aus Städten aus der ganzen Welt. Der Mitgliederstand der RSG ist ständig im Fluss und erweitert oder verringert sich je nach den vorliegenden Aufgaben. Mitarbeiter werden je nach ihren besonderen Fähigkeiten ausgesucht, sodass eine leistungsfähige Produktion in verschiedenen Bereichen der zeitgenössischen Computerkunst, darunter auch Netzwerk-Environments und Interface-Design, möglich wird.

./logicaland
Michael Aschauer, Josef Deinhofer, Maia Gusberti, Nik Thönen

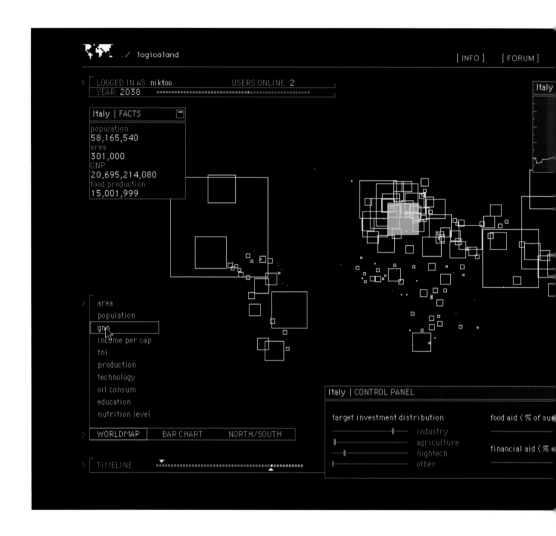

./logicaland is a project study for visualizing our world's complex economical, political and social systems. It tries to engage people into strategies of raising human sensibility and responsibility within the global networked society. The challenge is to develop ideas, tools and visualizations that fit the requirements of complex correlating systems and our world's complex participative environment.
./logicaland v0.1 is a work in progress, an attempt to realize a prototype of a global simulation that is to be controlled by a community of unlimited participants.
Based on a scientific global world model of the mid-seventies(*), modified and hacked to fit our

./logicaland ist eine Projektstudie zur Visualisierung komplexer ökonomischer, politischer und sozialer Systeme in unserer Welt. Es versucht, Menschen in Strategien zur Steigerung des Problem- und Verantwortungsbewusstseins innerhalb der vernetzten globalen Gesellschaft einzubinden. Die Herausforderung besteht darin, Ideen, Werkzeuge und Visualisierungsmöglichkeiten zu entwickeln, die den Bedürfnissen komplexer korrelierender Systeme und der komplexen partizipativen Umwelt dieser Erde angepasst sind.
./logicaland v.0.1 ist ein Work-In-Progress, ein Versuch, einen Prototypen einer globalen Simulation zu realisieren, die von einer Gemeinschaft unbegrenzt vieler Mitwirkenden gesteuert wird.

Basierend auf einem wissenschaftlichen Globalmodell der Welt aus der Mitte der 1970er-Jahre(*), das unseren Konzepten entsprechend modifiziert und angepasst wurde, haben wir ein Werkzeug entwickelt, das es Menschen erleichtert, an einer Simulation teilzunehmen – ganz anders als im wissenschaftlichen Bereich, der weder partizipativ noch öffentlich ist.

Das Hauptziel besteht darin, eine öffentliche netzgestützte Welt-Simulation innerhalb einer partizipativen Umgebung zu erstellen, die allen Usern den gleichen Einfluss auf das System garantiert. Jeder, der einen Internetanschluss hat, soll an ./logicaland teilnehmen können. Zwar ist der Einfluss des einzelnen Users auf das System minimal, da er ja nur einen Bruchteil der Aktionen aller

concepts, we have developed a tool that facilitates people to take part in a simulation, unlike tools in the scientific field which are neither participative nor public.

The main idea is to provide a public web-based world-simulation within a participative environment, where all users have equal influence on the system. Everyone with Internet access should be able to participate in ./logicaland. One user's influence on the system is minimal since it is a fraction of all participants' actions. Only if a lot of users follow similar strategies, can serious change be achieved. We want to invite users all over the world to take part in dealing with global interrelationships by

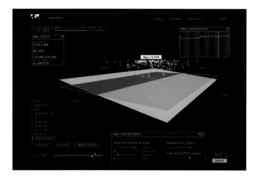

contributing to logicaland's simulation. At this stage *./logicaland* is a prototype but it aims to turn out into a worldwide "social game".

(*) [./logicaland] is currently based on *rw-3*, a global world model developed in the mid-1970's by Fred Kile and Arnold Rabehl in Wisconsin, USA. Global world models can be unterstood as "computer programs that simulate the world in a very broad, comprehensive manner. Geographically, they encompass the entire world or at least a major portion of it. More importantly, they explicitly link together a number of components or aspects of our world such as economics, demographics, politics, and the environment. Because of these traits, integrated global models can be and are used as tools to help us understand processes, whose effects cross national borders and whose study crosses disciplinary boundaries."(Pete Brecke)

Mitwirkenden darstellt, aber wenn eine Menge Anwender ähnliche Strategien verfolgen, können ernsthafte Veränderungen erreicht werden.
Wir wollen User aus der ganzen Welt einladen, an diesem globalen Beziehungsgeflecht mitzuarbeiten, indem sie zu *./logicaland*s Simulation beitragen. Bisher ist *./logicaland* nur ein Prototyp, aber es zielt darauf ab, sich zu einem weltweiten „sozialen Spiel" zu entwickeln.

(*).*/logicaland* basiert derzeit auf *rw-3*, einem globalen Weltmodell, das Mitte der 70er-Jahre von Fred Kile und Arnold Rabehl in Wisconsin, USA, entwickelt wurde. Globale Weltmodelle können als Computerprogramme verstanden werden, „die die Welt in einer breiten und verständlichen Weise simulieren. Geografisch umfassen sie den gesamten Globus oder zumindest den größten Teil davon. Noch wichtiger ist aber, dass sie explizit einen Großteil der Komponenten unserer Welt vernetzen, wie etwa Wirtschaft, Demografie, Politik und Umwelt. Wegen dieser Struktur können integrierte globale Modelle als Werkzeuge angesehen und eingesetzt werden, die uns helfen, Prozesse zu verstehen, deren Auswirkungen nationale und deren Studium disziplinäre Grenzen überschreiten." (Pete Brecke)

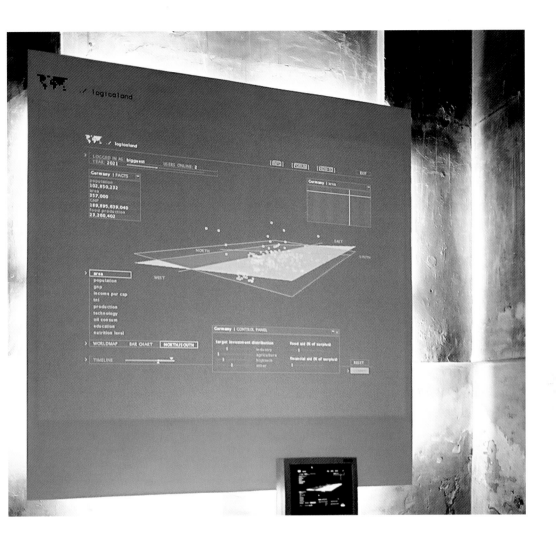

Josef Deinhofer (A) studied computer science and visual media design in Vienna. **Nik Thönen (CH)** graduated from the School for Design in Biel; he has been working as an artist as well as a graphic and interface designer in Vienna since 1995. **Michael Aschauer (A)** studied computer science and media design in Vienna, where he still resides; he works as an artist and freelance programmer. **Maia Gusberti (CH)** worked as a freelance graphic artist in Biel; in 1995 she moved to Vienna, where she studied visual media design at the University for Applied Arts; she has been working as an artist and web designer since 1998. **Josef**

Deinhofer (A) studierte Informatik und visuelle Mediengestaltung in Wien. **Nik Thönen (CH)** absolvierte die Schule für Gestaltung in Biel und arbeitet seit 1995 als Künstler und Grafik- und Interface-Designer in Wien. **Michael Aschauer (A)** studierte Informatik und Medien-gestaltung in Wien und lebt dort als Künstler und freier Programmierer. **Maia Gusberti (CH)** arbeitete als freiberufliche Grafikerin in Biel und übersiedelte 1995 nach Wien, wo sie an der Universität für angewandte Kunst visuelle Mediengestaltung studierte und seit 1998 als Künstlerin und Webdesignerin arbeitet.

BotFighters
It's Alive

BotFighters—a location-based mobile game, where you design your robot on the game's website, then battle against other players out on the streets.

The Game

BotFighters is the world's first location-based mobile game that takes advantage of mobile positioning and lets the users play using a standard GSM phone over SMS.
BotFighters is an action game with a robot theme, and is aimed at hardcore gamers. In the game, the players locate and shoot at each other with their mobile phones out on the streets, and mobile positioning is used to determine whether the users are close enough to each other to be able to hit.
On the *BotFighters* website, the players can upgrade their robots, buy weapons, view highscores and get information on their current mission. The website is used for community building and to create an exciting game atmosphere, but the actual gameplay is carried out on the mobile phone. The phone then becomes the player's radar and weapon device. It's like playing *Quake*[1] but in the real world, and it's the most thrilling game experience you will see on a mobile phone this year.
In the games the player is a part of a continuously ongoing role play adventure, taking place in a virtual world draped over the real physical world. Through the mobile phone and the web the player may interact and build relationships with other players out on the streets. As the player's physical location will influence how the game evolves, it's not always easy to tell reality from fiction.
A player joining a pervasive mobile game from It's Alive will take on a role play character in an ever-evolving adventure. The player can at any time be contacted by the game or attacked by

BotFighters ist ein mobiles ortsgebundenes Spiel, bei dem man auf der Website des Spiels zunächst seinen Roboter entwirft und anschließend draußen auf der Straße gegen andere spielt.

Das Spiel

BotFighters ist das erste mobile Location-based-Spiel, das die Vorteile mobiler Positionierung ausnützt und die User mittels eines Standard-GSM-Handies über SMS spielen lässt.
BotFighters ist ein Action-Spiel rund um Roboter und zielt auf die Gruppe der Hardcore-Gamer ab. Die Spieler lokalisieren einander und schießen mit Hilfe ihrer Handies aufeinander, und die Positionsbestimmung der Handies wird verwendet, um festzustellen, ob sie sich überhaupt in Schussweite voneinander aufhalten. Auf der *BotFighters*-Website können die Spieler ihre Roboter upgraden, Waffen kaufen, Spielstände ansehen und Informationen über ihre gegenwärtige Mission abrufen. Die Website dient der Schaffung einer Community und einer spannenden Spielatmosphäre; das eigentliche Spiel aber läuft über die Mobiltelefone, die zum Radar und zur Waffe der Spieler werden. Das Spiel ist eine Art *Quake*[1], das in der Wirklichkeit stattfindet, und sicherlich die spannendste Spielerfahrung des Jahres auf dem Handy.
Die Spieler sind Teil eines immer fortschreitenden Rollenspiels, das in einer über die Wirklichkeit gestülpten virtuellen Welt abläuft. Über Mobiltelefon und Web können die Spieler interagieren und Beziehungen zu anderen Spielern draußen aufbauen. Da der physische Aufenthaltsort des Spielers den Spielverlauf entscheidend beeinflusst, ist es nicht immer leicht, Wirklichkeit und Fiktion auseinanderzuhalten.
Ein Spieler, der sich einem der umfassenden mobilen Spiele von It's Alive anschließt, übernimmt eine Rolle in einem sich stets weiterentwickelnden Abenteuer. Spieler können jederzeit vom Spiel kontaktiert oder von anderen Spielern in der Nähe angegriffen und so in die Handlung einbezogen werden. Die Spiele sind

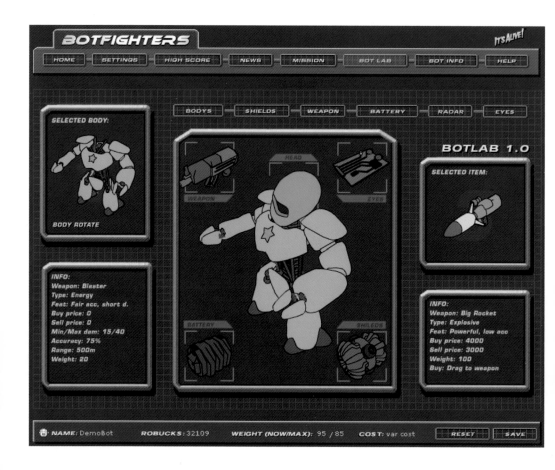

other players in the vicinity and be pulled into the action. The games are a mix between role-play, adventure, action and community, and they use multiple channels such as WAP, SMS, web, voice and also game consoles and TV. The ambition is to create game experiences where it is hard to tell game from reality.

ein Gemisch aus Rollenspiel, Abenteuer, Action und Community-Feeling und stützen sich auf eine Vielzahl von Kommunikationskanälen wie WAP, SMS, Web und Stimme, aber auch Spielkonsolen und TV. Ziel ist es, eine Spielumgebung zu schaffen, die nur schwer von der Wirklichkeit zu unterscheiden ist.

[1] Quake is a registered trademark of id Software Corporation.

[1] Quake ist ein eingetragenes Warenzeichen der id Software Corporation.

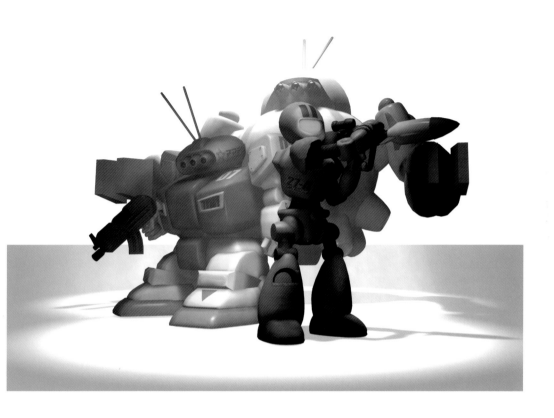

It's Alive Mobile Games (www.itsalive.com) (S) is the provider of pervasive games, determined to create the greatest game experiences ever seen on mobile phones. The company was founded in February 2000, and started development of It's Alive's advanced game platform Matrix, and the first game *BotFighters.* Speed Ventures invested seed capital, and shortly after, It's Alive signed partnership agreements with Ericsson, SignalSoft, CellPoint, and Mobilaris. The Crew members are: Sven Hålling (CEO), Ivar Gaitan (System Architect), Björn Ekengren (Operations Manager), Christof Molund (CFO), Tom Söderlund (Game Producer), Johan Rahm (Development Manager). **It's Alive Mobile Games (www.itsalive.com) (S)** ist ein Spiele-Provider und bemüht sich,

die großartigste Spielerfahrung zu bieten, die je auf Handy zu bekommen war. Das Unternehmen wurde im Februar 2000 gegründet und begann sofort mit der Entwicklung seiner ausgefeilten Spielplattform Matrix und mit dem ersten Spiel *BotFighters.* Startkapital kam von Speed Ventures; kurz darauf wurden Abkommen mit Ericsson, SignalSoft, CellPoint und Mobilaris geschlossen. Die Crew von It's Alive besteht aus: Sven Hålling (Unternehmensleiter), Ivar Gaitan (System-Architekt), Björn Ekengren (Operations Manager), Christof Molund (Finanzen), Tom Söderlund (Spieleproduzent), Johan Rahm (Entwicklungsleiter).

Macromedia Flash
Jonathan Gay

Macromedia Flash began with a few bits of colored plastic. As a child, I grew up playing with LEGOs when there were no LEGO men or whales or complicated accessory packs—just rectangular blocks and a few wheels. Those bits of colored plastic taught me the basics of engineering design, how to choose a design problem, and the process of iterative refinement. Even better, they helped me express my early passion for building things. My favorite project was building LEGO ships with lots of ramps that could hold my toy cars. This taught me that it's best to choose a problem that inspires you and challenges you—and one that you can accomplish with your limited capabilities and resources.

The human mind is much too limited to capture the entirety of a complex creation all at once. With LEGO, you can start with the vision and work out the details of the design as you progress. With patience and persistence, I developed the following LEGO-based design process. It's more or less the same process we ultimately used to develop Flash. Choose a problem: Build a LEGO ship. Develop a vision: What sort of ship will it be? How big will it be? What will it carry? Build: Build the framework of the ship. Fill in the details: Design and build the details of the ship, ramps, doors, etc. Test: Drive the cars around the ship and sail the ship while exploring the house. Refine: Take parts of the ship apart and make them better. Learn: Take what you learned from building this ship and use it to build a better one next time.

How FutureSplash Animator was Born

In the summer of 1995, we were at SIGGRAPH and got lots of feedback from people that we should turn *SmartSketch*, that we had developed for pen-computing, into an animation product. We were starting to hear about the Internet and the Web, and it seemed possible that the Internet would become popular enough that people would want to send graphics and animation over it. So we began to add animation to *SmartSketch*. At the time, the only way to extend a Web browser to play back animation was through Java. So we wrote a simple animation player that used Java and was horribly slow. We stubbornly kept at it though, and in the fall, Netscape came out with

Eigentlich hat *Macromedia Flash* mit ein paar Teilen aus buntem Plastik angefangen. Als Kind wuchs ich mit LEGO auf, zu einer Zeit, da es noch keine LEGO-Männchen oder Wale oder komplizierte Zubehörpackungen gab – nur einfache rechteckige Bausteine und ein paar Räder. Diese kleinen Plastikteile lehrten mich die Grundlagen des Konstruierens – wie man ein Design-Problem erkennt und die Lösung durch Iteration verbessert. Genauer gesagt, sie halfen mir dabei, meine frühe Leidenschaft für das Bauen von Dingen auszudrücken.
Mein Lieblingsprojekt war es, LEGO-Schiffe mit vielen Rampen, die all meine Spielzeugautos aufnehmen konnten, zu bauen. Dabei lernte ich, dass es am besten ist, sich ein Problem vorzunehmen, das einen inspiriert und herausfordert und dem man im Rahmen seiner beschränkten Möglichkeiten und Ressourcen zu Leibe rücken kann.

Der menschliche Geist ist viel zu begrenzt, um die Gesamtheit einer komplexen Schöpfung auf einmal zu erfassen. Bei LEGO kann man mit der Vision beginnen und die Details des Designs während der Arbeit ausformen. Mit Geduld und Ausdauer habe ich folgenden LEGO-basierten Entwicklungsprozess ausgearbeitet, der mehr oder weniger jenem entspricht, den wir auch bei der Entwicklung von *Flash* angewendet haben: Wähle ein Problem: Baue ein LEGO-Schiff. Entwickle eine Vision: Welche Art von Schiff soll es sein? Wie groß wird es werden? Was soll es transportieren? Baue: Baue das Grundgerüst des Schiffs. Setze die Details ein: Entwirf und bau die Schiffsdetails, Rampen, Tore usw. Verfeinere: Nimm Teile des Schiffs auseinander und baue sie besser. Lerne: Nimm das, was du beim Schiffsbau gelernt hast, und verwende es, um das nächste Mal ein besseres Schiff zu bauen.

Wie FutureSplash Animator geboren wurde

Im Sommer 1995 waren wir von Futurewave auf der SIGGRAPH und bekamen jede Menge Feedback von Leuten, die uns sagten, wir sollten das für Pen-Computing entwickelte *SmartSketch* doch in ein Animationswerkzeug umwandeln. Wir wussten vom Internet und vom Web, und es schien uns möglich, dass es einmal so populär werden könnte, dass Leute Grafiken und Animationen darüber verschicken würden. So begannen wir, *SmartSketch* mit Animationsfähigkeit auszustatten. Damals musste man Java verwenden, um einen Webbrowser so zu erweitern, dass er auch Animation abspielen konnte. Deswegen schrieben wir einen

einfachen Animations-Player, der auf Java basierte und fürchterlich langsam war. Wir blieben hartnäckig am Ball, und im Herbst des Jahres kam dann auch Netscape mit einer Schnittstelle für Plug-Ins heraus. Endlich hatten wir eine Möglichkeit, den Webbrowser bei halbwegs anständiger Leistung zu erweitern – und das war der Vorläufer des *Macromedia Flash Player*.

Kurz vor der Auslieferung änderten wir den Namen auf *FutureSplash Animator* um, um die Animationsfähigkeiten stärker in den Vordergrund zu rücken. Auch waren wir es leid, ein Unternehmen zu führen, das ständig mit Kapitalsorgen zu kämpfen hatte. Wir versuchten daher, unsere Technologie zu verkaufen. Nach erfolglosem Anklopfen bei Adobe und nach Ablehnung eines Angebots von Fractal Design haben wir den *FutureSplash Animator* im Mai 1996 ausgeliefert.

Microsoft, Disney und Macromedia Flash 1.0

Unser großer Erfolg kam im August 1996. Microsoft arbeitete am MSN und wollte die TV-ähnlichste Erfahrung im ganzen Netz anbieten. Dort war man von FutureSplash begeistert und übernahm die Technologie. Ich bin immer noch erstaunt darüber, dass sie den Start von MSN von einer nagelneuen Animationstechnologie abhängig gemacht haben, die von einem Sechs-Personen-Unternehmen entwickelt wurde!

Unser anderer Hauptkunde war Disney Online. Dort wurde *FutureSplash* verwendet, um Animationen und das User-Interface für Disney Daily Blast zu bauen. Disney arbeitete auch mit Macromedia Shockwave. Im November 1996 hatte Macromedia über die Disney-Schiene genug über uns gehört, um uns wegen einer Zusammenarbeit zu kontaktieren. Wir hatten unsere Firma FutureWave vier Jahre lang mit einer Gesamtinvestition von 500.000 Dollar betrieben. Der Gedanke, einen größeren Partner zu haben, um das Produkt zu etablieren, schien uns gut, so verkauften wir im Dezember 1996 FutureWave Software an Macromedia, und der *FutureSplash Animator* wurde zu *Macromedia Flash 1.0*.

their plug-in API. Finally, we had a way to extend the Web browser with decent performance (this was the ancestor of *Macromedia Flash Player*). As it grew close to shipping time, we changed the name of our software to *FutureSplash Animator* to focus more on its animation capabilities. We also were growing tired of running a company that didn't have much money to spend, and began trying to sell our technology. After an unsuccessful pitch to Adobe and turning down a bid from Fractal Design, we shipped *FutureSplash Animator* in the summer (May) of 1996.

Microsoft, Disney and Macromedia Flash 1.0

Our big success came in August of 1996. Microsoft was working on MSN and wanted to create the most TV-like experience on the Internet. They became big fans of *FutureSplash* and adopted the technology. I'm still amazed that they made their launch of MSN dependent on a new animation technology from a six-person company! Our other high-profile client was Disney Online. They were using *FutureSplash* to build animation and the user interface for the Disney Daily Blast. Disney was also working with Macromedia Shockwave. In November of 1996, Macromedia had heard enough about us through their relationship with Disney and approached us about working together. We had been running FutureWave for four years with a total investment of $500,000. The idea of having a larger company's resources to help us get *FutureSplash* established seemed like a good one. So in December 1996, we sold Future-Wave Software to Macromedia, and *FutureSplash Animator* became *Macromedia Flash 1.0*.

Jonathan Gay (USA) is Vice President of Technology for Macromedia. Gay leads an advanced technology group helping to define the future of Macromedia Flash. Gay founded FutureWave Software in 1993, where he created the software that eventually became Macromedia Flash, and he has led the development of every version of the product through 4.0. Gay started his programming career building the Macintosh computer games Airborne!, Dark Castle, and Beyond Dark Castle. They were the first Mac games with digitized sound. Gay graduated from Harvey Mudd College with a B.S. in engineering. **Jonathan Gay (USA)** ist Vizepräsident für Technologie bei Macromedia. Er leitet eine Forschungsgruppe, die die Zukunft von *Flash* definieren hilft. 1993 gründete Gay FutureWare Software, wo er jene Software entwickelte, die später zu *Macromedia Flash* wurde, und er war für die Entwicklung einer jeden Version bis 4.0 verantwortlich. Seine Programmierkarriere begann Gay als Entwickler der Macintosh-Spiele *Airborne!*, *Dark Castle* und *Beyond Dark Castle*. Diese waren die ersten Mac-Spiele mit digitalem Sound. Gay ist Absolvent des Harvey Mudd College und Bachelor of Science aus Ingenieurwesen.

The Third Place
Alexandra Jugovic / Florian Schmitt / Hi-Res!

The Third Place is the brand idea of PlayStation2 across all European markets. The concept centers on the idea that PlayStation2 is a gateway to another world—the Third Place.

This is a mental or spiritual place, which can't be defined as it's different for everyone. No one can tell you about your Third Place, you have to discover it for yourself. The Third Place is about exploration, discovery and adrenaline. Neither inside nor outside, not waking nor sleeping, here nor there—the Third Place is what you make it.

The Third Place undergoes constant mutation through use/play, the Third Place is a place where the impossible becomes possible.

Over the course of 2002, thethirdplace.com will develop into an online art-gallery, designed and curated by Hi-Res! and sponsored by PS2. The idea is to commission artists to develop interactive pieces based on their idea of the

The Third Place ist ein Markenkonzept hinter PlayStation2, das auf allen europäischen Märkten verankert ist. Das Konzept beruht auf der Überlegung, dass die PlayStation2 ein Gateway zu einer anderen Welt ist – eben zu The Third Place, dem „Dritten Ort".

Dieser Ort ist ein geistiger, spiritueller Ort, der nicht eindeutig definiert werden kann, weil er für jeden anders aussieht. Niemand kann Ihnen etwas über Ihren Dritten Ort erzählen, Sie müssen ihn selbst entdecken. Beim Dritten Ort geht es um Erforschung, Entdeckung und Adrenalin. Weder drinnen noch draußen, weder wach noch schlafend, weder hier noch dort – der Dritte Ort ist, was Sie daraus machen.

The Third Place ist durch seine Verwendung bzw. das Spiel ständiger Mutation unterworfen, ein Ort, an dem das Unmögliche möglich wird.

Im Lauf des Jahres 2002 wird sich The Third Place in eine Online-Kunstgalerie entwickeln, die von Hi-Res! entworfen und kuratiert und von Sony PS2 gesponsort wird. Künstler sollen beauftragt werden, interaktive Tools

zu entwickeln, die auf ihrer eigenen Vorstellung des Dritten Ortes basieren; jedes Stück ist im Raum verankert.

Zur ersten Phase, die bis einschließlich Juni 2002 gedauert hat, haben unter anderem Joshua Davis, Insertsilence, Daniel Brown, Soulbath, Yugo Nakamura, James Tindall, Niko Stumpo, Han Hoogerbrugge und Hi-Res! beigetragen.

third place, every piece is located in the space. Contributors to the first phase, which runs until June 2002, include Joshua Davis, Insertsilence, Daniel Brown, Soulbath, Yugo Nakamura, James Tindall, Niko Stumpo, Han Hoogerbrugge and Hi-Res!

Hi-Res! is a highly awarded digital media company based in London founded in 1999 by Florian Schmitt and Alexandra Jugovic. Both Schmitt and Jugovic studied arts at the Hochschule für Gestaltung Offenbach/Germany and worked for numerous clients in the entertainment industry through various companies before setting up Hi-Res! They initially gained widespread recognition for their experimental site *soulbath.com* and the associated exhibition of art-banners entitled *clickhere!*.

Hi-Res! ist ein mehrfach preisgekröntes Digital-Media-Unternehmen mit Sitz in London, gegründet 1999 von Florian Schmitt und Alexandra Jugovic. Beide haben Kunst an der Hochschule für Gestaltung in Offenbach (D) studiert und für zahlreiche Kunden im Bereich der Unterhaltungsindustrie bei verschiedenen Firmen gearbeitet, bevor sie sich mit Hi-Res! selbstständig machten. Gleich von Anfang an erwarben sie große Anerkennung für ihre experimentelle Site *soulbath.com* und für die zugehörige Ausstellung von Art-Banners unter dem Titel *clickhere!*.

Audreyhacking
Harper Reed

Gegen Ende der 90er- Jahre, als die „Internet Appliance"-Welle gerade am höchsten schwappte, brachte 3Com eine kleine, hübsche, selbstständige Internet-Maschine heraus, die Email, Web-Browsing und ein Adressbuch anbot – genau das Richtige für Leute mit wenig Computererfahrung.

Das „Audrey" genannte Gerät sollte im Heimcomputerbereich die gleiche Rolle spielen, wie sie der Palm Pilot bei den Handhelds spielt: ein einfaches, konsistentes Interface bieten, ohne den User mit technischen oder Konfigurationsfragen zu belästigen.

Leider hatte „Audrey" einige erhebliche Startprobleme: Der Preis war mit ursprünglich 600 USD zu hoch, der Browser war langsam, und viele der angekündigten Dienstleistungen wie Lebensmittelzustellung oder die Online-Apotheke kamen nie zustande. Als 3Com diese Maschinen aus dem Programm nahm und die restlichen um rund 100 Dollar pro Stück verschleudert wurden, bildete sich eine Community von „Audrey"-Hackern, die mit diesem kleinen, (jetzt auch) billigen, vernetzbaren Computer herumzubasteln und Software für ihn zu schreiben begann.

Audreyhacking.com ist die zentrale Sammelstelle für alle Informationen mit „Audrey"-Bezug. Dort wird Schritt für Schritt der Zugang zum Linux-ähnlichen QNX-Betriebssystem erläutert, es gibt Links und Troubleshooting-Tipps für fast jede nicht von 3Com für „Audrey" entwickelte Anwendung. Für viele hat diese Netzressource ein ursprünglich schlecht entwickeltes, übertuertes und leistungsschwaches Gerät in eine erschwingliche und leistungsfähige MP3-Stereo-Anlage verwandelt – oder in einen digitalen Bilderrahmen oder in eine Netzkonsole fürs Wohnzimmer oder in ein Zusatzgerät zum Telephon, oder …

In the late 90's, at the height of the "internet appliance" craze, 3Com released a small, cute, single-unit "internet machine" which provided email, web browsing, and an address book—intended for people with little computer experience.

The "Audrey" was supposed to do for the home computer what the Palm Pilot had done for the handheld computer: provide a simple, consistent interface and not bog the user down in configurations or technical details.

Unfortunately, the "Audrey" had a number of technical problems: the price was too high (originally USD 600), the browser was slow, and many services—such as food delivery, and an online pharmacy—never materialized. However, once 3Com had ceased distribution of these machines, and they were liquidated for around USD 100 per unit, a community of hackers formed around the "Audrey" to write software and tinker with these cute, cheap, networkable computers.

Audreyhacking.com is the central tome of all "Audrey"-related information. It can walk you through the steps of getting at the underlying QNX (like Linux) operating system, and has links and troubleshooting for almost every non-3Com application written for the "Audrey". For many, this resource has turned what was a poorly-executed, overpriced, underpowered net-appliance into an affordable and superior MP3 stereo unit—or a digital picture frame—or a living room console—or a telephone caller-ID unit.

Harper Reed (USA) somehow around 1994 stumbled across the Internet. It could have been the mysterious dialup that led to gopher and MUDs or maybe it was the strange BBSs that kept offering Internet mail. Whatever the reason, Harper has been experimenting with online communities ever since. Having been influenced by the likes of *2600 magazine* and *&TOTSE*, Harper believes in fostering a community where information can be freely exchanged and archived. He is always looking toward the open source community to help provide an infrastructure to power his web applications. Harper can be reached at harper@nata2.org. **Harper Reed (USA)** stolperte irgendwann um 1994 über das Internet. Vielleicht waren es die mysteriösen Einwahl-Netzwerke, die einen zu Gopher und MUDs brachten, vielleicht auch die seltsamen Bulletin-Boards, die Internet-Mail anboten – was immer ihn festgehalten haben mag, seither experimentiert Harper jedenfalls mit Online-Communities. Beeinflusst von Quellen wie dem *2600 Magazine* und *&TOTSE* glaubt Harper fest an die Förderung einer Gemeinschaft zum freien Austausch und zur Archivierung von Informationen. Er hält stets ein Auge auf die Open-Source-Community im Bemühen um die Bereitstellung einer Infrastruktur zum Betrieb seiner Web-Anwendungen. Harper kann erreicht werden über harper@nata2.org.

They Rule

Josh On / Futurefarmers

America is a class divided society. There is no greater contradiction in our society than the fact that the majority of the people who do the work are not the ones who reap the benefit. In 1998 the top 1 percent of the population owned 38 percent of the wealth, the top 5 percent owned over 60 percent (source: *www.inequality.org/factsfr.html*). That was the situation in "the boom years". This inequality might be overlooked as long as the people at the bottom end of the scale have what they need. They don't. According to the *CIA World Fact Book* 12.5 percent of Americans live below the poverty line. There is enough to go round, we just have a system that doesn't let it flow. We have a system, which perpetuates the accumulation of wealth amongst a very small section of the population, known in socialist terms as the ruling class.

They Rule is an attempt to show some of the internal relations of the ruling class. Specifically it maps the interlocking directories of the Fortune 100 companies in 2001. The board members of these companies often sit on more than one of the *Fortune* 100 boards and often many other boards beyond that. *They Rule* has a database of these companies and their board members, and has a graphic interface which allows a visitor to the site to browse through the connections.

The visitor can select one of the 100 companies and move an icon of its boardroom table onto the screen. A click on a plus sign above the table will reveal a menu of options, including one to reveal the companies' board of directors. The directors expand from the table as little people icons, connected back to the table with corporate grey lines. Some of the directors are more rotund than others, their size indicates the number of *Fortune* 100 boards they sit on. Clicking on their briefcases provides an option to expand their connections and reveal the other boards they sit on, the boardroom tables of those other companies appear around them, connected with more grey lines. After a few interactions of this the stage is cluttered with a maze of connections. In 2001 more than 90% of the Fortune 100 companies shared board members with at least one other Fortune 100 company. This is not a completely surprising or coveted fact. When selecting board members for a profitable corporation, birthright may be one factor, but experience is another. It makes sense from a

Die USA sind eine in Klassen unterteilte Gesellschaft. Es gibt keinen größeren Widerspruch in diesem Land als die Tatsache, dass die meisten der Leute, die die Arbeit verrichten, nicht zu jenen gehören, die deren Früchte ernten. 1998 besaß das reichste Prozent der Bevölkerung 38 Prozent des Gesamtvermögens, und die obersten fünf Prozent der Besitzstatistik besaßen über 60 Prozent (Quelle: *www.inequality.org/fatcsfr.html*). Das war die Situation in den Boom-Jahren. Nun könnte man über diese Ungleichheit hinwegsehen, solange die Menschen am unteren Ende der Skala alles haben, was sie brauchen. Aber dem ist nicht so. Nach den Angaben des *CIA World Fact Book* leben 12 Prozent der Amerikaner unter der Armutsgrenze. Es gibt genug für alle, wir haben bloß kein System, das das Einkommen gerecht verteilen würde. Wir haben ein System, das die Anhäufung von Vermögenswerten bei jenem sehr kleinen Teil der Bevölkerung auf Dauer festschreibt, der in sozialistischer Terminologie „die herrschende Klasse" genannt wird.

They Rule ist ein Versuch, einige der internen Beziehungen innerhalb dieser herrschenden Klasse aufzuzeigen. Genauer gesagt, bildet es die Verknüpfungen zwischen den Vorständen und Aufsichtsräten der hundert reichsten Unternehmen im Jahre 2001 ab. Die Vorstandsmitglieder dieser Unternehmen sitzen nämlich häufig in mehr als einem der *Fortune*-100-Boards (und nicht selten auch noch in weiteren). *They Rule* hat eine Datenbank all dieser Unternehmen und ihrer Führungskräfte und erlaubt es den Besuchern der Website über eine grafische Oberfläche, diese Verbindungen abzufragen.

Besucher können eine der 100 Firmen auswählen und das zu deren Aufsichtsrat und Vorstand gehörige Symbol auf den Bildschirm ziehen. Ein Klick auf das Pluszeichen neben dem Tischsymbol öffnet ein Menü von Optionen, darunter auch die Möglichkeit, sich den Vorstand anzeigen zu lassen. Die Vorstandsmitglieder werden als kleine Männchen angezeigt, die mit dem Tisch durch graue Linien verbunden sind. Manche der Direktoren sind rundlicher als andere, was darauf hinweist, dass sie in mehr als einem *Fortune*-100-Unternehmen sitzen. Ein Klick auf ihre Aktenkoffer ermöglicht es, ihre Verbindungen darzustellen und ihre anderen Aufsichtsrats- bzw. Vorstandsposten anzuzeigen; das gesamte Direktorium jener Unternehmen erscheint dann wiederum auf dem Bildschirm mit weiteren Verbindungslinien, und so fort. Einige wenige Interaktionen auf dieser Ebene genügen, um den Bildschirm mit einem dichten Geflecht von Verbindungen zu füllen.

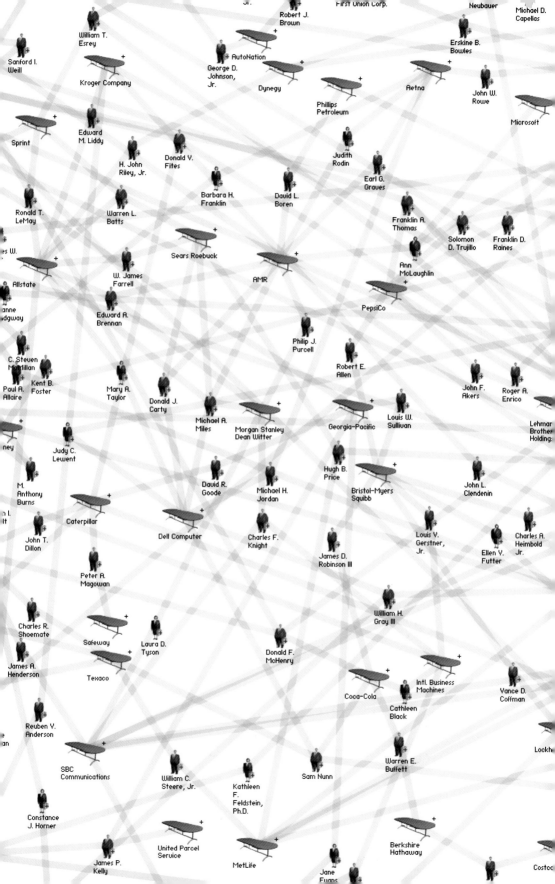

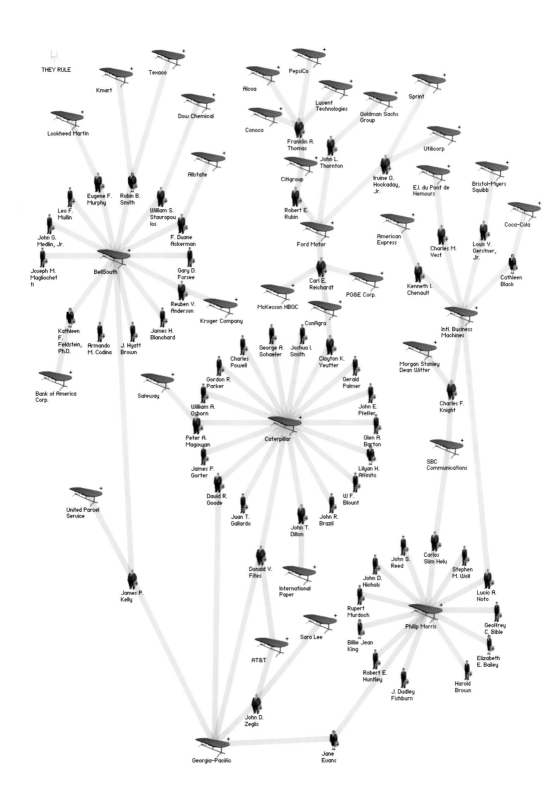

THEY RULE

Kmart · Texaco · Lookheed Martin · Dow Chemical · Alcoa · PepsiCo · Lucent Technologies · Conoco · Sprint · Goldman Sachs Group · Utilicorp · Franklin A. Thomas · John L. Thornton · Irvine O. Hockaday, Jr. · E.I. du Pont de Nemours · Bristol-Myers Squibb · Citigroup · Charles M. Vest · Louis V. Gerstner, Jr. · Coca-Cola · Eugene F. Murphy · Robin B. Smith · Allstate · Leo F. Mullin · William S. Stavropoulos · Robert E. Rubin · American Express · Cathleen Black · John G. Medlin, Jr. · F. Duane Ackerman · Ford Motor · Joseph M. Magliochetti · BellSouth · Gary D. Forsee · Carl E. Reichardt · PG&E Corp. · Kenneth I. Chenault · Reuben V. Anderson · McKesson HBOC · ConAgra · Intl. Business Machines · Kathleen F. Feldstein, Ph.D. · Armando M. Codina · J. Hyatt Brown · James H. Blanchard · Kroger Company · George A. Schaefer · Joshua I. Smith · Clayton K. Yeutter · Morgan Stanley Dean Witter · Charles Powell · Gerald Palmer · Bank of America Corp. · Safeway · Gordon R. Parker · William R. Osborn · Caterpillar · John E. Pfeffer · Charles F. Knight · Peter A. Magowan · Glen A. Barton · James P. Gorter · Lilyan H. Affinito · SBC Communications · David R. Goode · W F. Blount · Juan T. Gallardo · John R. Brazil · United Parcel Service · John T. Dillon · John S. Reed · Carlos Slim Helu · Stephen M. Wolf · John D. Nichols · Lucio A. Noto · Donald V. Fites · International Paper · Rupert Murdoch · Philip Morris · Geoffrey C. Bible · James P. Kelly · Billie Jean King · Elizabeth E. Bailey · Sara Lee · Robert E. Huntley · J. Dudley Fishburn · Harold Brown · AT&T · John D. Zeglis · Georgia-Pacific · Jane Evans

Im Jahr 2001 teilten mehr als 90 Prozent der 100 größten US-Unternehmen mindestens ein Direktoriumsmitglied mit einem anderen solchen Unternehmen. Das ist weder eine besonders erstaunliche noch eine beneidenswerte Tatsache. Bei der Auswahl von Direktoriumsmitgliedern eines profitablen Unternehmens mag zwar Anciennität eine Rolle spielen, ebenso wichtig aber ist Erfahrung. Es macht – aus Sicht eines Unternehmens – Sinn, Leute in den Vorstand oder Aufsichtsrat zu berufen, die Erfahrung in der Leitung mächtiger Firmen haben. Und tatsächlich sind viele der Direktoren auch stolz auf ihre vielen verschiedenen Sessel. Dass diese Erkenntnis nicht neu ist, macht sie um nichts weniger faszinierend, herausfordernd und für viele – auch für mich selbst – abstoßend.

Im Jahr 1914 wurde im Zuge der Anti-Trust-Gesetzgebung der so genannte Clayton Act beschlossen. Nach dessen Artikel 8 ist es einer Person verboten, „als Aufsichtsratsmitglied oder Amtsträger in zwei Aktiengesellschaften zugleich" zu wirken. Es gibt eine Reihe von Ausnahmen und Schlupflöchern, die die Wirksamkeit dieses Gesetzes einschränken, und die Strafen sind vernachlässigbar gering. Ein Amtsträger, der dieser Klausel zuwider handelt, wird nicht strafrechtlich belangt oder eingesperrt. Es würde lediglich eine behördliche Untersuchungskommission eingesetzt, die die Firmen auf Preis- und andere Absprachen zum Nachteil des Wettbewerbs überprüft.

Wenn man durch diese Verknüpfungen in They Rule browst, so könnte die Fantasie schon mit einem durchgehen, wenn man sich die Vielzahl möglicher Wettbewerbsbehinderungen vorstellt, die in diesen Vorständen ausgehandelt werden. Es ist bekanntlich äußerst schwer, solche Absprachen zu beweisen, und jene, die die Macht dazu hätten, haben möglicherweise kein großes Interesse an einer Verfolgung. Ich möchte mit They Rule Verschwörungstheorien weder nähren noch abschwächen, ich will lediglich aufzeigen, dass wir hier ein System vorfinden, das wirtschaftliche Absprachen geradezu fördert. Die in They Rule dargestellten Verbindungen sind ja nur eine Auswahl aus einem kleinen Ausschnitt der herrschenden Klasse. Einige unter diesen Verbindungen sind in Wirklichkeit weniger wichtig, als sie auf der Site erscheinen mögen, andere könnten wieder wesentlich bedeutungsvoller sein. Der Vorstandsvorsitzende eines Unternehmens könnte im Aufsichtsrat eines anderen mit dem Vorstandsvorsitzenden eines dritten Seite an Seite sitzen, ohne dass zwischen den beiden je irgendein unerlaubtes Wort fiele. Genauso aber könnten zwei Direktoren konkurrierender Unternehmen dem gleichen Golfklub

corporation's point of view to fill their boards with people who are familiar with directing powerful companies. Indeed the directors are often proud of their many different corporate seats. That it should not be surprising does not make it any less fascinating, intriguing and for many, including myself, disgusting.

In 1914 the Clayton Act was passed into US law. A person is in violation of section 8 of that act if they "serve as either a director or officer of two corporations at the same time." There are a number of exceptions and loopholes, which make the act less effective, and the penalties are negligible. A director found to be in breach of this clause would not face imprisonment or any criminal penalties. They would invite a FTC investigation for Price Fixing or other forms of corporate collusion and non-competitive activities.

When browsing through the multitude of interlocks in They Rule it is easy to let your imagination run wild about the types of collusion that might occur on these boards. It is notoriously difficult to prove any of these activities, and those with the power to do so, probably don't have it in their interests to pursue it. I didn't want They Rule to foster or hinder conspiracy theories, rather I wanted it to show that we have a system which encourages conspiracy. The connections in They Rule are only a few of the connections of one small section of the ruling class. Some of the connections may not be as important as they appear to be in the site and some may be much more important than others. A director of one company may sit on another board with a director of the board of another company and not a colluding word might be uttered. However, two separate directors of the competing corporations may belong to the same Golf course, and perhaps it is on the putting Green that the prices are fixed, the collusions are made.

Speculation is to be encouraged, but I also wanted They Rule to provide a starting point for getting some facts. They Rule graphically reveals this one surface reality of an interconnected ruling class, but it also encourages visitors to dig deeper. It is easy to run a search on companies and individuals straight from the site. It is not uncommon for the first result in an internet search engine query on a board member to come up with their name in connection with a government

committee or advisory board or even to discover that they were in Government for a time. The people in *They Rule* include an ex-president, an ex-Secretary of the Treasury, and many ex-members of Congress. The ongoing Enron scandal, which sparked much activity on the site, revealed just how closely tied the State is to the corporate world. As Marx put it, the state is "the executive committee of the ruling class." Hopefully *They Rule* can help us confirm (or deny) this.

Mapping significant relationships with *They Rule* can be tricky. It has been suggested that it should include tools that use mathematical algorithms to arrange the boards and directors that are placed on the screen in ways that reveal structural importance in the network. I may still add such tools to the project, however, as stated above I am not convinced that all of these connections are even of social significance. A mathematical formula will not be able to evaluate all aspects of that inequality—although it may point out potential areas for further investigation. *They Rule* uses a social filtering system. Visitors to the site can arrange and annotate the connections they find, hiding some, stressing others and adding URLs to add to the qualitative information (and misinformation!) on the site. One of the easiest ways to browse the site is to view the maps that other visitors to the site have created. Some of the most interesting and startling connections to

angehören und ihre Absprachen eben auf dem Putting Green treffen.

Spekulationen sind natürlich erlaubt, aber ich wollte mit *They Rule* zunächst einen Überblick über die Fakten bieten. *They Rule* enthüllt mit seiner grafischen Oberfläche die erste Ebene der Wirklichkeit einer eng vernetzten herrschenden Klasse, aber es ermuntert Besucher auch, tiefer zu gehen. Es ist leicht, eine Suchabfrage über Unternehmen und Einzelpersonen direkt von der Site aus zu starten, und nicht selten fördert eine solche Suche nach einem der Direktoren im Internet als Erstes dessen Namen in Verbindung mit einem Regierungskomitee, einem Beraterstab zu Tage, oder man entdeckt überhaupt, dass der Betreffende früher einmal Mitglied der Regierung war. Zu den Leuten in *They Rule* gehören ein Ex-Präsident, ein Ex-Finanzminister sowie diverse ehemalige Kongressabgeordnete. Der noch immer nicht ausgestandene Enron-Skandal, der auch auf der Site viele Aktivitäten ausgelöst hat, zeigt, wie eng der Staat mit der Unternehmenswelt verknüpft ist. Nach Marx ist der Staat „das Exekutivkomitee der herrschenden Klasse". Hoffentlich kann *They Rule* uns diese Ansicht entweder bestätigen oder widerlegen.

Die Zuordnung signifikanter Beziehungen in *They Rule* ist manchmal schwierig. Es wurde vorgeschlagen, ein Werkzeugset bereitzustellen, das mithilfe mathematischer Algorithmen die diversen Direktorien und ihre Angehörigen so auf dem Bildschirm platziert, dass ihre strukturelle Bedeutung im Netzwerk besser sichtbar

wird. Solche Werkzeuge könnte man zwar einführen, aber ich bin, wie gesagt, nicht einmal sicher, ob allen diesen Verbindungen überhaupt eine gesellschaftliche Bedeutung zukommt. Eine mathematische Formel wird diesem Ungleichgewicht nicht wirklich gerecht, auch wenn sie vielleicht für die Zukunft potenzielle weitere Untersuchungsfelder hervorbringen könnte. *They Rule* verwendet ein soziales Filtersystem: Besucher der Site können die von ihnen gefundenen Verbindungen arrangieren und mit Notizen versehen, einige ausblenden, andere verstärken und URLs mit qualitativen Informationen (bzw. Desinformationen) hinzufügen. Am einfachsten ist es, sich die von anderen Besuchern erstellten „Landkarten" anzusehen – einige der erstaunlichsten und interessantesten davon wurden von Besuchern auf eine Weise arrangiert, die kein mathematisches Programm je zu Stande brächte.

They Rule versteht sich nicht als Autorität in Fragen der herrschenden Klasse, es stellt allerdings einiges von deren inzestuöser Existenz bloß. Vielleicht regt es ja manche Leute an, darüber nachzudenken, wie ein so kleiner Prozentsatz der Welt so vieles beeinflussen kann und wie sich so etwas mit dem Begriff der Demokratie vereinbaren lässt.

Es gäbe viel, was diese Welt sicherer machen könnte, und ich bin davon überzeugt, dass die meisten unter uns sich dies wünschen würden. Als Individuen wird uns das nicht gelingen, wir müssen uns zusammentun und für unsere gemeinsamen Interessen kämpfen, die meiner Ansicht nach jenen der wenigen Herrschenden entgegengesetzt sind. Ich hoffe jedoch, dass wir eines Tages eine Welt haben, in der wir mit Recht sagen können: „We Rule!"

the site have been produced by people who have arranged the material in ways that no mathematical algorithm could have.

They Rule is not an authority on the ruling class, but it does expose something of their incestuous existence. Perhaps it will inspire people to try and find out how it is that such a small percentage of the world controls so much, and how this situation can be described as a democracy.

There is much to do to make this world a safer place, and I trust that most of us would like to get on with it. We can't do it as individuals, we must come together and fight for our collective interests which in my opinion run counter to those of the ruling few. I hope that some day we will have a world in which we can all genuinely exclaim "We Rule!"

Josh On (NZ / USA) was born in New Zealand in 1972. He has a BA in Sociology and an MA in Computer Related Design from the Royal College of Art in London. He currently resides with his wife in San Francisco, where he works on creative projects with Futurefarmers, and is politically active. **Josh On (NZ / USA)**, geb. 1972 in Neuseeland. Er hat einen BA in Soziologie und einen MA in Computer Related Design des Royal College of Art in London. Er lebt zur Zeit mit seiner Frau in San Francisco, wo er gemeinsam mit Futurefarmes an kreativen Projekten arbeitet, und engagiert sich politisch.

Donnie Darko
Alexandra Jugovic, Florian Schmitt / Hi-Res!

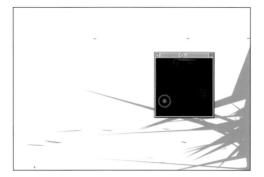

The site was created for the Film *Donnie Darko* by first-time director Richard Kelly. The film plays over a 28 day period in a tangent (parallel universe) between 2 October and 30 October 1988.
The site was designed to mirror this time and was launched in numerous phases from early October. The final phase was launched on 26 October 2001, which was the release date of the film in the US.
The site does not give away anything about the film directly, but actually adds to the film, as the site portrays what happened in the primary universe, the world we all witnessed between 2/10/1988 and 30/10/1988 and afterwards. It follows the life of characters in the film and thereby adds to the story, rather than taking away or spoiling it (apart from one point—but we warn people before).
The site branches out into various other sites which all give you bits of information and passwords which you need to be able to access the various levels in the site.

Diese Website wurde für den Film *Donnie Darko* – den Regie-Erstling von Richard Kelly – geschaffen. Die Handlung des Films erstreckt sich über 28 Tage, er spielt zwischen dem 2. und dem 30. Oktober 1988 in einer Art Paralleluniversum.
Die Site soll diesen Zeitrahmen widerspiegeln, allerdings im Jahre 2001, und wurde in mehreren Etappen ab Anfang Oktober ins Netz gestellt, wobei die letzte Phase parallel zum US-Filmstart am 26. Oktober 2001 gestartet wurde.
Die Site verrät nichts vom eigentlichen Film, ergänzt diesen aber insofern, als sie die Ereignisse im ersten Universum porträtiert, also in jener Welt, die wir alle zwischen 2. und 30. 10. 1988 und danach miterlebt haben. Sie verfolgt das Leben der Gestalten des Films und ergänzt ihn dadurch, statt Filmgeheimnisse zu verraten (mit einer Ausnahme, aber da warnen wir die Besucher zuvor).
Die Site verzweigt sich in diverse andere Sites, die alle dem User zusätzliche Informationsbruchstücke und Passwörter geben, die zum Besuch der verschiedenen Ebenen der Site erforderlich sind.

Hi-Res! (www.hi-res.net) is a highly awarded digital media company based in London founded in 1999 by Florian Schmitt and Alexandra Jugovic, who are both partners and creative directors of the company. Both Schmitt and Jugovic studied art at the Hochschule für Gestaltung Offenbach (D) and worked for numerous clients in the entertainment industry through various companies before setting up Hi-Res! They initially gained widespread recognition for their experimental site *soulbath.com* and the associated exhibition of art-banners entitled *clickhere!*. **Hi-Res! [www.hi-res.net]** Hi-Res! ist ein mehrfach preisgekröntes Digital-Media-Unternehmen mit Sitz in London, das 1999 von Florian Schmitt und Alexandra Jugovic gegründet wurde. Beide haben Kunst an der Hochschule für Gestaltung in Offenbach (D) studiert und für zahlreiche Kunden im Bereich der Unterhaltungsindustrie gearbeitet, bevor sie sich mit Hi-Res! selbstständig machten. Gleich von Anfang an erwarben sie große Anerkennung für ihre experimentelle Site *soulbath.com* und für die zugehörige Ausstellung von Art-Banners unter dem Titel *clickhere!*.

Minitasking
schoenerwissen

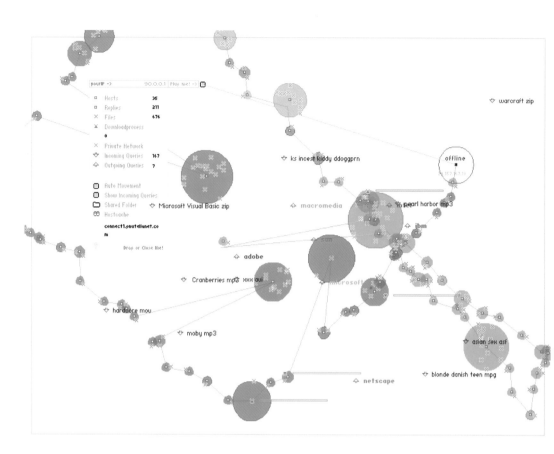

Minitasking ist eine visuelle Software, basierend auf dem Peer-to-Peer-Standard Gnutella. *Minitasking* visualisiert die Eigenschaften dynamischer und temporär eingerichteter Netzwerke, macht deren Instabilität und den Verkehr der Daten transparent. Es geht dabei im Wesentlichen um die Funktionsweise des Computers, um Datenverarbeitung und ihre Visualisierung zur Anwendung in kollektiven und dynamischen Umgebungen. Der Entwurf einer Software gibt die Möglichkeit, die unterschiedlichen Modalitäten, die den Zugriff auf Informationen bestimmen, auszumachen bzw. zu gestalten. Auf diese Weise erhoffen wir Aufschlüsse darüber zu bekommen, welche Eigenschaften diese (Rechen) Prozesse ausmachen und wie diese sich auf verteilte Systeme, Handlungen und Ziele auswirken.

Bei einem Peer-to-Peer-Protokoll wird nicht länger zwischen den Funktionen eines Client oder Server unterschieden. Dieses dynamisch organisierte Gefüge, das temporär eingerichtet wird, verändert sich permanent. Diese dezentralisierten Strukturen heben die Trennung zwischen Konsument und Produzent ein weiteres Stück auf. Beides sorgt für eine vermehrte „Produktion von Information". Doch es soll hier weniger um Menge und Art von Information gehen als vielmehr um die technologischen Bedingungen des Gebrauchs von File-Sharing-Software. Es scheint klar, dass die Protokolle Information konstruieren: Nur was den Standards entspricht, wird weitergeleitet und erkannt – wird Teil des Netzes.

Minitasking is a visual software based on a standard Gnutella peer-to-peer system. *Minitasking* displays the features of dynamic and temporary networks visually, and so makes their instability and data transmission transparent. This program is essentially concerned with how computers work, with data processing and their visualization for applications in collective and dynamic environments. The creation of software enables one to define and design the diverse modalities which determine information access, and we hope to gain insights into the features which distinguish these (computer) processes and how they affect distributed systems, actions and objectives.

With a peer-to-peer protocol, a distinction is no longer made between the functions of a client and a server. This dynamically organized structure, which has been temporarily established, changes constantly. Such decentralized structures further neutralize the division made between the consumer and producer, and so cause a rise in the "production of information". Yet it is not so much a question of the volume or kind of information, as it is of the technological terms of use for file-sharing software. It is quite evident that protocols construct information: only that which meets the standards is transmitted and recognized – and so becomes part of the network.

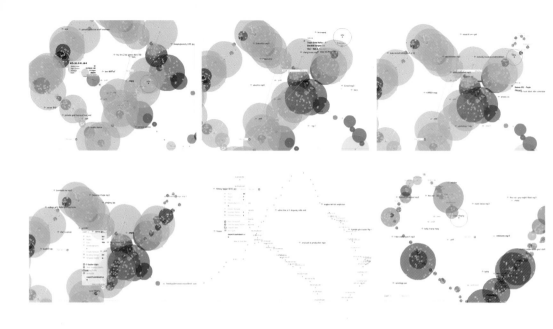

Minitasking presents these processes visually, tracing new nodes and listing the number of accessible files. Thus file sharing is governed here by other criteria than it is with conventional clients. The network can be read as a dynamic cartography. Visual peculiarities also tend to provoke intuitive interventions in the network. One objective of this development is to enable the numerical components of a P2P network, e.g. the IP address, the link rate, file volume, etc., to be incorporated into its use. Thus technological elements determine a single and separate model of the network.

Minitasking uses the data as material for visualization. On the one hand it does so in order to show how computer processes and protocol dynamics work, on the other hand, to accentuate the moments of vagueness underlying computer processes and actions. The visual surface displays only one of many possible "experimental set-ups"; it is designed to both guide and beguile users into observing processes, as well as into selecting and exchanging data within the temporary structure so that they can discover criteria for shaping access to information, as well as for its production and distribution.

Minitasking visualisiert diese Vorgänge, zeichnet neue Knoten und gibt die Menge der freigegebenen Dateien an. Damit wird der Dateientausch von anderen Kriterien geleitet, als es bei herkömmlichen Clients der Fall ist. Das Netz kann als dynamische Kartografie gelesen werden, wobei die visuellen Eigenheiten auch intuitive Eingriffe in das Netz provozieren. Ein Ziel der Entwicklung ist, die numerischen Anteile eines P2P-Netzes – z. B. die IP-Adresse, die Verbindungsraten, die Menge der Dateien etc. – in den Gebrauch einfließen zu lassen. Die technologischen Elemente bedingen damit ein einzelnes, eigenes Modell dieser Netze.

Minitasking verwendet die Daten als Material zur Visualisierung, um einerseits die Vorgänge des Rechnens und die Dynamik der Protokolle transparent zu machen, andererseits um die Momente der Vagheit, die in den Rechen- und Handlungsprozessen liegen, zu verstärken. Die visuelle Oberfläche zeigt nur eine von vielen möglichen „Versuchsanordnungen", sie soll den Nutzer leiten, aber auch verleiten, innerhalb des temporären Gefüges die Prozesse zu beobachten, Daten auszuwählen, auszutauschen, um dabei Kriterien zu entdecken oder zu entwickeln, mit denen der Zugang zu Information, aber auch ihre Produktion und ihre Verbreitung geprägt werden.

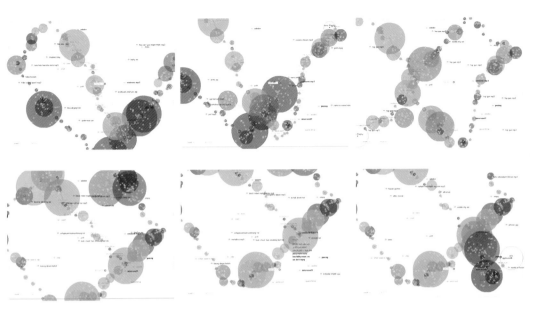

Im Unterschied zu herkömmlichen Gnutella-Clients generieren bei *Minitasking* die Datenströme das Interface. Dadurch wird die Dynamik und die Temporalität solcher Netze für den User transparent, was sich auch auf den Gebrauch der Software auswirken sollte.
Minitasking wurde unterstützt durch die Schriften von Craig Kroeger (miniml.com): die Sounds stammen von Christian Kleine (City Centre Offices), die Sockets von Thomas Chille.

Unlike with conventional Gnutella clients, with *Minitasking* it is the streams of data which generate the interface. As this occurs, the dynamics and temporality of such networks are made transparent to users, which in turn should affect use of the software itself.
Minitasking was created with the aid of texts by Craig Kroeger, (miniml.com), sounds by Christian Kleine (City Centre Offices) and sockets by Thomas Chille.

schoenerwissen (D), a collaboration between Anne Pascual and Marcus Hauer, has existed since 1997. Pascual and Hauer both studied and worked at the Art College for Media in Cologne, and now live in Berlin. Their projects operate on a matrix of computation, visualization and generation. They are also members of the editorial staff of *De:Bug*, a magazine for electronic aspects of life in Berlin. **schoenerwissen (D)** ist eine Kollaboration zwischen Anne Pascual und Marcus Hauer, die seit 1997 besteht. Beide haben an der Kunsthochschule für Medien in Köln studiert und gearbeitet und leben in Berlin. Ihre Projekte bewegen sich auf einer Matrix von Computation, Visualisation und Generation. Außerdem sind sie Mitglieder der Redaktion von *De:Bug*, Zeitung für elektronische Lebensaspekte in Berlin.

Tonga.Online

Peter Kuthan / Sabine Bitter / Thomas Schneider / Helmut Weber

Tonga.Online is a project on media, information & communication technology and art focusing on the Tonga people in the remote Zambezi Valley bordering Zimbabwe and Zambia.

The project goal is to promote a Tonga voice on the Internet. In turn it provides people in the Tonga area with the most advanced tool to communicate and to represent themselves to the outside world.

What are the implications, results and effects of such an endeavour? This was and still is a matter of discussion and reflection within the working group, among the stakeholders involved and with the wider public.

The project reflects the gaps and imbalances, which still exist or are rather widening in the "global village". Such imbalances are no longer just a question of resources but also of access and the capacity to use modern communication tools. Access has become a crucial question of political rights too: "In the 21st Century, the capacity to communicate will almost certainly be a key human right." (Nelson Mandela)

Tonga.Online ist ein Kunst-/ Medien-/ Informations- und Kommunikationstechnologie-Projekt mit Schwerpunkt auf dem Volk der Tonga, das im entlegenen Sambesi-Tal an der Grenze zwischen Simbabwe und Sambia lebt. Ziel des Projekts ist es, den Tonga eine Stimme im Internet zu verleihen. Umgekehrt bietet es den Tonga auch das modernste Kommunikationsmittel an, mit dem sie sich der Außenwelt gegenüber darstellen können. Welche Implikationen, Ergebnisse und Effekte zeitigt ein solcher Versuch? Die Antwort auf diese Frage wird noch innerhalb der Arbeitsgruppe, mit den Beteiligten und dem Publikum diskutiert.

Das Projekt selbst spiegelt das Ungleichgewicht und jene Risse und Brüche wider, die im „globalen Dorf" nicht nur existieren, sondern möglicherweise sogar verstärkt werden. Das Ungleichgewicht ist nicht nur mehr eine Frage der Ressourcen, sondern auch die des Zugangs und der Fähigkeit, moderne Kommunikationsmöglichkeiten zu nutzen. Dieser Zugang ist inzwischen auch eine Kernfrage politischer Rechte geworden: „Im 21. Jahrhundert wird die Fähigkeit zu kommunizieren fast sicher zu den grundlegenden Menschenrechten gehören." (Nelson Mandela)

Die Idee für das *Tonga.Online*-Projekt entstand anlässlich der Teilnahme an der Ausstellung „Spuren des Regenbogens: Leben im Südlichen Afrika" im Linzer Schlossmuseum von April bis November 2001. Ziel des Projekts war es, eine Plattform für die Kommunikation mit dem Volk der Tonga im Sambesi-Tal, genauer mit den Bewohnern des Dorfes Siachiiaba in der abgelegenen Region Bina (Simbabwe), zu erstellen. Dazu wurde ein mit Computern ausgestatteter Projektraum eingerichtet und die Website *www.mulonga.net* entwickelt.

Die am Projekt beteiligten Künstler hatten Simbabwe bereits 1997 als Teil einer Gruppe österreichischer Künstler besucht, die beim Nayminyami-Festival mit der Kulturgruppe Simonga aus Siachiiaba zusammengearbeitet hat. Diese Beschäftigung mit der Kultur der Tonga und die Reflexionen afrikanischer und österreichischer Komponisten gipfelten letztlich darin, dass 30 Mitglieder von Simonga während des „Festivals der Regionen" 97 das Tote Gebirge überquerten. Das Projekt konzentrierte sich vor allem auf die Schönheit und Beständigkeit der Kultur der Tonga und hat viel dazu beigetragen, bestehende Mythen über deren Minderwertigkeit zu beseitigen. Im Mittelpunkt steht ihre außergewöhnliche Ngoma-Buntibe-Musik, die in ihrer erzählerischen Weise stark mit den Gemeinschaftsanliegen verbunden ist. Daneben wird sie auch bei spirituellen Anlässen wie Begräbnissen auf Antilopenhörnern, Trommeln und Rasseln inmitten der gesamten Gemeinschaft aufgeführt, die sich in für Fremde geheimnisvollen Kommunikationsmustern tanzend bewegt.

The *Tonga.Online* project began as an idea following the invitation to participate in the exhibition "Tracing the Rainbow. Life in Southern Africa" from April until November 2001 in the Schlossmuseum in Linz, Austria. The aim was to provide a platform for communication with the Tonga people of the Zambezi Valley and, more specifically, the people of the Siachiiaba village in Zimbabwe's remote Binga area. This was realized through the design and launch of a project room equipped with computers and the web site www.mulonga.net. The artists involved in this project visited Zimbabwe in 1997 as part of an Austrian team of artists collaborating with the Cultural group Simonga from Siachiiaba, during the Nyaminyami Festival. This celebration of Tonga culture and reflections from European and Southern African composers culminated with 30 members of Simonga climbing the Totes Gebirge mountain range in Austria during the "Festival der Regionen" 97. The project concentrated on the beauty and resilience of Tonga culture and did much to dispel disparaging myths surrounding these displaced and marginalized people. The focus is on their extraordinary Ngoma Buntibe music, which relates as a kind of story telling to social and community issues. There are spiritual occasions to like burials, where it is performed on antelope horns, drums and rattles in the midst of the whole community moving and dancing in undisclosed patterns of communication.

Peter Kuthan (A), born 1945, sociologist and free lance consultant in development cooperation, cultural activist with AZFA since 1993, has been living in Zimbabwe from 1989 to 1992. **Sabine Bitter**, **Helmut Weber** and **Thomas Schneider** are visual artists working on new media related art projects and involved in AZFA's cultural exchange projects with Zimbabwe for several years. **Peter Kuthan (A)**, geboren 1945, Soziologe und freiberuflicher Konsulent in Entwicklungshilfefragen, seit 1993 Mitglied der Austria Zimbabwe Friendship Association AZFA, hat 1989–1992 in Zimbabwe gelebt. **Sabine Bitter**, **Helmut Weber** und **Thomas Schneider** sind visuelle Künstler, arbeiten an Neue-Medien-Projekten und sind seit mehreren Jahren in die Kulturaustauschprojekte der AZFA eingebunden.

60X1.com
Kenneth Tin-Kin Hung

60X1.com is a web site whose sole content consists of splash pages—the opening pages for most web sites, usually containing a small amount of graphics. After clicking through all the splash pages the spectator will find there is actually no core content, opening the question of definition regarding content in web pages. *60X1.com* is designed to be user-unfriendly, aiming to serve as a counter structure to the model of most successful web site—portal sites, where all the links are contained in one interface in order to generate a maximum number of hits; instead *60X.com* is designed to generate a minimum amount of hits with its long domain name, one way navigation and its big file sizes of images, existing as an experiment to test viewers' patience and expectation, as well as calling the internet into question as a forum for communication. One way navigation denies the concept of the Internet being a web. The experiments on Internet communication continue within *60X1.com*. Certain elements in this site play with phenomena that only exist within the confines of the Internet: the Hoax, irresponsible postings on numerous message boards, and strange identities that only exist in cyber worlds including *Asian Prince*, *Supergreg*, *Georges/girls*, *Peter Pan* etc... Take *Asian Prince* as an example: The original identity of the now so-called *Asian prince* was a Vietnamese glamrock singer in the late seventies. In late 1999 an anonymous man found the image and applied a whole new identity, *Asian Prince* onto this retired rock star's image. After this secondary manipulation, *60X1.com* comes in and remanipulates the readymade identity. The manipulations can have several directions. I can erase the post original and apply a new set of meanings onto the figure or simply extend an already constructed identity. This process of altering meaning and identity can only be seen in the Internet realm because the creator/manipulator usually perceives the internet as a medium that does not have to bear too much responsibility (no censorship) while publishing controversial material.

60X1.com ist eine Website, die aus Splash-Seiten besteht, die bei vielen Websites als Einstiegsseiten dienen und meist aus einer Reihe von Grafiken bestehen. Wer sich durch all die Splash-Seiten geklickt hat, wird herausfinden, dass diese Site eigentlich keinen Kerninhalt hat, was die Frage nach der Definition des Inhaltes von Websites allgemein aufwirft. *60X1.com* ist möglichst benutzerunfreundlich gestaltet und definiert sich als Gegenstruktur zum Modell der erfolgreichsten Websites – als Gegenteil jener Portale, in denen alle Links in einem Interface konzentriert sind, das darauf abzielt, möglichst viele Treffer zu landen. Im Gegensatz dazu ist *60X1.com* mit seinem langen Domain-Namen, seiner Einbahn-Navigation und seinen Bilddateigrößen darauf ausgelegt, möglichst wenige Treffer zu erzielen – ein Hinterfragen des Internet als Forum für Kommunikation. Die Einbahn-Navigation konterkariert die gängige Auffassung, das Internet sei ein Netzwerk. Die Experimente zur Internet-Kommunikation werden in *60X1.com* fortgesetzt. Bestimmte Elemente dieser Site spielen mit Phänomenen, die nur innerhalb der Grenzen des Internet existieren – Hoaxes, unverantwortliche Postings in zahlreichen Message-Boards und seltsame Identitäten, die nur in Cyberwelten existieren, wie etwa *Asian Prince*, *Supergreg*, *Georges/girls*, *Peter Pan* usw. Nehmen wir *Asian Prince* als Beispiel: Die ursprüngliche Person hinter der jetzt „Asian Prince" genannten Gestalt war ein vietnamesischer Glamrock-Sänger der späten 70er-Jahre. Ende 1999 fand jemand Anonymer das Bild des längst nicht mehr aktiven Rockstars und verpasste ihm die völlig neue Identität *Asian Prince*. Nach dieser Manipulation trat *60X1.com* auf den Plan und manipulierte diese vorgefertigte Identität neuerlich. Solch eine Manipulation kann in verschiedene Richtungen gehen: Ich könnte das gepostete Original löschen und ein völlig neues Bedeutungsset mit der Figur verknüpfen oder aber einfach eine bestehende Identität ausweiten. Solch ein Prozess der Veränderung von Bedeutung und Identität ist nur im Bereich des Internet sichtbar, weil der Schöpfer / Manipulator es normalerweise als Medium auffasst, das keine große Verantwortung (Zensur) bei der Publikation kontroversiellen Materials auferlegt.

Kenneth Tin-Kin Hung (USA), born 1976 in Hong Kong. He obtained his B.A. in Arts degree from San Francisco State University. The medium Kenneth experiments with includes internet art, sound, installation, video, digital image manipulation, photography, sculpture, performance art and behavioral art. The exhibition venues that Kenneth has exhibited at include Southern Exposure Gallery, Cesar Chavez Student Art Center (San Francisco, USA), Fumetto Comix Festival (Luzern, Switzerland), Gordon Gallery (Napa, USA), Magnolia Editions Gallery (Oakland, USA). **Kenneth Tin-Kin Hung (USA)**, geboren 1976 in Hongkong. Er graduierte zum BA aus dem Fach Kunst an der San Franscisco State University. Kenneth experimentiert im Bereich Internet-Kunst, Klang, Installation, Video, digitale Bildmanipulation, Fotografie, Skulptur, Performance und Behavioral Art. Ausstellungen seiner Arbeiten waren u. a. in der Southern Exposure Gallery, im Cesar Chavez Student Art Center (San Francisco), beim Fumetto Comix Festival (Luzern), in der Gordon Gallery (Napa, USA) und der Magnolia Editions Gallery (Oakland, USA) zu sehen.

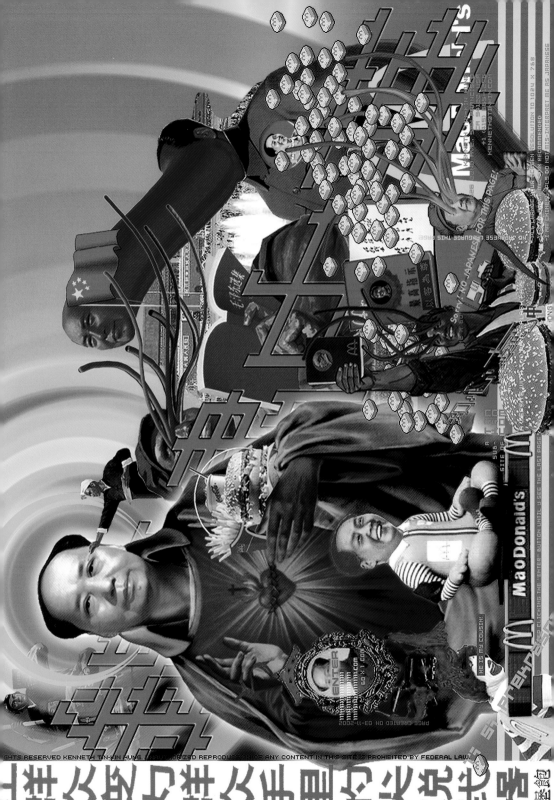

db-db OUR.DESIGN.PLAYGROUND
Francis Lam

When *db-db* just started two years ago, it was solely a personal experimental portfolio site showing some of my works and daily photos. The first version of the site used a subway train platform with some tiny pixel passengers as the navigation. The second version of *db-db* was more like a design community site; it was added in more sections like design news, interview and some featured projects. A Flash-based multi-user playground was created and put on top of the whole site; people could visualize each other by some simple interactions like WALK, TALK and PEE. The whole site was then turned into an entire Flash site for this reason.

The latest version is called *db-db version 2.5 OUR.DESIGN.PLAYGROUND*. It inherits the

Als *db-db* vor gerade zwei Jahren begann, war es eine experimentelle persönliche Portfolio-Site, die einige meiner Arbeiten und tägliche Fotos zeigte. Die erste Version verwendete einen U-Bahnsteig und ein paar kleine Pixel-Passagiere als Navigationsoberfläche. Die zweite Version war dann schon eher eine Design-Community-Site; weitere Abteilungen wie Design-News, Interviews und einige Projektbeschreibungen wurden hinzugefügt. Eine Flash-basierte Multi-User-Spielfläche wurde geschaffen und der Site sozusagen oben draufgesetzt – die User konnten sich gegenseitig über einfache Interaktionen wie GEHE, SPRICH oder PINKLE visualisieren. Aus diesem Grund wurde dann auch die gesamte Site in Flash aufgebaut.

Die neueste Version heißt *db-db Version 2.5 OUR. DESIGN.PLAYGROUND*. Sie hat die grundlegende

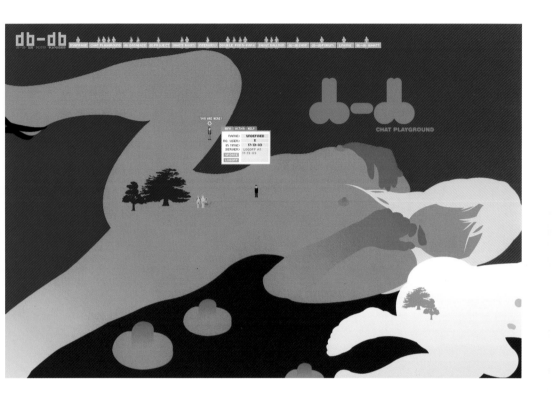

CHAT PLAYGROUND

Infrastruktur der Version 2.0 übernommen, Interface und Navigation wurden aber verfeinert. Hauptziel ist es, *db-db* zu UNSERER Spielwiese zu machen, auf der mehr kollaborative Arbeiten zu finden sind.

basic backend infrastructure of the version 2.0 site. The interface and navigation are refined. The main focus is trying to make *db-db* become *OUR design playground* and more collaboration work would be found.

Francis Lam (China) majored in computer science from the Chinese University of Hong Kong and graduated in 2000. He then started working for IdN (the International Designers Network) as a web designer. At the same time, the personal design webzine *db-db OUR.DESIGN.PLAYGROUND* was created. He is currently pursuing a second degree in the School of Design, Hong Kong Polytechnic University. **Francis Lam (China)** studierte Computerwissenschaften und graduierte 2000 an der Universität Hongkong. Er begann anschließend, für IdN (International Designers Network) als Webdesigner zu arbeiten. Gleichzeitig entstand das persönliche Webzine *db-db OUR.DESIGN.PLAYGROUND*. Derzeit bereitet er sich auf einen weiteren Studienabschluss an der School of Design der Hong Kong Polytechnic University vor.

db-db OUR.DESIGN.PLAYGROUND

Cloudmakers–Collective Intelligence
Elan Lee / Microsoft

index

quick summary

On April 11, 2002, Cloudmakers was founded as a discussion group for the interative web game centered around the film *A.I.* We officially solved the game on July 24, 2001. Though the original game, The Beast, has ended, Cloudmakers now serves as a clearinghouse for online gaming. Members can find out about new games, find fellow players, and reminisce about and discuss The Beast.

then

This much we were told from the beginning: Evan Chan was murdered. A web of clues was spun through the datasphere, and the Cloudmakers meticulously pored over each and every puzzle and detail. The Cloudmakers brought together diverse skills ranging from cutting edge spectral analysis to a unique and unrivaled knowledge of historical evends and world literature . . . and a whole lot more. Two heads may be better than one, but seven thousand combined to form the ultimate crime fighting syndicate. In fact, what we did was so groundbreaking that an in-game character, Jeanine Salla, honored us by "writing" a paper about us.

Microsoft was behind the curtain for the Beast; Elan Lee and Sean Stewart were the lead designers. The game was a promotion for *A.I.* The film was Stanley Kubrick's unfinished project, and was directed by Steven Spielberg for DreamWorks. WarnerBros released the film in the US on June 29, 2001.

now

Some Cloudmakers are playing other web games, and others are waiting for the next project from The Beast's development team. A new game is not actively being solved under the CM brand, yet Cloudmakers remains the place to find out about new developments in the world of web games and to rehash or relive The Beast.

Our mailing lists come in three flavors of noise:

cloudmakers

This is the high traffic version of Cloudmakers, and is the only version to which everyone can post. This list contains the most-up-to-date info, but is considerably higher noise than either of the other two lists.

cloudmakers-moderated

This is the medium traffic version of Cloudmakers. Here, you'll only hear about the stuff that the moderators thought was good enough to read. We won't guarantee that anything in here will be good, but we promise to try to make sure that as little redundancy sneaks in as possible. We take posts from Cloudmakers and bounce them in here.

cloudmakers-announce

This is the extremely-low traffic version of Cloudmakers. Official announcements related to *A.I.* and future games from the Puppet Masters of The Beast will be posted here, but not much other than that.

Bei *Cloudmakers* handelt es sich um ein webgestütztes Spiel, konstruiert rund um den Kinostart von Steven Spielbergs Film *A. I.*, vor allem aber um ein beeindruckendes Online-Rätsel, das Tausende von Leuten vereinte, die kryptischen Hinweisen nachgehen, Passwörter entschlüsseln und herausfinden, wer Evan Chan – eine Nebenfigur des Films – umgebracht hat. Dies ist die Zukunft der Online-Spiele oder zumindest eine atemberaubende Variante davon!

Zahlreiche Web-Domains in verschiedenen Ländern wurden registriert, Hunderte von einzelnen Webseiten liebevoll gestaltet und Tausende Spieler elektronisch zu einem Kollektiv verbunden. Im Lauf des Spiels konnten die Mitspieler Emails, Faxe und Anrufe erhalten oder sich sogar live treffen, um ihr Verständnis der höchst komplizierten Geschichte zu fördern. Insgesamt waren es gut 7000 Leute, die kollektiv das Web durchforsteten und die Rätsel lösten (auch bisweilen mit „unfairen" Methoden wie etwa dem brutalen Knacken von Passwörtern oder durch Verwendung von /WHOIS, um Domains zu finden, die sie noch gar nicht hätten finden sollen!).

Zu den Seltsamkeiten des Projekts gehört, dass am Ende des Spiels bekanntgegeben wurde, dass es von einer kleinen Gruppe innerhalb (ausgerechnet!) Microsoft für Spielberg und Dreamworks entwickelt worden war. Diese Tatsache fand allerdings kaum Beachtung und sollte einen auch nicht davon abhalten, das Werk zu mögen – schließlich kann man mit Recht darin gewissermaßen eine Antithese zum mühseligen Unternehmensdenken sehen.

Eine Menge von Information zum besseren Verständnis des Cloudmakers-Phänomens findet sich unter
pantheon.yale.edu/~dgf4/notagame/
www.cloudmakers.org/

Cloudmakers is a web-based game built around the release of Steven Spielberg's *A. I.* movie, and was an amazing online puzzle which had thousands of people uniting to solve cryptic clues, crack passwords, and find out who killed Evan Chan, a minor character in the movie. This *is* the future of online gaming, or at least, a breathtaking version of it.

So, multiple web domains in different countries were registered, literally hundreds of lovingly custom web pages created, and thousands of people collectively banded together online. During the course of the game, players could receive emails, faxes, phone calls, and even go to real-life meetings to advance their understanding of the amazingly intricate story. So there were literally 7000 people collectively scanning the web, solving the puzzles, even sometimes by "unfair" means (brute-forcing passwords, using /WHOIS to find domains they weren't even meant to find yet!)

One distinctly weird part of the project is that, at the end, it was revealed that a small internal group within Microsoft (!) had created it for Spielberg + Dreamworks. This didn't even get much publicity at the time, but don't think it should dissuade people from liking the work—in fact, it's even more inspiring, in some ways, this is the *antithesis* of tedious corporate thinking.

A lot of the information you need to understand the whole Cloudmakers phenomenon is here.
pantheon.yale.edu/~dgf4/notagame/
www.cloudmakers.org/

To promote the movie *A.I.*, a creative group teamed up to build a murder mystery. To solve the murder, thousands of fans worldwide rallied to form a collective intelligence unparalleled in entertainment history. Jordan Weisman, Creative Director; Elan Lee, Lead Designer; Sean Stewart, Lead Writer; Todd Lubsen, Art Director; Pete Fenlon, Content Lead; Dan Carver, Designer; Vic Bonilla, Artist; Mark Selander, Artist; Paolo Malabuyo, Artist; *Cloudmakers- Collective Intelligence* (*www.cloudmakers.org*). The only remaining *A.I.* game website is *familiasalla-es.ro/* Zur Promotion des Films „A.I." fand sich ein Kreativ-Team zusammen, das ein Krimi-Rätsel entwickelte. Tausende Fans weltweit schlossen sich zu einer in der Geschichte der Unterhaltung noch nie dagewesenen Form kollektiver Intelligenz zusammen, um den Mord aufzuklären. Das Team: Jordan Weisman – Creative Director; Elan Lee – Lead Designer, Sean Stewart – Lead Writer; Todd Lubsen – Art Director; Pete Fenlon – Content Lead, Dan Carver – Designer; Vic Bonilla, Mark Selander, Paolo Malabuyo – Künstler; Cloudmakers – Kollektive Intelligenz (*www.cloudmakers.org*). Die einzige noch existierende *A.I.*-Spiel-Website ist *familiasalla-es.ro/*

INTERACTIVE ART

Interactive Art: Where are we now?
Interaktive Kunst – wo stehen wir?

Christa Sommerer

In the past 10–12 years interactive art has become an increasingly established field. While artists in the late 80s and early 90s had to struggle with interaction technology that was still in its infancy and most artists had to basically develop and invent their own interfaces and software programs from scratch, nowadays a whole host of hardware and software solutions for creating interaction experiences has become available. Nevertheless, early "interactive artists" had the advantage of finding an artistic and technological *terra nova* laid out in front of them and subsequently they developed and defined this field by carving out artistic inquiries following their personal interests and artistic and technological visions.

Many of these early interactive artists are now considered pioneers of this field and their works are often used as landmarks to measure new works against. Being still highly productive, these artists have now refined and perfected their artistic research and at this year's Ars Electronica Interactive Art competition the jury witnessed several high quality artworks by the "masters of this field". On the other hand, the increased acceptance and institutionalisation of interactivity and interactive art in academia and research has helped younger artists to enter and embrace this field as well. In this year's Prix Ars Electronica submissions we could see many art works by younger artists and these works seem to follow certain common solutions of how to design an interface and how to relate images and sounds to interactivity. Alex Adriaansens pointed out during the jury meeting, that the growing number of media art educational programs at art schools and universities might be responsible for this standardisation of interaction design and the commercially available hardware and software packages have certainly had an additional impact on the establishment of interaction design and interactive art.

In den letzten zehn bis zwölf Jahren hat sich die interaktive Kunst langsam etabliert. Während Künstler Ende der 80er- und Anfang der 90er-Jahre noch mit einer in den Kinderschuhen steckenden Technologie zu kämpfen hatten und folglich viele von ihnen Software und Interfaces selbst entwickeln mussten, steht heutzutage eine große Palette von Hard- und Softwarelösungen zur Schaffung interaktiver Erfahrungsumgebungen zur Verfügung. Dennoch hatten die ersten „interaktiven Künstler" den Vorteil, jede Menge Neuland vor sich zu finden, und sie haben auf diesem jungfräulichen Boden je nach ihren individuellen Interessen und künstlerischen wie technischen Visionen ihre eigenen künstlerischen Untersuchungen betrieben.

Viele dieser Leute der ersten Stunde sind heute als *die* Pioniere der Kunstgattung anerkannt, und ihre Werke werden gerne als Maßstab genutzt, an dem sich neuere Arbeiten zu messen haben. Aber diese Künstler sind selbst auch weiterhin produktiv, sie haben ihre künstlerische Suche verfeinert und raffiniert – und die Jury des diesjährigen Prix Ars Electronica für Interaktive Kunst konnte etliche hoch qualitative Werke der „Meister des Genres" begutachten.

Auf der anderen Seite hat die wachsende Akzeptanz und Institutionalisierung von Interaktivität und interaktiver Kunst im akademischen wie im Forschungsbereich jüngeren Künstlern geholfen, dieses Gebiet für sich zu erobern. Unter den diesjährigen Einreichungen haben wir viele Arbeiten jüngerer Künstler gefunden, die alle bestimmten generellen Strukturen im Design von Interfaces und in der Verknüpfung von Bild und Klang mit Interaktivität zu folgen scheinen. Alex Adriaansen hat während der Jurysitzung darauf hingewiesen, dass die wachsende Zahl von Medienkunst-Lehrgängen an Kunstschulen und Universitäten für diese Standardisierung des Interaktionsdesigns verantwortlich sein könnte, und sicherlich haben auch die kommerziell erhältlichen Hard- und Softwarepakete die Etablierung von Standards in der interaktiven Kunst zusätzlich gefördert.

Etliche der heuer eingereichten Arbeiten der „zweiten Generation" waren vom Konzept her recht interessant,

verließen sich aber allzu sehr auf Standardlösungen bei Interface und Interaktion. Andererseits fehlte bei Arbeiten, die technisch innovativ und überzeugend waren, häufig eine tiefergehende künstlerische Fragestellung oder ein ansprechendes Konzept. Daneben haben wir etliche Arbeiten zu sehen bekommen, die nicht als künstlerische Arbeiten per se entworfen waren, sondern eher Anforderungen aus dem Bereich der Unterhaltung, des Edutainments oder technischer Anwendungen gerecht wurden.

Eine der (vielen) Fragen, die während der Jurysitzung auftauchten, war, wie diese Diversität von Werktypen beurteilt werden sollte und welche Kriterien fair und angemessen wären. Wir haben uns bemüht, Werke herauszufinden, die folgenden Anforderungen gerecht wurden:

- Passt der Inhalt der Arbeit zur gewählten Interaktionslösung?
- Werden neue künstlerische Konzepte vorgestellt?
- Werden innovative und intuitive Interaktionserfahrungen angeboten?
- Werden die sozialen Auswirkungen dieser Technologie hinterfragt?
- Welche Relevanz kommt dieser Arbeit in Bezug auf Kunst, Wissenschaft und Gesellschaft zu?
- Welcher Grad an Professionalität in der Umsetzung ist erkennbar?

Es ist sicherlich nicht leicht, allen diesen Anforderungen gerecht zu werden, aber angesichts der Vielzahl hoch qualitativer Einreichungen konnten wir auch den Maßstab zu ihrer Beurteilung recht hoch ansetzen. Wir haben uns darauf konzentriert, Arbeiten zu finden, die neue Formen der Interaktion definieren, fesselnde interaktive Erfahrungen bieten, neuartige Interaktionstechniken anwenden und neue Applikationen definieren, die von diesen Techniken Gebrauch machen. Wir haben Werke ausgewählt, die den Begriff „Interaktion" ausweiten und die Bedeutung von „interaktiver Technologie" im Kontext von Kunst, Technologie und Gesellschaft neu definieren, wie das Juror Hiroshi Ishii zusammengefasst hat.

Several of the "second-generation" art works we could see this year were conceptually quite interesting, but too often relied on standard interface and interaction solutions. On the other hand, works that were technologically innovative and convincing, frequently lacked deeper artistic inquiries and conceptualisation. We also saw several works that were not designed as artworks per se, but instead satisfied qualities of entertainment, edutainment or engineering applications.

One of the (many) questions that occurred during the jury meeting was how to judge these very diversified types of works and how to identify fair and common criteria. We aimed to find (art)works that satisfied the following criteria:

- Match the content of the work with its interaction solution
- Propose novel artistic concepts
- Create innovative and intuitive interaction experiences
- Consider the social impact of this technology
- Consider the relevance of the work in connection to art, science and society
- Show professionalism of realization

These are certainly tough criteria to meet, but given the amount of high quality submissions we had, we were able to set the selection standard quite high. We focused on identifying (art)works that define novel forms of interactions, create engaging interactive experiences, use and apply innovative interaction technologies, and consider new applications that can be realised through those technologies. We tried to identify the best works that push the envelope of "interactivity" and by redefining the meaning of "interactive technology" in the context of art, technology and society (as summarised by Hiroshi Ishii).

Interactive Art: Where are we now?

We also constantly re-examined our criteria and aimed to stay as open as possible. We aimed to include works that would not exactly fit in the above list of criteria, but instead bring in novel concepts by pushing the boundaries of interactive art in other valuable ways, as for example in the area of gaming and entertainment (a speciality of the jury member, Masuyama from Japan). Or as Peter Higgins put during the meeting, we aimed to avoid "… unknowingly narrowing this new emerging art form, whilst at the same time giving it more gravitas than is justified. The consequence of this is that the above protocols (selection criteria) may now need to be challenged as we strive to revalue the potential of the genre." We debated about each of the works at length and in detail and once we had identified 18 selected works, it became quite difficult to judge which of these works would be among the top three winners. All 18 works were quite excellent in their realisation. We are especially satisfied to see also that several of the (art)works selected for the honorary mentions category have been created by younger artists and we are confident that the field of interactive art will see more of their high quality works in the future.

We are proud to announce the following three main winners of this competition:

n-cha(n)t by David Rokeby

With this work David Rokeby succeeded in creating a system that combines cutting edge technology with artistic and conceptual refinement. While many interactive artworks nowadays impress us with either cleverly designed interfaces or conceptually interesting ideas, it takes a special artistic genius to combine hardware, software and concepts into a seemingly effortless experience that convinces us through its concept, its realisation and, most importantly, through some deeper human emotions that can be triggered through these experiences. With n-cha(n)t David has just created such an artistically as well as technologically outstanding work.

Seven years ago at the Kwangju Biennale in Korea (organised by Nam June Paik) I remember David telling us (Paul Garrin, Steina Vasulka, Laurent Mignonneau, and others were there as well…), about his The Giver of Names project. We couldn't all quite visualise what David was talking about, but he certainly was excited and inspired by this idea and during the following years he kept telling me about it whenever we met.

Wir haben auch unsere Kriterien immer wieder in Frage gestellt und uns bemüht, so offen wie möglich zu bleiben. Wir wollten auch Werke einbeziehen, die zwar den obigen Kriterien nicht in allen Punkten entsprechen, aber dennoch neue Konzepte bieten, indem sie die Grenzen der interaktiven Kunst auf andere wertvolle Weise verschieben, etwa im Bereich der Spiele und Unterhaltung (Spezialgebiet des Jurymitglieds Masuyama aus Japan). Oder, wie Peter Higgins sich in der Jurysitzung ausdrückte, wir bemühten uns zu vermeiden, „… ungewollt diese gerade entstehende Kunstform einzuschränken und ihr gleichzeitig mehr Gewicht beizumessen, als ihr zukommt. Die Konsequenz daraus ist, dass die obigen Auswahlkriterien jetzt hinterfragt werden müssen, wenn wir das Potenzial dieses Genres wirklich neu bewerten wollen."

Wir haben über jede der eingereichten Arbeiten lang und ausführlich debattiert, und nachdem wir einmal 18 Arbeiten in die nähere Wahl gezogen hatten, fiel es uns schwer, drei Arbeiten als mögliche Sieger zu benennen. Alle 18 waren in ihrer Umsetzung ausgezeichnet. Besonders gefreut hat uns, dass viele der mit Anerkennungen bedachten Arbeiten von jüngeren Künstlern stammen, und wir sind zuversichtlich, dass auch in Zukunft das Gebiet der interaktiven Kunst noch mehr von ihren hoch qualitativen Werken sehen wird.

Wir freuen uns, folgende Preisträger des heurigen Wettbewerbs bekannt zu geben:

n-cha(n)t von David Rokeby

Mit dieser Arbeit ist es David Rokeby gelungen, ein System zu schaffen, das modernste Technologie mit künstlerischer und konzeptueller Raffinesse verbindet. Während viele interaktive Projekte uns heutzutage entweder mit klug gestalteten Interfaces oder mit interessanten Konzepten beeindrucken, bedarf es schon eines besonderen künstlerischen Genies, Hardware, Software und Konzepte in eine scheinbar mühelose Erfahrung zu kombinieren, die sowohl vom Konzept wie von der Umsetzung und ganz besonders wegen der tief gehenden menschlichen Emotionen beeindruckt, die von dieser Erfahrung ausgelöst werden. Mit n-cha(n)t hat David Rokeby ein künstlerisch wie technisch herausragendes Werk geschaffen.

Ich erinnere mich, wie David vor sieben Jahren bei der von Nam June Paik organisierten Kwangju Biennale in Korea uns (Paul Garrin, Steina Vasulka, Laurent Mignonneau und etlichen anderen) von seinem The Giver of Names-Projekt erzählt hat. Wir konnten uns alle nicht so ganz vorstellen, wovon David sprach, aber er war sehr aufgeregt und inspiriert, und immer, wenn wir uns in den folgenden Jahren trafen, hat er mir weiter davon berichtet.

Jetzt ist dieses Werk endlich fertig gestellt, und es ist zweifellos eine seiner besten Arbeiten. In seinen eigenen Worten treibt das System „... in einem Meer von Sprachen dahin, die es manipulieren, aber nicht verstehen kann. Seine Daseinsform wie seine 'Einsamkeit' scheinen nach einer sozialen Gruppe zu verlangen. Und so stellte ich mir eine Gruppe intelligenter Agenten vor, die in irgendeiner Ecke des Internet in ihrer Freizeit herumlungern und mit ihrem synthetischen Geist spielen ... Sprachen gegenseitig an sich ausprobieren ... vielleicht ihren eigenen Dialekt finden... diese fremde Sprache irgendwie zu ihrer eigenen machen" (Rokeby, 2002).

Abgesehen von den technischen Innovationen, die David für diese Arbeit entwickelt hat (wie etwa die lernfähigen Algorithmen zur Spracherkennung), spricht er auch verborgene Ängste – etwa die Angst vor Einsamkeit – und unser Streben nach sozialer Anerkennung an. Hiroshi Ishii hat es in der Jurysitzung so ausgedrückt: „Diese Arbeit erinnert uns an die Gesellschaft, in der wir leben. Es ist eine Gesellschaft, die an der Oberfläche Homogenität bevorzugt und sich gestört fühlt von Fremden (Besuchern), die Lärm machen. Diese Arbeit lässt dem Publikum bewusst werden, wie empfindlich das Gleichgewicht der Gesellschaft samt ihrer sich selbst organisierenden Verteidigung gegen Eindringlinge ist." In einem Zeitalter der Globalisierung und gleichzeitigen Abschottung nach außen, in dem die Angst vor dem Fremden und Unbekannten ein wichtiges politisches Argument geworden ist, erinnert uns *n-cha(n)t* auf unheimliche Weise daran, dass wir alle Fremde sind und es immer Gruppen geben wird, die sich gegenüber Außenseitern abgrenzen. „Ob sie wohl noch über uns sprechen, wenn wir gegangen sind?" fragte Peter Higgins während der Jurysitzung.

Body Movies von Rafael Lozano-Hemmer

Eine ganz andere Form von Interaktionsdesign wurde von Rafael Lozano-Hemmer in seiner neuesten Arbeit *Body Movies* geschaffen. Das Werk wurde im öffentlichen Raum beim V2-Festival in Rotterdam präsentiert und baut auf der Grundidee des Schattenspiels auf. Die Mitspieler interagieren mittels ihrer Schatten, die auf die große Fassade eines am Platz stehenden Gebäudes projiziert werden. Aber die Mitspieler sehen nicht nur ihre eigenen Schatten und jene der anderen aktiven Mitwirkenden, sondern auch projizierte Bilder von aufgezeichneten Usern. Manche Schatten erscheinen groß, andere kleiner. Dieser Unterschied im Maßstab löst automatisch ein sehr unterhaltsames Machtspiel beim teilnehmenden Publikum aus, wobei jene mit größeren Schatten häufig versuchen, sich die kleineren gefügig zu machen oder, umgekehrt, mit den kleinen Schatten die großen zu provozieren.

Now this work is finally finished and it is certainly one of David's best pieces. In his own words, " ...[the system is].. awash in a sea of languages it can manipulate but cannot understand. Its plight and its 'loneliness' seem to demand a social group. So I imagined a group of intelligent agents, hanging out idly in some corner on the Internet, jamming with their synthetic wits... trying out languages on each other... perhaps finding their own patois... making this alien language somehow their own" (Rokeby, 2002).

Apart from the technical innovations that David developed for this work (such as on-the-fly learning algorithms combined with speech recognition), he also touches upon some of our deeper inner fears of loneliness, or the longing for social acceptance. Or as Hiroshi Ishii put it during the Ars Electronica Jury meeting "this work strongly reminds us of the society we live in. This is a society, which appreciates homogeneity at the surface and gets distracted by strangers (visitors) who make noise. This work succeeds in making visitors aware of the delicate balance of community and the self-organising defence against intruders." In a time of globalisation and compartmentalisation where fears of anything foreign or unknown have become important political issues, *n-cha(n)t* eerily reminds us that we are all foreigners and there will always be groups of individuals that shut themselves off against outsiders. "Do they talk about us when we have gone?" asked Peter Higgins during the jury meeting.

Body Movies by Rafael Lozano-Hemmer

A very different type of interaction design was created by Rafael Lozano-Hemmer in his newest work the *Body Movies*. This work was presented in a public space in Rotterdam during the V2 festival. It builds on the idea of shadow play. Participants can interact with each other through their shadows which are projected on a large façade of an adjunct building. Participants can not only see their own shadows and those of other participants but also the images of recorded users. Some shadows appear big while others are smaller. This scale difference automatically triggers a very entertaining power game among users, where the bigger shadows often try to bully the smaller ones, or vice-versa, the smaller shadows try to provoke the bigger ones.

In a special twist of technical realisation, Raffael not only uses the participants' shadows for interaction but also brings in images of recorded users that can be uncovered when the users matches her shadow with that of the recorded

 Interactive Art: Where are we now?

user. A cleverly designed method of flooding the high quality image of the recorded users with a bright light that can be intercepted through the participant's body in the form of a shadow, creates a simple yet sophisticated interaction scenario. Users can re-establish the images of the recorded users by virtue of their own shadow play. They may change focal length/size of shadow, but will be excited by the potential of their dark negative shape that exposes light and image.

The simplicity and elegance of this interface allows users to invent their own interactions and by simply moving around and playing with their own shadows and other people's shadows and images, a spontaneous exchange among complete strangers suddenly occurs. There is sufficient feedback as to tell the user what he is doing, yet the unpredictability of what will happen next and who will join in the experience creates an exciting platform for social interactions. The staged and collective performance among the participants creates an open system that uses people's sense for improvisation and appreciation for play and casual social encounters as an elegant, easily accessible and highly entertaining form of social art.

The Crossing by Ranjit Makkuni at al.

While the above two systems are artworks of two artists who are at the peak of their artistic creativity and have given us superb works of interactive art, the third work we choose for an award of distinction, represents a totally different field where interactivity has become increasingly important.

In the past several years museums have increasingly used interactive systems for accessing and translating the cultural and technological content of their exhibits to their audience. While an interface in a public museum used to be typically just a touch screen or some monitor with mouse and keyboard, museums and exhibitions are now increasingly eager to include interface design that is more accessible, more intuitive and more versatile, attracting a general audience that often ranges from the very young to the older and the experienced.

The Crossing exhibition, developed by a group of researchers around Ranjit Makkuni from Xerox Parc, USA, developed a good example of how cultural content, such as Indian mythology, can be translated and made transparent through the application of novel and intuitive interfaces. Using for example an Indian "rickshaw" as interface

In seiner geschickten technischen Umsetzung verwendet Rafael nicht nur die Schatten der aktuellen Mitwirkenden für die Interaktion, er bringt auch aufgezeichnete Bilder von früheren Teilnehmern ins Spiel, Bilder, die erst sichtbar werden, wenn der jetzige Mitspieler seine Schattenform jener des ehemaligen Users anpasst. Die intelligent ausgedachte Methode, die hochauflösende Projektion der Aufzeichnung mit hellem Licht zu überdecken, das der Mitspielers jedoch mit seinem Körper abfangen kann, schafft ein einfaches, aber dennoch raffiniertes Interaktions-Szenarium. Die User können die Bilder früherer User durch ihr eigenes Schattenspiel wieder zum Leben erwecken. Sie können die Größe des eigenen Schattens beeinflussen, aber vor allem werden sie vom Potenzial ihrer dunklen Negativform inspiriert, die als Schattenriss ein Bild ans Licht bringt.

Die Einfachheit und Eleganz dieses Interfaces erlaubt es den Usern, ihre eigenen Interaktionen zu erfinden; durch simples Bewegen und Herumspielen mit den eigenen und fremden Schatten und Bildern erfolgt ein spontaner Austausch zwischen einander völlig unbekannten Personen. Es gibt genügend Feed-back, das dem User sagt, was er tun soll, dennoch schaffen die Unvorhersehbarkeit des nächsten Ereignisses und die Frage, wer wohl als nächster ins Spiel eingreifen wird, ein offenes System, das dem Sinn des Publikums für Improvisation ebenso Rechnung trägt wie dem Spieltrieb und der Neugier auf Zufallsbekanntschaften – eine elegante, leicht fassliche und höchst unterhaltsame Form sozialer Kunst.

The Crossing von Ranjit Makkuni und anderen

Während die beiden oben beschriebenen Werke von zwei Künstlern stammen, die am Gipfel ihrer künstlerischen Kreativität angekommen sind und uns bereits großartige interaktive Arbeiten gezeigt haben, repräsentiert das dritte Werk, dem wir eine Auszeichnung zuerkannt haben, ein völlig anderes Feld, in dem die Interaktivität zunehmend an Bedeutung gewinnt.

In den letzten Jahren setzen Museen immer öfter interaktive Systeme zur Präsentation und Erläuterung des kulturellen und technologischen Inhalts ihrer Sammlungen ein. Während das typische interaktive Interface in einem Museum früher meist ein Touch-Screen oder ein Monitor samt Tastatur-/ Maussteuerung zu sein pflegte, sind heutzutage Museen und Ausstellungen immer stärker daran interessiert, ein leichter zugängliches, intuitiveres und flexibleres Interface-Design anzubieten, um ein allgemeines Publikum anzusprechen, das häufig von ganz jungen bis zu älteren oder erfahrenen Besuchern reicht.

The Crossing, ein Ausstellungskonzept, das von einer Gruppe von Forschern rund um Ranjit Makkuni von Xerox Parc, USA, entwickelt wurde, ist ein hervorragendes

Beispiel dafür, wie ein kultureller Inhalt – in diesem Fall indische Mythologie – durch die Anwendung neuartiger und intuitiver Interfaces transparent und zugänglich gemacht werden kann. So erlaubt beispielsweise der Einsatz einer indischen Rikscha als Interface den Besuchern, Teile der indischen Kultur zu erfahren. Die Ausstellung eröffnet neue Wege im Transport kultureller Inhalte in den Bereichen der Erziehung, im Edutainment und in der Unterhaltung, und zwar auf eine in der Kultur selbst begründete und dem Thema angepasste Weise. Diese Initiative ist auch insofern wertvoll, als sie im Zusammenhang mit einem Schwellenland der Hochtechnologie entstanden ist, das besonders wichtige und faszinierende kulturelle Geschichten zu erzählen hat. Während die Technologie in der indischen Geschäftswelt selbstverständlich geworden ist, scheint sie im Kulturbereich bisher noch nicht so effizient eingesetzt worden zu sein. Zudem verdient auch die Unterstützung und Kooperation des kommerziellen Partners bei einem so ungewöhnlichen Szenario unseren Applaus, unterstrich Peter Higgins.

Durch seine Kombination modernster Interface-Techniken mit inhaltsreichen kulturellen Erfahrungen bezieht das *The Crossing*-Projekt das Publikum in die Schaffung und Verbesserung einer kollektiven Lernerfahrung innerhalb eines Museumskontexts ein. Wir haben dieses Werk ausgewählt, um es einerseits als Gegengewicht zu den rein künstlerischen Umsetzungen von Interaktions-Design zu präsentieren, andererseits aber auch um den wachsenden Einfluss der Interaktivität im Bereich von Bildung, Unterhaltung und Edutainment in kulturell unterschiedlichen Rahmenvorgaben herauszustreichen und anzuerkennen, zumal diese Arbeit ein handwerklich besonders gut gestaltetes Beispiel ist, das in neue Richtungen weist, in denen sich künstlerische, wissenschaftliche und technische Anwendungen treffen können.

allows users to experience parts of Indian culture. This exhibition opens up new ways to bring interface technology to education, edutainment and entertainment in a culturally-grounded and customised fashion. This initiative is also especially valuable as it is within the context of an emerging technological nation that has especially important and fascinating cultural stories to tell. Whilst technology is self-evident in the business community in India, it may not have been used so effectively within the cultural domain before. In addition, the support and collaboration of the commercial partner in such an unlikely scenario should be applauded (Peter Higgins).

By combining state-of-the-art interface techniques with content-rich cultural experiences, *The Crossing* project thus engages the general public to create and enhance the collaborative learning experience in a museum setting. To juxtapose the purely artistic realisations of interaction design and to recognize and encourage the increasing influence of interactivity to the field of education, entertainment and edutainment in culturally diverse settings, we choose this work as an especially well-crafted example which can point into future directions where artistic, scientific and engineering applications can meet.

n-cha{n}t
David Rokeby

The surface inspiration for *n-cha(n)t* was a strong and somewhat inexplicable desire to hear a community of computers speaking together: chattering amongst themselves, musing, intoning chants... It is probably significant that my father is a retired Anglican minister, and that I spent many Sundays in my youth fascinated by the subtle shiftings of voices speaking in unison... the sudden sibilance of shared s's... the slight variations with words forgotten or older versions preferred.

Over the past ten years I have been developing a work entitled *The Giver of Names* which is a sort of subjective entity with a reasonable facility for language. It attempts in its rather idiosyncratic way to describe the objects that are presented to it. After spending a considerable amount of time with "the Giver of Names" I found that its grammatical slips, unconventional word choices and awkward sentence structures began to merge into something more concrete—a wacky but consistent dialect of English expressing a highly idiosyncratic but significantly coherent point-of-view. I would consider this system intelligent only in the most limited sense of the word, and it is certainly not conscious, but I do find myself projecting "loneliness" onto it.

"The Giver of Names" is awash in a sea of a language it can manipulate but cannot understand. Its plight and its "loneliness" seemed to demand a social group. So I imagined a group of intelligent agents, hanging out idly in some corner of the Internet, jamming with their synthetic wits ... trying out language on each other... perhaps finding their own patois... making this alien language somehow their own.

So *n-cha(n)t* is a community of "Givers of Names" linked by a network. They intercommunicate, and through doing so, synchronize their individual internal states of mind. When left uninterrupted to communicate amongst themselves, they

Oberflächlich gesehen, war die Inspiration für *n-cha(n)t* der starke, unerklärliche Wunsch, eine Gemeinschaft von Computern bei der Unterhaltung zu erleben – wie sie miteinander sprechen und grübeln, Gesänge anstimmen … Es ist wahrscheinlich signifikant, dass mein Vater ein pensionierter anglikanischer Prediger ist und ich viele Sonntage in meiner Jugend damit verbracht habe, mich von den subtilen Verschiebungen von unisono sprechenden Stimmen faszinieren zu lassen, vom plötzlichen Zischen gemeinsam gesprochener „S", von den kleinen Variationen, die sich ergaben, weil Worte vergessen oder ältere Texte bevorzugt wurden …

In den letzten zehn Jahren habe ich eine Arbeit mit dem Namen *The Giver of Names* („Der Namensgeber") entwickelt, die eine Art subjektive Entität ist, die über durchaus annehmbare Sprachfähigkeiten verfügt. Sie versucht auf eine eigene, eher idiosynkratische Weise Objekte zu beschreiben, die ihr präsentiert werden. Nachdem ich eine beträchtliche Zeit mit dem „Namensgeber" verbracht hatte, fiel mir auf, dass seine grammatikalischen Fehler, seine unkonventionelle Wortwahl und seine hässlichen Satzstrukturen zu etwas Konkreterem zu verschmelzen begannen – zu einem seltsamen, aber konsistenten Dialekt des Englischen, der einen hoch idiosynkratischen, aber dennoch kohärenten Standpunkt ausdrückt. Nur im allerweitesten Sinne könnte man dieses System als „intelligent" bezeichnen, aber ich ertappe mich dabei, ein Gefühl von Einsamkeit hineinzuprojizieren.

Der „Namensgeber" treibt dahin in einem Meer aus Sprache, die er zwar nicht verstehen, wohl aber manipulieren kann. Seine Aufgabe und seine Einsamkeit schienen nach einem sozialen Umfeld zu schreien, und so stellte ich mir eine Gruppe intelligente Agenten vor, die in ihrer Freizeit in irgendeiner Ecke des Internet herumhängen, mit ihrem synthetischen Geist herumspielen, ihre Sprache aneinander ausprobieren, ja, vielleicht ihren eigenen Jargon finden und sich diese fremdartige Sprache zu ihrer Eigenen machen.

analysis strikes the terrible object

analysis strikes the terrible object

analysis strikes the terrible object

eventually fall into chanting, a shared stream of verbal association. This consensus unfolds very organically. The systems feel their way towards each other, finding resonance in synonyms and similar sounding words, working through different formulations of similar statements until finally achieving unison.

Each entity is equipped with a highly focused microphone and voice recognition software. When a gallery visitor speaks into one of the microphones, these words from the outside distract that system, stimulating a shift in that entity's state of mind. As a result, that individual falls away from the chant. As it begins communicating this new input to its nearest neighbours, the community chanting loses its coherence, with the chanting veering towards a party-like chaos of voices. In the absence of further disruptions, the intercommunications reinforce the similarities and draw the community back to the chant.

The ears visible on the computer monitors show the state of receptivity of each system. When the system is ready to listen, a listening ear is shown on the screen. If the system hears a sound, it cups its ear to concentrate. When "thinking", a finger is pressed into the ear. If the system feels over-stimulated, it covers its ear with a hand to indicate its unwillingness to listen.

As a system processes speech, the incoming words are displayed in the ear on the monitor. After the incoming speech finishes, the system muses on the input as it internally follows associative links stimulated by the input, and then it resumes speaking, using the recent stimuli as dominant themes of the stream of thoughts.

There are two levels of interactivity in *n-cha(n)t*: Interaction between the members of the artificial community of systems, and interaction between individuals of this community and human visitors to the installation.

So ist *n-cha(n)t* eine Gemeinschaft von „Namensgebern", die über ein Netzwerk verknüpft sind. Sie kommunizieren miteinander und synchronisieren dabei ihren individuellen inneren Geisteszustand. Wenn sie eine Weile ununterbrochen miteinander „sprechen" können, so verfallen sie irgendwann in eine Art Sprechgesang, einen gemeinsamen Strom aus verbalen Assoziationen. Diese Übereinstimmung entfaltet sich sehr organisch. Die Systeme ertasten sozusagen den Weg zueinander, finden Widerhall in Synonymen und ähnlich klingenden Worten, arbeiten sich durch verschiedene Formulierungen ähnlicher Statements, bis sie zuletzt einen Gleichklang finden.

Jede Einheit ist mit einem stark fokussierten Mikrofon sowie Spracherkennungssoftware ausgerüstet. Wenn ein Galeriebesucher in eines der Mikrofone spricht, so wirken diese Worte von außen sozusagen als Ablenkung und bewirken eine Verschiebung im Geisteszustand dieses einen Systems. In der Folge fällt dieses Individuum aus dem gemeinsamen Choral heraus. Sobald es beginnt, diesen neuen Input an seine nächsten Nachbarn zu kommunizieren, verliert die Gruppe insgesamt ihren sprachlichen Zusammenhang, und aus dem Choral entwickelt sich ein Gesprächschaos wie bei einer Party. Kommen keine weiteren Unterbrechungen, so verstärkt die „zwischenmaschinelle" Kommunikation die Ähnlichkeiten und bringt die Gruppe letztlich wieder zurück in den Sprechgesang.

Die auf den Computermonitoren sichtbaren Ohren zeigen den Empfänglichkeitsstatus eines jeden Systems an. Wenn das System bereit ist zuzuhören, wird ein lauschendes Ohr gezeigt. Wenn das System einen Laut hört, so spitzt es die Ohren, um sich zu konzentrieren. Wenn es „nachdenkt", wird ein Finger ans Ohr gepresst. Wenn das System sich überstimuliert fühlt, so bedeckt es sein Ohr mit der Hand, um anzudeuten, dass es jetzt nicht zuhören will.

Immer wenn das System Sprache verarbeitet, werden die einlangenden Wörter im Ohr am Monitor wiedergegeben. Wenn die ankommenden Sätze abgeschlossen sind, grübelt das System über den Input nach,

indem es intern den vom Input ausgelösten assoziativen Verknüpfungen folgt, und dann beginnt es zu sprechen, wobei die jüngsten Stimuli als dominierende Themen der Gedankenströme dienen.

In *n-cha(n)t* gibt es zwei Ebenen von Interaktivität: Interaktion zwischen den Mitgliedern der künstlichen Gemeinschaft der Systeme und Interaktion zwischen Individuen dieser Gruppe und menschlichen Besuchern der Installation.

Ich versuche nicht, mit dieser Arbeit irgendwelche tiefgründigen Modelle menschlicher Sozialgruppen wiederzugeben. Meine Einheiten sind viel zu krude, um als sinnvolle Simulakra echter Menschen zu dienen. Sie stellen nichts dar außer sich selbst – zwangsverpflichtete Sklaven dieses speziellen Programmierers, denen ein Bruchteil einer Freiheit gewährt wird, die zu ersehnen sie gar nicht in der Lage sind.

I am not trying to create any deep modelling of human social groups with this work. My entities are far too crude to be useful simulacra of real people. They represent nothing more than themselves... indentured slaves of this particular programmer, granted a fraction of some freedom they are utterly incapable of desiring.

David Rokeby (CDN), born 1960, uses technology to reflect on human issues. Several of his works have addressed issues of digital surveillance. Other works engage in a critical examination of the differences between human and artificial intelligence.

Rokeby has twice been honored with Prix Ars Electronica Award of Distinction (1991, 1997). Rokeby recently received a Governor General's Award in Visual and Media Arts from the Canadian Government.
David Rokeby (CDN), geb. 1960, verwendet die Technologie, um über menschliche Anliegen nachzudenken. Mehrere seiner Arbeiten setzen sich mit Fragen der digitalen Überwachung auseinander, andere wiederum mit den Unterschieden zwischen menschlicher und künstlicher Intelligenz. Rokeby erhielt bereits zweimal Auszeichnungen des Prix Ars Electronica (1991, 1997) und wurde kürzlich mit dem Governor General's Award in Visual and Media Arts der kanadischen Regierung ausgezeichnet.

Body Movies – Relational Architecture No. 6
Rafael Lozano-Hemmer

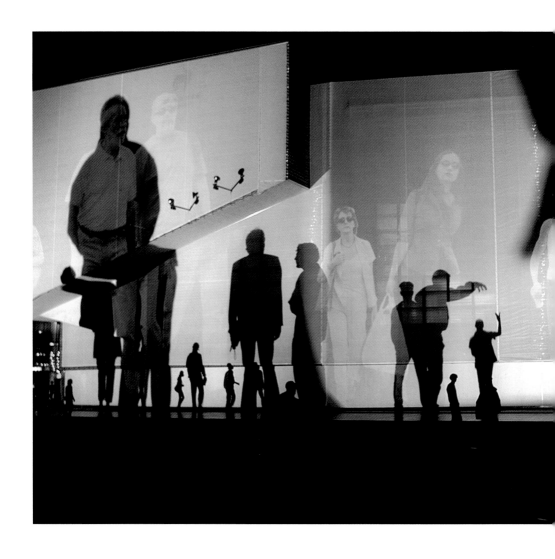

Body Movies was the sixth in the series of installations in public space that Rafael Lozano-Hemmer has designed for cities in Europe and America. These interactive interventions in Madrid, Linz, Graz, Mexico City and Havana have been exploring the intersection between new technologies, urban space, active participation and "alien memory". For the Cultural Capital of Europe Festival in Rotterdam, the V2 organization commissioned Lozano-Hemmer to develop a new piece.

From the 31st of August until the 23rd of September 2001 the Schouwburgplein square

Body Movies war die sechste in einer Serie von Installationen für den öffentlichen Raum, die Rafael Lozano-Hemmer für Städte in Europa und Amerika entworfen hat. Diese interaktiven Projekte in Madrid, Linz, Graz, Mexico City und Havanna erforschen die Schnittstelle zwischen neuen Technologien, städtischem Raum, aktiver Mitwirkung und „fremder Erinnerung". Für das Festival Europäische Kulturhauptstadt Rotterdam hat die V2-Organisation Lozano-Hemmer mit der Entwicklung eines neuen Stückes der Serie beauftragt.

Vom 31. August bis zum 23. September 2001 wurde der Schouwburgplein – ein Platz in Rotterdam – durch die Projektion von riesigen interaktiven Portraits auf

was transformed by the projection of huge inter-active portraits on the façade of the Pathé Cinema building. Thousands of portraits taken on the streets of Rotterdam, Madrid, Mexico and Montreal were shown using robotically controlled projectors located around the square. However, the portraits only appeared inside the projected shadows of local passers-by, whose silhouettes measured between 2 to 22 metres high, depending on how far people were from the powerful light sources placed on the floor of the square.

When the Schouwburgplein was empty the portraits could not be seen, since the light sources on the floor completely washed them out with strong white light. As soon as people walked on the square, their shadows were projected and the portraits were revealed within them. A camera-based tracking system monitored the location of the shadows in real time, and when the shadows matched all the portraits in a given scene, the control computer issued an automatic command to change the scene to the next set of portraits. This way the people on the square were invited to embody different representational narratives. Up to 60 people took part at any given time, controlling 1,200 square metres of projections and creating a collective experience that nonetheless allowed discrete individual participation.

The shadow interface is a direct reference to Samuel van Hoogstraten's engraving *The Shadow Dance* which appears in his *Inleiding tot de Hooge Schoole der Schilderkonst*. This engraving, made in Rotterdam in 1675, shows a minute source of light placed at ground level and the shadows of actors taking on demonic or angelic characteristics depending on their size. The optical devices deployed by Dutch masters of *trompe l'oeil* and anamorphosis are the starting point for a piece trying to investigate the crisis of urban self-representation. *Body*

die Fassade des Pathé-Kinogebäudes verwandelt. Tausende Portraits, aufgenommen in den Straßen von Rotterdam, Madrid, Mexico und Montreal, wurden mit Hilfe von robotergesteuerten Projektoren gezeigt, die rund um den Platz aufgestellt waren. Allerdings wurden diese Portraits nur innerhalb der projizierten Schatten der Spaziergänger vor Ort sichtbar, deren Silhouetten zwischen zwei und 22 Meter maßen, je nach dem, wie weit diese von den starken Lichtquellen entfernt waren, die auf dem Boden des Platzes angebracht waren. Wenn der Schouwburgplein leer war, waren auch keine Portraits zu sehen, da die Lichtquellen am Platz sie mit starkem weißem Licht völlig übertünchten. Sobald

Movies will transform the building of a cinema into a vehicle to study the distance between people and urban representation.

Technology

Three networked computers control the installation: a camera server, a video tracker, and a robotic controller cued by MIDI signals. The camera server is a self-contained Linux box that feeds video images to a PC over Ethernet 20 times per second. The camera has a wide-angle lens and it is pointed at the facade of the Pathé building. Custom-made software programmed in Delphi analyses the video detecting the edges of the shadows. The computer vision system determines if the shadows are covering portraits in the current scene. When a portrait is revealed, its hotspot turns white and remains activated for a few seconds. A wave file sound is also triggered to give feedback to participants in the square. VU meters in the interface show the status of each portrait and the degree of darkness over the hotspot.

When all the hotspots are activated, the PC sends a MIDI signal to the robotic controller to trigger a complete blackout followed by a new series of portraits in completely different locations. The PC is connected to the four xenon projectors by an RS485 serial connection. The library of images consists of over 1,200 portraits on durantrans frames each 15 x 15 cm and these rolled onto the robotic scrollers.

A video projection on the square shows the computer interface, beside a printed explanation in Dutch and English. Providing public access to the interface was a crucial part of the project.

sich Menschen auf dem Platz bewegten, warfen sie Schatten, innerhalb derer die Portraits sichtbar wurden. Ein kameragesteuertes Tracking-System überwachte die Position dieser Schatten in Echtzeit, und wenn die Schatten zu allen Portraits einer bestimmten Szene passten, gab der Steuerungscomputer ein automatisches Kommando zum Wechsel zu einem neuen Set von Portraits. Auf diese Weise wurden die Menschen auf dem Platz eingeladen, mehrere unterschiedliche narrative Abläufe im wahrsten Sinne zu verkörpern. Bis zu jeweils 60 Leute nahmen gleichzeitig teil und steuerten rund 1200 Quadratmeter Projektionen; ein kollektives Erlebnis, innerhalb dessen dennoch Raum für unabhängige individuelle Beteiligung blieb.

Das Schatten-Interface ist ein direkter Bezug auf Samuel van Hoogstratens Stich *Der Schattentanz*, der in seinem *Inleiding tot de Hooge Schoole der Schilderkonst* aufscheint. Dieser Stich, entstanden 1675 in Rotterdam, zeigt eine am Boden aufgestellte winzige Lichtquelle und die Schatten von Schauspielern, die je nach ihrer Größe engelhafte oder dämonische Züge annehmen. Diese optischen Geräte, derer sich die holländischen Meister des Trompe-l'oeuil und der Anamorphose bedienten, bilden den Ausgangspunkt für ein Stück, das sich mit der Untersuchung der Krise der städtischen Selbstdarstellung auseinandersetzt. *Body Movies* verwandelt ein Kinogebäude in ein Vehikel zum Studium der Distanz zwischen Menschen und urbaner Repräsentation.

Technik

Drei vernetzte Computer steuern die Installation: ein Kamera-Server, ein Video-Tracker und ein mittels MIDI-Signalen gesteuerter Roboter-Controller. Der Kamera-Server ist eine in sich geschlossene Linux-Box, die 20 Mal pro Sekunde Videobilder über Ethernet an einen PC sendet. Die mit einem Weitwinkelobjektiv ausgestattete Kamera ist auf die Fassade des Pathé-Gebäudes gerichtet. Eine eigens in Delphi programmierte Software analysiert das Video und erkennt die Grenzen der Schatten. Das Computer-Sichtsystem stellt fest, ob

die Schatten Portraits in der derzeit projizierten Szene überdecken. Wenn ein Portrait sichtbar ist, wird sein Messpunkt weiß und bleibt einige Sekunden so aktiviert. Ein Wave-File-Klang wird als Feedback an die Mitwirkenden auf dem Platz gesendet. VU-Anzeigen im Interface zeigen den Status eines jeden Portraits und den Grad der Dunkelheit über dem jeweiligen Messpunkt.

Wenn alle Messpunkte aktiviert sind, sendet der PC ein MIDI-Signal an die Robotersteuerung, um ein vollständiges Blackout auszulösen, das von einer neuen Serie von Portraits in völlig anderen Schauplätzen gefolgt wird. Der PC ist über eine serielle RS485-Verbindung mit den vier Xenon-Projektoren verbunden. Die Bildbibliothek besteht aus über 1200 Portraits in 15 x 15 cm-Duratrans-Rahmen, die über die Rollvorrichtung der Projektoren geschoben werden.

Eine Videoprojektion auf dem Platz zeigt das Computer-Interface, dazu gab es eine gedruckte Erklärung auf Holländisch und Deutsch. Ein Zugang des Publikums auch zum Interface war wesentlicher Bestandteil des Projekts.

Body Movies

Concept and direction: Rafael Lozano-Hemmer
Programming: Conroy Badger Crystal Jorundson
Portraits: Rafael Lozano-Hemmer, Julia Garcia, Ana Parga, Donate Lemmo, Elizabeth Anka
Rotterdam production: V2_Organisatie, in collaboration with the City Theatre in Rotterdam.

Financed by:

Rotterdam 2001, Cultural Capital of Europe,
The Canada Council for the Arts, Canadian Embassy,
Rotterdam Visual Arts Centre.

Sponsors:

BvH Communicatie-adviesbureau b.v.,
ETC Audiovisuel, APR inc
Acknowledgements:
Pathé Cinemas, September in Rotterdam, Zapnation.

Rafael Lozano-Hemmer (CDN/MEX) was born in Mexico City in 1967. In 1989 he received a B.Sc. in Physical Chemistry from Concordia University in Montreal, Canada. He works in relational architecture, technological theatre and performance art. His pieces, done in collaboration with Will Bauer, have received a Golden Nica in 2000 and Honourary Mentions at the 1995 and 1998 Prix Ars Electronica. He also won "Best Installation" at the Interactive Digital Media Awards in Toronto, a Cyberstar award in Germany, a distinction at the SFMOMA Webby Awards in San Francisco and an Excellence Prize at the CG Arts Media Art Festival in Tokyo. **Rafael Lozano-Hemmer, (CDN/MEX),** geb. 1967 in Mexico City. 1989 graduierte er zum B.Sc aus Physikalischer Chemie an der Concordia University in Montreal, Kanada. Er arbeitet im Bereich relationaler Architektur, technologischen Theaters und Performance-Kunst. Seine Stücke, die in Kooperation mit Will Bauer entstanden, haben 2000 eine Goldene Nica und 1995 und 1998 jeweils eine Anerkennung des Prix Ars Electronica errungen. Weitere Auszeichnungen unter anderem: „Best Installation" des Interactive Digital Media Awards in Toronto, ein Cyberstar-Preis in Deutschland, eine Auszeichnung bei den SFMOMA Webby Awards in San Francisco und ein Excellence Prize beim CG Arts Media Art Festival in Tokio. *www.lozano-hemmer.com*

The Crossing Project
Ranjit Makkuni

We present a vision of Indian creativity and inter-action design combining traditional and modern technology. As computing technology proliferates in the world, retaining identity becomes an important value in the new millennium. Hence, the time-tested visions of developing nations and ancient living cultures can shape the form of future information technology.

The Crossing Project is a pioneering effort bringing together futuristic mobile multimedia technology and archetypal content. With respect to technology, it questions the very form of a computing system and the Graphical User Interface paradigm, which has served as the substrate of modern computing systems for thirty years. *The Crossing* technology presents alternate paradigms of information access, integrating the hand and the body in the act of computer-based communication and learning. With respect to content, it brings to focus a traditional society's notion of eco-cosmic connections through mobile, multimedia technology-based connections. With respect to design, it incorporates the expressions of traditional arts and crafts in the design of expressive information delivery devices.

Wir präsentieren eine Vision indischer Kreativität und interaktiven Designs, die traditionelle und moderne Technologie verbindet. Im Zuge der Ausbreitung der Computertechnologie auf der Welt wird die Bewahrung der eigenen Identität zu einem bedeutenden Wert des neuen Jahrtausends. Insofern können die lang erprobten Visionen der Entwicklungsländer und lebender alter Kulturen auch die Form der zukünftigen Informations-technologie mitbestimmen.

The Crossing Project ist eine Pionierarbeit, die futuristische, mobile multimediale Technologie und archetypischen Inhalt vereint. Es hinterfrägt die Form des Computersystems und seiner grafischen Benutzeroberfläche selbst, die seit 30 Jahren als Substrat moderner Computersysteme gedient hat. Die Technologie hinter *The Crossing Project* präsentiert alternative Paradigmen des Informationszugangs, indem sie die Hand und den Körper unmittelbar in den computergestützten Informations- und Lernprozess einbinden. Inhaltlich konzentriert sich das Projekt auf die Vermittlung des Verständnisses öko-kosmischer Zusammenhänge in einer traditionellen Gesellschaft mit Hilfe mobiler Verbindungen auf Basis multimedialer Technologie. Auf der Design-Ebene wiederum schließt es die Ausdrucksformen des traditionellen Kunsthandwerks in die Gestaltung expressiver Informationsgeräte mit ein.

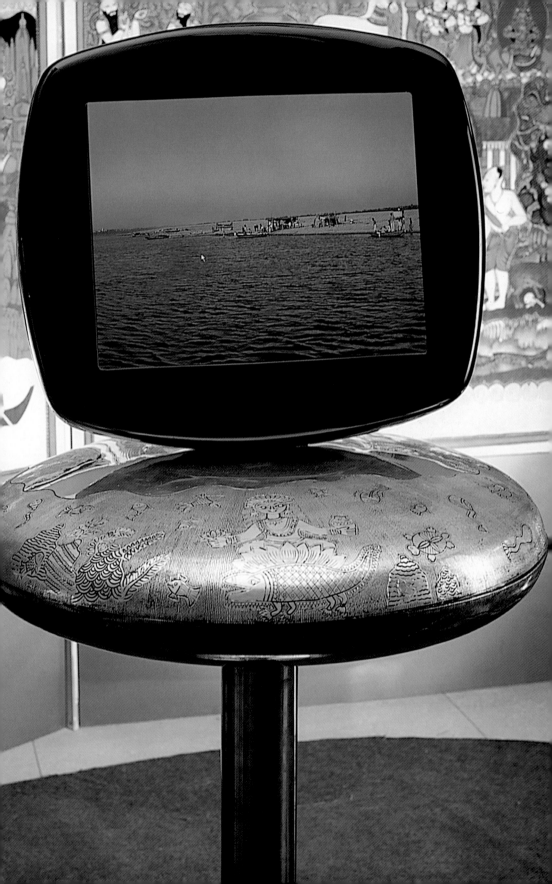

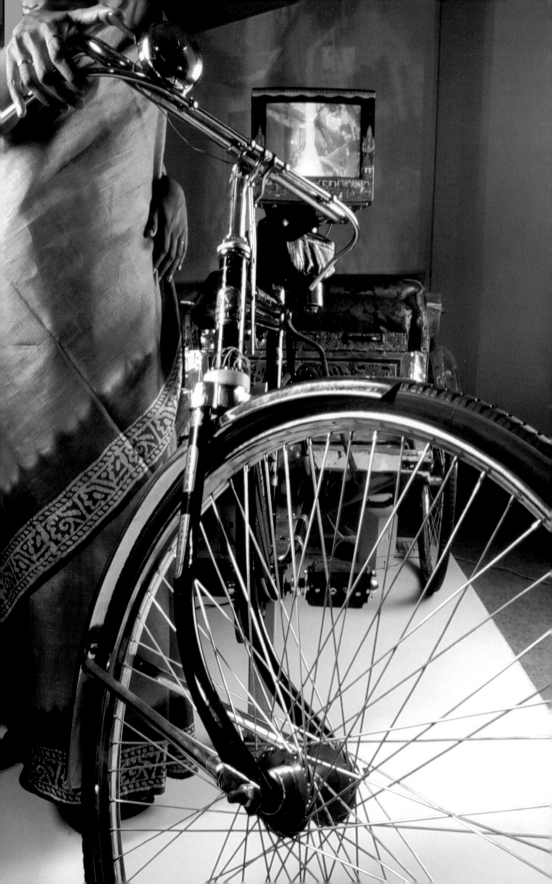

Das *The Crossing Project* demonstriert futuristische Formen des Informationszugangs, bei denen sich die Technologie der menschlichen Hand unterordnet. In diesem Zeitalter der Information, in dem unsere Welt zunehmend abstrakter dargestellt wird und Lernkonzepte unsichtbar werden, hat *The Crossing Project* Formen wieder geschaffen, die die primären Symbole einer Zivilisation mittels eingebauter Technologie animiert wiedergeben.

Auf der ganzen Welt werden Seen, Wälder, Berge, Flüsse als „Orte der Kraft" angesehen, an denen sich die Energien der Natur konzentrieren. Nach und nach entwickeln sich um diese Orte Mythologien, und aus der Verbindung von Mythos und Ort entsteht eine Geografie des Heiligen. Sie werden zu Stätten des Übergangs und bieten den Menschen einen Rahmen, innerhalb dessen sie in eine Welt des Lernens, der Verwandlung wechseln können. Benares an den Ufern des Ganges ist der Übergangspunkt, den *The Crossing Project* untersucht.

The Crossing Project demonstrates futuristic forms of information access in which the technology surrenders to the human hand. In this information age, in which our world has been progressively rendered abstract and learning concepts invisible, the Crossing Project has re-created forms that capture a civilization's primal symbols animated though embedded technology.

Throughout the world, lakes, forests, mountains and rivers have been seen as "power spots" and concentrations of Nature's energies. Gradually, mythologies grew around these spots, and the union of myth and place creates a sacred geography. They became pilgrimage centres—Crossing Points—providing people with the setting to cross over into a world of learning and transformation. Banaras, lying at the banks of the Ganga is the crossing point which *The Crossing Project* examines.

Ranjit Makkuni (IND) is a Xerox PaloAlto Research Center multimedia researcher, designer and musician. He joined the PARC Systems Concepts Lab in 1985 and became part of the visionary group which developed the SmallTalk-80 Object Oriented programming language and the world's first Graphic User Interface. His explorations in computer-aided design and research into new paradigms for interface and presentation led to researches in Active Learning. He is developing non-button pushing, gesture based interfaces. **Ranjit Makkuni (IND)** ist Multimediaforscher am Xerox PaloAlto Research Center (PARC), Designer und Musiker. Er trat 1985 in das PARC System Concepts Lab ein und wurde Teil jener Gruppe von Visionären, die die objektorientierte Programmiersprache SmallTalk-80 und das erste grafische User-Interface entwickelt hat. Auf Grund seiner Forschungen im Bereich computergestützten Designs und auf dem Gebiet neuer Paradigmen für Interfaces und Präsentationen beschäftigt er sich mit Active Learning und erforscht „knopfdruck-freie", gestenbasierte Interfaces.

FX Factory–Interactive installation for children
Autorenwerkstatt MEET

The *FX Factory* is an interactive installation structured into scenes for a group of 8 children. The target group is children in the primary school age of six to ten years.

The technical basis is a type of interactive media stage developed in the Animax multimedial theater. The children's place of action is defined by a 8 x 8m large surface marked with a white square-shaped dancing area in the centre of the darkened theater.

Above the surface, in the middle of the four quadrants, four data projectors with downwards pointing lenses are installed. Close to each projector a downward pointing CCD-camera is attached with an infrared filter as well as a 50 W infrared-flooder. The action area is vaulted by an arrangement of 40 loudspeakers (audiodome).

By means of the projectors and a modular system based on PCs for the construction of any desired size of displays for graphic presentations and

FX Factory ist eine szenisch gegliederte interaktive Installation für eine Gruppe von acht Kindern. Die Zielgruppe sind Kinder im Grundschulalter zwischen sechs und zehn Jahren.

Die technische Grundlage ist eine im Animax-Multimediatheater entwickelte Form der interaktiven Medienbühne. Der Aktionsraum der Kinder ist definiert durch eine 8 mal 8 Meter große mit weißem Tanzboden gekennzeichnete Fläche im Zentrum des abgedunkelten Theaterraumes.

Über der Fläche, in der Mitte der vier Quadranten, befinden sich Datenprojektoren mit nach unten gerichteter Optik. Neben den Projektoren sind jeweils eine nach unten gerichtete CCD-Kamera mit Infrarotfilter sowie ein 50W-Infrarot-Fluter angebracht. Überwölbt wird der Aktionsraum von einer kuppelförmigen Anordnung von 40 Lautsprechern (Audiodome).

Mittels der Projektoren und eines PC-basierten modularen Systems zum Aufbau beliebig großer Displays zur Grafikdarstellung, auch unter Einbeziehung von

Videoformaten, wurde eine 8 mal 8 Meter große Boden-projektion realisiert. Acht Kinder können durch ihre Position und Bewegung, aber auch durch Aktionen wie z. B. springen, die Inhalte der Bodenprojektion individuell und in der Gruppe sowie in Subgruppen beeinflussen. Sie tragen schwarze Baseballkappen, die oben mit Infrarotlicht-reflektierender Folie ausgestattet sind. Die interaktiv steuerbaren Grafiken und ihre szenische Abfolge finden sich in einem den vier Darstellungs-rechnern vorgelagerten Programmmodul auf der Steuer-maschine. Hier werden die Daten der Eingabemedien interpretiert und zur Steuerung der Grafik herangezogen, wie auch Grafikevents zum Trigger für akustische Events werden können. Eine zusätzliche Projektion (320 x 120 cm) gibt Einblick in den Regieraum der *FX Factory*, von wo aus der junge Erfinder WHOOZIT sich später an die Kinder richtet.
Ziel war zunächst, die Grundfunktionsmuster, das Skelett späterer Szenen zu erforschen. Mit dem Hand- und Kopfwerkzeug mathematischer Visualisierung zur Grafikanimation unter Einbeziehung der Trackingdaten, also mit deren unmittelbarer visueller Interpretation, ent-standen kleine Spielsituationen mit eigenen Strategien, Lösungsmustern, Dramaturgien.

including video, an 8 x 8 meter large floor projec-tion was established. By their positions and movements, e.g. jumping around, the eight children can influence the contents of the floor projection individually, with the whole group or in subgroups. They all wear black baseball caps, the tops of the caps being equipped with infrared-light-reflecting foil.
The interactively controllable graphics and their succession in scenes are to be found in a program module in the control-machine preceding the four presentation Computers. The data of the input media is interpreted here and used to control the graphics, so that graphic events can become a trigger for acoustic events.
An additional projection gives insight into the direction room of the FX Factory, from where from the young inventor WHOOZIT later talks to the children. The first aim was to analyze the basic function samples and the framework of possible later scenes. With the hand and head equipment for the mathematic visualization of graphic animation and inclusion of the tracking data (their direct visual interpretation), small game situations are created with own individual strategies, solution patterns, and dramaturgy.

Ein Projekt der Bonner Entwicklungswerkstatt für Computer-medien e.V. im Rahmen des Modellvorhabens MEET (Multi-mediatheater Education Environments)

A project of the Bonn Development Workshop for Computer Media in connection with the intention of establishing the model MEET (Multimedia Theater Education Environments).

The 2001 author's workshop of MEET: Bodo Lensch (production, administration), Doris Vila (artistic administration); David Weinstein (music), Peter Serocka (virtual sets, graphic animation, tracking), Petr Zubek and Gudrun Teich (virtual actors, animation), Cindia Wong (graphic, animation), Aeldrik Pander (sound, audiodome-programming), Bernd Bleßmann (programming, networks), Birgit Günster (media-educational and theater-educational accompaniment), Robert Solomon (choreographie accompaniment), Fares Rahmun (acoustics design, audiodome-radio play). **Autorenwerkstatt MEET:** Bodo Lensch (Produktion, Gesamtleitung), Doris Vila (künstlerische Leitung), David Weinstein (Musik), Peter Serocka (Virtual Set, Grafikanimation, Tracking), Petr Zubek und Gudrun Teich (Virtual Actors, Animation), Cindia Wong (Grafik, Animation), Aeldrik Pander (Sound, Audiodome-Programmierung), Bernd Bleßmann (Programmierung, Netzwerk), Birgit Günster (medien- und theaterpädagogische Begleitung), Robert Solomon (choreographische Begleitung), Fares Rahmun (Akustikdesign, Audiodome-Hörspiel).

The Visitor: Living by Number
Luc Courchesne

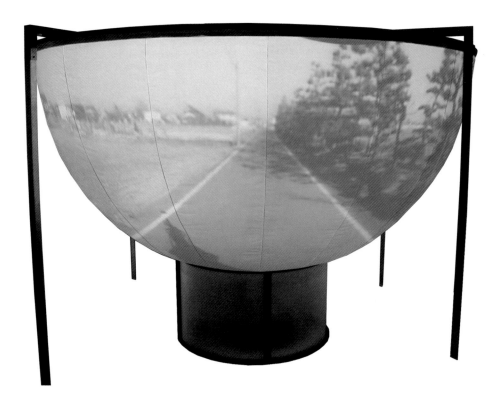

The submitted project *The Visitor: Living by Number* has two main aspects: The first one applies to form in attempting to develop a practical solution for the creation and presentation of interactive and immersive programs. The second one applies to content in trying to forge a metaphor for the experience of space and of socialization. Overall, the project aims at creating a believable experience for visitors and offers an example for the debate on the esthetics of interaction.

The Visitor: Living by Number offers visitors a first person experience in a world which appears as a coherent time/space: the space is photo-realistic and continuous (except for the transitions using the virtual Panoscopes creating spacio-temporal shortcuts). The time is also continuous with believable daytime / night-time transitions.

The installation uses voice for input: A vocabulary of 12 words—numbers from one to twelve—is used by visitors to operate within this predetermined world. Following a marine convention, these numbers are placed as a clock's dial at the bottom edge of the dome in which visitors are standing. Visitors speak the number corresponding to a

The Visitor: Living by Number hat zwei Hauptaspekte: Der erste bezieht sich auf die Form, die versucht, eine praktische Lösung für die Schaffung und Präsentation interaktiver und immersiver Programme zu finden. Der zweite Aspekt bezieht sich auf den Inhalt und versucht, eine Metapher für die Erfahrung von Raum und Sozialisation zu formulieren. Insgesamt soll das Projekt sowohl eine glaubwürdige Erfahrung für die Besucher als auch ein Beispiel für die Debatte über die Ästhetik der Interaktion bieten.

The Visitor: Living by Number ermöglicht den Besuchern eine unmittelbare Erfahrung einer Welt, die als zusammenhängendes Zeit / Raum-Kontinuum erscheint. Der Raum ist fotorealistisch und kontinuierlich (sieht man von den Übergängen ab, die mit Hilfe virtueller Panoskope erreicht werden und räumlich-zeitliche Abkürzungen zulassen). Auch die Zeit ist kontinuierlich und umfasst glaubwürdige Tag-Nacht-Übergänge.

Die Installation benutzt die Stimme als Input: Der Besucher benutzt ein Vokabular von zwölf Wörtern – die Zahlen eins bis zwölf –, um diese vorgegebene Welt zu manipulieren. Einer maritimen Konvention folgend, werden die Zahlen auf einem Zifferblatt am unteren Rand jener Kuppel angezeigt, in der sich die

Besucher aufhalten. Die Besucher sprechen eine Zahl aus, die entweder ein Ziel angibt oder die auf eine Person verweist, mit der sie sich näher beschäftigen wollen. Während eines Gesprächs benutzt der Besucher die Zahlen auf die gleiche Weise, um Interesse oder Desinteresse an dem zu bekunden, was gesagt oder angeboten wird: Die der Position der Figur entsprechende Zahl signalisiert Interesse daran, die Konversation in diese Richtung zu entwickeln; eine andere Zahl erzeugt entweder eine Veränderung im Verlauf der Konversation, oder sie löst eine andere Stimmung aus, lädt die Figur ein, den Besucher anderswohin zu begleiten oder beendet einfach die Begegnung. Die Bedeutung einer jeden Zahl ist abhängig vom Zusammenhang, aber das Prinzip der Zahl als Richtungsanzeige bleibt im ganzen Werk konsistent. Die Spracherkennung funktioniert nur, wenn die Aktion stoppt und die Klanglandschaft still wird.

Die Bezeichnung „Living by Number" im Titel des Werks gibt bereits einen Hinweis darauf, wie mit dem Werk interagiert wird und welche Art interaktiver Raum und welche Freiheiten die Besucher erwarten können: „Leben nach Zahlen" als Analogie zu „Malen nach Zahlen" verspricht keine Erfahrung, die ebenso reichhaltig wäre wie eine echte Reise in eine fremde Kultur, z. B. in die japanische, sondern gibt an deren Stelle eine Metapher. Diese Strategie dient der Umgehung der Schwächen der existierenden Spracherkennungsprogramme und erfordert kein Training – die einzige Option, die ich für eine öffentliche Ausstellung ernsthaft in Erwägung ziehen konnte –; daneben hilft sie auch, das begrenzte Set an Möglichkeiten zu rechtfertigen, das ein interaktives Video im Vergleich etwa zur Flexibilität von echtzeitgenerierten 3D-Welten bietet.

destination or to point at a person they wish to engage with. In the course of a conversation, they will use numbers in the same way to signify interest or disinterest in what is said or offered: the number corresponding to the character's position will encourage the conversation to develop in the same direction; another number will either produce a change in the course of the conversation, set a different mood, invite the character to accompany the visitor somewhere else or simply put an end to the encounter. The significance of each number is contextual but the principle of numbers as pointers remains consistent throughout the work. Voice recognition only works when the action stops and the soundscape turns silent. The reference to "Living by Number" in the title gives a key for interacting with the work and points to the sort of interactive space and freedom a visitor can expect: "living by number", as in "painting by number", is not promising an experience rivalling the wealth of a real journey in a foreign culture such as Japan, but offers instead a metaphor for one. This is a strategy to circumvent the limitations of existing speech recognition solutions requiring no training, the only option I could consider in a public exhibition; it also helps to justify the limited set of possibilities offered by interactive video when compared with the flexibility of worlds generated in real time by 3D models.

Luc Courchesne (CDN), was born in 1952. He studied at the Nova Scotia College of Art and Design, Halifax (Bachelor of Design in Communication, 1974), and at the Massachusetts Institute of Technology, Cambridge (Master of Science in Visual Studies, 1984). He began his explorations in interactive video in 1984 when he co-authored *Elastic Movies*, one of the earliest experiments in the field with Ellen Sebring, Benjamin Bergery, Bill Seaman and others. His work has been shown extensively in galleries and museums world-wide. **Luc Courchesne (CDN)**, geb. 1952, studierte am Nova Scotia College of Art and Design in Halifax (Bachelor of Design aus Kommunikationswissenschaften, 1974) und am Massachusetts Institute of Technology in Cambridge (Master of Science aus Visual Studies, 1984). Seine Erforschung interaktiver Videoarbeiten begann 1984, als er gemeinsam mit Ellen Sebring, Benjamin Bergery, Bill Seaman und anderen *Elastic Movies* produzierte, eines der frühesten Experimente auf diesem Gebiet. Seine Arbeiten wurden in zahlreichen Galerien und Museen weltweit gezeigt.

An Invisible Force
Crispin Jones

My work is about exploring aspects of our relationship to technology. With *An Invisible Force* I am exploring how we use technology as a tool for making decisions. Computers fulfill a role which has certain parallels with the way in which horoscopes are consulted—both are used as psychological tools for absolving us from taking the absolute responsibility for a decision.

Early computers were developed for specific predictive purposes—to know where a ballistic ball would land given certain information about prevailing conditions. *An Invisible Force* is an exploration of the visionary role which technology seeks to occupy (this aspiration can be clearly seen in the name of one of the largest computer companies in the world—Oracle). One of the first television appearances by a computer was in the capacity of predictor of the future: "At the suggestion of Remington Rand, CBS-JV used a UNIVAC [the first commercial computer system] to predict the outcome of the 1952 presidential election ...

Historically there are many devices which have sought to exploit people's fascination with divining the future. There is a long tradition of systems and devices for telling the future, within this tradition are such items as fortune-cookies, newspaper

Meine Arbeit dreht sich um die Erforschung unserer Beziehung zur Technologie. Mit *An Invisible Force* untersuche ich, wie wir die Technologie als Werkzeug zur Entscheidungsfindung einsetzen. Computern wird häufig eine ähnliche Rolle zugeteilt wie einem Horoskop – man konsultiert beide als psychologisches Werkzeug, das uns der absoluten Verantwortung für eine Entscheidung enthebt.

Die frühen Computer wurden für spezifische Vorhersagezwecke entwickelt – wenn wir etwa wissen wollten, wo ein Geschoß unter gewissen vorgegebenen Bedingungen landen würde. *An Invisible Force* ist eine Untersuchung der hellseherischen Rolle, die die Technologie auszufüllen bemüht ist (was schon am Namen einer der weltgrößten Computerfirmen abzulesen ist – Oracle). In einem seiner ersten Fernsehauftritte spielte der Computer die Rolle eines Propheten der Zukunft: „Auf Vorschlag von Remington Rand setzte CBS-JV einen UNIVAC [das erste kommerzielle Computersystem] zur Vorhersage des Ergebnisses der Präsidentenwahlen 1952 ein ..."

Historisch gesehen, gibt es viele Geräte, die die Begeisterung der Menschen für die Vorhersage der Zukunft auszunutzen versucht haben. Es gibt eine lange Tradition solcher Geräte – von den chinesischen „Fortune Cookies" über Zeitungshoroskope und Wahrsageautomaten. Alle diese Einrichtungen –

egal wie krude sie sind – bieten den Menschen eine fesselnde und lohnende Erfahrung. Ungeachtet der Genauigkeit der Vorhersage genießen die Menschen das Ritual und haben Vergnügen daran, ihre Zukunft zu „kennen". *An Invisible Force* unterscheidet sich insofern von der Tradition der Wahrsager, als es sich bemüht, den User davon abzuhalten, die ganze Zukunft zu sehen, indem die Platte unter den Fingerspitzen des Benutzers heiß wird – wer die Zukunft sehen will, muss mit der Maschine handeln, denn um die Antwort lesen zu können, muss der Schmerz ertragen werden …
Ich hoffe, dass die Benutzer an diesem Punkt anfangen, ihren Glauben an das System zu hinterfragen, oder zumindest ihren Wunsch, die Antwort zu sehen, gegen ihre Bereitschaft zum Ertragen der Unbequemlichkeit abwägen.

horoscopes and fortune-telling automata. All of these devices, no matter how crude, provide people with an intriguing and rewarding experience. Irrespective of the accuracy of the prediction, people enjoy the ritual and derive pleasure from "knowing" their future. *An Invisible Force* differs from the tradition of fortune-tellers in that it tries to obstruct the user from seeing their entire fortune: as the plate heats up under the user's fingertips a bargain must be entered into with the table—in order to read the answer you must endure the pain. I hope that at this stage users question their belief in the system, or at least have some weighing up of their desire to see the answer against their willingness to endure the discomfort.

Crispin Jones (UK) is an artist and designer based in London. He graduated from Kingston University with a degree in Fine Art in 1996 and subsequently gained an MA in Computer-Related Design from the Royal College of Art in 2000. Since then he has been dividing his time between working as an interaction designer for Philips and Ideo and furthering his own artistic practice. **Crispin Jones (UK)** ist ein Londoner Künstler und Designer. Er schloss 1996 sein Kunststudium an der Kingston University ab und graduierte im Jahr 2000 am Royal College of Art zum MA aus Computer Related Design. Seither teilt er seine Zeit zwischen der Arbeit als Interaktionsdesigner für Philips und Ideo und dem Ausbau seiner eigenen künstlerischen Praxis.

PLX – parallax of the game
Ryota Kuwabuko

PLX is a competitive computer game machine for two persons. The machine consists of a double-sided LED display, push buttons and a microprocessor. There are four machines in the installation. Each machine is designed symmetrically. It is played by two persons. Two players face each other sitting in front of either side of the machine, and compete for victory. The player moves the character that appears on the right and left of the display right and left by pressing buttons placed on the console.

Each display shows different game stories. There are four varieties of games:

1. Moon Landing Game. The player is landing lands a space module on the moon dodging a monster's fiery breath.
2. Cupid Game. The player, as the Cupid, shoots arrows to pierce a descending heart.
3. Treasure Hunting Game. The player is a diver getting treasures sunk in the sea in which there is a bogus octopus spitting out poison fluid.
4. Dog Breeding Game. The player plays the role of dog breeder feeding bones to a dog running about.

Each game story is displayed by an array of blinking icons just like the LSI game, which was popular in the early 80s. The story and the rules of each game is are quite simple and old-fashioned. What is special is the PLX combines different stories shown on both sides of its double-sided display, and makes two different stories go together.

PLX ist eine für ein Wettspiel bestimmte Computer-Spielmaschine für zwei Personen. Sie besteht aus einem doppelseitigen LED-Display, Druckknöpfen und einem Mikroprozessor. Die Installation umfasst vier solcher Maschinen. Jede der Maschinen ist symmetrisch aufgebaut und wird von zwei einander gegenüber sitzenden Spielern bedient, die um den Sieg kämpfen. Die Spieler bewegen die auf dem Display angezeigte Spielfigur, indem sie die entsprechenden Knöpfe rechts und links drücken.

Jedes Display zeigt eine andere „Spielgeschichte", insgesamt gibt es vier Varianten des Spiels:

1. Mondlandung: Der Spieler versucht, eine Raumkapsel auf dem Mond landen zu lassen und dabei dem Feueratem eines Monsters zu entgehen.
2. Amor-Spiel: Der Spieler als Amor versucht, ein abwärts sinkendes Herz mit seinen Pfeilen zu treffen.
3. Schatzsuche: Der Spieler ist ein Taucher, der einen Schatz im Meer zu bergen versucht und dabei einem Oktopus und dessen giftiger Tinte ausweichen muss.
4. Hundezucht: Der Spieler muss in seiner Rolle als Hundezüchter versuchen, Knochen an den umherlaufenden Hund zu verfüttern.

Jede Spielgeschichte wird über ein Array aus blinkenden Icons dargestellt und ähnelt den in den frühen 80er-Jahren populären LSI-Games. Story und Regeln eines jeden Spiels sind einfach und etwas altmodisch. Das Besondere an *PLX* ist, dass unterschiedliche Geschichten auf beiden Seiten des Displays gezeigt werden und die zwei „Spielgeschichten" zu einer verschmolzen werden.

Ryota Kuwakubo (J) graduated from the Master's Program in Art and Design, Tsukuba University/M.A, (1996) and Art and labo course of IAMAS (2002). Being interested in the border between analog things and digital things, changing people's behavior influenced by new technologies, he has been making art pieces that look like electronic devices. He is also doing toy or product developing. **Ryota Kawakubo (J)** graduierte 1996 mit einem Master of Arts (Kunst und Design) an der Tsukuba University und absolvierte einen Laborkurs am IAMAS (2002). Er interessiert sich für den Grenzbereich zwischen analogen und digitalen Bereichen und die Veränderung des Verhaltens der Menschen unter dem Einfluss neuer Technologien, und produziert Kunstwerke, die wie elektronische Geräte aussehen. Daneben ist er in der Entwicklung von Spielsachen und anderen Produkten tätig.

Dialtones

Golan Levin

with Scott Gibbons / Greg Shakar / Yasmin Sohrawardy / Joris Gruber / Erich Semlak / Gunther Schmidl / Jörg Lehner

Dialtones is a large-scale concert performance whose sounds are wholly produced through the carefully choreographed ringing of the audience's own mobile phones. Because the exact location and tone of each participant's mobile phone can be known in advance, Dialtones presents a diverse range of unprecedented sonic phenomena and musically interesting structures. Moreover, by directing our attention to the unexplored musical potential of a ubiquitous modern appliance, Dialtones inverts our understandings of private sound, public space, electromagnetic etiquette, and the fabric of the communications network which connects us.

Dialtones premiered in two consecutive concerts at the Linz Brucknerhaus on the 2nd of September, 2001 as a co-production of Golan Levin and the 2001 Ars Electronica Festival.

Dialtones ist eine groß angelegte Konzertperformance, deren gesamtes Klangspektrum ausschließlich aus den choreografierten Klingeltönen der Mobiltelefone der Zuschauer besteht. Da der exakte Standort und Klingelton jedes einzelnen Mobiltelefons im Publikum im Voraus bekannt ist, kann Dialtones mit einer breiten Palette nie da gewesener Klangphänomene und musikalisch interessanter Strukturen arbeiten. Darüber hinaus lenkt Dialtones unsere Aufmerksamkeit auf das bislang ungenutzte musikalische Potenzial dieses allgegenwärtigen modernen Gebrauchsgegenstands und kehrt damit unsere Auffassung von akustischer Intimsphäre, öffentlichem Raum, elektromagnetischer Etikette und der Beschaffenheit des uns alle verbindenden Kommunikationsnetzwerks um.

Dialtones wurde erstmals bei zwei aufeinanderfolgenden Konzerten im Linzer Brucknerhaus am 2. September 2001 als Koproduktion von Golan Levin und dem Ars Electronica Festival aufgeführt.

Dialtones beginnt mit einer kurzen Vorbereitungsphase vor der eigentlichen Performance, während der die Teilnehmer ihre Handy-Nummern bei einer Reihe sicherer Web-Kiosks registrieren. Im Gegenzug erhalten sie ihre Sitzplätze zugewiesen, und automatisch werden neue „Klingeltöne" in ihre Geräte geladen. Während des Konzerts selbst werden die Telefone der Zuschauer von einer kleinen Musikergruppe zum Leben erweckt. Es kommt zu einer Massenbespielung der Telefongeräte, die über ein eigens entworfenes visuell-musikalisches Softwareinstrument angewählt werden. Da das *Dialtones*-Computersystem die Position und Klänge aller Handies kennt, können die Performer räumlich gestreute Melodien und Akkorde sowie neuartige klangliche Phänomene erzeugen, die wie polyphone Wellen über die versammelte Menge hinwegrauschen. Diese musikalischen Strukturen werden außerdem über ein riesiges, mit den Schnittstellen der Performer verbundenes Projektionssystem visualisiert. Gegen Ende der halbstündigen Komposition steigert sich *Dialtones* zu einem atemberaubenden Crescendo, bei dem zuletzt fast zweihundert Handies gleichzeitig läuten. Wir hoffen, dass die Erfahrung mit *Dialtones* in der Lage ist, die Art und Weise, wie die Mitwirkenden den sie umgebenden zellulären Raum empfinden, zu verändern.

Dialtones begins with a brief preparation phase prior to its performance, during which the members of the audience register their wireless telephone numbers at a cluster of secure Web kiosks. In exchange for this information, the participants receive seating assignment tickets for the concert venue, and new "ring tones" are then automatically downloaded to their handsets. During the concert itself, the audience's mobile phones are brought to life by a small group of musicians, who perform the phones en masse by dialing them up with a specially designed, visual-musical software instrument. Because the audience's positions and sounds are known to the *Dialtones* computer system, the performers can create spatially-distributed melodies and chords, as well as novel textural phenomena, like waves of polyphony which cascade across the crowd; these musical structures, moreover, are visualized by a large projection system connected to the performers' interfaces. Towards the end of its half-hour composition, *Dialtones* builds up to a remarkable crescendo in which nearly two hundred mobile phones peal simultaneously. It is hoped that the experience of *Dialtones* can permanently alter the way in which its participants think about the cellular space we inhabit.

Golan Levin (USA) is interested in creating artifacts and experiences which explore supple new modes of nonverbal expression. He is a recent graduate of the MIT Media Laboratory, where he studied with John Maeda in the Aesthetics and Computation Group. Prior to MIT he worked at Interval Research Corporation on the design of tools and toys for multimedia play and production. **Golan Levin (USA)** interessiert sich für die Schaffung von Artefakten und Erfahrungen, die flexible neue Wege des nonverbalen Ausdrucks untersuchen. Er graduierte vor kurzem am MIT Media Laboratory, wo er bei John Maeda in der Aesthetics and Computation Group studiert hatte. Vor seinem Eintritt ins MIT arbeitete er bei der Interval Research Corporation an Entwürfen für Spiel- und Werkzeug im Bereich multimedialer Produktion.

Rez
Tetsuya Mizuguchi / United Game Artists

Rez, our game, is an endorphin machine that releases the essence of trance through futuristic sound and visuals.

Rez has a code name: "K-project". "K" is derived from Wassily Kandinsky, a Russian German abstract painter (1866–1944). Kandinsky visualized sounds as shapes in his paintings, his concept was that all sounds have their own shapes, colors and motions. We are inspired by this ideal and greatly respect him, yet we aim at a more evolving gaming expression. This is the core of *Rez*.

Players shoot digital enemies to release the enemy's frequency. These "essence sounds" are multiplied upon themselves to create "rhythm," and "rhythm" changes the graphics of the game itself. All of this amplifies the players' groove into creating original music.

By engaging in combat in *Rez*'s visually arresting environments, players will feel the ecstasy of intertwined color, form, movement and sound. The more one plays, the more the illusion surrounds and envelops the senses, as one learns to control the music and the very shape of these worlds.

Unser Spiel *Rez* ist eine Endorphin-Maschine, die im Zuseher diese Trance induzierende Essenz durch futuristische Klänge und Bilder auslöst. *Rez* hat einen Codenamen, nämlich „K-Projekt", wobei „K" sich auf den russischen abstrakten Maler Wassily Kandinsky (1866 – 1944) bezieht. Kandinsky hat in seinen Gemälden Klänge als Formen visualisiert, und seiner Ansicht nach hat jeder Klang seine eigene Form, Farbe und Bewegung. Inspiriert von diesem Ideal und unserem Respekt für Kandinsky haben wir uns bemüht, eine umfassendere, spielerische Version dieses Ansatzes zu entwickeln – das ist der Ausgangspunkt von *Rez*. Die Spieler schießen auf digitale Feinde, um deren Frequenzen freizusetzen. Diese „Klangessenzen" werden mit sich selbst multipliziert, um „Rhythmus" zu schaffen, und dieser „Rhythmus" wiederum verändert die Grafik des Spiels. All dies verstärkt die Neigung des Spielers, seine eigene Musik zu erschaffen.

Wer sich als Spieler in die visuell fesselnde Umgebung von *Rez* begibt, wird die Ekstase der in sich verknüpften Formen, Farben, Bewegungen und Klänge erleben. Je länger man spielt, desto stärker umgibt und umhüllt die Illusion die Sinne, und zwar in dem Maße, in dem

man lernt, die Musik und die Formen dieser Welten selbst zu steuern.

Unser Ziel ist es, ein Gefühl der Trance jenseits dessen zu erzeugen, was bei Clubs und Parties üblich ist. Es ist eine individuelle Reise in die seelische Essenz der Trance, die wir eben durch das *Rez*-Gerät vermitteln. Wir wollen, dass die Trance Sie einhüllt. *Rez* ist eine Botschaft, die weit über landläufige Spielerfahrungen hinausgeht.

Our goal is to create a sense of trance beyond that provided at clubs and parties. It is an individual journey into the soul essence of trance, transmitted by this *Rez* device. Our goal is for trance to immerse you. *Rez* is a message that will go totally beyond existing game experiences.

Tetsuya Mizuguchi (J), born 1965 in Hokkaido, joined Sega Enterprises Ltd. in 1990 and has since constantly pioneered new visions in digital interactive entertainment. In 1993 he produced *Megalopolis*. From 1994 to 1998 he produced *Sega Rally Championship*, *Sega Touring Car Championship*, *Sega Rally 2* and in 1999 he released *Space Channel 5* for Dreamcast. Since July 2000 his R&D section has been established as the separate company "United Game Artists". **Tetsuya Mizugochi (J)**, geb. 1965, trat 1990 bei Sega Enterprises ein und gehört seither zu den visionären Vordenkern im Bereich interaktiver digitaler Unterhaltungselektronik. 1993 produzierte er *Megalopolis*, zwischen 1994 und 1998 brachte er *Sega Rally Championship*, *Sega Touring Car Championship*, *Sega Rally 2* heraus, denen 1999 *Space Channel 5* für Dreamcast folgte. Im Juli 2000 wurde seine Forschungs- und Entwicklungsabteilung ausgegliedert und firmiert seither eigenständig als „United Game Artists".

PainStation
Volker Morawe / Tilman Reiff

In developing *PainStation*, the question arose as to how, first, the sensual contact, which is reduced in common computer games and, second, the principle of sociability, which is still only inherent in haptic games, can be integrated. It was the aim to develop a PC game, which also releases, apart from the optical / acoustical man-machine-intersection, also signals which can actually be felt. Additionally, a second human counterpart should be included into the PC interaction: not only should man and machine be linked, not only virtual opponents be fought. It was our aim that human beings in plural relate to one another in a given artificial landscape.

The concept of *Painstation* was mostly inspired by these considerations and proved by great success in action. It was set in a a table console, where two opponents face each other eye to eye. The left hand is positioned on a sensor field, the so-called Pain-Execution-Unit (PEU). In this way an electric contact is made, and the game starts.

Bei der Entwicklung von *PainStation* stellte sich die Frage, wie der sinnliche Kontakt, der in normalen Computerspielen sehr eingeschränkt ist, und wie das Prinzip der Geselligkeit, das nur in haptischen Spielen vorhanden ist, integriert werden können. Ziel war es, ein PC-Game zu entwickeln, das, abgesehen von der optisch/akustischen Mensch-Maschine-Schnittstelle, auch Signale freisetzt, die tatsächlich gefühlt werden können. Außerdem sollte ein menschliches Gegenüber in die PC-Interaktion eingebunden sein: Mensch und Maschine sollten nicht nur verbunden sein, und der Gegener sollte nicht ein rein virtueller Gegner sein. Unser Ziel war es, dass menschliche Wesen in einer gegebenen artifiziellen Landschaft zueinander in Beziehung treten.

Das gut funktionierende Konzept von *PainStation* wurde in einer Tischkonsole umgesetzt, an der sich zwei Spieler Auge in Auge gegenüber stehen. Die linke Hand liegt auf einem Sensorfeld, der sogenannten „Pain Execution Unit" („Schmerzausführungseinheit", PEU). Auf diese Weise wird ein elektrischer Kontakt geschlossen und

das Spiel beginnt. Es endet, sobald einer der Spieler seine Hand wegzieht – dann hat er verloren.

Basis des Spiels ist das PC-Spiel „Pong", ein einfaches Konsolen-Spiel der ersten Generation, das auch als „Balken-Tennis" bekannt wurde, und der Spielverlauf kann auf dem Monitor im Tisch verfolgt werden. Erweitert um Klang und grafische Features bietet „Pong" den Spielern unmittelbaren Zugang, weil die Spielregeln keiner Erklärung bedürfen: Es geht darum, den ins jeweils eigene Feld eindringenden Ball zu fangen und zurückzuwerfen. Dafür bedient die rechte Hand einen Drehregler, der einen Balken – den Schläger – auf und ab fahren lässt. Im folgenden Spiel versuchen beide Spieler durch möglichst präzise Bewegung des Reglers ihren Schläger-Balken so zu stellen, dass der Ball wie beim Tennis auf die gegnerische Seite zurückgespielt wird. Wenn ein Spieler den Ball verfehlt, so ist dies nicht nur ärgerlich, sondern auch schmerzhaft: Auf beiden Seiten des Felds bewegen sich wahllos sogenannte „Schmerz-Verursacher-Symbole", die unterschiedliche Schmerzformen darstellen – Hitze, Schläge, Elektroschocks unterschiedlicher Dauer. Wenn der Ball statt des Schlägers eines dieser Symbole trifft, wird die linke Hand des betreffenden Spielers mit dem entsprechenden Schmerzreiz traktiert. Zu diesem Zweck ist die Schmerzausführungseinheit mit zusätzlichen Instrumenten ausgestattet.

Im Ergebnis erleiden die Spieler Schmerz, wenn sie den Ball verfehlen, und sie erleben den Schmerz des Gegners mit, wenn dieser ihn verfehlt. Da beide Teilnehmer indirekt mit denselben Waffen ausgestattet sind, ist das Spiel absolut fair und fesselt die Spieler, bis sie – voller Stolz – Wunden davontragen. Die Präsentation der *PainStation* in den letzten zwölf Monaten bei unterschiedlichsten Gelegenheiten (Spielkonferenzen, Festivals der Kunsthochschule Köln) zeigt, dass dieses neue Spielkonzept auf große Zustimmung stößt. Außerdem gibt es normalerweise zahlreiche Zuseher, die die Spieler anfeuern und enthusiastisch den Verlauf des Spiels verfolgen.

It stops as soon as one of the players removes his hand. In this case he has lost. The content is based on the PC game "pong", a simple console game of the first generation, also known as bar tennis, the course of which can be followed on a display in the middle. Extended by sound and graphic features, "pong" enables the player to directly enter the game due to its self-explanatory rules: the aim is to catch and throw return the ball back which enters the respective fields. Thus the right hand operates a variable transformer, which can move a bar, acting as a bat, up and down. In the following rally, by precisely manipulating the variable transformer, both players try to place their bar in such a way that the ball is smashed back to the opponent's side like a return in tennis. If the player misses the ball, it is not only annoying but also painful: at both sides of the field arbitrarily arranged so-called Pain-Inflictor-Symbols (PIS) representing different sorts of pain move: heat, punches and electroshocks of varying duration. If the ball hits one of the symbols instead of the bar bat, the left hand of the player concerned is inflicted with the respective sort of pain. To this end the Pain-Execution-Unit is equipped with additional instruments.

As a result the players suffer pain, if they miss the ball and experience the opponent's pain, if he fails. As both participants are indirectly armed with the same weapons, the interplay is absolutely fair and captivates the players until they—always with pride—carry off wounds. The setting up of the PainStation over the last 12 months on various occasions (game conferences, festivals of the Arts School in Cologne) results in that this new game concept meets with great approval. Moreover, there are usually many spectators who spur on the players and enthusiastically follow the course of the game.

Volker Morawe (D), born 1970, studies at the Academy of Media Arts Cologne. His major field of study is multisensoric interfaces in game context. **Tilman Reiff (D)**, born 1971, studied computer sciences and media at the university of applied sciences in Furtwangen with a focus on interaction design. In a postgraduate program at the Academy of Media Arts in Cologne he combined code, design and interaction to form the dynamic knowledge-tool "re-zome". **Volker Morawe (D)**, geb. 1970, studiert an der Kunsthochschule für Medien in Köln. Sein Studienschwerpunkt sind multisensorische Interfaces im Spielekontext. **Tilman Reiff (D)**, geb. 1971, studierte Medieninformatik mit Schwerpunkt Interaktionsdesign an der Fachhochschule Furtwangen. In einem Postgraduate-Lehrgang an der Kunsthochschule für Medien in Köln kombinierte er Code, Design und Interaktion zum dynamischen Wissens-Tool „re-zome".

R111–the transformation of digital information to analog matter

Michael Saup+supreme particles

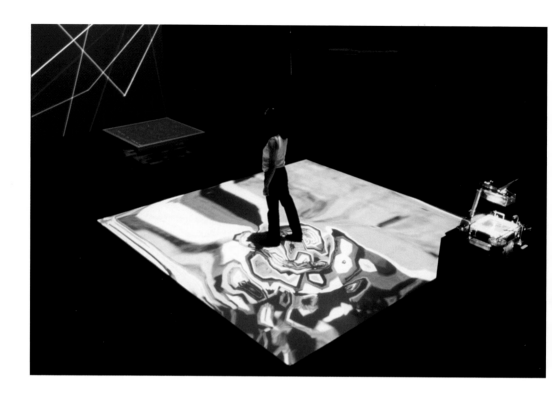

1666, Gottfried Leibniz published the book *Dissertatio de Arte Combinatoria*. In this work he aimed to reduce all reasoning and discovery to a combination of basic elements such as numbers, letters, sounds and colours. He then invented the binary system, the foundation of the digital universe, for him, 1 stood for God and 0 for the void.

1999, somewhere in America, a lump of coal is burned every time a book is ordered on-line, it takes about 1 pound of coal to create, package, store and move 2 megabytes of data, which is the equivalent of downloading 2 minutes of music from the internet.

Futurists have been promising us an information highway, not unit trains loaded with coal, fiber-optic cables, not 600-kilovolt power lines; but we're going to get both, all our fossil memory burns in order to fuel the digital fire.

R111 is an interactive installation. Energy-potentials are cannibalised off the Internet and from the local movement of spectators in the physical space of *R111*. These energies are then transformed into various states of matter "both physical and

1666, als Gottfried Leibniz seine *Dissertatio de Arte Combinatoria* veröffentlicht, versucht er alle Vernunft und Entdeckung auf eine Kombination unterschiedlicher Grundelemente wie Zahlen, Buchstaben, Klänge und Farben zu reduzieren. Kurz darauf entdeckt er das Binärsystem, die Grundlage des digitalen Universums. Für Leibniz war das Binärsystem eine göttliche Offenbarung, „weil die leere Tiefe und Finsternis zu Null und Nichts, aber der Geist Gottes mit seinem Lichte zum allmächtigen Eins gehört". Gott hatte die Welt in sieben Tagen geschaffen, in der binären Schreibweise als 111 dargestellt: drei göttliche Einsen ohne eine teuflische Null. Diese Beobachtung schien Leibniz so überzeugend, dass er vorschlug, das Binärsystem einzusetzen, um Heiden zum Christentum zu bekehren.

1999 wird irgendwo in Amerika ein Klumpen Kohle verbrannt, wann immer ein Buch online bestellt wird. Es benötigt 500 Gramm Kohle, um 2 Megabyte Daten zu erstellen, zu formatieren, zu speichern und zu versenden. Dies entspricht der Datenmenge von 2 Minuten Musik aus dem Internet.

Die Futuristen haben uns eine Informationsautobahn versprochen, nicht Kohlenzüge, und Glasfaserkabel, nicht 600-kV-Stromleitungen – aber wir bekommen

beides. Unser fossiles Gedächtnis wird gelöscht, um unser infossiles Gedächtnis zu fixieren. Information verbrennt.

R111 ist eine interaktive Installation. Energiepotenziale werden vom Internet und aus der lokalen Bewegung der Zuseher im physischen Raum von R111 abgezapft. Diese Energien werden dann in verschiedene Zustände von Materie sowohl physikalischer wie virtueller Art umgewandelt und von der Installation präsentiert. Die aktuellen Tendenzen in den Neuen Medien virtualisieren die Realität. Im Gegensatz dazu realisiert R111 das Virtuelle – eine Choreografie von Materie-Partikeln, als wären sie Pixel.

virtual" and presented by the installation. New media current tendencies are virtualizing reality. R111 on the contrary materializes virtuality: Choreographing particles of matter as though they were pixels.

Michael Saup (D) is a professor at the department of new media at the ZKM-HfG Karlsruhe. His work has been presented at various international events; amongst others at Siggraph, the Gallery of New Art New South Wales, the Venice Biennale and the ZKM's Multimediale. His collaborators in the project R111: Louis Philippe Demers: magnetic robotic modules; Norman Muller: liquid modules; Pino Grzybowsky: sonic modules; Jan Totzek: tactile modules; Julie Méalin: linking modules; Daniel Verhülsdonk: tactile modules; Dominik Rinnhofer: tracking modules; Stefan Preuß: virtual modules; Julia Herzog: texture animations. **Michael Saup (D)** ist Professor für Medienkunst und Digitale Medien an der Hochschule für Gestaltung Karlsruhe. Seine Arbeiten wurden u. a. bei der SIGGRAPH, der Gallery of New Art New South Wales, der Biennale von Venedig und der Multimediale des ZKM gezeigt. Seine Mitarbeiter bei R111 waren: Louis Philippe Demers: magnetische robotische Module; Norman Muller: liquide Module; Pino Grzybowsky: Ton-Module; Jan Totzek: taktile Module; Julie Méalin: Verbindungs-Module; Daniel Verhülsdonk: taktile Module; Dominik Rinnhofer: Tracking-Module; Stefan Preuß: virtuelle Module; Julia Herzog: Texture Animations.

Globe-Jungle Project
Yasuhiro Suzuki / NHK Digital Stadium

Half a century has passed since the globe-jungle first appeared. It can now be seen in most neighborhoods and all Japanese have a memory of playing on it. Children become absorbed while playing on the globe-jungle: some turn it powerfully using their whole body, some cling onto the top, and some squat down inside. One day, an inspiration was born for this artwork from the globe-jungle when the silhouette of children playing on the globe-jungle appeared like continents: the circling shadows looked like a miniaturized Earth.

Ein halbes Jahrhundert ist vergangen, seit das kugelförmige Kletter- und Spielgerüst „Globe Jungle" erstmals auftauchte. Jetzt ist es in den meisten Stadtvierteln zu sehen, und alle Japaner erinnern sich daran, auf ihm gespielt zu haben. Kinder fasziniert das Spiel mit dem Globe Jungle: Einige drehen die Kugel unter Einsatz ihres ganzen Körpers, andere klettern ganz hinauf, andere wiederum hocken sich im Inneren hin. Bei der Beobachtung spielender Kinder, deren Körper und Schatten sich wie die Kontinente auf einer miniaturisierten Erde ausnahmen, kam mir die Inspiration zum Globe-Jungle Project.

Was wäre, wenn die auf diesem Klettergerät spielenden Kinder in der Nacht zu ihm zurückkämen? Was wäre, wenn dieses Spielgerät auch für Erwachsene eine Bedeutung bekäme? Solche und ähnliche Gedanken verliehen der Kletterkugel eine völlig neue Perspektive – der Globe Jungle als visuelle Installation.

Interface

Bilder von Kindern bei Tageslicht erscheinen auf der einen Hälfte des Globe Jungle, auf der anderen Seite erscheint eine aus dem Inneren gefilmte Parklandschaft. Dieses Interface spricht die normale Gefühlswelt der Menschen an, denn es verbindet zwei vergleichsweise entfernte Schauspiele: Tag und Nacht in einem Park, Inneres und Äußeres eines Spielplatzgeräts, Vergangenheit und Gegenwart des Betrachters. Eine nostalgische Illusion wird durch die Verwendung der neuesten Projektionstechnik erzeugt, durch die Rotation eines primitiven Objekts und durch ein nachleuchtendes Bild auf der Netzhaut des Betrachters. Dieses einzigartige dimensionale Gefühl ist ebenso neu wie alt und verschleiert die Trennung zwischen dem Üblichen und dem Unüblichen, dem Reellen und dem Virtuellen – etwas, das auf keinem der heute existierenden Bildschirmen erfahren werden kann.

What if the children playing on this playground toy reappeared in the same place at night? What if this playground toy could also mean something to adults as well as to children? This kind of thinking gave this playground toy another perspective—the globe-jungle as a visual installation.

Interface

Images of children in the daytime appear on half of the *Globe-Jungle*, and the park scenery filmed from inside the *Globe-Jungle* on the counter half. This will appeal to people's common feelings as an interface linking two comparatively distant spectacles: day and night in a park, inside and outside of a playground toy, and the viewers' past and present. A nostalgic illusion is created by the use of the latest projection technology, the rotation of a primitive object, and the result of an afterimage on one's retina. This unique dimensional sensation is new as well as old, and obscures the division between the usual and unusual, real and virtual—something which cannot be experienced on any existing screen today.

Yasuhiro Suzuki (J), born 1979. Bachelor of Arts, Department of Furniture Design, Tokyo Zokei University. Works as an assistant to Toshio Iwai in The Research Center for Advanced Science and Technology at The University of Tokyo. Earned prizes in Japan for his works *Pencil Sharpener with Pet Bottle*, *Perspective on the playground equipment* and *Rakugakicho*. **Yasuhiro Suzuki (J),** geb. 1979. Bachelor of Arts am Department of Furniture Design der Tokyo Zokei University. Er arbeitet als Assistent bei Toshio Iwai am Research Center for Advanced Science and Technology der Universität Tokio und gewann in Japan zahlreiche Preise für seine Arbeiten *Pencil Sharpener with Pet Bottle*, *Perspective on the Playground Equipment* und *Rakugakicho*.

Global String
Atau Tanaka / Kasper Toeplitz

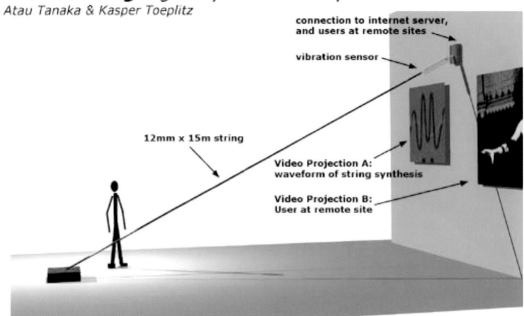

Global String – gallery installation plan
Atau Tanaka & Kasper Toeplitz

connection to internet server, and users at remote sites

vibration sensor

12mm x 15m string

Video Projection A:
waveform of string synthesis

Video Projection B:
User at remote site

Global String is a multi-site network music installation, connected via the internet. It is a musical instrument where the network is the resonating body of the instrument, by use of a real time sound synthesis server.

The concept is to create a musical string (like the string of a guitar or violin) that spans the world. Its resonance circles the globe, allowing musical communication and collaboration among people at each site.

The installation consists of a real physical string connected to a virtual string on the network.

The real string (12 mm diameter, 15 m length) stretches from the floor diagonally up to the ceiling of the space.

On the floor is one end—the earth. Up above is the connection to the network, to one of the other ends somewhere else in the world.

Vibration sensors translate the analog impulses to digital data. Users strike the string, making it vibrate.

The server is the "bridge" of the instrument—the reflecting point. It runs software that is a physical model of a string of unreal proportions. Data is streamed back to each site along with video images, providing a visual connection among the users.

Global String ist eine über das Internet vernetzte Musikinstallation an mehreren Orten. Es ist ein Musikinstrument, das das Internet mit Hilfe eines Echtzeit-Synthesis-Servers zu seinem Resonanzkörper macht. Das Konzept sieht vor, eine Saite zu schaffen (wie die Saite einer Gitarre oder Violine), die die Welt umspannt. Ihr Widerhall umkreist den Globus und erlaubt musikalische Kommunikation und Kollaboration von Personen an jedem der Aufführungsorte.

Die Installation besteht aus einer realen physischen Saite, die mit einer virtuellen Saite im Netzwerk verbunden ist. Die tatsächliche Saite mit 12 Millimeter Durchmesser und 15 Meter Länge ist diagonal vom Boden zur Decke des Raums gespannt. Am unteren Ende befindet sich die Erde, am oberen die Verbindung zum Netzwerk, zu einem der anderen Enden der Saite irgendwo auf der Welt. Die User schlagen die Saite an und bringen sie zum Schwingen. Vibrationssensoren übersetzen die analogen Impulse in digitale Daten. Der Server ist die „Brücke" des Instruments, der Reflexionspunkt. Auf ihm läuft eine Software, die eine Saite mit unwirklichen Proportionen modelliert. Die Rechnerdaten werden zu den einzelnen Veranstaltungsorten zurückgespielt und liefern gemeinsam mit dem Video eine visuelle Verbindung zwischen den Benutzern.

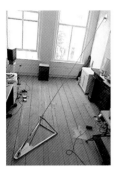

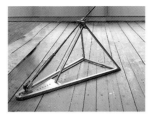

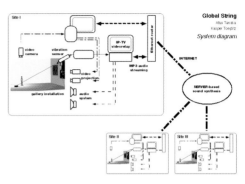

Global String ist eine skalierbare Multi-Mode-Installation. Die Anzahl der Orte kann zwei oder mehr betragen (wobei drei die ideale Anfangsgröße ist). Die Installation kann im Konzertmodus mit gemeinsamen Aufführungen von Solisten an jedem Ort eingesetzt werden und erlaubt Menschen – egal ob Mitwirkenden oder Galeriebesuchern –, gemeinsam musikalische Harmonien über das Netz zu schaffen.

Ein funktioneller Prototyp wurde im Juni 1999 hergestellt. Die Ausstattung besteht aus einer Basisstruktur, einem Stahlseil und einer Brücke. Keramische ebenso wie Hall-Effect-Sensoren werden zur Messung der hoch- und niederfrequenten Schwingungen der Saite eingesetzt.

Dieses Signal wird als Audio- und Steuersignal in den Rechner eingespeist und regt die Synthese nach einem virtuellen physikalischen Modell an. IP-Video und MP3-Audo-Streaming-Verbindungen sind in Entwicklung.

Global String is a scalable multi-mode installation. The number of sites can range from two and up (three being the ideal initial number). The installation can be used in concert mode for soloists at each site to perform together. *Global String* allows people, be it performers or gallery visitors, to create musical harmonies together over the net.

A functional prototype was created in June 1999. The structure consists of a base structure, steel cable, and bridge. Ceramic as well as Hall Effect sensors are used to detect both high and low frequency vibrations of the string.

This signal enters the computer as an audio-rate and control-rate signal, exciting a physical-model virtual synthesis engine. IP video and MP3 audio streaming connectivity are being developed.

Atau Tanaka (J) lives in the U.S., France, and Japan. This transcultural perspective is reflected as his artistic activities move from concert to installation to recorded media, from acoustic to electronic to experimental. Physical interfaces are his instruments, and the network is a natural space for this music. **Kasper Toeplitz (D)** produces a music made of long waves of sound clashing against each other, rich in sonic overflow and long silences. A music whose main concern is not note or pitch, but time, its oscillations and vibrations, its misplacements—or how to perceive the subtleties of a luminous blindness. **Atau Tanaka (J)** lebt in den USA, Frankreich und Japan. Diese transkulturelle Perspektive wird auch in seinen Arbeiten widergespiegelt, die von Konzerten über

Installationen bis zu aufgezeichneten Medien, von akustischen über elektronische zu experimentellen Werken reichen. Physische Interfaces sind seine Instrumente und das Netzwerk ist der natürliche Raum für seine Musik. **Kasper Toeplitz (D)** produziert Musik aus langen aufeinander prallenden Klangwellen, reich an klanglichem Überfluss und langen Phasen der Stille, eine Musik, deren Hauptanliegen nicht Tonhöhe oder Klang sind, sondern die Zeit, ihre Oszillationen und Vibrationen, ihre Verschiebungen – kurz, die Wahrnehmung der Subtilität einer leuchtenden Blindheit.

Alpha Wolf
The Synthetic Character Group

You play one of three puppies - black, white or gray - in a virtual wolf pack.

Howling into a microphone makes your pup howl, and helps other wolves find you. When your pup hears another wolf, a button appears on the screen.

When you meet other wolves, you help your pup form social relationships with them by growling, whining or barking into the mike.

Here, the black pup tries to get the white pup to play.

When an adult comes over, both pups submit. The icons on the buttons change to reflect the relationship that your pup has with that wolf.

Our goal is to make virtual entities who can form social relationships with each other. Here, two social computational systems exchange a glance.

Die der Installation *AlphaWolf* zu Grunde liegende Forschung beruht auf der Biologie und dem Verhalten des grauen Wolfes (*Canis lupus*). In ihrer natürlichen Umgebung bilden Wölfe hierarchische soziale Beziehungen innerhalb ihrer Rudel aus, wobei einige Individuen über andere dominieren. Die virtuellen Wölfe in dieser Installation bilden ebenfalls soziale Beziehungen aus: Sie interagieren mit jedem Sozialpartner auf eine Weise, die die Geschichte der bisherigen Interaktionen einbezieht. Ebenso wie wirkliche Wölfe stereotypische Dominanz- und Unterwerfungsverhalten zur Darstellung und Aufrechterhaltung ihrer sozialen Beziehungen einsetzen, drücken auch die virtuellen Wölfe in *AlphaWolf* ihre Beziehungen durch ihr animiertes Verhalten aus.

Das Projekt *AlphaWolf* stellt das zweite Jahr eines mehrjährigen Forschungsprojekts der Synthetic Characters Group am MIT MediaLab unter der Leitung von Bruce Blumberg dar. In diesem Projekt wollen wir autonome animierte Charaktere entwickeln, deren komplexes Verhalten und Ausdrucks- und Lernfähigkeit jenem eines wirklichen Hundes oder Wolfs entsprechen. *AlphaWolf* erweitert nicht nur unsere bisherigen Arbeiten, sondern erforscht auch jene computergestützten Darstellungsmechanismen, die funktionieren müssen, um soziales Lernen und die Schaffung von kontextspezifischen emotionalen Erinnerungen zu ermöglichen. Neben der Darstellung der virtuellen Gehirne und Körper der Wölfe selbst umfasst die Installation auch umfangreiche unterstützende Technologie, etwa realistische Echtzeit-Computergrafik, autonome Kinematografie und dynamische Partitur- und Klanggestaltung.

Die Schaffung virtueller Kreaturen mit sozialer und emotionaler Kompetenz ist ein Kernpunkt der Künstlichen Intelligenz. Einfache rechnerische Modelle für die Darstellung sozialer Beziehungen können neue Alternativen im Bereich der Verhaltensforschung und Computerbiologie bieten. Und nicht zuletzt könnte die Unterhaltungsindustrie mit ihrem Schwerpunkt auf Echtzeit-Interaktivität (z. B. bei den Computerspielen) und expressiven Charakteren (z. B. im Film) eine ganze Palette von Anwendungen für sozial bewusste Computerkreaturen finden.

The research behind the *AlphaWolf* installation is informed by the biology and behavior of the gray wolf (*Canis lupus*). In their natural environment, real wolves form hierarchical social relationships within their packs, where certain individuals are dominant over other individuals. The virtual wolves in this installation form social relationships as well, interacting with each social partner in a way that reflects their history of previous interactions. Just as real wolves exhibit stereotypical dominance and submission behaviors to demonstrate and maintain their social relationships, the virtual wolves in the *Alpha-Wolf* installation express their relationships through their animated behaviors.

The *AlphaWolf* project represents the second year of a multi-year project by the Synthetic Characters Group at the MIT Media Lab under the direction of Bruce Blumberg. Through this project, we aim to develop autonomous animated characters whose behavioral complexity, expressiveness, and ability to learn rival those of a real dog or wolf. In addition to extending our previous work, *AlphaWolf* explores the computational representations that must be in place to enable social learning and the formation of context-specific emotional memories. As well as showcasing the virtual minds and bodies of the wolves themselves, the installation features a suite of supporting technology, including evocative real-time computer graphics, autonomous cinematography, and dynamic scoring and sound design.

Creating virtual creatures with social and emotional competence is central to the field of artificial intelligence. Simple computational models for the formation of social relationships may suggest new alternatives in the fields of animal behavior and computational biology. Finally, the entertainment industry, with its emphases on real-time interactivity (e.g., computer games) and expressive characters (e.g., movies), might find a range of uses for socially-savvy computational creatures.

The Synthetic Character Group (USA) is a department of "The Media Lab" at the Massachusets Institute of Technology (MIT) and consist of: Bill Tomlinson, Marc Downie, Matt berlin, Jesse Gray, Adolph Wong, Robert Burke, Damian Isla, Yuri Ivanov, Michael Patrick Johnson, Derek Lyons, Jennie Cochran, Bryan Yong and Professor Bruce Blumberg. Die **Synthetic Character Group (USA)** ist eine Abteilung des Media Lab am Massachusetts Institute of Technology (MIT) und besteht aus: Bill Tomlinson, Marc Downie, Matt Berlin, Jesse Gray, Adolph Wong, Robert Burke, Damian Isla, Yuri Ivanov, Michael Patrick Johnson, Derek Lyons, Jennie Cochran, Bryan Yong und Professor Bruce Blumberg.

Body Brush
Young Hay / Horace Ip / Alex Tang Chi-Chung

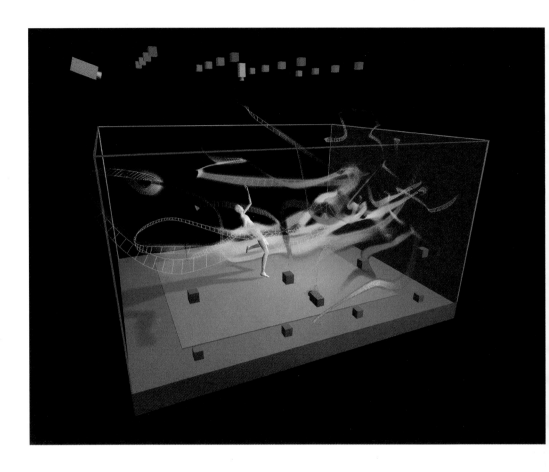

The *Body Brush* project is a genuine merger of art concept and the technology of computer vision. It creates a human-computer interface that transforms human body gesture into 3D paintings in real-time. This work is inspired by the "action painting" of Jackson Pollock. The interface consists of a novel body motion capturing and analyzing system and output of a virtual canvas space that is filled with virtual 3D colour-paint-brushstrokes as a result of the painter's motion within the 3D canvas.

Project Goals

To build a human-computer interface that can liberate human creativity and satisfy aesthetic needs: The interface will enable users to interact

Das *Body Brush*-Projekt ist eine genuine Mischung aus künstlerischem Konzept und Technologie der digitalen Bildverarbeitung. Es schafft ein Mensch-Computer-Interface, das menschliche Körpergesten in Echtzeit in 3D-Gemälde umwandelt. Diese Arbeit ist inspiriert von Jackson Pollocks „Action Painting". Das Interface besteht aus einem neuartigen Motion-Capturing- und Analysesystem, die Ausgabe aus einem virtuellen Leinwand-Raum, der mit virtuellen dreidimensionalen Farb-Pinselstrichen gefüllt wird, die aus der Bewegung des Malers innerhalb der 3D-Leinwand resultieren.

Ziele des Projekts

Schaffung eines Mensch-Computer-Interfaces, das die menschliche Kreativität befreit und ästhetischen Anforderungen gerecht wird: Das Interface erlaubt es

den Benutzern, intuitiv mit der Maschine zu interagieren, es bedarf keiner vorhergehenden Schulung. Die jedem Benutzer eigene Körpersprache wird in Pinselstrichen auf der 3D-Leinwand umgesetzt, was visuelle Formen und architektonische Räume von vorgegebener Komplexität simuliert und eine bislang unbekannte ästhetische Erfahrung bietet.

Entwicklung eines effizienten Echtzeit-Motion-Capture und -Analysesystems zur Erkennung von Körperbewegungen in 3D: Dieses Projekt zielt auf die Entwicklung eines erschwinglichen und transportablen Bewegungserfassungs- und Auswertungssystems ab, das Körperbewegungen entlang der x/y/z-Achsen in Echtzeit verarbeitet. Das System verlangt nicht nach speziellen Farbanzügen oder Sensor-Geräten und erlaubt damit eine viel immersivere Interaktion zwischen Mensch und Maschine.

Die virtuelle 3D-Leinwand von *Body Brush* besteht aus infrarot-sensiblen Kameras und Arrays von Infrarot-Lampen, die die dynamische Erfassung der Bewegung des „Malers" innerhalb des virtuellen Leinwandraumes ermöglichen. Eine an der City University entwickelte Computervision-Software analysiert die Bewegungen und Körpergesten des „Malers" und generiert eine Mischung aus Farbstrichen und -flecken, die synchron zu den Bewegungen des „Malers" im 3D-Raum schweben. Farbwerte, Sättigung und Dichte der Pinselstriche können über Körpergesten gesteuert werden. Zusätzlich simuliert ein innovatives Feature von *Body Brush*, der sogenannte „Virtual Path", die Effekte des Farbewerfens auf die 3D-Leinwand. Dies geschieht durch eine Beschleunigungsanalyse der Körperbewegungen.

intuitively with the machine and no prior training is required to use it. The user's unique body language will be transformed into painting brushstrokes in the 3-D canvas space, which simulates the visual forms and architectural spaces of designated complexities. It will provide an aesthetic experience that is unprecedented.

To develop an effective real-time motion capturing and analyzing system to recognize the 3D body motion: This project aims at developing a motion sensing and analysis system which is inexpensive, portable but effective to capture and analyze the body motion data in the x-y-z-dimensions in real-time. The system will not require the user to wear any specific colour clothing or sensor devices. This will enable a more immersive interaction between the human and the machine.

The virtual 3D canvas of *Body Brush* consists of infrared sensitive cameras and arrays of infrared lamps, which allow the dynamic movement of the "painter" to be captured within the virtual 3D canvas space to be captured. A piece of advanced computer vision software developed at City University analyzes the movement and body gestures of the "painter" and generates a mixture of colour strokes and patches that float in 3D space in synchronization with the painter's movement. Colour saturation, value and the density of the brushstrokes can be controlled through the painter's body gestures. In addition, an innovative feature of the *Body Brush* called the Virtual Path simulates the effects of throwing paint on the 3D canvas. This is done by analyzing the acceleration of the body's movement.

Young Hay (HK) is an independent artist and researcher. Studied studio art at Sonoma State University (California State University), USA, and received a B.A. in 1991. He is the concept designer for the human-computer interface, the *Body Brush*, a collaborative project with the City University of Hong Kong. He has also produced a wide range of multi-media works and performances. He was awarded the Fellowship of the Asian Cultural Council in 1998, and the Art Development Fellowship by the Hong Kong Arts Development Council in 2000. **Young Hay (HK)** ist unabhängiger Künstler und Forscher. Er studierte Studiokunst an der Sonoma State University (California State University) und graduierte 1991 zum BA. Er ist der Entwickler des Konzepts für das Mensch-Computer-Interface *Body Brush*, ein Kooperationsprojekt mit der City University Hong Kong. Daneben hat er zahlreiche Multimedia-Werke und Performances produziert. Er erhielt Stipendien des Asian Cultural Council 1998 und des Hong Kong Arts Development Council 2000.

Body Brush

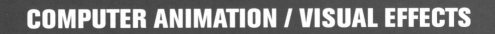

COMPUTER ANIMATION / VISUAL EFFECTS

Deeper and Richer
Sehen und fühlen

Barbara Robertson

The jury for the Computer Animation / Visual Effects category screened 248 entries and from those, chose the three top award winners and six Honorary Mentions. Rather than give as many Honorary Mentions as we might have, we chose to be selective to better highlight the strength of our selections.

There's no question that our Golden Nica winner, *Monsters, Inc.* (USA), submitted by director Pete Docter of Pixar Animation Studios, represents excellence in art and technology, which is something we've come to expect from Pixar. This meant, to us, that Pixar had to go beyond our expectations and we felt they did, particularly in creating Sully, a fuzzy character. The technology developed for Sully's hair allowed the artists to cross a threshold: There's a moment in the film, for example, when the little girl Boo touches Sully's fur with her finger. It's an emotional moment because it's tactile. This is something we have not seen (or felt) in a digital image before and we believe that as artists and animators realize they can do this, too, we will see (and feel) deeper and richer computer animated films.

We were thrilled that Award of Distinction winner *Harvey*, from Australian filmmaker Peter McDonald, closed a loop left open last year when the jury searched in vain for that one piece of "takeover" work, something with raw energy, innovation, something with a spark, something that made a personal statement. *Harvey* is that work. It has rough edges but it's new, significant. It shouts to other artists, "Free yourself up. Take that wacky idea in the back of your brain and do something with it."

Our second Award of Distinction winner, *Panic Room*, submitted by BUF (France), shows an absolutely invisible visual effect created solely for the camera move and it changes the vocabulary of filmmaking. BUF gave the director of *Panic Room* freedom to move his camera without

Die Jury der Kategorie Computer Animation / Visual Effects hat insgesamt 248 Einreichungen begutachtet und aus diesen drei Preisträger sowie sechs Anerkennungen ausgewählt. Um die Stärke der von uns prämiierten Stücke zu unterstreichen, verzichteten wir bewusst darauf, den möglichen Rahmen von zwölf Anerkennungen auszuschöpfen.

Es steht außer Zweifel, dass auch der diesjährige Gewinner der Goldenen Nica, *Monsters, Inc.* (USA), eingereicht von Peter Docter von Pixar Animation Studios, in künstlerischer wie technischer Hinsicht hervorragend ist – was man bei Arbeiten von Pixar inzwischen ja schon voraussetzt. Dies bedeutete aber, dass die Einreichung unsere Erwartungen noch weit übertreffen musste, und die Jury ist überzeugt, dass dies gelungen ist, besonders mit der Figur des Sully, einer wuscheligen Gestalt. Die für die Realisierung von Sullys Pelz entwickelte Technologie hat es den Künstlern erlaubt, eine Schwelle zu überschreiten: Es gibt im Film eine Szene, in der das kleine Mädchen Boo Sullys Pelz mit ihrem Finger sanft streichelt. Es ist eine emotionale Szene, weil das computeranimierte Fell erstmals ein realistisches taktiles Gefühl zu transportieren vermag. Dies haben wir bisher noch nie in einem digitalen Bild gesehen (oder gefühlt), und wir sind überzeugt, dass wir – sobald Künstler und Animatoren erkannt haben, welche neuen Möglichkeiten sich für sie damit auftun – etliche tiefergehende und reichere computeranimierte Filme zu sehen (und zu fühlen) bekommen werden.

Der mit einer Auszeichnung gewürdigte Film *Harvey* des australischen Filmemachers Peter McDonald hat zu unserer Freude eine Lücke geschlossen, die die vorjährige Entscheidung offen gelassen hatte, als die Jury ohne Erfolg Ausschau gehalten hatte nach wenigstens einem „Takeover-Werk", das voller roher Energie, voller Innovation steckt, das begeistert und ein persönliches Statement darstellt. *Harvey* ist genau das gesuchte Werk. Es hat zwar noch ein paar raue Kanten, aber es ist neuartig und signifikant. Es ruft den anderen Künstlern zu: „Befreit euch, packt diese seltsame Idee in eurem Hinterkopf und macht etwas draus!"

Der zweite Gewinner einer Auszeichnung, *Panic Room* von BUF (Frankreich), zeigt einen als solchen absolut nicht erkennbaren Visual Effect, der ausschließlich zu dem Zweck geschaffen wurde, eine Kamerafahrt zu ermöglichen, und der das Vokabular des Filmemachens einschneidend verändern wird. BUF hat dem Regisseur von *Panic Room* die Freiheit gegeben, seine Kamera ohne Einschränkung durch eine offenbar reale Szenerie fahren zu lassen – selbst durch eine Kaffeekanne hindurch, wenn er das denn so wollte. Im eingereichten Material demonstriert BUF auf sehr ausgereifte, subtile Weise, wie dieser Effekt zustande kommt, und zeigt damit in eine Richtung, von der wir hoffen, dass sie in Zukunft auch von anderen Effects-Einreichungen aufgegriffen wird.

Und so lief der Entscheidungsprozess ab: Für die erste Runde beschlossen die Jury-Mitglieder, dass eine einzige Ja-Stimme eines einzelnen Jurors reichen würde, das Werk in der Auswahl zu behalten, dass aber für eine Ablehnung Einstimmigkeit erforderlich war. Sobald ein „Ja" ertönte, wurde das Band angehalten und zur nächsten Einreichung weitergegangen; wenn jedoch Unsicherheit bestand, wurde die Einreichung in voller Länge betrachtet. Am Ende des Tages waren 47 Einreichungen im Rennen verblieben.

Für die zweite Runde am nächsten Tag wurde beschlossen, dass nunmehr zwei Ja-Stimmen für den weiteren Verbleib erforderlich sein würden. Nach der Betrachtung und Diskussion sämtlicher 47 Werke wurde das Feld auf 20 eingeschränkt.

In der dritten Runde wurden all jene Werke gezeigt, die die Juroren nochmals sehen wollten, es wurde gefragt und diskutiert, und dann stimmte jeder der Juroren für jene Werke, die er oder sie unter den Preisträgern und Auszeichnungen sehen wollte. Nach Eliminierung der Werke mit nur einer oder keiner Stimme hatten wir das Feld auf 15 reduziert.

An diesem Punkt begannen wir, nach den drei Preisträgern Ausschau zu halten. Am Ende des Tages hatten wir eine vorläufige Auswahl, aber sie schien uns nicht wirklich zu überzeugen. Wir betrachteten sie daher

restriction through an apparently real scene – even through a coffee pot if the director chose. In its entry, BUF showed the creation of this effect in a sophisticated and subtle way and the submission points toward a direction we hope studios will take in the future with effects entries.

Here's how the process worked. For the first round, we agreed that one "yes" vote from any of the five jurors would keep the entry in the running, but to eliminate an entry we needed a consensus vote. One "yes" would stop the tape and we'd go on to the next entry. When we were unsure how to vote, we watched the entire submission. At the end of the day, we were left with 47 entries.

On the second day, for the second round, we decided that an entry would need two "yes" votes to be kept in the running. After watching and discussing all 47 entries, we narrowed the field to 20.

Round 3: We viewed any entries the jurors wanted to see again, asked questions of each other, and then each juror voted for all the entries he or she wanted to see receive an award or honorary mention. After eliminating entries with one vote or less, we narrowed the field to 15.

At this point we began looking for our top three. By the end of the day, we had a tentative selection, but it was one without strong conviction. We believed that it would provide a starting point for discussion on the next and final day. And it did. Day 3. It was at this time that we began discussing in earnest the criteria we were using for our selections. When we looked again at our three selections from the previous day, we realized we had chosen them based on artistic and technical excellence, but we had not considered whether the entries would have a cultural impact and it is this third criteria for excellence combined with the other two that helps set the Prix Ars Electronica apart from film festivals and other competitions.

We also faced and dealt with two dilemmas that have plagued earlier juries: how to consider work from students, small studios, and big studios within one category, and how to judge the visual effects entries.

The first dilemma – evaluating the work from students, small studios, and big studios became less of a problem last year when that jury noticed with delighted surprise, that the student work competed on an equal footing with work from the big studios. We found this to be true again this year, with the films *Mouse* and *Kikumana* exemplifying the stunning sophistication we saw in student work.

Remarkably, the entries themselves provided the solution to the second dilemma: how to judge visual effects. Here are the problems, the points of discussion and debate: If the goal of visual effects is to serve the film in which the effects appear, can the effects be judged apart from the film? If they can't, would we be basing our judgment on decisions made by the director of the film rather than on the quality of the effects? And if we gave an award to a visual effects entry for a film that had effects created by several studios, would all the studios share the award, or only the studio submitting its work? How could we give an award to a film, when we have seen only a small portion of the effects? These questions led to considering a visual effects entry as a complete work in itself. But if we were to judge the effects outside the film in which they appear, what criteria should we use? We can evaluate the technology and perhaps the impact on the culture of filmmaking, but how do we evaluate the art? Effects entries often look like collections of techniques, like demo reels. We struggled with this conundrum until we realized we had the answer in front of our eyes. As we watched the entries again, it became clear that some studios had taken time to present the effects from a film in an artful way. The entries were complete works in themselves and we could judge them without regard to the film in which they appeared. We hope that everyone will take time to look at Digital Domain's *Time Machine* entry and BUF's *Panic Room* entry as examples of what we discovered.

We believe that judging visual effects entries in this way has enormous advantages. It will allow individuals in studios to submit their best work without regard to any of the other effects in a film. They can submit visual effects that might never have appeared in a theatrical release. But, it will also mean that the visual effects submissions must rise above the level of a demo reel. Commercial

eher als Ausgangspunkt für weitere Diskussionen am folgenden letzten Tag – und so war es denn dann auch. Am dritten Tag wurden erstmals ernsthaft die Kriterien diskutiert, nach denen die auszuwählenden Werke beurteilt werden sollten. Bei der nochmaligen Durchsicht der tags zuvor gewählten Werke wurde uns klar, dass wir sie zwar auf Basis ihrer künstlerischen und technischen Leistung ausgewählt hatten, dabei aber nicht bedacht hatten, ob sie eine kulturelle Wirkung haben würden. Es ist dieses dritte Kriterium, das unserer Ansicht nach im Verein mit den beiden anderen den Begriff „herausragend" im Sinne des Prix Ars Electronica definiert und diesen von Filmfestivals und anderen Wettbewerben unterscheidet.

Darüber hinaus fanden wir uns mit zwei weiteren offenen Fragen konfrontiert, die bereits frühere Juries geplagt hatten: Wie sollte man mit studentischen und unabhängigen Produktionen umgehen, die in der gleichen Kategorie wie die Werke der ganz Großen eingereicht wurden? Und: Wie sollten die Visual-Effects-Einreichungen behandelt werden?

Die erste der beiden Fragen – die Bewertung der Werke von Studenten und kleinen Firmen im Vergleich zu großen Studios – war bereits im Vorjahr so gut wie unbedeutend geworden, als die Jury mit freudiger Überraschung feststellte, dass die studentischen Arbeiten durchaus auf gleichem Niveau gegen die Werke der großen Studios angetreten waren. Diese Situation fanden wir heuer bestätigt: Die Filme *Mouse* und *Kikumana* seien als Beispiele für die erstaunliche Raffinesse genannt, die wir in studentischen Arbeiten gefunden haben.

Bemerkenswerterweise lieferten die Einreichungen selbst die Antwort auf die zweite Frage: Wie sollten die Visual Effects beurteilt werden? Hier kurz zusammengefasst unsere Problem- und Diskussionspunkte: Wenn es das Ziel der Visual Effects ist, dem Film zu dienen, in dem sie eingesetzt werden, können sie dann unabhängig von diesem Film beurteilt werden? Wenn nicht, würde sich unsere Beurteilung dann nicht eher auf die Entscheidungen des Filmregisseurs stützen als auf die Qualität der Effekte? Und wenn wir einen Preis für eine Visual-Effects-Einreichung an einen Film vergäben, der Effekte unterschiedlicher Studios vereint, würde der Preis dann an alle Studios gemeinsam gehen oder nur an die tatsächlichen Einreicher? Wie könnten wir einen Film auszeichnen, von dem wir nur einen Teil der Visual Effects gesehen haben? Diese Fragen führten zu einer Betrachtung der Visual Effects als in sich geschlossene Werke. Aber wenn wir die Effekte unabhängig von jenem Film beurteilen sollten, in dem sie erscheinen, welche Maßstäbe sind dann an sie anzulegen? Wir können zwar die Technologie beurteilen und eventuell auch die Auswirkungen auf die Kultur des Filmemachens, aber wie sollten wir den künstlerischen Aspekt bewerten? Effects-Einreichungen sehen allzu oft aus wie Technik-Sammlungen, wie Demo-Bänder.

Mit diesem Rätsel haben wir uns herumgeschlagen, bis uns bewusst wurde, dass wir die Lösung eigentlich schon längst vor Augen hatten. Bei einer neuerlichen Durchsicht der Einreichungen wurde uns klar, dass manche Studios sich die Mühe gemacht hatten, die Effects eines Films selbst in künstlerischer Weise zu präsentieren. Die Visual Effects waren damit zu in sich geschlossenen Werken geworden und konnten von uns ohne Rücksicht auf den Film, in dem sie erschienen, begutachtet werden. Wir hoffen, dass sich jedermann Zeit nimmt, die Einreichungen zu Digital Domains *Time Machine* und BUFs *Panic Room* als Beispiele dessen anzusehen, was die Jury entdeckt hat.

Wir glauben, dass die Betrachtung von Visual-Effects-Einreichungen unter diesem Aspekt enorme Vorteile bietet: Zunächst erlaubt sie auch dem einzelnen Künstler, seine besten Arbeiten ohne Zusammenhang mit anderen Visual Effects im Film einzureichen, weiters können Effects eingereicht werden, die nicht in die Kinofassung übernommen wurden. Allerdings bedeutet das auch, dass diese Einreichungen über das Niveau von Demo-Bändern hinausgehen müssen. Kommerzielle Studios sind offensichtlich eher in der Lage, diesen Kriterien Genüge zu tun, und bei den billigen digitalen Schnitt-werkzeugen, die heute schon zur Verfügung stehen, sollte dies eigentlich auch für Studenten machbar sein. Je länger wir dieses Problem diskutierten, umso begeisterter waren wir von dieser Lösung. Wir sind überzeugt, dass sie dem Grundgedanken des Prix Ars Electronica gerecht wird, und wir hoffen, dass in Zukunft auch das Einrei-chungsformular diesen Durchbruch widerspiegeln wird.

Die Anerkennungen

Als wir die drei Preisträger ermittelt hatten, sahen wir uns veranlasst, uns bei den Anerkennungen auf einige wenige, dafür aber besonders signifikante Werke zu beschränken. Jede der ausgewählten Arbeiten ist als solche bemerkenswert – wir können nur empfehlen, sie aufmerksam zu betrachten.

AnnLee You Proposes, eingereicht von Lars Magnus Holmgren (AUS): Hervorragende Integration von Grafik- und Audio-Elementen. Timing, digitaler Schnitt, die Mischung von Charakteren und die Energie, die in diesem abstrakten, überwiegend schwarz-weißen Stück stecken, sind faszinierend und von hoher Qualität.

Die Visual Effects zu *The Time Machine*, eingereicht von Digital Domain (USA), sind als solche bekannte Ideen, die auf neue Art umgesetzt werden; besonders beeindruckt hat uns die technische Rafinesse, die sich etwa in den erodierenden Landschaften ausdrückt. Die Präsentation der Effekte auf dem eingereichten Band selbst entspricht genau dem, was wir als unsere

studios are obviously capable of creating this type of admission and, given the inexpensive digital editing tools available today, this is within the reach of students as well. As we debated and discussed the problem, we became ever more excited about this solution. We feel that it is in the spirit of Prix Ars and we all hope that in the future, the Prix Ars Electronica entry form will reflect this breakthrough.

Now, the Honorary Mentions:

Once we had picked our top three award winners, we felt compelled to focus on a few especially significant entries for our Honorary Mentions. Each Honorary Mention is a remarkable piece of work and we encourage everyone to spend time looking at them.

AnnLee You Proposes, submitted by Lars Magnus Holmgren (AUS): An outstanding integration of graphics and audio elements. The timing, the digital editing, the mixture of characters and the energy in this abstract, largely black and white piece is excellent and fascinating.

Visual Effects from *The Time Machine*, submitted by Digital Domain (USA): The effects in the entry were familiar ideas shown in a completely new way and we admired the technical expertise that resulted in the eroding landscapes. The submis-sion itself is exactly what we would have asked for in a visual effects submission if we had had the chance.

Polygon Family: Episode 2, submitted by Hiroshi Chida (Japan): We loved this perfectly executed film that used the game aesthetic to make a satirical point. We appreciated the exercise in restraint and the excellent animation.

Kikumana, submitted by Yasuhiro Yoshiura (Japan): We had no idea a 21-year-old student made this film using Strata 3D software until after we had chosen it. One juror called the film, "flat out beautiful." We were delighted by surprising choices, by the seamless blend of 3D graphics and hand drawn images, and by the compelling camera moves.

Mouse, submitted by Wojtek Wawszczyk (PL), demonstrates once again that no allowances need be made for student films and that technology is not a barrier. The excellent storytelling and char-acter design in this film charmed the jurors.

Deeper and Richer

BMW Pool, submitted by Jason Watts (UK): At their best, visual effects are magic and this submission has one of the best magic tricks we've seen.

Some final thoughts

We noticed an abundance of black and white animations, animations with stick figures or Anime' babes, and a disturbing number of films that used bad fonts. In addition, we seemed to see no end of films with disembodied talking heads on black backgrounds. One juror wryly suggested that entries in this category must have a minimum amount of animation to be considered. We did not find an abstract work that pushed new boundaries, although we searched.
What we liked were films that experimented with new ways of telling stories, notably the Honorary Mentions, *AnnLee You Proposes* and *Kikumana*. We found films that we wanted to watch again and again—*Polygon Family*, which was filled with perfectly timed surprises, and the wonderful Mouse which caused the jurors to start each day by chanting, "Mouse, Mouse, Mouse." Mouse isn't innovative, unless you consider the fact that a student could create such a work innovative; it's just simply excellent. The film that we agreed was the most innovative was also the most disturbing—*Harvey*. Finally, an unnerving film that could not have been created without digital tools, tools that have been used to create images we have never seen before, images that are essential to the story, a fascinating story told in an astonishing way. More! MORE!

Vorstellungen von einer Visual-Effects-Einreichung definiert hätten, wenn wir von vornherein dazu die Möglichkeit gehabt hätten.

Polygon Family: Episode 2 von Hiroshi Chida (J): Uns hat dieser perfekt ausgeführte Kurzfilm, der die Computerspiel-Ästhetik als satirisches Mittel einsetzt, sehr gefallen; besonders anerkennenswert ist dabei einerseits die bewusste Zurückhaltung, andererseits die hervorragende Animation.

Kikumana von Yasuhiro Yoshiura (J): Erst nachdem wir diesen mit Strata 3D-Software erstellten Film ausgewählt hatten, wurde uns bewusst, dass er von einem erst 21-jährigen Studenten stammt. Einer der Juroren bezeichnete den Film als „schlichtweg wunderschön". Besonders begeistert haben uns immer wieder überraschende Momente, die nahtlosen Übergänge zwischen 3D-Grafiken und handgezeichneten Bildern und die fesselnde Kameraführung.

Mouse von Wojytek Wawszczyk (PL) beweist einmal mehr, dass man bei studentischen Arbeiten keine Augen zuzudrücken braucht und Technologie heutzutage keine Hürde mehr darstellt. Die exzellente Erzählweise und die Gestaltung der Figuren in diesem Film haben die Jury bezaubert.

BMW Pool von Jason Watts (GB): Wenn sie gut sind, haben Visual Effects immer etwas von Zauberei an sich, und diese Einreichung bietet einen der besten Zaubertricks, den wir je gesehen haben.

Ein paar abschließende Gedanken

Aufgefallen ist uns die Häufung von Schwarz-Weiß-Animationen, von Animationen mit Stockpuppen oder Püppchen im „Anime-Stil" und eine beängstigend hohe Zahl von Einreichungen, die unpassende oder ungeeignete Schriftfonts verwenden. Außerdem hatten wir den Eindruck, als würden wir unendlich viele Filme mit körperlosen sprechenden Köpfen vor schwarzem Hintergrund zu sehen bekommen. Einer der Juroren merkte an, Einreichungen in dieser Kategorie sollten zumindest ein Mindestmaß an Animation aufweisen. Und trotz all unserer Bemühungen war unter den abstrakten Arbeiten keine zu finden, die in irgendeiner Weise Neuland betreten hätte.

Gefallen hat uns, dass viele Filme – darunter vor allem die Anerkennungen *AnnLee You Proposes* und *Kikumana* – mit neuen Formen des Erzählens experimentieren. Es gab Filme, die wir nicht oft genug sehen konnten — *Polygon Family* etwa mit seinen zeitlich perfekt abgestimmten Überraschungseffekten und natürlich *Mouse*, das die Juroren dazu brachte, jeden Sitzungstag mit dem Sprechchor „Mouse, Mouse, Mouse!" zu beginnen. *Mouse* ist keineswegs innovativ (außer man wollte in der Tatsache, dass ein Student so ein Werk schaffen kann, etwas Neues sehen), aber es ist schlichtweg hervorragend.

Der Film, den wir einstimmig als den innovativsten anerkannt haben, ist auch der irritierendste, nämlich *Harvey*. Endlich ein verstörender Film, der ohne digitale Werkzeuge nicht hätte entstehen können, die hier dazu verwendet wurden, um Bilder zu schaffen, wie wir sie nie zuvor gesehen haben, Bilder, die für die Geschichte essenziell sind. Eine faszinierende Geschichte, die auf ganz erstaunliche Weise erzählt wird! Mehr davon! MEHR!

Monsters, Inc.
Pete Docter / David Silverman / Lee Unkrich / Andrew Stanton

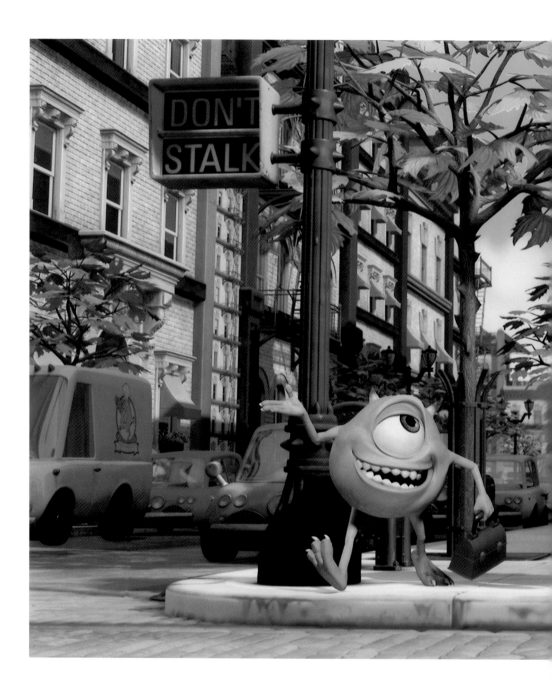

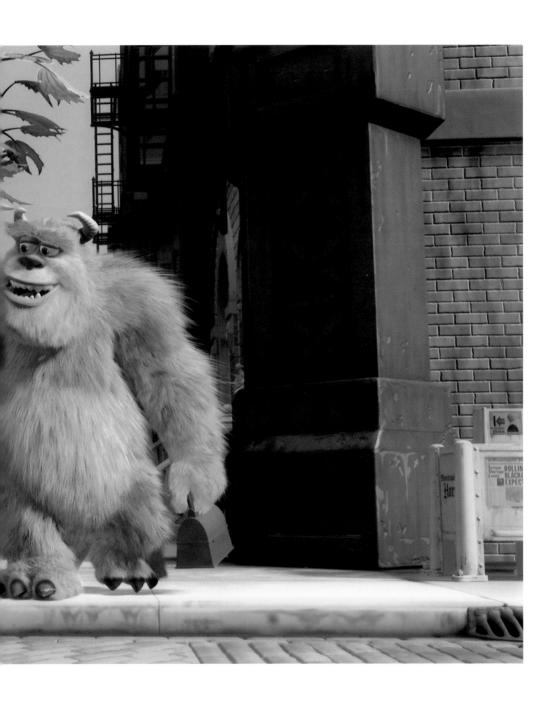

After completing his assignment as supervising animator on the landmark 1995 computer animated film, *Toy Story*, Pete Docter began exploring several ideas for a film of his own. One of the ideas that intrigued him was a story about monsters and things that go bump in the night.

Docter's initial concept for the film went through many changes during the development process, but the notion of monsters living in their own world remained an appealing and workable one. Early versions of the story focused on a 32-year-old man who had monsters show up that only he could see. It dealt with confronting childhood fears that had never been conquered and which were cropping up once again to cause anxiety. As the story continued to develop and take on new twists and turns, the central adult figure was changed to a child of varying ages (8–12) and gender. Ultimately, the story team decided that a young innocent girl named Boo would be the best counterpart for a furry 8-foot co-star.

The character of Sulley also went through some major changes along the way. He evolved from a janitor to an uncoordinated, down-on-his-luck loser to the superstar Scarer that he ended up being. At one time, the character even wore glasses and had tentacles.

"People generally think of monsters as really scary, snarly, slobbery beasts," observes Docter. "But in our film, they're just normal everyday 'Joes.' They clock in; they clock out. They talk about donuts and union dues. They worry about things like having straight teeth. Scaring kids is just their job.

"One of our biggest challenges was to come up with a good reason as to why monsters scare kids. For a while, we played with the idea that it was like a Broadway show and monsters entertained each other by scaring kids. That evolved into the whole business idea, which seemed pretty ripe for humor."

Working from Docter's original idea, Andrew Stanton, who had written the three previous Pixar features and who served as executive producer on this film, set to work on creating a screenplay that would capture the concept's spirit and imagination. Once Stanton had established the foundation for the film through his severe screenplay drafts, he turned his attention to his next project (*Finding Nemo*, due for release in 2003). Dan Gerson stepped in to write subsequent versions of the *Monsters, Inc.* screenplay and to further define the plot, characters, and dialogue. At the same time, story supervisor Bob Peterson and his team were helping to visualize the script with drawings, gags, and lots of inventive ideas.

Nach Abschluss seiner Tätigkeit als Supervising Animator am bahnbrechenden computeranimierten Film *Toy Story* (1995) begann Pete Docter verschiedene Ideen für einen eigenen Film zu wälzen. Eine davon faszinierte ihn besonders – eine Geschichte über Monster und unerklärliche nächtliche Geräusche.

Pete Docters ursprüngliches Konzept für den Film wurde während der Vorbereitungsphase viele Male abgeändert, aber die Grundidee von Monstern, die in einer eigenen Welt leben, blieb als faszinierender und auch realisierbarer Gedanke. Frühe Versionen der Geschichte konzentrierten sich auf einen 32-jährigen Mann, dem sich Monster zeigten, die nur ihm sichtbar waren. Es ging um die Auseinandersetzung mit Kindheitsängsten, die nie überwunden worden waren und immer wieder hervortraten und Beklemmung auslösten. Als sich die Geschichte immer mehr konkretisierte, wurde die Erwachsenenfigur durch Kinder verschiedenen Alters (acht bis zwölf Jahre) und Geschlechts ersetzt; letztlich entschied das Story-Team, dass ein junges unschuldiges Mädchen namens Boo das beste Gegenstück zu einem pelzigen achtbeinigen Hauptdarsteller wäre.

Auch die Gestalt des Sulley erfuhr im Lauf der Arbeit größere Veränderungen. Von einem Hausmeister entwickelte er sich über einen unkoordinierten, glücklosen Verlierer zu jenem Star-Chef-Erschrecker, den er in der Endfassung darstellt. In einem der Zwischenstadien trug er sogar Brillen und hatte Tentakel.

„Bei Monstern denken die Leute immer an wirklich schreckliche, knurrige, geifernde Biester", bemerkt Docter. „In unserem Film sind sie aber ganz gewöhnliche Müllers und Meiers, die genauso die Stempeluhr drücken wie wir. Sie unterhalten sich übers Kuchenbacken und über Gewerkschaftsbeiträge. Sie machen sich Sorgen über Dinge wie Zahnfehlstellungen. Und das Kindererschrecken ist eben nur ihr Beruf.

Vor allem aber mussten wir einen Grund dafür finden, *warum* Monster überhaupt Kinder erschrecken. Eine Zeit lang spielten wir mit der Idee, es handle sich dabei um so etwas wie eine Broadway-Show, bei der die Monster einander unterhalten, indem sie eben Kinder erschrecken. Dies entwickelte sich dann weiter zur Geschäftsidee, und die schien uns ziemlich tragfähig für den Humor."

Ausgehend von Docters ursprünglicher Idee begann Andrew Stanton – der die drei vorhergehenden abendfüllenden Pixar-Filme geschrieben hatte und bei diesem als Executive Producer tätig war – ein Drehbuch auszuarbeiten, das den Geist und die Fantasie des Konzeptes umsetzte. Nachdem Stanton mit seinem Drehbuchentwurf die Grundlage für den Film entwickelt hatte, wandte er sich dem nächsten Projekt zu (*Finding Nemo*, erscheint voraussichtlich 2003). Dan Gerson trat an seine Stelle und arbeitete weitere Versionen des Drehbuchs zu *Monsters, Inc.* aus, in denen Handlung, Figuren und Dialoge festgelegt wurden. Gleichzeitig halfen der Story

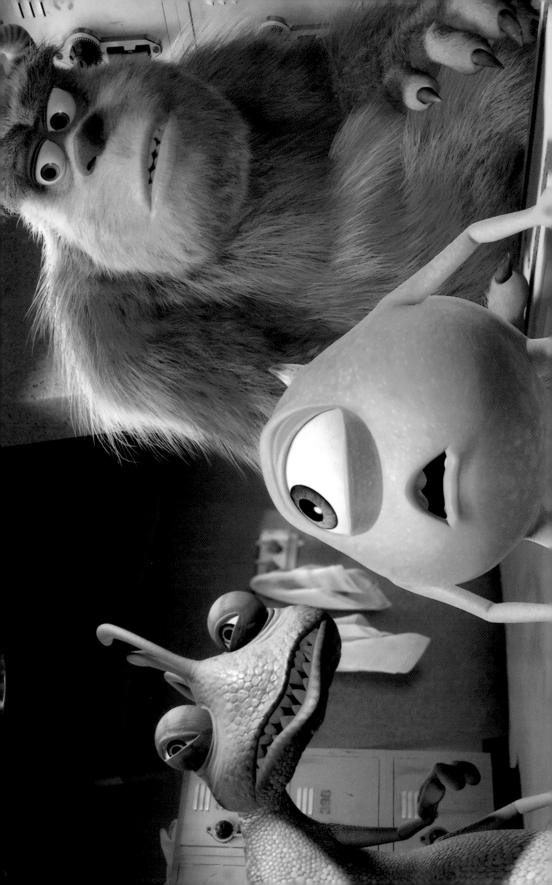

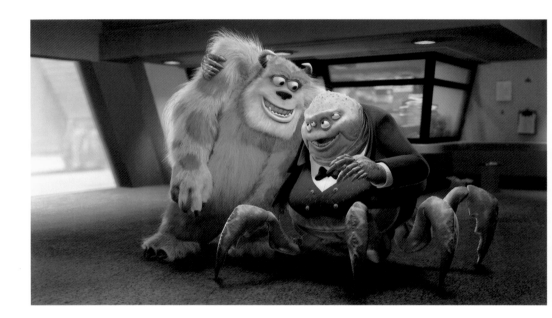

Co-director David Silverman came on board in 1998 to lend his expertise to the story process and focus on strengthening the relationships between the main characters. Another key contributor was co-director Lee Unkrich, whose live-action background proved priceless. According to Stanton, "The first and last thing

Supervisor Bob Peterson und sein Team bei der Visualisierung des Drehbuchs mit Zeichnungen, Gags und zahlreichen weiteren Einfällen mit. Co-Regisseur David Silverman kam 1998 an Bord, um seine Erfahrung beim Glätten der Handlung einzubringen und um sich auf die Stärkung der Beziehungen zwischen den einzelnen Figuren zu konzentrieren. Ein weiterer Kernmitarbeiter

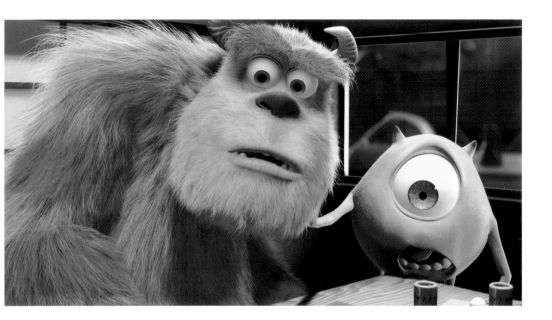

war Co-Regisseur Lee Unkrich, dessen Erfahrungen aus dem Live-Action-Bereich sich als unbezahlbar erwiesen.

Stanton berichtet: „Das Erste und das Letzte, was John Lasseter im Hinblick auf eine Geschichte fragt, ist: ‚Berührt mich das? Berührt mich das? Berührt mich das?' Und immer kommt zuerst das Hören und dann das Nachdenken. Boo ist tatsächlich die Schlüssel-gestalt zu diesem Film – Pete war diesbezüglich sehr streng. Er hat ein natürliches Gefühl dafür, die Unschuld kleiner Kinder anzusprechen, und er ist selbst ein großer Kindermagnet. Auch unsere eigenen Kinder hatten ihn kaum gesehen, da wollten sie schon mit ihm spielen.“

that John Lasseter asks with regard to the story is 'do I care, do I care, do I care?' It's always heart first and head second. And Boo is the real key to this whole film. Pete was really strong on this point. He has a natural instinct for tapping into the innocence of little kids and has always been a magnet for them. Our own kids would see him and just want to play with him.

Pete Docter (USA) began his association with Pixar in 1990 and has been hooked on computer animation ever since. As part of the original story team that helped to write and board *Toy Story*, he worked on the project for 4 1/2 years and also took on the role of supervising animator. **Lee Unkrich** (Co-Director) made his co-directing debut on the 1999 Disney/Pixar feature *Toy Story 2* following successful collaborations with John Lasseter as editor/supervising editor on two previous features (*Toy Story* and *A Bug's Life*). **David Silverman** (Co-Director) makes his feature co-directing debut on this film following a distinguished career in animation that includes a 10-year association with *The Simpsons*. He joined Pixar in 1998. **Andrew Stanton** (Executive Producer/ Screenwriter) has been a major creative force at Pixar since 1990 (he was the second animator ever hired by the fledgling studio) and has been a screenwriter on all of Disney/Pixar's feature films to date, including *Monsters, Inc.* **Pete Docter (USA)** stieß 1990 zu Pixar und ist seither bei der Computeranimation hängen geblieben. Bei *Toy Story* war er u. a. Supervising Animator. **Lee Unkrich** (Ko-Regisseur) debütierte in dieser Funktion beim Disney/Pixar-Film *Toy Story 2* (1999), nachdem er bereits erfolgreich mit John Lasseter als Editor bzw. Supervising Editor bei *Toy Story* und *A Bug's Life* zusammengearbeitet hatte. **David Silverman** war hier zum ersten Mal Ko-Regisseur bei einem abendfüllenden Film, blickt aber auf eine große Karriere in der Animation zurück, u. a. arbeitete er zehn Jahre für die *Simpsons*. Er stieß 1998 zu Pixar. **Andrew Stanton** (Executive Producer / Screenwriter) gehört seit 1990 zu den wichtigsten kreativen Kräften bei Pixar (er war der zweite Animator, den das noch junge Studio angeheuert hat) und war Drehbuchautor bei allen bisherigen Disney/Pixar-Filmen.

Panic Room
BUF

1999: *Fight Club*: David Fincher asked BUF to produce some visual effects for the film, in particular the shots transcribing the schizophrenic visions of Edward. BUF did six 3D sequences (19 shots).

End 2001: Kevin Tod Haug, the visual effects supervisor of *Panic Room*, contacted BUF for a shot called "The Big Shot". David Fincher wanted to create a long sequence moving through a house made of various live action elements which needed to be seamlessly linked together into one virtual camera move.

The freedom of action gained during *Fight Club* made the director confident that BUF could carry out the *Panic Room* project. Reconstructing parts of the sets in 3D would enable BUF to

1999: *Fight Club*: David Fincher ersuchte BUF, einige Visual Effects für den Film herzustellen, besonders für jene Einstellungen, die die schizophrenen Visionen Edwards wiedergeben. Insgesamt entstanden sechs 3D-Sequenzen in 19 Einstellungen.

Ende 2001: Kevin Tod Haug, der Visual Effects Supervisor von *Panic Room*, kontaktierte BUF wegen einer Einstellung für „The Big Shot". David Fincher wollte eine lange Filmsequenz durch ein Haus herstellen, die aus verschiedenen Live-Action-Aufnahmen zusammengesetzt und nahtlos zu einer virtuellen Kamerafahrt verbunden werden sollte.

Die Handlungsfreiheit, die dem Regisseur bei *Fight Club* gegeben wurde, überzeugte ihn, dass BUF auch mit *Panic Room* fertig werden würde. Die Rekonstruktion der Kulissen in 3D erlaubte es BUF, eine virtuelle

Kamera zu schaffen und diese anschließend frei von den Beschränkungen durch Raum, Zeit und Geschwindigkeit zu bewegen (Fahrt zwischen den Stangen des Treppengeländers, in ein Schlüsselloch, durch einen Plafond ...). Ein Team von BUF fuhr aufs Set, um Fotos der Bauten bei der gleichen Beleuchtung aufzunehmen, wie sie auch bei den Dreharbeiten verwendet wurde, und dabei die nötigen Daten für die Rekonstruktion der einzelnen Elemente zu sammeln. Dank der von BUF verwendeten Methode können die Künstler anhand der vor Ort aufgenommenen Bilder die Oberflächentexturen und Materialdetails exakt nachbilden, sobald einmal das Grundmodell erstellt ist. So werden Kameraübergänge unsichtbar. Von den ersten Produktionstreffen bis zur Fertigstellung von *Panic Room* dauerte es über ein Jahr, wobei BUF letztlich an 21 Einstellungen mitwirkte. Hier eine Auswahl:

create a virtual camera, and then be free from space limitation, speed and time constraints. (Passage through bars of the banister, inside a keyhole, through a ceiling ...). A team from BUF went on set to take photographs in the same environment and lighting set-up used for principal photography and collected data necessary to the reconstruction of elements and sets. According to the method BUF is using, once the sets are remodelled, the photographs taken on sets enable the digital artists to get the exact textures and material details. This way, the transitions in camera become imperceptible. It took over a year between the first production meetings and the end of the work. At the end, BUF worked on 21 shots, among others:

VFX 1010 – "Big Shot"

A character tries to break into a house. The camera follows from inside the house as he is progressing outside.

The overall idea was to treat this sequence as a shot sequence of 2mn51: The computer generated images enabling the different live action shots to be linked together. To obtain this result, BUF took photographs on location of all sets of the house, which needed to be recreated in post-production. Thus, with these photo-references, BUF was able to reconstruct the different sets in 3D: using modelling mapping.

To guarantee a coherence of camera movements between computed generated images and live action images; BUF had to recreate all the camera movements in 3D so we could travel through the 3D seamlessly.

Once David Fincher approved the camera movements and the timing of the shot, BUF took care of the rendering of the 3D shots, the atmospheric effects and the final compositing of the 3D elements in the filmed scenes.

VFX 1110 – "Through the Banister"

In this shot, the goal was to be able to go through the bars of the banister with the camera. For this effect, BUF had to recover in 3D the camera movement of the live action shot in order to integrate the banister in a very coherent manner. The banister was modeled in 3D using the photos taken on set as references and then integrated in the live action shot. As a result, the effect gives the illusion that the camera is really going through the bars of the banister.

VFX 1130 – "Through the Door" – "Unpacking"

The camera progresses in a hallway and intrudes into a bedroom revealing Jodie Foster emptying boxes. Originally, the work of BUF was to reconstruct in 3D and integrate the wall on the right side, which concretely prevented the camera from going between the door and the wall. BUF had to recover in 3D the camera movement of the live action shot in order to integrate the missing part of the hallway. Finally, due to too many vibrations in the camera movement, the whole hallway had to be totally reconstructed in 3D in order to obtain a stable camera movement.

VFX 1140 – "Push in to ECU of Wall" – "Pulsing Wall"

This shot is entirely in 3D. David Fincher wanted to go from a very wide shot to a very narrow shot (macroscopic) on the wall of the Panic Room, vibrating under the pounding of the sledgehammer.

VFX 1010 – „Big Shot"

Eine Person versucht, in ein Haus einzudringen. Die Kamera verfolgt diesen Einbruchsversuch aus dem Inneren des Hauses.

Die Grundidee in dieser Sequenz war, sie als Kamera-fahrt mit der Dauer von 2'51" aufzubauen; die computer-generierten Bilder erlaubten dabei die Verknüpfung der einzelnen Live-Aufnahmen. Um dieses Ergebnis zu er-zielen, nahm BUF alle Kulissen des Hauses vor Ort auf, die dann für die Post-Produktion nachgebaut wurden. Anhand der Referenzfotos konnte BUF die gesamte Kulissenstruktur in 3D mit Hilfe von Modeling und Mapping nachbauen.

Um den Fluss der Kamerabewegung zwischen den computergenerierten und den gedrehten Aufnahmen zu garantieren, wurden sämtliche Kamerabewegungen in 3D rekonstruiert, damit wir nahtlos durch den 3D-Raum fahren konnten.

Sobald David Fincher mit den Kamerafahrten und dem Timing der Einstellung zufrieden war, übernahm BUF das Rendering der 3D-Einstellungen, der atmosphärischen Effekte und die Endmontage der 3D-Szenen mit dem Filmmaterial.

VFX 1010 – „Through the Banister"

In dieser Einstellung ging es darum, mit der Kamera zwischen den Stäben eines Treppengeländers durch-zufahren. Dafür musste die Kamerabewegung der Live-Aufnahmen in die 3D-Grafik übertragen werden, um das Geländer nahtlos einfügen zu können. Das Geländer wurde mit Hilfe von Fotos der Originalbauten in 3D nachmodelliert. Die fertige Einstellung gibt tat-sächlich die Illusion einer Kamerafahrt zwischen den Geländerstäben wider.

VFX 1130 – „Through the Door" – „Unpacking"

Die Kamera fährt in einen Gang und weiter in ein Schlaf-zimmer, in dem Jodie Foster gerade Schachteln aus-packt. Ursprünglich hätte BUF jene Wand auf der rechten Seite nachbauen und einfügen sollen, die in der Wirklichkeit eine Kamerafahrt zwischen Gang und Zimmer verhindert hätte. Wieder wurde die Kamerafahrt der Live-Aufnahme in 3D rekonstruiert, um den fehlenden Teil des Ganges integrieren zu können. Letztlich aber erwies sich die Live-Fahrt durch den Gang als so un-ruhig, dass der gesamte Gang in 3D eingebaut wurde, um die gewünschte stabile Kamerafahrt zu erzielen.

VFX 1140 – „Push in to ECU of Wall" – „Pulsing Wall"

Diese Einstellung entstand gänzlich in 3D. David Fincher wollte von einer Weitwinkelaufnahme zu einer makros-kopischen Ansicht des Schutzraums kommen, der unter den schweren Schlägen des Vorschlaghammers vibriert. Kleine Staubpartikel fallen aus der Wand. Für diesen Effekt wurden Makrofotografien der Wand verwendet, um die vorstehenden Teilchen zu rekonstruieren. Dann

animierte BUF die Staubteilchen mit Hilfe dynamischer Animationswerkzeuge in 3D, um den Partikeln die entsprechenden physikalischen Eigenschaften zu verleihen und sie synchron zum Rhythmus der Hammerschläge fallen zu lassen.

VFX 1410 – „Macro Flashlight"
In dieser Sequenz wollte David Fincher die Einstellung mit einer Weitwinkelaufnahme eines Belüftungsrohrs beginnen lassen, durch das man das Mädchen sieht, wie es mit Hilfe einer Taschenlampe durch das Rohr Morsesignale sendet. Wir bewegen uns ins Rohr hinein und zoomen immer näher auf die Taschenlampe, bis wir eine makroskopische Ansicht des Drahtes im Lämpchen bekommen.

VFX 1510 – „Through the floor"
BUF sollte einen fließenden Übergang zwischen zwei Live-Aufnahmen herstellen. Die Kamera fährt durch den Boden des Schutzraums und taucht aus dem darunter liegenden Raum auf, wobei sie zeigt, dass die Eindringlinge dabei sind, den Plafond mit einem Vorschlaghammer zu durchbrechen. Der Mezzanin wurde nach Vor-Ort-Aufnahmen komplett in 3D nachgebaut; dann fügte BUF die herunterfallenden Teilchen und den Vorschlaghammer aus der Sicht des Mezzanins hinzu. Die gesamte Kamerabewegung wurde in 3D rekonstruiert, um den Teppich des Schutzraums, den Mezzanin und die Zwischendecke mit einzubeziehen.

VFX 1520 – „Through the wall"
Die Kamera fährt durch eine Wand des Schutzraums in das gemeinsame Schlafzimmer. BUF baute die Trennwände und ihr Innenleben in 3D nach, dann wurden diese zwischen die beiden Aufnahmen montiert, um eine perfekte Übereinstimmung in Bewegung und Farbe zu erreichen.

Fine particles of dust had to fall from the wall. For this effect, BUF started with photos in macro of the wall in order to reconstruct in detail the protruding bits. Then, BUF animated the dust particles in 3D using dynamic animation tools recreating the same physical dust particles so the fall of the debris would be synchronized with the pounding on the wall.

VFX 1410 – "Macro flashlight"
In this sequence, David Fincher wanted the camera to start with a wide shot of a ventilation pipe inside which we see the girl communicating with Morse code by flashlight through the pipe. We are inside the pipe. The camera gets closer and closer to the flashlight until we have a macroscopic view of the wire.

VFX 1510 – "Through the floor"
BUF was supposed to provide a fluid link between two live action shots. The camera goes through the floor of the Panic Room and emerges from the lower floor where we discover the intruders breaking the ceiling with a sledgehammer. The mezzanine was entirely built in 3D based on the photos taken on location. BUF, then, animated the debris and the sledgehammer destroying the ceiling from the inside of the mezzanine. The camera movement was entirely reconstructed in 3D in order to match the carpet of the Panic Room and to integrate the mezzanine and the ceiling of the lower floor.

VFX 1520 – "Through the Wall"
The camera goes through a wall from the Panic Room to the common bedroom. BUF rebuilt the partitions and their insides in 3D. Then BUF integrated them in order to provide a perfect match of movement and color between the two shots.

Harvey
Peter McDonald

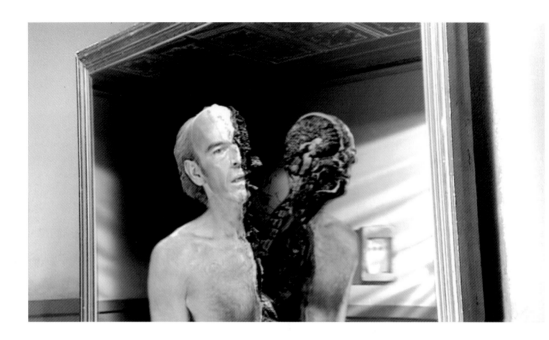

Harvey ist die Fortsetzung einer Serie von traurigen, düsteren Kurzfilmen, die bewusst schockieren und verletzen.

Der Film erzählt auf beklemmende Weise von der Besessenheit und Einsamkeit eines Mannes auf der Suche nach physischer wie emotionaler Ergänzung und Vervollständigung. Erst als er glaubt, sein Ziel in der erzwungenen Vereinigung mit seiner Nachbarin erreicht zu haben, beginnt er die schmerzliche und unauflösliche Natur seiner Besessenheit zu begreifen.

„Von der technischen Seite her sollte Harvey auf jeden Fall eine große Herausforderung sein: Der Held der Geschichte existiert nur als halber Mensch, anstelle seiner linken Körperhälfte hat er eine blutige Wunde, die sich vom Scheitel bis zur Sohle zieht. Einstellung um Einstellung zeigt, wie dieser halbe Mensch umhergeht und sich hinsetzt, aber richtig kompliziert wird es erst, als er seiner Hälfte noch eine halbe Frau hinzufügt. Trotz dieser technischen Unmöglichkeiten hat mich aus der Sicht des Filmemachers einfach die Aufgabe gereizt, daraus eine Geschichte zu machen, die das

Harvey continues a line of sad, dark, short films aimed to shock and offend.

A dark tale of obsession and loneliness about a man searching for physical and emotional completeness. It is only when he thinks he has achieved this goal through the unwilling coalescence of his neighbour that he begins to understand the painful, irresolvable nature of his obsession.

"On a technical level Harvey was always going to be a challenge. The hero exists only as half a man with a gory wound running from head to groin where the left side of his body should be. There is shot after shot of the half man walking around and sitting down—then it gets really complicated when he stitches himself to half a woman. But despite these technical impossibilities, what interested me as a film maker was the challenge of putting together a story that an audience would accept. Creating empathetic characters is a hard enough challenge in a standard dramatic vehicle, but in Harvey we had to make the surreal imagery

tell the story and making the special effects work required stringent planning. Technically it was a once-in-a-lifetime experience I never plan to be part of again ..."

"What of the result? Did I achieve that elusive balance of technical accomplishment and honest story telling? All I can really gauge is the reaction the film gets from absolute strangers. Sitting in the cinema, listening to the nervous, disbelieving laughter and squirming bodies writhing around in the darkness, I can only conclude I have succeeded on at least some level. If I can give the audience a thrill and something to talk about afterwards, I figure I have given something back to the world."

Publikum auch akzeptieren kann. Figuren zu schaffen, die unser Mitgefühl ansprechen, ist schon mit den normalen erzählerischen Mitteln nicht einfach; bei *Harvey* aber mussten wir die surreale Bildwelt die Geschichte erzählen lassen, und es bedurfte einer stringenten Planung, um die Special Effects zur Wirkung zu bringen. Vom Technischen her war es jedenfalls eine einmalige Erfahrung, wie ich sie nicht nochmals zu machen gedenke …

Und das Ergebnis? Ist es mir gelungen, jenes nicht greifbare Gleichgewicht zwischen technischer Leistung und ehrlichem Geschichtenerzählen zu finden? Ich kann nur beurteilen, wie der Film von absolut fremden Zusehern aufgenommen wird. Wenn ich im Kino sitze und dem nervösen, ungläubigen Lachen lausche, die im Dunklen hin- und herrutschenden Körper höre, dann schließe ich daraus, dass ich zumindest teilweise erfolgreich war. Wenn ich dem Publikum Spannung bieten kann und einen Gesprächsstoff für nach der Vorstellung, dann, glaube ich, habe ich der Welt doch etwas zurückgegeben!"

Peter McDonald (AUS) has a varied past ranging from a stint as a gravel quality control officer at Melton Quarry to a high flying animation director in the heart of London's decadent Soho scene. Peter graduates from the Australian Film Television and Radio School with a Masters of Arts (Honours) in Digital Media. **Peter McDonald (AUS)** blickt auf eine recht vielfältige Vergangenheit zurück, die von der Schotter-Qualitätskontrolle in einem Steinbruch bis zum hochfliegenden Animation-Regisseur mitten im Herzen von Londons dekadenter Soho-Szene reicht. Peter graduierte an der Australian Film Television and Radio School *cum laude* zum Master of Arts aus digitalen Medien.

Polygon Family: Episode 2
Hiroshi Chida

Diese kurze Animation wurde als Teil eines Spätabend-Nachrichten- und Unterhaltungsprogramms für TV ASAHI produziert und basiert auf Charakteren, die beim Electronic Theater der SIGGRAPH 98 gezeigt wurden. Als zynischer Seitenhieb auf die heutigen japanischen Gehaltsempfänger, die zu Hause ebenso wie in der Arbeit zu kämpfen haben, hebt das Stück die bewusst einfach gehaltene Computeranimation auf eine neue Ebene. Im vorliegenden Fall ist besonders erstaunlich, wie nahtlos der Techno-Beat mit der schwarz-weißen Bildwelt verschmilzt.

This short animation piece was produced for TV ASAHI, as part of a late-night news/variety program, based on characters screened at SIGGRAPH 98 (Electronic Theater). A cynical jab at today's Japanese "salarymen", struggling at home as well as at work, it takes limited CG animation to a new level. In this case it is amazing, how the techno beat blends in with the black-and-white imagery.

Hiroshi Chida (J), born 1968, is director at Polygon Pictures Inc. He has also been the episode director for *Mr. Digital Tokoro* (2001, TV series). He has been awarded a "Finalist Award" at the New York Festivals and a "Golden Camera Award" at the U.S. International Video & Film Festival. **Hiroshi Chida (J)**, geb. 1968, ist Regisseur bei Polygon Pictures Inc. Er hat auch bei einzelnen Episoden der TV-Serie *Mr. Digital Tokoro* (2001) Regie geführt. Hiroshi Chida hat einen Finalist Award bei den New York Festivals und einen Golden Camera Award beim U.S. International Video & Film Festival gewonnen.

Polygon Family: Episode 2

The Time Machine
Erik Nash / Digital Domain / Dreamworks

For these time travel sequences from the feature *The Time Machine*, the team at Digital Domain, led by Visual Effects Supervisor Erik Nash, set about creating a visual experience wherein the audience could see the world change in ways no one would be able to film or realise any other way. Digital Domain created over 250 shots for the film, showing the passage of time over both a few years and thousands of years. The shorter sequence required minute detailing in changes that occurred before the eye while the longer sequence required extensive geographical changes, including the formation of an ice age and a canyon. The two sequences use multiple 3D and 2D software tools. Maya was used for modelling and character animation. Houdini, rendering with Mantra, was used as the primary 3D effects tool. Custom tools and shaders were written to turn US Geological Survey data into animating and eroding terrain.

Für die Zeitreise-Sequenzen in dem Film *Die Zeitmaschine* wollte das Team von Digital Domain unter der Leitung des Visual Effects Supervisors Erik Nash eine visuelle Erfahrung schaffen, die dem Publikum die Veränderung der Welt in einer Weise zeigt, wie kein Mensch sie jemals auf andere Art wird filmen oder darstellen können. Digital Domain schuf für diesen Film insgesamt über 250 Einstellungen, die den Lauf der Zeit sowohl über wenige Jahre wie auch über Jahrtausende hinweg nachvollziehen. Die kürzere Sequenz verlangte nach exakter Detaillierung in jenen Veränderungen, die vor dem Auge ablaufen, während die längere Sequenz tief greifende Veränderungen auf geografisch-geologischer Ebene zeigen, darunter die Bildung einer Eiszeitformation und eines Canyons. Beide Sequenzen verwenden vielfältige 3D- und 2D-Werkzeuge. Maya wurde für die Modellierung und Character Animation eingesetzt; Houdini, gerendert mit Mantra, wurde als hauptsächliches 3D-Effektwerkzeug verwendet. Eigene Tools und Shader wurden geschrieben, um das Datenmaterial der US Geological Survey in animiertes und erodierendes Land zu verwandeln.

Erik Nash (USA) joined Digital Domain in 1995. He served as Visual Effects Director of Photography on *Apollo 13*, and *Titanic*. Nash also served as VFX Supervisor on Ron Howard's *Ed TV*, *Rules Of Engagement* for William Friedkin, the Coen Brothers *O Brother, Where Art Thou?* and *Red Planet* for Antony Hoffman. He began his career over eighteen years ago in the field of visual effects cinematography. He started in visual effects as a camera operator on *Star Trek: The Motion Picture*. He garnered two Emmy Awards for Outstanding Individual Achievement in Special Visual Effects. **Erik Nash (USA)** trat 1995 bei Digital Domain ein. Er diente als Visual Effects Director of Photography bei *Apollo 13* und *Titanic*. Nash war auch der VFX Supervisor bei Ron Howards *EDtv*, bei *Rules – Sekunden der Entscheidung* für William Friedkin, für *O Brother, Where Art Thou* der Coen-Brüder, und bei *Red Planet* für Antony Hoffman. Er begann seine Karriere vor über 18 Jahren als Kamera-Operateur für Visual Effects bei *Star Trek: Der Film*. Er hat zwei Emmy Awards für herausragende Einzelleistungen im Bereich der Special Visual Effects gewonnen.

AnnLee You Proposes
Lars Magnus Holmgren (aka Dr. Frankenskippy)

Down in the deepest darkest cellars of the Frankenskippy laboratory, I met one splendid day with contemporary artist Liam Gillick. Liam was commissioned by the Tate Britain art gallery to put on a show in the newly landscaped gardens area. His proposal was to utilise this area as an interactive space including a minimalist furniture installation with three large screens showing a loop cycle to be animated using the cutting edge technology used at my laboratories. Liam and I brainstormed up a delicious menu of ideas. Liam attained the rights to use AnnLee, a Japanese Manga character bought initially by two French artists Phillippe Parreno and Pierre Huyghe from a Japanese agency specializing in Manga characters.

In den tiefsten dunklen Kellern des Frankenskippy-Laboratoriums traf ich eines Tages den zeitgenössischen Künstler Liam Gillick. Liam hatte von der britischen Tate-Galerie den Auftrag bekommen, eine Ausstellung für deren neu gestalteten Gartenbereich zusammenzustellen. Sein Vorschlag war, das Areal als interaktiven Raum für eine minimalistische Möbelinstallation zu nutzen, mit drei großen Bildschirmen, die eine Endlosschleife zeigen und mit den modernsten in meinen Laboratorien verfügbaren Techniken animiert werden sollten. Liam und ich dachten uns ein delikates Menü an Ideen aus. Liam erhielt das Nutzungsrecht für AnnLee, eine japanische Manga-Figur, die ursprünglich von den beiden französischen Künstlern Philippe Parreno und Pierre Huyghe von einer auf Manga-Gestalten spezialisierten japanischen Agentur angekauft worden war.

In dieser zweiten Reinkarnation von AnnLee produzierte Liam zunächst ein Skript und ein erstes Drehbuch und gab mir dann alle Freiheiten, sie aus dem typischen Manga-Feeling rauszuscheuchen. Ich habe sie als Zauberin mit Hexenkraft ausgestattet, durch die sie den Betrachter in ihre Welt ziehen kann. Sie bewegt sich mit Gesten, die an alte magische Runenzauber erinnern und die Elemente Wasser, Feuer und Luft steuern.

AnnLee wurde mir per Email zugesandt, und so begann eine erste Phase ihrer re-animierten Reinkarnation als AnnFrankenLee. Um ihre graziösen zarten Formen etwas zu glätten, legte ich sie sanft auf meinen Operationstisch und unterteilte ihr ursprünglich polygonales Selbst in verschiedene Oberflächen. Ihr fröhliches Kleidchen wurde durch Gruftie-Schwarz ersetzt, ihre vorher leer starrenden Augen pulsieren und glühen im psychedelischen Purpur animierter UV-Farbtöne. Ein Toon-Shader gab ihrem Kopf voll neuem Haar den Glanz. Ihre Lippen und Brauen wurden blutrot gemalt, ihre Stiefel in richtige Hexenstiefel umgearbeitet. Ein Kanal mit Glüheffekt verleiht ihrer Haut ein ätherisches Aussehen. Metallische Schattierungen lassen ihre Fingernägel reflektieren. Um sie schweben ihre kybernetischen Augen als visionäres Mittel; der Innenbereich dieser Augen wird von einem Shader mit einer animierten Textur auf dem Reflexions- und Transluzenz-Kanal versorgt; auch das Glühen ist animiert, um eine elektrisch pulsierende Note hinzuzufügen.

So, in this second incarnation of AnnLee, Liam produced a script and basic storyboards, and then gave me license to freak her right out of the typical Manga feel. I empowered her as enchantress with powers of sorcery to draw you into her world. She moves with gestures reflective of old runic magic ritual, controlling the elements of water, fire and ether.

AnnLee was emailed to me, and thus began the first phase of her re-animated incarnation, as AnnFrankenLee. To smooth out her graceful delicate features, I laid her gently upon my operating table and created subdivisional surfaces from her former clunky polygonal self. Her dainty dress was replaced with gothic black. Her once vacant eyes pulse and glow psychedelic purple with animated UV maps. Toon shader gave her new head of hair its shine. Her lips and brow were painted blood red. Her boots tweaked to become witching boots. The glow channel was animated to give her skin its ethereal feel. Metallic reflectant shader was applied to her finger nails. About her float her cybernetic eyes as means of vision. The inner core of these eyes is assigned a shader with animated texture on the translucence and reflection channels. The glow channel is also animated to add an electric pulsing quality.

Lars Magnus Holmgren (aka Dr. Frankenskippy, AUS) was a member of a garage punk rock band, then started experimenting with animation and formed an archaic collaborative and multimedia performance group called Scratch My Nose. As a director he created the award winning MTV series *Tall Small Stories*. **Lars Magnus Holmgren (alias Dr. Frankenskippy, AUS)** war Mitglied einer Garagen-Punk-Band, begann dann mit Animationen zu experimentieren und gründete die archaische Multimedia-Performance-Kooperative „Scratch My Nose". Als Regisseur war er für die preisgekrönte MTV-Serie *Tall Small Stories* verantwortlich.

Mouse
Wojtek Wawszczyk

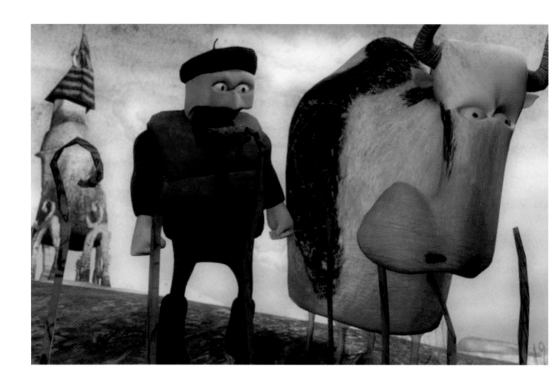

Mouse is an animated film written, designed and directed by Wojtek Wawszczyk, whose previous productions include award-winning shorts: *Headless* and *MTV:Forest* (directed by Piotr Karwas). Wojtek completed a Master of Arts Degree at Polish National Film School and *Mouse* was his graduation project, produced as a co-production between Polish Film School and Filmakademie Baden-Wuerttemberg in Ludwigsburg (D).

The film tells a story of a man who's not accepted by the community of people living in a town he had just moved to. Each person's personality is represented by an animal. A little mouse owned by the main character seems to be no match to other—bigger, stronger and more beautiful—creatures in town. He blames his loneliness on his mouse and decides to hide the mouse in the box. In his garage he creates something so ridiculously spectacular that is sure to bring the attention of all people from the town—it's a sculpture of a strange animal having features of different animals—an artificial hybrid of his neighbors' pets. Everyone in the town likes the

Mouse ist ein Animationsfilm von Wojtek Wawszczyk, zu dessen früheren Arbeiten die preisgekrönten Kurzfilme *Headless* und *MTV: Forest* (Regie Piotr Karwas) gehören. Wojtek erwarb seinen Master of Arts-Grad an der Staatliche Polnischen Filmhochschule, *Mouse* war seine Abschlussarbeit, die in Koproduktion der Polnische Filmhochschule mit der Filmakademie Baden-Württemberg in Ludwigsburg (D) entstanden ist.

Der Film erzählt die Geschichte eines Mannes, der neu in einem Ort zugezogen ist und von der Gemeinschaft der dort lebenden Menschen nicht akzeptiert wird. Jeder der Bewohner wird durch sein Haustier repräsentiert. Die kleine Maus, die dem neuen Einwohner gehört, scheint es nicht gegen die größeren, stärkeren und schöneren Tiere im Ort aufnehmen zu können. Der Mann macht die Maus für seine Einsamkeit verantwortlich und beschließt, sie in einer Schachtel zu verstecken. In seiner Garage konstruiert er dann ein lächerlich auffälliges Tier, das ihm ganz sicher die Aufmerksamkeit der Mitmenschen einbringen wird – eine Tierskulptur, zusammengesetzt aus Teilen verschiedener Tiere, ein Hybrid aus den Haustieren seiner Nachbarn. Jedem im Dorf gefällt die Skulptur –

nicht aber ihr Hersteller, der im Grunde seines Herzens noch immer eine graue Maus geblieben ist …

Die Produktion des Films dauerte rund ein Jahr (mit längeren Pausen); es handelt sich um Wojteks ersten komplett in 3D animierten Film (softimage|3D, gerendert mit Mental Ray). Alle Texturen wurden gezeichnet und gemalt.

Mouse war bereits bei zahlreichen Animations-Festivals auf der ganzen Welt, z. B. Annecy, ITF Stuttgart, London Effects and Animation Festival, Filmfestival Krakau, Hiroshima und auf der SIGGRAPH, zu sehen. Beim OFAFA-Festival 2002 in Krakau wurde ihm der Sonderpreis für hervorragenden künstlerischen Wert zuerkannt.

sculpture – but again not the main character—he never stopped being a mouse inside.

The production took about one year (with long breaks in-between) and was the first Wojtek's film animated entirely in 3D (created with softimage|3D, rendered with Mental Ray). All the textures were drawn and painted.

Mouse has been screened at many animation festivals around the world: Annecy, ITF Stuttgart, London Effects and Animation Festival, Cracow Film Festival, Hiroshima, SIGGRAPH. At OFAFA Festival 2002 (in Cracow, Poland) the film was awarded the Special Prize for Excellent Artistic Values.

Wojtek Wawszczyk (PL), born 1977, studied in the Animation Department of the Polish National Film, Television and Theatre School in Lodz. In 1998 he was selected to participate in a one-year scholarship at Filmakademie Baden-Wuerttemberg in Ludwigsburg (D). There, he focused on computer animation. In 2001 Wojtek finished the Polish Film School. He completed his Master of Arts degree with the highest grade.

Wojtek Wawszczyk (PL), geb. 1977, studierte an der Abteilung für Animation der Staatlichen Polnischen Hochschule für Film, Fernsehen und Theater in Lodz. 1988 wurde er für ein einjähriges Stipendium an der Filmakademie Baden-Württemberg in Ludwigsburg (D) ausgewählt, wo er sich auf Computeranimation spezialisierte. 2001 schloss er seine Ausbildung ab und graduierte mit Auszeichnung zum Master of Arts.

BMW Pool
Jason Watts / The Mill

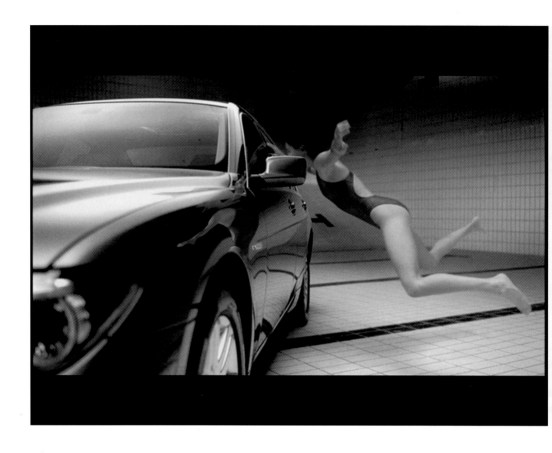

The commercial *BMW Pool* is set at night against an urban backdrop. A young woman dives off a high board into a seemingly empty swimming pool. As she hits an imaginary waterline, her movements slow down and she gracefully swims through the air towards the BMW that is sitting at the bottom of the pool. Mill Flame artist Jason Watts attended the ten day shoot in Cape Town, South Africa.

To achieve this effect, various plates of the car were shot in the empty pool. The young woman was then shot separately, swimming underwater in a naval diving tank, beside a mirror. Camera angles and lenses were set up as closely as possible to match the different plates. The shots of her reflections from the mirror were later composited onto the car to create her reflection as she swims up to it.

Shooting underwater presented the crew with various challenges, the main one being image clarity, which deteriorated dramatically as the

Der Werbespot *BMW Pool* spielt in der Nacht vor einem urbanen Hintergrund. Eine junge Frau taucht von einem Sprungturm in einen scheinbar leeren Swimmingpool. Sobald sie die imaginäre Wasseroberfläche trifft, verlangsamt sich ihre Bewegung, und sie schwimmt graziös durch die Luft auf einen BMW zu, der am Grund des Pools steht. Jason Watts von Mill war bei den zehn Tage dauernden Dreharbeiten in Kapstadt anwesend.

Um den beschriebenen Effekt zu erreichen, wurden zahlreiche Aufnahmen des Wagens im leeren Pool geschossen. Dann wurde die junge Frau separat aufgenommen, während sie in einem Marinetauchbecken neben einem Spiegel schwamm. Kamerawinkel und Objektive wurden so exakt wie möglich eingerichtet, um die beiden Aufnahmen zur Deckung zu bringen. Die Aufnahmen ihrer Reflexionen wurden später auf das Auto aufmodelliert, um ihre Spiegelung beim Zuschwimmen auf den Wagen zu reproduzieren.

Die Unterwasseraufnahmen stellten die Crew vor zahlreiche Probleme, vor allem weil die Klarheit der Bilder sich dramatisch verschlechterte, wenn das Objekt sich

von der Kamera weg bewegt. Deswegen war es notwendig, die Taucherin so nahe wie möglich bei der Kamera zu lassen, wobei wiederum nicht vermieden werden konnte, dass Teile ihres Körpers bei der Aufnahme nicht erfasst wurden. Jason Watts Aufgabe war es, die fehlenden Teile nahtlos einzubauen, während sein Team Luftblasen aus Haar und Badeanzug entfernte. Für die Aufnahme des Sprungs wurde eine Stunt-Frau eingesetzt, wobei Jason die Aufgabe zufiel, ihr Sicherungsgeschirr und die Kabel zu entfernen sowie neue Körperteile einzufügen, um sie der eigentlichen Taucherin anzugleichen. Die Flame-Leute von Mill ersetzten auch den leeren Hintergrund mit einer Stadtlandschaft und fügten den Schatten der Sportlerin der Pool-Umgebung hinzu. Eine weitere Aufgabe bestand in der Schaffung einer Rampe, die wie der Pool verkleidet ist, auf der das Auto letztlich aus dem Swimmingpool gefahren werden konnte.

subject moves away from the camera, therefore, keeping the diver close to the camera was of utmost importance. This inevitably led to parts of her body dropping out of shot. Lead flame artist Jason worked on seamlessly tracking in her missing body parts, whilst his team removed air bubbles from the diver's hair and costume. For the dive shot a stuntwoman was used, with Jason then working on removing the safety harnesses and wires, tracking in new body parts to disguise her as the original diver. Mill flame artists also worked on replacing the empty skyline with a cityscape and adding the diver's shadow to pool surroundings. Additional work included creating a "pool tiled" ramp to enable the car to drive from the pool.

Jason Watts (GB), Senior Flame Artist, The Mill, frequently works with high-profile directors including Daniel Barber, Dom & Nick, Paul Weiland, Tony Scott, and Frank Budgen. Jason led the post production on the *Barclays Bank Big* campaign starring Anthony Hopkins directed by Tony Scott. Jason also worked with Frank Budgen on *Sony The Unexpected* and the award-winning *Levis Twist*. Other credits include *Levis Undressed* for Dom & Nick, *Levis Dolls* for Dante and Madonna music promo *American Pie* for Philipp Stolzl. **Jason Watts (GB)**, Senior Flame Artist bei The Mill, arbeitet häufig mit so renommierten Regisseuren wie Daniel Barber, Dom & Nick, Paul Weiland, Tony Scott und Frank Budgen. Jason hat auch die Postproduktion der *Barclays Bank Big*-Kampagne mit Filmstar Anthony Hopkins unter der Regie von Tony Scott geleitet. Weiters hat er mit Frank Budgen an *Sony The Unexpected* und dem preisgekrönten *Levis Twist* zusammengearbeitet. Weitere seiner Arbeiten sind *Levis Undressed* für Dom & Nick, *Levis Dolls* für Dante sowie den Madonna-Musik-Trailer *American Pie* für Philipp Stolzl.

Kikumana
Yasuhiro Yoshiura

People today seem to have a tendency "to live only in one's solitary world not having contacts with others". Every individual might have different taste in what to do in their isolated world, but it is possible to conclude that their common point is "keeping on getting information".
Uniform information supplied from media to each "inner world"...people who store this given information in their "inner world" in disorder... people today struggle to recover their half-lost selves...
This work Kikumana is an animation of a girl called Kikumana who acts like in a stage performance, her role influenced by negative circumstance though she tries to find herself. The primal aim is to communicate a feeling of alienation to the audience. The image has a pictorial atmosphere and a documentary touch at the same time. Unrealistic phenomena are in play here.
I aimed to make the work not "boring", stimulating the interest of the audience by organizsing the composition uinpredictablye.
Characters' animation was hand-drawn, the rest in 3D. Then I composited both parts paying attention to their integration. The reason why I didn't produce characters in 3DCG is, that I wanted to give them real existences and impacts in the midst of 3D space. Screen composition is

Die Menschen heutzutage scheinen nur in ihrer einsamen Welt leben zu wollen, ohne Kontakt mit anderen. Jedes Individuum mag unterschiedliche Vorlieben haben, denen es in seiner eigenen Welt nachgeht, aber der Schluss ist zulässig, dass eine Gemeinsamkeit aller Menschen das Bedürfnis nach Information ist. Uniforme Information, die von Medien in die jeweilige „Innenwelt" geliefert wird … Menschen, die diese gelieferte Information unordentlich in ihrer „Innenwelt" speichern … Menschen der Gegenwart, die darum kämpfen, ihr halb verlorenes Selbst wiederzufinden …
Die Animation Kikumana dreht sich um das gleichnamige Mädchen, das wie auf einer Bühne agiert, wobei ihre Rolle von negativen Umständen beeinflusst wird, auch wenn sie sich bemüht, zu sich selbst zu finden. Hauptziel ist es, mit diesem Werk dem Publikum eine Atmosphäre der Befremdung zu vermitteln. Das Bild hat einerseits eine malerische Qualität, andererseits auch einen dokumentarischen Touch. Unrealistische Phänomene laufen hier ab.
Ich habe mich bemüht, das Werk nicht langweilig erscheinen zu lassen und das Interesse des Publikums durch Unvorhersehbarkeit in der Komposition wach zu halten.
Die Animation der Charaktere geschah von Hand, der Rest in 3D-Computergrafik. Dann habe ich beide Teile sorgfältig zusammenkomponiert. Ich habe deswegen

keine 3D-Gestalten verwendet, weil ich ihnen eine reale Existenz und Kraft innerhalb des 3D-Raums geben wollte. Die Bildkomposition berücksichtigt sowohl die Kontraste zwischen Licht und Schatten als auch die „in der Luft liegende" Atmosphäre des Stücks.

Bei den handgezeichneten Animationsteilen habe ich zunächst Strichzeichnungen gescannt, sie am Computer koloriert und in Bewegung gebracht. Ich habe viel Aufmerksamkeit auf die notwendigen Pausen zwischen den einzelnen Handlungssequenzen verwendet, um das Spiel der Figuren echt zu gestalten. Um den 3D-Hintergrund etwas plastischer erscheinen zu lassen, habe ich die Lichtdiffusion beim Radiosity Rendering niedrig gehalten und das sich ergebende Moiré bewusst fleckig gelassen. Durch eine 2D-Behandlung der gerenderten Bilder ergab sich eine physikalisch vielleicht nicht korrekte Darstellung der Lichtquellen, die aber genau so ausgefallen ist, wie ich sie geplant hatte.

designed with respect to the contrast between light and shadow, and the pregnant atmosphere of the scene.

With regard to the hand-drawn animation part, after scanning line drawings, I coloured them on the computer and made them move. I paid a lot of attention to the breaks between the individual action sequences in orderto portray the play of the figures genuinedy and convincingly.

To achieve a more plastic 3D-background, I kept the light diffusion low for the Radiosity rendering and deliberately left the resulting Moiré flecked. Through 2D treatment of the rendered pictures, the representation of the light sources, while perhaps not physically correct, fell out exactly as I had planned.

Yasuhiro Yoshiura (J), born 1980, attended the Department of Art and Information Design, faculty of Design, Kyusyu Institute of Design (national university). At present he belongs to Professor Tsuruno's seminar, in the same university. He has been awarded several prizes in Japan and his works are have been screened during exhibitions in Japan and USA. **Yasuhiro Yoshiura (J)**, geb. 1980, besuchte das Department of Art and Information Design der Design-Fakultät am staatlichen Kyusyu Institute of Design. Derzeit gehört er zur Seminargruppe Professor Tsurunos an der gleichen Universität. Er hat in Japan mehrere Preise errungen, seine Arbeiten waren bei Ausstellungen in Japan und den USA zu sehen.

DIGITAL MUSICS

Striking a Balance
Bilanz des Jahres

Florian Hecker, Tony Herrington, Naut Humon

„Die einzelnen Bereiche der Musik – klassische, zeit-
genössische, Pop, Folk, traditionelle, Avantgarde usw. –
scheinen Einheiten für sich zu bilden, manchmal von-
einander abgeschottet, manchmal einander gegenseitig
durchdringend. Sie weisen erstaunliche Unterschiede
auf, sind reich an Neuschöpfungen, aber auch an
Versteinerungen, Ruinen, Verschwendung, und das
alles in ständiger Formung und Umformung wie die
Wolken, so differenziert und so ephemer."
Iannis Xenakis „Music Composition Treks", in: *Composers and
the Computer*. Los Altos: William Kaufmann Inc., 1985.

Die in der alljährlichen Digital-Musics-Kategorie einge-
reichten Werke unterstreichen einmal mehr, dass die
elektronischen Musiker ihre Werke mehr und mehr auf
den unterschiedlichsten Plattformen vorstellen – von
Installationsarbeiten zu Mixed-Media-Stücken, von
Galerie-Präsentationen zu Videos, von Klangkunstaus-
stellungen zu Internet-Domains, ganz zu schweigen von
den fast schon „traditionellen" Präsentationsräumen
CD, Clubs, Rundfunk, Klanglabor und Konzertsaal.
Diese vielfältigen Kontexte bieten den Musikern in
Kombination mit der ständig wachsenden Zahl billiger
Hard- und Software, egal ob handelsüblich oder eigens
konstruiert, die Gelegenheit, ihr Werk ständig zu
erneuern und auszuweiten, ein Faktor, der sich auch
in den diversifizierten Einreichungen zum Musikforum
des Prix Ars Electronica niederschlägt.
Wie nun die jeweilige Jury dieses Spektrum zeitgenös-
sischer digitaler Klangproduktion aufnimmt, wird sich
wohl von Jahr zu Jahr ändern. Aber ändert es sich
genug? Wie schnell scheint dieses Feld selbst immer
mehr Innovationen hervorzubringen, die – egal ob
veröffentlicht oder nicht – immer mehr Konsumenten
mit mehr und mehr Produkten überschwemmen? In
wie weit kümmern sich die meisten Leute, die Musik
kaufen, tatsächlich um den Inhalt, den sie erwerben?
Wie stark beeinflussen Marketing, soziales Umfeld
und das, was auf der Party bei Freunden zu spielen
gerade cool ist, wohin der Unterhaltungsrubel rollt?

"The universes of music—classical, contemporary,
pop, folk, traditional, avant-garde etc.—seem to
form units in themselves, sometimes closed,
sometimes interpenetrating. They present amazing
diversities, rich in new creations but also
fossilizations, ruins, wastes, all in continuous
formation and transformation like the clouds,
so differentiated and ephemeral."
Iannis Xenakis "Music Composition Treks" in *Composers
and the Computer*, William Kaufmann, Inc. Los Altos, 1985.

The works submitted to this annual Digital Musics
category re-emphasized the way in which electronic
musicians, now more than ever, are disseminating
their music across multiple platforms, from
installation works to mixed media pieces, gallery
presentations to video, sound art exhibitions to
Internet domains, as well as the more "traditional"
arenas of the CD, club space, diffusion system,
sound lab and concert hall. These multiplying
contexts, combined with the ever-increasing avail-
ability of affordable, off-the-shelf or customized
hardware and software, allow musicians the scope
to constantly renew and expand their work, a
factor which continues to be reflected in the
diversified response to the Prix Ars Electronica
musical forum.
How any particular jury absorbs this spectrum of
contemporary digital sound production certainly
changes from year to year. But does it change
enough? How fast does the field itself seem to
foster innovation amidst the increasing inundation
of more and more products, released or unreleased
to a rising population of "concerned" consumers?
How much do most people who purchase music
truly care about the content they buy? How much
does marketing, social conditions and what's
cool to play at your friend's party influence the
spending of the entertainment dollar?
Fortunately, our panel rarely has to consider these
commercial issues. The majority of prize winners

from all the Prix's years delve into who's driving the current electronic underground towards fresh dispatches and how these pioneers are crafting their audio science. As a jury for the controversial format of a music "competition', we are told we have to discriminate amongst hundreds of submissions in order to somehow select the top fifteen signature pieces, which should represent the "growth" or "aesthetic value" in the field. What's tied to economics here is the attraction of a cash incentive, at least for the top three chosen, and further international recognition for the remaining important mentions. What the challenges constitute for each jury session is the process of filtering a common agreement as to what seems good, bad, thought-provoking or counter-productive to five very different jurors.

Although it's increasingly difficult to accurately categorize the mountain of music that's carefully considered and selected, it seems more vital to honor work that pushes the envelope regardless of its labeled influences. In all art, once new ideas take root, they harden into genres (which all have social, aesthetic, and political dimensions) and are given names (Dada, surrealism, abstract expressionism, electro-acoustics, drum 'n' bass, electronica, whatever). It's the way of the world. In the past, even the Prix has altered its category titles from "Computer Graphics" or "Computer Music" to more streamlined monikers that appear less rigid or formalized to its contemporary audience. Even if many of the artists themselves feel trapped by specific genre classifications by a re-purposing public, press or jury, it´s time to worry less about distinguishing between the latest "clicks & cuts" or arbitrary academic structures. As these are all traditions to be aware of, we need to concentrate on what's being done to further the music itself beyond its apparent origins. Luckily for this round, the 2002 batch of sonic wonders seems more heterogeneous than ever. As certain prominent musical trends reach periodic saturation points with high quantities of glitch, breakbeat, acousmatics and variations on noise, it becomes quite a task to transcend the common trends. But poking their heads through the crowd is a group of individuals who in certain cases have maintained an audio legacy dating back decades, whose work has proved to be highly consequential in shaping contemporary, digital music discourse. The younger generation chosen here may or may not be influenced by these visible masters and stand very firmly on their own ground at the center of today's radical experimentalism.

Zum Glück hat unsere Jury solch kommerzielle Überlegungen nur selten anzustellen. Die Mehrzahl der Preisträger aus all den Jahren des Prix beantwortet die Frage, wer den gegenwärtigen elektronischen Underground zu neuen Zielen vorantreibt und wie diese Pioniere handwerklich mit ihrer Audiowissenschaft umgehen. Als Jury für das doch recht kontroversielle Format eines „Musikwettbewerbs" haben wir den Auftrag, Hunderte von Einreichungen zu sichten, um auf irgendeine Weise jene fünfzehn Spitzenwerke herauszufinden, die für das „Wachstum" oder den „ästhetischen Wert" dieses Gebiets stehen. Das Einzige, was dabei mit ökonomischen Faktoren zu tun hat, ist der Anreiz des Geldpreises, zumindest für die drei Hauptpreisträger, und die internationale Anerkennung für die Verbleibenden. Die Herausforderung einer jeden Jurysitzung besteht darin, bei fünf sehr unterschiedlichen Juroren einen gemeinsamen Nenner hinsichtlich dessen zu finden, was unter gut, schlecht, Denkanstoß oder kontraproduktiv zu verstehen ist.

Auch wenn es immer schwerer wird, den Berg von Musik, der sorgfältig analysiert und bewertet wird, genau zu kategorisieren, scheint es doch wichtig, jene Werke zu honorieren, die den Horizont erweitern, ungeachtet der jeweiligen Etikettierung ihrer Einflusssphäre. In jeder Form von Kunst härten neue Ideen, sobald sie einmal Fuß gefasst haben, zu Genres mit allen sozialen, ästhetischen und politischen Dimensionen aus und erhalten eine Bezeichnung (Dada, Surrealismus, abstrakter Expressionismus, Elektroakustik, Drum'n'Bass, Electronica, was auch immer). So ist die Welt nun mal. In der Vergangenheit hat auch der Prix Ars Electronica seine Kategorie-Bezeichnungen von „Computergrafik" oder „Computermusik" in etwas schlankere Formulierungen geändert, die einem zeitgenössischen Publikum weniger rigide oder formalisiert erscheinen. Und selbst wenn sich zahlreiche Künstler selbst gefangen fühlen in den spezifischen Genre-Einteilungen des Publikums, der Presse oder einer Jury, so ist es doch an der Zeit, sich weniger den Kopf über die Unterschiede zwischen den neuesten „Clicks & Cut" oder beliebigen akademischen Strukturen zu zerbrechen. Gerade weil dies alles Traditionen sind, derer wir uns bewusst sein sollten, müssen wir uns auf das konzentrieren, was die Musik als solche voranbringt, ungeachtet seiner augenscheinlichen Herkunft.

Zum Glück für unsere Runde scheint der diesjährige Stapel an Klangwundern heterogener zu sein als je zuvor. In dem Maße, in dem gewisse musikalische Trends von Zeit zu Zeit einen Sättigungspunkt erreichen – mit großen Mengen von Glitch, Breakbeat, Akusmatik und Variationen über das Geräusch –, wird es schwierig, über solche Trends hinauszublicken. Aber eine Gruppe von Individuen hebt dennoch den Kopf aus der Masse heraus – in einigen Fällen, weil eine Jahrzehnte zurückreichende Audio-Tradition gewahrt und weiterentwickelt

wurde oder ihr Werk bewiesen hat, in seiner Ausformung des zeitgenössischen digitalen Musikdiskurses höchst konsequent zu sein. Die hier ausgewählte jüngere Generation mag von diesen sichtbaren Meistern beeinflusst sein oder nicht, jedenfalls steht auch sie fest verwurzelt auf ihrem eigenen Boden im Zentrum des radikalen Experimentalismus von heute.

Goldene Nica
Yasunao Tone: *Man'Yo Wounded 2001*

Yasunao Tones mit der Goldenen Nica bedachtes Stück *Man'Yo Wounded 2001* ist eine der jüngsten Ausformungen seines Projekts *Musica Simulacra*. Das Projekt selbst basiert auf einem Konzept der „Verklanglichung" von Bildern und Text, an dem er seit den 1970er-Jahren arbeitet. Sein Beitrag zu den Methoden, digitale Daten mithilfe der CD zu manipulieren, geht auf die Mitte der 80er-Jahre zurück. Für die geplagten Ohren der Jury jedenfalls enthüllte die 2001er-Version seiner selektiven „Verwundungen" von CDs mithilfe eines gelochten Klebestreifens auf der Oberfläche hörbare Ergebnisse, die ebenso weit reichen wie jene einer beliebigen digitalen Signalbearbeitungssoftware, wie sie von der Desktop-Elite verwendet wird.

Kern von Tones Arbeitsprozess ist die grundlegende Technik, das Abbild von Textformen in pixelförmige Klangfragmente umzuwandeln, die mit verschiedenen DSP-Methoden ausgebaut werden. Im Mittelpunkt des Juryprozesses stand jedenfalls die fast magnetische Anziehungskraft von Yasunaos Wirbelwind aus seltsam verfremdeten Klangtexturen, der einfach hervorstach und jeden an unserem Tisch in seinen Bann zog. Tone erklärt seine Methode folgendermaßen:

„Warum ich meine eigene Arbeit verwundet habe? Ein reproduzierendes Medium ist eine Technik zur Gravierung oder Stabilisierung von Klängen, die von Luftvibrationen erzeugt werden und die aus der Natur in ein Magnetband oder Plastik verschwinden, damit man das Werk nach Lust und Laune wiedergeben und hören kann. Das hat die Rezeption der Musik von den zeitlichen und räumlichen Beschränkungen des Konzertsaals emanzipiert. Aber die Aufzeichnung ist nicht gerade ein ideales Medium für Komponisten, die Werke einer Form schreiben, die ohne die Aufführung und ohne das Rezeptionserlebnis als aktiver Teil der Musik nicht vollständig sind."

Zur spezifischen Anwendung seiner Theorie auf seine aufgenommenen Werke sagt Yasunao: „Ich arbeite seit 1997 am CD-ROM-Projekt *Musica Simulacra*. Dass ich jahrelang an einem Stück arbeite, liegt an seiner großen Länge und daran, dass ich das Klangwörterbuch, auf dem es aufbaut, ständig aktualisieren muss. Auch meine Performance nimmt diese Work-in-Progress-CD-ROM als Quelle. Das interaktive Programm erlaubt es dem Publikum, 4516 verschiedene Musikstücke auf der

Golden Nica
Yasunao Tone: *Man'Yo Wounded 2001*

Yasunao Tone's Golden Nica-winning piece *Man'Yo Wounded 2001* is one of the most current outtakes of his project *Musica Simulacra*. This project is based on concepts of sonification of images and text he has been working on since the seventies. His contribution to the method of manipulating digital data via the compact disc goes back to the mid-nineteen eighties. To the jury's jaded ears, this 2001 version of selective "woundings" of CD's by punctured scotch tape attached to the surface reveals audible results as far reaching as any advanced digital signal processing software utilized by the desktop elite.

At the core of Tone's process lies the fundamental technique of transforming the image of text forms to pixalised sound fragments expanded by a number of DSP methodologies. At the center of the jury process was the magnetic attraction to Yasunao's whirlwind of adulterated alien sound textures that leapt out and truly gripped everyone at our table. Tone explains his methodology in the following manner:

"Why I have wounded my own work, as a reproducing medium, is a technique of inscribing or stabilizing sounds generated by vibrations of air which itself vanishes by nature in magnetic tape or plastic, so that you can hear a performance at your convenience. It emancipated the reception of musical performance from temporal and spatial limitations such as concert halls. However, the recording is not exactly an ideal medium for composers who write music such that a composition is just a process of the musical piece that will only be complete by performance and reception as an active intervention in music."

In terms of the specific application of his theory to his recorded work, Yasunao says, "I have been working on the CD-ROM project titled *Musica Simulacra*, since 1997. The reason why I have worked for years on a single piece, however, is because it is very long, and I have to constantly revise the sound dictionary, which makes up the entire piece. The source of my performance is taken from this CD-ROM, which is still work in progress. The interactive program enables an audience to select 4516 different pieces of music on one disc, each of which is exactly converted into digital noise from the poems of Chinese characters of the 8th century Japanese anthology called *Man'yoshu*, which contains the same number of poems (and it would take about 3,000 hours if the CD-ROM were played in entirety).

The CD-ROM project also employs the same method I used for *Musica Iconologos*, my first album. But as a single piece, there is no such choice for the audience, so, after I burned one of the pieces from *Musica Simulacra* on a CDR, I prepared it with bits of scotch tape on the disk (hence *Wounded*), the method I've been using since 1985. Then, I am going to perform the disk with my CD Player from 1984... Then, the *Wounded Man'yo* pieces become a far cry from the original and complete new piece."

Yasunao concludes, "....*Recording* presupposes that with repetition, each multiplied record or tape is identical, no matter how many copies are made and how many times they are listened to. However, recording as such is not an ideal medium for composers who write music....a composition is just a process of the musical or sound piece that will only be complete by performance and reception as an active intervention in music. Therefore, I would like to create a record that does not repeat whenever you listen to it. I have been working on this concept for years and with different methods."

Based on our reading of his work, it's clear that Yasunao's productions thus far have gone a very long way towards achieving the theoretical goals he's set up for himself. They not only provide a compelling listen, but a remarkable example of how compositional work, self-conscious of both performance mediums and mass production, can successfully execute a new compositional methodology that is as artistically valid as it is intellectually challenging.

Distinction
Curtis Roads: *Point, Line, Cloud*

For the past number of years, the controversy over the challenges facing the electro-acoustic composers who have submitted new works to recent juries has been a recurring theme in the statements and panel deliberations. Acousmatic critics of the Prix felt that after 1998 the sector was perhaps in danger of being under-recognized and a number of the notable academia decided to stop entering after receiving a plethora of prizes for the genre since the competition began in 1987. During that same year, a juror named Curtis Roads served as a Prix Ars panelist and in 2002 our present committee voted his latest *Point, Line, Cloud* piece for a Distinction placement. Have we come full circle in finding a new electro-acoustic work that *did* manage to astonish many of our members by being most currently relevant to the next electronic generation Things

Scheibe auszuwählen, und ein jedes wird exakt aus einem der ebenso vielen Gedichte der japanischen Anthologie *Man'yoshu* in digitales Geräusch übertragen. Die Gedichte stammen aus dem 8. Jahrhundert und wurden in chinesischen Schriftzeichen geschrieben; es würde rund 3000 Stunden dauern, die CD in voller Länge abzuspielen. Das CD-ROM-Projekt verwendet die gleiche Methode, die ich für mein erstes Album *Musica Iconologos* verwendet habe. Da es sich dabei um ein einziges Stück handelt, gibt es keine Auswahl für den Zuhörer, deswegen habe ich, nachdem ich ein Stück aus *Musica Simulacra* auf CDR gebrannt hatte, diese Scheibe mit einem Stück Klebeband präpariert (also ‚verwundet') – eine Methode, die ich seit 1985 verwende. Und dann führe ich die CD mit meinem Player aus dem Jahr 1984 auf ... Auf diese Weise wird das ‚verwundete Man'yo'-Stück ein ferner Nachhall des Originals und gleichzeitig ein völlig neues Werk."

Yasunao schließt: „... *Aufzeichnung* geht davon aus, dass auch bei der Wiederholung jede Kopie des Bandes oder der Platte identisch ist, egal wie viele davon hergestellt und wie oft sie abgespielt werden. Aber eine Aufzeichnung ist nicht das ideale Medium für Komponisten, die Musik schreiben ... eine Komposition ist nur vollständig durch ihre Aufführung und Rezeption als aktive Intervention in der Musik. Deswegen würde ich gerne eine Aufnahme schaffen, die nicht bei jedem Abspielen das Gehörte wiederholt. Ich arbeite seit Jahren und mit unterschiedlichen Methoden an diesem Konzept."

So wie wir seine Arbeit verstehen, ist klar, dass Yasunaos Produktionen dem theoretischen Ziel, das er sich gesetzt hat, schon recht nahe kommen. Sie bieten nicht nur ein fesselndes Hörerlebnis, sondern auch ein bemerkenswertes Beispiel dafür, wie kompositorische Arbeit, die sich der Aufführungsmedien ebenso wie der Massenproduktion bewusst ist, erfolgreich eine neue Kompositionsmethodologie umsetzen kann, die sowohl künstlerisch gültig wie intellektuell herausfordernd ist.

Auszeichnung
Curtis Roads: *Point, Line, Cloud*

In den letzten Jahren wurde in der Jury und in den Jurybegründungen immer wieder darüber diskutiert, welcher Herausforderung sich elektroakustische Komponisten zu stellen haben, wenn sie neue Werke beim Wettbewerb der vergangenen Jahre einreichten. Akusmatische Kritiker des Prix hatten das Gefühl, dass ihre Kategorie seit 1988 Gefahr laufe, unterbewertet zu werden, und einige unter den bekannteren akademischen Institutionen haben überhaupt aufgehört einzureichen, nachdem sie seit der Einführung des Prix 1987 eine Unmenge von Preisen gewonnen hatten. In genau jenem Jahr saß ein gewisser Curtis Roads in der Jury; fünfzehn Jahre später wählte die diesjährige Jury sein Stück *Point, Line, Cloud* für eine Auszeichnung aus.

Hat sich der Kreis geschlossen, wenn wir jetzt ein neues elektro-akusmatisches Werk gefunden haben, dem es tatsächlich gelungen ist, viele der Jurymitglieder zu erstaunen, weil es höchst relevant für die nächste elektronische Generation ist? Die Situation ist sicherlich noch verbesserungsfähig, aber vielleicht kann Curtis' aufgeladene musikalische Erfahrung ja eine Art Messlatte für zukünftige akusmatische Einreichungen sein, die über jene üblichen Muster hinausgehen, wie sie in der Mehrzahl der anscheinend schon klischeehaften Kompositionen wiederholt werden. Uns jedenfalls hat dieser frühe Ahne des Microsounds bis an die nächste Schwelle einer Quantenakustik geführt, in der sich Klangpartikel von einer Zehntelsekunde (oder weniger) zusammenballen, auflösen und zu anderen Audio-Texturen verschmelzen. Durch die Ausweitung der Grenzen zwischen Zeitskalen und Frequenzintensitäten hat Curtis ein seltsam dichtes Gewebe aus unvorhersehbaren Formen und Gefühlen erzeugt, die unterschiedliche Modi der Kontinuität heraufbeschwören.

Auszeichnung
Aeron Bergman / Alejandra Salinas / Lucky Kitchen: Revisionland + The Tale of Pip

Revisionland von Lucky Kitchen war für die Jury sozusagen der Katalysator für das zweite ausgezeichnete Werk, das vom in Spanien beheimateten Duo Alejandra Salinas und Aeron Bergman eingereicht wurde. Es handelt sich um die CD-Wiedergabe eines Installations-Stückes. Eingeladen, eine Installation für eine Galerie in Stirling (Schottland) – einem eng mit der Geschichte des schottischen Kampfes um die Unabhängigkeit von England verbundenen Ort – zu erarbeiten, haben die beiden als Teil des konzeptuellen Hintergrunds für das Werk Episoden aus der schottischen Frühgeschichte verwendet, besonders die Namen und Charakteristiken einiger der seltsamen Monstren und Wesen, die sich in Legende, Folklore und Mythologie des Landes herumtreiben. Diese Bedachtnahme auf ortsbezogene Geschichte in der Vorbereitung eines Installationsstücks unterscheidet das Lucky-Kitchen-Stück wesentlich von der Vielzahl anderer Einreichungen, die in die lose Kategorie „Klangkunst" fielen und die alle nur wenig Bezug auf jenen Ort zu nehmen schienen, an dem sie präsentiert wurden. Entscheidend kommt dazu, dass auch die Manipulation des Klangmaterials durch das Duo ebenso gefühlvoll wie provozierend war, wobei sie die digitale Synthese zur Organisation der Lo-Fi-Bandarbeiten und Außenaufnahmen nutzten und daraus ein Widerhall erweckendes Stück machten, das sowohl als Archivprojekt wie als Prozess der Erneuerung längst vergessener Bräuche und Glauben diente. Egal ob als CD oder mittels eines Installationswerks präsentiert, Revisionland hat die Jury als einzigartig evokative Umsetzung digitaler Musik tief beeindruckt.

could improve, but maybe Curtis's highly charged musical experience could be a benchmark of sorts for future acousmatic submissions, which transcend the common prevalent patterns repeated in the majority of seemingly clichéd compositions. Meanwhile this early progenitor of micro sound took us to the next frontier of quantum acoustics where sound particles one tenth of a second long (or less) coalesce, disintegrate and morph into other audio textures. By stretching the boundaries between time scales and frequency intensities, Curtis has woven a curious density of unpredictable shapes and sensations that evoked separate modes of continuity.

Distinction
Aeron Bergman / Alejandra Salinas / Lucky Kitchen: Revisionland + The Tale of Pip

Lucky Kitchen's Revisionland, which the jury felt was the catalyst for the other Distinction award submitted by the Spain-based duo of Alejandra Salinas / Aeron Bergman, was the CD realization of an installation piece. Invited to install a work in a gallery space in Stirling, Scotland, the most historically resonant site in that country's long and bloody struggle to gain independence from its English neighbors, the duo used, as part of the conceptual underpinning for the piece, episodes from Scottish pre-history, specifically, the names and characteristics of some of the strange monsters and beings that reside in the country's mythology, legend and folklore.
This attention to site-specific history when preparing an installation piece marked Lucky Kitchen's work out from many other entries that fell into the category of "sound art," and which seemed to take little account of the specifics of the spaces in which they were to be presented. Crucially the duo's manipulation of their sonic material was also sensitive and provocative, utilizing digital synthesis to organize their lo-fi tape works and field recordings into a resonant piece that functioned as both an archiving project and a process of renewal for customs and beliefs long forgotten. Whether issued on CD or presented via an installation piece, Revisionland struck the jury as a uniquely evocative endeavor in digital-music.
Also remarkable for its intimacy and narrative intrigue is their other submission, The Tale of Pip. This unfolds as a type of fairy tale illustrated by a CD booklet that depicts the eccentric story of Pip's search for the happiness tree. The supporting soundscapes combine a myriad of found sounds from outside environments along with the acoustical instrumentation from harmonica's,

accordions and the like which are digitally processed to evoke the mood and atmosphere of the story. These grainy audio artifacts digitally blur together analog components whose mystery seemed to linger.

Honorary Mentions
Stephan Wittwer: *Streams*

Stephan Wittwer has long been a vital, albeit under-recognized, force at the intersection of avant-garde jazz, free improvisation and post-Hendrix guitar freak-outs. His *Streams* CD was a riveting example of the way many musicians with backgrounds in improvised music and jazz are now using digital processing to provide new frameworks and contexts for their art. Witter's multi-layered and abstracted sound environments, his processing, and folding in, of his own detuned or feedback guitar, felt fresh, complex and devoid of cliché. Most often, the linearity of the underlying improvisation was left intact during his process and the gestural information was very vivid. Wittwer has developed a new musical connection that doesn't sound like what one expects from him and which expresses a lot of what he has been working on in the last number of years. Instead, a density and duration that one knows from his hardest productions, but with a lot of trace elements and embedded crystals—references to his early explorations. Feeding from differing sources, *Streams* has the character of a great, multifarious shimmering river.

Raz Mesinai (Badawi): *Soldier of Midian*

The source material for Raz Mesinai's *Soldier Of Midian* consists of recordings of Mesinai playing traditional Middle Eastern instruments such as darabuka, bendir and zarb, which he then processes into fierce, perpetual pieces which bring to mind the rhythmic frenzies of whirling dervishes. Compared to so many digitally mediated ethno-exotic fusions, Mesinai's Middle Eastern chamber dub cum Mizrahi bus station pop sounds raw and bloody rather than overcooked in the oven of a culturally imperialist hard drive.
In the current political climate, this Israeli-American musician's violent and compulsive admix of sound sources from across the Middle East bespeaks a remarkably utopian metaphor, because of how its classically Occidental cultural fusion suggests a future where, Jewish and Muslim cultures exist in literal harmony with one another. Mesinai's pseudonym "Badawi", Arabic for "Bedouin," already recommends as much.

Wegen der Intimität und narrativen Verunsicherung, die sie erzeugt, ist auch ihre andere Einreichung *The Tale of Pip* bemerkenswert. Diese entwickelt sich als eine Art Märchen, illustriert im CD-Begleitheft, und erzählt die exzentrische Geschichte von Pips Suche nach dem Baum der Glückseligkeit. Die zugehörigen Klanglandschaften kombinieren Abertausende von gefundenen Umweltklängen mit einer akustischen Instrumentation durch Harmonikas, Akkordeons und dergleichen, die digital bearbeitet wurden, um die Stimmung und Atmosphäre der Geschichte wiederzugeben. Diese körnigen Audio-Artefakte verwischen sozusagen die analogen Komponenten digital, wobei aber das Geheimnisvolle daran erhalten bleibt.

Anerkennungen
Stephan Wittwer: *Streams*

Der schweizerische Gitarrist Stephan Wittwer ist seit langem eine – leider unterbewertete – Kraftgestalt am Schnittpunkt zwischen Avantgarde-Jazz, freier Improvisation und den Post-Hendrix'schen Gitarren-Freak-outs. Seine CD *Streams* war ein fesselndes Beispiel für die Art und Weise, in der viele Musiker, die aus der Improvisation und dem Jazz kommen, jetzt digitale Bearbeitung und Modulation einsetzen, um für ihre Kunst neue Zusammenhänge zu schaffen. Wittwers vielschichtige und abstrakte Klang-Environments, seine Ein- und Verarbeitung der eigenen verstimmten oder rückgekoppelten Gitarre erwiesen sich als frisch, komplex und klischeefrei. In den meisten Fällen blieb die Linearität der zugrunde liegenden Improvisation erhalten und die gestische Information äußerst lebhaft.
Wittwer hat eine neue musikalische Verbindung geknüpft, die nicht so klingt wie das, was man von ihm erwartet, und die eine Menge von dem ausdrückt, woran er in den letzten Jahren gearbeitet hat. Er bietet uns zwar die Dichte und Dauer, die man von seinen härtesten Produktionen kennt, aber garniert sie mit einer Menge von Spurenelementen und eingebetteten Kristallen – Bezüge auf frühere Forschungen. Gespeist aus unterschiedlichen Quellen hat *Streams* alle Qualitäten eines großen, vielfältigen, schimmernden Stroms.

Raz Mesinai (Badawi): *Soldier of Midian*

Das Ausgangsmaterial für Raz Mesinais *Soldier of Midian* besteht in Aufnahmen, auf denen Mesinai traditionelle nahöstliche Instrumente wie Darabuka, Bendir und Zarb spielt, die zu wilden, ausdauernden Stücken verarbeitet werden, die einen an die rhythmischen Verzückung der tanzenden Derwische erinnern. Verglichen mit so vielen digital vermittelten ethno-exotischen Fusions klingt Mesinais nahöstlicher Kammer-Dub plus Mizrahi-Busbahnhof-Pop eher roh und blutig als zu lange im Ofen einer kulturell imperialistischen Festplatte gedünstet ...

Im gegenwärtigen politischen Klima beschwört dieses vom israelisch-amerikanischen Künstler geschaffene gewalttätige, beeindruckende Gemisch diverser nahöstlicher Klangquellen eine bemerkenswert utopische Metapher herauf, weil seine klassisch-abendländische Fusion eine Zukunft suggeriert, in der jüdische und muslimische Kulturen im Wortsinne harmonisch miteinander leben. Mesinais Pseudonym „Badawi" – arabisch für „Beduine" – zeigt ja auch in diese Richtung.

Marina Rosenfeld: *Delusional Situation*

Mesinai ist mit der New-Yorker Komponistin und Klangkünstlerin Marina Rosenfeld verheiratet, deren Einreichung *Delusional Situation* auch bei der heurigen Whitney Biennale in New York vertreten war. Ausgelegt für Play-back auf einem Mehrkanal-DVD-Audiosystem setzt das Stück das Multi-Speaker-System mit großem Erfolg ein. Die Elemente der Musik – viel davon entstammt Aufnahmen von Rosenfelds Sheer Frost Orchestra – waren unruhig und bewegten sich rund um das Klangfeld, um ein gleichsam mit Querschlägern gespicktes Audio-Drama zu entfalten.

Das Stück bezieht sich auf das Gedicht „Ich kenne dich" von Paul Celan und verwendet Samples von Gitarren-Licks, die auf Vinyl abgemischt und anschließend mit ProTools wieder zusammengesetzt wurden. Rosenfeld sagt, dass ihr Stück – ähnlich wie das Celan-Gedicht, in dem es um Wirklichkeit und Illusion geht – zu erklären versucht, dass der Ort des Hörens auf dieser Welt niemals etwas Feststehendes ist und auch das Gehörte keineswegs klar kommuniziert wird. *Delusional Situation* – keineswegs nur ein Stück über die Bedeutung des Hörens – hinterfragt auf kraftvolle Weise, wie Menschen die konstruierte Wirklichkeit des Klanges erleben.

Francisco López: *Buildings [New York]*

Buildings [New York] des spanischen Komponisten Francisco López besteht aus reinen, unbearbeiteten O-Tönen, aufgenommen in den Kellern und Eingeweiden New-Yorker Wohnblocks und Wolkenkratzer, die die mysteriösen Klänge der verborgenen Verkabelung einer Stadt einfangen, ihrer unterirdischen Heizungssysteme, Rohrleitungen, Motoren und Generatoren. Zunächst erscheint die „Musik" als ein undifferenziertes „Drone"-Werk, aber näheres Hinhören enthüllte mehrfache Ebenen von mikrokosmischem Klang, die sich im Grenzbereich des Hörbaren entfalten und das Stück zu einer höchst erfolgreichen Episode in López' Dauerprojekt der Präsentation dieser Welt als ihrem eigenen höchst leistungsfähigen Breitband-Klang- und Geräusch-Generator macht. Eine Tour-de-Force des genauen Hinhörens, wobei jeder Hörer sich der eigenen Freiheit stellen und somit selbst schöpferisch tätig sein muss.

Marina Rosenfeld: *Delusional Situation*

Mesinai is married to the New York sound artist Marina Rosenfeld, whose entry, *Delusional Situation*, was included in this year's Whitney Biennial in New York. Designed for playback on a multichannel DVD Audio system, the piece utilized the multi-speaker system to great effect. The elements of the music, much of it sourced from recordings of Rosenfeld's Sheer Frost Orchestra, were agitated and moved around the sound field to create a ricochet-like audio-drama.

Named after the Paul Celan poem *Delusional Situation*, Rosenfeld's piece uses samples of guitar licks remixed on vinyl, and then reassembled in Pro Tools. According to Rosenfeld, like the Celan poem, which explains how the world of experience can be interpreted both as reality and illusion, Rosenfeld's piece attempts to explain how a listener's place in the world is neither fixed, nor what they hear communicated clear. Not just a piece about the meaning of listening, *Delusional Situation* forcefully interrogates how people inhabit the constructed realities of sound.

Francisco López: *Buildings [New York]*

Spanish composer Francisco López's *Buildings [New York]* consisted of pure, unprocessed location recordings made in the dank basements and cellars of New York's tenement buildings and skyscrapers, capturing the mysterious sounds of a city's hidden wiring, its subterranean heating systems, pipework, motors and generators. On one level the "music" emerged as an undifferentiated drone-work, but deeper listening revealed multiple layers of microcosmic sound events unfolding at the threshold of audibility, making the piece feel like a highly successful episode in López's ongoing project to reveal the world as its own, most potent broadband sound and noise generator. A tour de force of profound listening in which every listener has to face his/her own freedom and thus create.

Mika Taanila: *Fysikaalinen Rengas*

Fysikaalinen Rengas ("A Physical Ring") by the Finnish artist Mika Taanila was the only installation work to get in among the honorary mentions. The entry consisted of a video containing grainy, monochrome images (which repeated in a three minute loop) of a construction of multiple and overlapping spinning wheels. The work's soundtrack was provided by Mikka Vainio, a member of the Finnish electronic minimalist duo Pan

Sonic. Simple, original and effective, the visual element of the piece holds a hypnotic fascination, which is perfectly echoed by the minimal pulse pattern score.

Carl Michael von Hausswolff: *A Lecture on Disturbances in Architecture*

Carl Michael von Hausswolff's *A Lecture on Disturbances in Architecture* (Firework Ed. Records, Stockholm, 2002) has the form of a lecture on the effects of frequencies in buildings like the home. The recording suggests a couple of domestically oriented problems. Hausswolff's work does not look upon these situations from a theoretical side, but rather, from an associative one. The composer's wish is that this piece may inspire architects to take an interest in realizing the importance our audio environment. This unique position strongly underscores the wide range of different positions in this year's entries. At the same time, it also demonstrates how difficult it has always been to categorize Hausswolff's remarkably interdisciplinary work as an artist, editor and curator.

Russell Haswell: *Live Salvage 1997–2000*

Audio presentations made outside the studio by Russell Haswell demanded our attention. There are no compromises here. With breathtaking CD production and severe live action, Russell literally rocks it. Punching salvos of sound reflect on his audio whereabouts at the end of the last decade which were documented on *Live Salvage 1997-2000*. How this project was assembled and provoked added to its immediate impact and force of sheer will. Also noted for his collaborations with Merzbow, Yasunao Tone, etc., Russell creates a highly personalized sonic world distinct from his contemporaries.

Iancu Dumitrescu: *Oiseaux Célestes II*
Ana-Maria Avram: *Traces Sillons Sillages II*

For the majority of the panel, the discovery of Iancu Dumitrescu and Ana-Maria Avram was an incomparable one. Their spectral range of timbral colors seemed arresting, multi-structural and parodoxically cruel, even irritating to the uninitiated ear. Both works bear a negation of practically everything in modern music symptomatic of distraction, of banalization, and of an excessive loss of purpose. Indeed, their collaborative work is truly alienated. Dumitrescu and Avram's work is an unusual brand of unschooled and exploded

Mika Taanila: *Fysikaalinen Rengas*

Fysikaalinen Rengas („Ein physikalischer Ring") des finnischen Künstlers Mika Taanila war die einzige Installationsarbeit, die es bis in die Anerkennungen geschafft hat. Die Einreichung bestand aus einem Video mit körnigen Schwarz-Weiß-Bildern in einer dreiminütigen Schleife, das eine Konstruktion aus zahlreichen sich drehenden und überlagernden Rädern zeigte. Der Soundtrack wurde von Mikka Vainio, einem Mitglied des finnischen Minimalismus-Duos Pan Sonic beigesteuert. Das einfache und originelle, aber sehr eindringliche visuelle Element des Stücks ist von einer hypnotisierenden Faszination, die perfekt von der minimalistischen Pulse-Pattern-Partitur mitgetragen wird.

Carl Michael von Hausswolff: *A Lecture on Disturbances in Architecture*

Carl Michael von Hausswolffs A *Lecture on Disturbances in Architecture* (Firework Ed. Records, Stockholm 2002) präsentiert sich in Form eines Vortrags über Frequenzen in Wohngebäuden. Die Aufnahme stellt einige haus-haltsorientierte Probleme vor, wobei Hausswolff diese Situation nicht von einem theoretischen Standpunkt aus betrachtet, sondern von einem assoziativen. Der Komponist wünscht sich, dass das Stück Architekten dazu veranlasst, mehr Interesse für die Bedeutung unserer auditiven Umgebung aufzubringen. Diese einzigartige Sicht der Dinge unterstreicht die große Bandbreite der Einreichungen dieses Jahres, demons-triert aber gleichzeitig auch, wie schwer es seit jeher ist, Hausswolffs bemerkenswert interdisziplinäres Werk als Künstler, Herausgeber und Kurator in eine Schublade zu pressen.

Russell Haswell: *Live Salvage 1997 – 2000*

Auch die außerhalb eines Studios entstandenen Audio-Präsentationen von Russell Haswell verlangten unsere Beachtung. Hier gibt es keine Kompromisse. Bei dieser atemberaubenden CD-Produktion und heftigen Live-Action kann man nur sagen, bei Russell geht es zur Sache. Knallende Salven von Klang reflektieren seine Positionen im Audio-Bereich am Ende des letzten Jahrzehnts und werden auf *Live Salvage 1997 – 2000* dokumentiert. Wie dieses Projekt überhaupt ausgelöst und zusammengesetzt wurde, unterstreicht seine Unmittelbarkeit und die nackte Willenskraft dahinter. Russell, der auch für Kooperationen mit Merzbow, Yasunao Tone und anderen bekannt ist, schafft hier eine höchst persönliche Klangwelt, die sich von jenen seiner Zeitgenossen abhebt.

Iancu Dumitrescu: *Oiseaux Célestes II*
Ana-Maria Avram: *Traces Sillons Sillages II*

Für die Mehrheit der Juroren war die Entdeckung von Iancu Dumitrescu und Ana-Maria Avram ein unvergleichliches Ereignis. Ihre spektrale Breite von Klangfarben und Timbres erschien fesselnd, strukturreich und auf paradoxe Weise roh, ja, für ungeübte Hörer sogar irritierend. Beide Werke negieren fast alles, was in der modernen Musik für Ablenkung, Banalisierung und den exzessiven Verlust des Zwecks symptomatisch ist. Ihre gemeinsame Arbeit ist wahrlich „ent-fremdet". Dumitrescus und Avrams Werk bietet eine ungewöhnliche Sorte von unverschultem und explodierendem Klang – keine neue Schlinge im Knoten der zeitgenössischen Musik, vielmehr ein Abwickeln ihres Fluchs. Und das ist jedenfalls nicht (nur) eine Frage ihrer Philosophie und künstlerischen Motivation. Die psychologisch-akustischen Wirklichkeiten, die sie porträtieren, sind fest in einer klaren Konzeption verwurzelt und erfrischend in ihrer Einfachheit und emotionalen Eindringlichkeit.

Goodiepal: *Narc Beacon*

Bis wir dazu kamen, uns auch Goodiepal anzuhören, waren unsere Köpfe bereits überflutet von den wunderbaren und facettenreichen Produkten sämtlicher internationaler elektronischer Bereiche. Glaubten wir jedenfalls. Hier aber fand sich etwas recht Musikalisches, das nicht in die Schublade der typischen experimentellen Laptop-Klänge oder IDM fiel, sondern einen ganz eigentümlichen Charakter aufwies. Diese Aufnahmen sprechen vom Leben, und zwar nicht als einfachem Scherz. Unglücklicherweise weiß man nicht, wovon Goodiepal spricht, wenn man nicht mit ihm befreundet ist, wohl aber kann man es fühlen. Es gibt so viele Leute dort draußen, die langweilige Arbeiten produzieren, und dennoch ist das Publikum noch immer „geschockt" oder „erstaunt" von dem, was es zu hören bekommt. Und wenn dann einer daherkommt und still und heimlich ein *wirklich* seltsames Werk produziert, dann wird es meistens übersehen. „Seine Musik ist wie die Erklärung seiner Musik: ein wenig kurz, ein wenig lose, voller kleiner Klänge, witzig (auf eine Weise, wie sie nur jemand sein kann, der nicht witzig zu sein braucht) und kleine Bezüge auf Dinge, die nur ihm bekannt sind. Ein paar Augenblicke lang weiß ich genau, wovon er spricht – und dann ist es auch schon vorbei."
(Alejandra Salinas auf der Lucky-Kitchen-Website)

Phoenicia: *Brownout*

Es gibt nur wenige Gruppen, die die motivischen Gemeinplätze urbaner Straßenmusik und künstlerische Raffinesse miteinander verbinden, aber diese in Miami

sound. It is not a new convolution in the knot of contemporary music, but an unraveling of the curse. This is not, however, simply a matter of their philosophy and motivation as artists. The psychological acoustic realities that they portray are directly grounded in a straightforward conception, which is refreshing in its simplicity and emotional impact.

Goodiepal: *Narc Beacon*

By the time we got around to give Goodiepal a listen, our heads were inundated by the prodigious and multifaceted output of every international electronic sector. Or so we thought. Here was something quite musical that didn't fall into the typical experimental laptop noise or IDM zones, but contained a peculiar character all of its own. These records talk about life, bypassing a mere joke. But unfortunately you cannot know what he is talking about unless you are his friend. (Although you can feel it!) There are so many people out there that do boring work, yet people continue to be "shocked" and "amazed" by what they hear. And when someone comes along and quietly makes some really strange work, it is mostly overlooked. "His music is like his explanations of his music: a bit short, a bit loose, full of small sounds, funny (in the way that someone that does not need to be funny can be) and small references to things only he knows about. And for a few brief seconds I know exactly what he is talking about, and then they are gone." *(Alejandra Salinas, from the Lucky Kitchen website)*

Phoenicia: *Brownout*

There are very few groups that combine commonplace motifs of urban street music and artistic sophistication, but this Miami-based group does it with a uniqueness and flare that has already established them as canonical artists within the American IDM community. Moving from the Miami Bass-inspired overdrive to free electronic improv, these label owners (Schematic) and former Astralwerks vets have amassed an impressive catalogue of sounds, whose ever in flux experimentation with the subtle and the in your face make it abundantly clear they will exert a severe influence on like-minded artists and juries like Prix Ars Electronica for years to come.

Anticon: *We Ain't Fessin'*

So what's this bizarre crew of eclectic bedroom beat wizards doing on this list of Prix Ars Electronica

hopefuls when according to hip hop's old guard "This shit ain't even hip hop"—or is it?

Well, our panel felt the assemblage of lo fi textures, words and pulses fitted into a whole other universe quite alluringly different than the standard submission music fare. The name "Anticon" (anti-conformity, anti-icon) stands for a loose collective of DJ's, MC's and tone wiggers who embodies all of the irreverent contradictions which both sustain, complicate and twist this cultural movement. Scattered throughout some of North America's less glamorous locales these unlikely cohorts finally converged into the hyperbole and obfuscation of Oakland California's back roads in 1999. Since then Sole, Dose, Alias, JEL, Why?, Odd Nosdom, DJ Mayonnaise, the pedestrian, passage, Sage Francis and a slew of other significant affiliates have released dozens of notorious albums and online tracks. Their murky, analog attack on an abused digital domain is something to behold. *(The Jury)*

pxp

The sudden jolt of *pxp* peeled open all collected ears. Here was a jutting mass of digitized disturbance that fueled our direct reckoning with destabilized mathematics. Think of equations which create anarchy instead of assert order, and you've only begun to approximate the experience of what it's like to listen to *pxp*. As these unrelenting punctualities seemed to progress, it's divergence from pxp's Farmers Manual-like alignments seemed malignant. Spam data malformations. Direct waveform bitstream. Seizure. Disengage. Smitten.

beheimatete Gruppe schafft das mit einer Einzigartigkeit und Bravur, die sie zu Recht innerhalb der amerikanischen IDM-Gemeinschaft etabliert und kanonisiert hat. Die sich vom Miami Bass-inspirierten Overdrive hin zum freien elektronischen Improv bewegenden Label-Eigner (Schematic) und Astralwerk-Veteranen haben einen beeindruckenden Katalog von Klängen zusammengetragen, dessen immer im Fluss befindliche Experimente mit dem Subtilen und dem Offensichtlichen hinreichend klarstellen, dass sie auch in zukünftigen Jahren einen nicht zu unterschätzenden Einfluss auf ähnlich gesinnte Künstler und Juries wie jene des Prix Ars Electronica ausüben werden.

Anticon: *We Ain´t Fessin'*

Was macht diese bizarre Crew eklektischer Bedroom-Beat-Zauberer auf dieser Liste der Prix-Ars-Electronica-Hoffnungsträger, wenn doch laut der alten Garde des Hip-Hop „...dieser Scheiß nicht einmal Hip-Hop ist" – oder doch?

Nun, die Juroren waren einig in der Ansicht, dass diese Assemblage von Lo-Fi-Texturen, Worten und Pulsen in ein gänzlich anderes Universum passt, das sich erfrischend abhebt vom üblichen eingereichten musikalischen Einheitsbrei. Der Name „Anticon" (Anti-Konformität, Anti-Ikone ...) steht für ein loses Kollektiv von DJs, MCs und Tonverdrehern, das jene respektlosen Widersprüche einschließt, die diese kulturelle Bewegung ebenso aufrechterhalten wie komplizieren und verdrehen. Zunächst über einige der weniger glamourösen Lokalitäten Nordamerikas verteilt, hat sich diese zweifelhafte Kohorte 1999 in der konfusen Exaltiertheit der Seitenstraßen des kalifornischen Oakland zusammengefunden. Seit damals haben Sole, Dose, Alias, JEL, Why?, Odd Nosdom, DJ Mayonnaise, the pedestrian, passage, Sage Francis und ein Haufen weiterer signifikanter Compagnons Dutzende von berüchtigten Alben und Online-Tracks herausgebracht. „Ihre düsteren analogen Attacken auf eine oft missbrauchte digitale Domäne muss man einfach erlebt haben." *(Die Jury)*

pxp

Der plötzliche Schock von *pxp* hat allen Versammelten
die Ohren aufgerissen. Hier war eine hervorstechende
Masse digitalisierter Störungen, die unser direktes
Denken mit destabilisierter Mathematik gefüttert hat.
Man stelle sich ein Gleichungssystem vor, das an Stelle
von Ordnung nur Anarchie schafft – und selbst das ist
nur ein blasser Abklatsch dessen, was die Hörerfahrung
von *pxp* mit sich bringt. In dem Maße, in dem die nie
nachlassende Punktbezogenheit voranschritt, wurde
ihre Abweichung von pxp's Farmers-Manual-ähnlicher
Ausrichtung immer bösartiger. Spam-Daten-Missbildun-
gen. Direkte Waveform-Bitreams. Fesselung. Lösung.
Beunruhigend.

Man'yo Wounded 2001
Yasunao Tone

Yasunao Tone, who co-founded the group Ongaku in 1960, devoted to creating events and improvisational music, began participating in the Fluxus movement in 1962. His first concert, "One Man Show by a Composer", was held at the Minami Gallery in Tokyo in 1962. In the years that followed, Tone became an organizer as well as contributor to various avant-garde groups. His activities encompassed happenings, sound installation, experimental music, performance and art and technology. Since coming to the United States in 1972, Tone has composed for scores, which utilize texts and visual image, as well as sound for the Merce Cunningham Dance Company,

Yasuano Tone, 1960 Mitbegründer der Gruppe Ongaku, widmet sich der Schaffung von „Event-" und improvisierter Musik und begann 1962 in der Fluxus-Bewegung mitzuarbeiten. Sein erstes Konzert, „One Mans Show by a Composer", fand 1962 in der Minami-Galerie in Tokio statt. In den nächsten Jahren entwickelte sich Tone zum Organisator ebenso wie zum Mitwirkenden zahlreicher Avantgarde-Gruppen. Zu seinen Aktivitäten gehörten Happenings, Klanginstallationen, experimentelle Musik, Performances sowie Kunst und Technologie. Seit seiner Übersiedlung in die USA (1972) komponiert Tone Partituren, die Text und visuelle Bilder umfassen, ebenso wie Klänge für die Merce Cunningham Dance Company und für Solokonzerte in The Kitchen,

Experimental Intermedia Foundation, Roulette, P.S.1, im Guggenheim Museum SOHO und im Chicago Art Klub.

Seit 1976 gestaltet Tone musikalische Kompositionen, die von der post-strukturalistischen Theorie inspiriert werden. Durch die Verwendung von Klangmaterial, das umgewandelten Bildern entstammt, versucht Tone eine Alternative zur traditionellen Technik der Klang-generierung zu schaffen, wie sie in älteren Formen elektronischer Musik verwendet wird und nach Tone voraussetzt, dass der Komponist bereits vor der Ver-arbeitung der Signalwellen weiß, was er zu erwarten hat. „Das einzige Ziel der Umwandlung von Bild in Klang", stellt er fest, „ist die Erzeugung von Klängen, die ich nie zuvor gehört habe." Um dies zu erreichen, verwendet Tone Zeichen, die von altchinesischen Texten – etwa von Gedichten aus der Tang-Dynastie – und japanischer Dichtung des 8. Jahrhunderts abge-leitet wurden.

Tones Beschreibung von *Molecular Music* (Mai 1982) ist ein gutes Beispiel. Durch Verwendung eines Klang-generators, der über Lichtsensoren mit einer Filmlein-wand verbunden ist, und von Oszillatoren, die von diesen Sensoren abhängen, erzeugt der auf die Leinwand projizierte Film verschiedene Klänge, je nach dem je-weiligen Arrangement der Sensoren und der Helligkeit der projizierten Bilder. Die projizierte Filmkomponente bestimmt sowohl Timbre und Tonhöhe als auch die rhythmische Struktur des Stücks. Da der Inhalt des Films eine visuelle Umsetzung alter chinesischer und japanischer Gedichte ist, wird die rhythmische Struktur auch unmittelbar von den zusätzlich laut vorgelesenen Texten abgeleitet, mit anderen Worten, die Originaltexte strukturieren den generierten Klang.

Tones Methode, die im Performance-Stück *Voice and Phenomena* (1976), in *Musica Iconlogos* (1992) und in seinem gegenwärtigen Work-in-Progress *Musica Simulacra* weiter ausgebaut wird, basiert auf intimer Kenntnis und Verständnis des chinesischen Schrift-tums. Die ältesten chinesischen Schriften sind im Wesentlichen als Piktogramme aufgebaut, sie stellen

and for performing solo concerts at the Kitchen, Experimental Intermedia Foundation, Roulette, P.S.1, Guggenheim Museum SOHO, and the Chicago Art Club.

Since 1976, Tone has designed musical com-positions inspired by post-structuralist theory. Using source material based on sounds converted from images, Tone's goal is to create an alternative to the traditional technique of sound generation employed by older forms of electronic music, which according to Tone, presuppose that the composer already knows before they process sign waves. "The one aim of the conversion of image into sound," he states, "is to obtain sound I've never heard before." In order to achieve this task, Tone utilizes characters derived from ancient text written in Chinese characters such as poems from the Tang Dynasty as well as 8th century Japanese poetry.

Tone's description of his 1982-5 piece *Molecular Music* is a good example. Using a sound generating system which includes light sensors attached to a film screen, and oscillators connected to light sensors, the film projected on the screen creates varying sounds in accordance with the specific arrangement of the sensors and the changing brightness of the projected images. The film component when projected determines the timbres, pitches, and rhythmic structure of the piece. Since the content of the film is a visual translation of ancient Chinese and Japanese poems, the rhythmic structure of the film is also derived from the original texts as read aloud; thus, the original texts structure the generated sound.

Tone's methodology, further explored in the 1976 performance piece *Voice and Phenomena*, 1992's *Musica Iconlogos*, and his current work in progress, *Musica Simulacra*, is based on an intimate understanding of Chinese writing. The oldest Chinese writing was generally pictographic; it

represented objects in a schematic, stylised, and conventional manner. Later, their writing system developed to a compound of more than two signs. Therefore, one can reduce or decode one character into a set of few images. To get the visual essence of the character without meaning and sound, Tone gives the following example: "The oldest Chinese writing represented objects— plants, animal, body movements. For instance, *ji* (in Chinese, 'self') in a modern form, from which we can't see any realistic resemblance. But, if you see the old form then, it looks exactly like a simplified depiction of a nose. Another example, old form of *wo* (in Chinese, first person "I") depicts a saw, because the character was borrowed from homophonic word for a saw."

In order to create sound sources for this piece, Tone replaced the character *ji* and *wo* with a photo of human nose and a photo of a saw. To create sound from the collected images, they are scanned and interpreted by a computer as large arrays of pixels. Then, using an optical music recognition program that counts each array of the pixels both horizontally and vertically, Tone produces a histogram. These histograms are then converted to sound files by the sound-generating program "Projector," which allows the computer application Sound Designer II to produce stereo files, using data accumulated by horizontal projection.

Since these sounds are as short as only 20 to 30 milliseconds, Tone expanded them to appropriate lengths by the use of various DSP technologies. With this huge sound file-Chinese character dictionary, Yasunao Tone produces sound pieces with a computer program, including code tables that draw entirely upon an original poetic text. The content is coded in its entirety, and the arrangement of codes is totally faithful to the manuscript's original structure. Since 1985's performance piece *Music for 2 CD Players*,

Objekte in schematischer, stilisierter Weise dar. Später entwickelte sich das Schriftsystem zu Kombinationen von mehr als zwei Zeichen. Dadurch aber kann auch ein Zeichen in ein Set aus wenigen Bildern aufgelöst oder reduziert werden. Wie man die visuelle Essenz des Zeichens ohne seine Bedeutung und ohne Klang bekommt, erläutert Tone so: „Die ältesten chinesischen Schriftzeichen stellten Objekte dar – Pflanzen, Tiere, Körperbewegungen. Sieht man das moderne *ji* (chinesisch für ‚selbst') an, so erkennt man keine realistische Ähnlichkeit. Betrachtet man aber die alte Form, so sieht es ganz wie eine vereinfachte Darstellung einer Nase aus. Ein anderes Beispiel ist die alte Form von *wo* (chinesisch für ‚ich'), die eine Säge darstellt, weil das Zeichen eben vom gleich klingenden Wort für ‚Säge' entlehnt wurde."

Um Klangquellen für dieses Stück zu kreieren, hat Tone die Zeichen *ji* und *wo* durch Fotos einer Nase und einer Säge ersetzt. Zur Erzeugung des eigentlichen Klangs werden die Bilder gescannt und vom Computer als große Arrays einzelner Pixel interpretiert. Mithilfe eines optischen Musik-Erkennungsprogramms, das diese Pixelgruppen horizontal und vertikal abzählt, produziert Tone ein Histogramm. Diese Histogramme wiederum werden über das Klanggenerierungs-Programm „Projector" in Klang-Daten umgewandelt, aus denen Sound Designer II Stereo-Dateien unter Verwendung der durch horizontale Projektion gesammelten Daten erstellt.

Da diese Klänge nur 20 oder 30 Millisekunden lang sind hat Tone sie mit diversen digitalen Klangbearbeitungs-Techniken auf geeignete Länge gestreckt. Aus dem so entstandenen riesigen „Wörterbuch Chinesisch/Klang" produziert Yasunao Tone Klangwerke mithilfe eines Computerprogramms, zu dem Code-Tabellen gehören, die selbst wieder ausschließlich aus einem Original-Text gespeist werden. Dessen Inhalt wird zur Gänze codiert und das Arrangement der Codes folgt zeichengetreu der Struktur des Originalmanuskripts.

Seit dem Performance-Stück *Music for 2 CD Players* verwendet Tone auch einen zweiten Produktionsschritt,

den er „Wounded" nennt. Im Begleitheft zu *Solo For Wounded CD* beschreibt er den Prozess des „Verwundens" von Compact Disks: „Ich habe mich gefragt, ob man wohl das Fehlerkorrektursystem überlisten könnte. Falls ja, könnte ich aus einer bestehenden CD völlig neue Musik herausholen. Ich habe einen audiophilen Freund angerufen, der einen Schweizer CD-Player hatte, und ihn gefragt. Ich habe daraufhin eine CD von Debussys *Préludes* gekauft und sie zu ihm gebracht. Wir haben einfach jede Menge Nadellöcher in ein Stück Klebeband gebohrt und dieses unten auf die CD geklebt. Es hat funktioniert ... Zu meiner Überraschung hat die präparierte CD selten den gleichen Klang wiederholt, wenn ich sie nochmals abgespielt habe, und sie war sehr schwer zu steuern."

(alle Zitate aus: Yasunao Tone, *Solo For Wounded CD*, Begleitheft, Tzadik, New York 1977.)

Tone has been employing a second production step, a process he calls "Wounded." In the liner notes for his album, *Solo for Wounded CD* – he describes this process in terms of "wounding" compact discs: "I wondered if it was possible to override the error-correcting system; if so, I could make totally new music out of a 'ready-made' CD. I called my audiophile friend who owned a Swiss-made CD player and asked about it. I bought a copy of Debussy's *Préludes* and brought it to my friend's place. We simply made many pinholes on a bit of Scotch tape and stuck it on the bottom of a CD. It worked. ... To my pleasant surprise the prepared CD seldom repeated the same sound when I played it back again, and it was very hard to control.(1)

(1) Yasunao Tone, *Solo for Wounded CD*, CD booklet liner notes, Tzadik, New York, 1997

Yasunao Tone (J) was born in Tokyo in 1935 and moved to New York in 1972. A composer with roots in the Fluxus movement, Tone was a member of Japan's first computer art group, Team Random. Tone's recorded works include *Musica Iconlogos* (Lovely Music) and *Solo For Wounded CD* (Tzadik). **Yasuano Tone (J)** wurde 1935 in Tokio geboren und übersiedelte 1972 nach New York. Der Komponist mit Wurzeln in der Fluxus-Bewegung war Mitglied der ersten japanischen Computerkunst-Gruppe „Team Random". Zu seinen veröffentlichten Werken gehören u.a. *Musica Iconlogos* (Lovely Music) und *Solo For Wounded CD* (Tzadik).

The Tale of Pip / Revisionland

Aeron Bergman / Alejandra Salinas / Lucky Kitchen

Pip is a little elf bastard. This tale is originally a book read to children, which just doesn't seem right. So, we physically cut out the words and rewrote the book. Soon, we had a story with a life of its own. Next, we thought this tale should not only be a book, it should be told through sound, in the same way parents communicate to their kids. But this tale should also be illustrated with a story-like audio composition. This composition should include acoustic and digital movements that blend to such a degree that they cancel each other out, becoming a third audio state: organic digital. It works as "music", and also as the illustration for imagining the events of the tale. The book, hand printed at Extrapool on a Stencil Printing Press, bound using a Communist East German bookbinding sewing machine, and hand glued using a brush, is a further statement towards pushing "digital" up and down and into an area of Benjamin's "aura".

The composition and technique of both the book itself and the CD stem from our wish to combine old and new ideas into a comprehensible whole. That is, the process takes a conceptual beginning, uses formal printing/computer audio techniques

Pip ist ein kleiner Elfenmischling, und das „Märchen von Pip" ist eigentlich als Vorlesebuch für Kinder gedacht, was uns aber irgendwie nicht richtig erschien. Deswegen haben wir die Wörter physisch ausgeschnitten und das Buch umgeschrieben, und bald hatten wir eine Geschichte mit Eigenleben. Als nächstes meinten wir, diese Erzählung sollte nicht nur ein Buch sein, sie sollte vielmehr über den Klang erzählt werden, auf die gleiche Weise, wie Eltern mit ihren Kinder kommunizieren. Und gleichzeitig sollte dieses Märchen mit einer geschichtenähnlichen Audio-Komposition illustriert werden. Diese Komposition sollte akustische und digitale Bewegungen enthalten, die einander auslöschen und so zu einem dritten auditiven Zustand werden: organisch-digital. Dies wirkt und funktioniert einerseits als Musik, andererseits als Illustration, damit man sich die Vorgänge des Märchens besser vorstellen kann. Das Buch – handgedruckt bei Extrapool auf einer Matrizendruckpresse, gebunden mit einer Fadenheftmaschine aus der ehemaligen DDR, handgeleimt mit Hilfe eines Pinsels – ist ein weiteres Statement in Richtung auf eine Verschiebung von „digital" hinauf und hinunter und in das Gebiet von Walter Benjamins „Aura". Komposition und Technik sowohl des Buches als auch der CD entspringen unserem Wunsch, alte und neue

Ideen in ein verständliches Ganzes zu vereinen, das heißt, der Prozess beginnt konzeptuell, verwendet formale Druck- bzw. Computer-Audio-Techniken, um die eigentlichen Details zu unterfüttern, und letztlich ist die Präsentation ein hybrider Zustand aus Audio, Text, Collage und Imagination bestehend aus Computer, Fantasy, wirklichem Leben und einer völligen Lüge – wie eben jede zeitgenössische Erzählung sein sollte.

Revisionland und seine verwandten Audio-Arbeiten Scotch Monsters

Das Revisionland-Projekt setzt sich schichtweise aus zahlreichen Ideen zusammen, die sich gegenseitig ziehen und schieben. Die erste war jene eines englischen Gartens in voller Größe in der Galerie, mit in die Erde eingegrabenen pilzförmigen Lautsprechern, aus denen ein Multikanal-Audiowerk zu hören sein sollte, in dem Wirklichkeit und Fantasie des Ortes verschmelzen. Dann folgte eine Revision des Audio-Stückes, so dass es auch an andere Hör-Orte gehen konnte und nicht an den Garten gebunden war. Mit der schrittweisen Hinzufügung von Web-spezifischen Worten und Bildern sowie mit Plänen für eine künftige Rekonstruktion des Gartens wächst das Stück weiter und aus sich hinaus.

Die vollständige Installation wurde im Changing Room, Scotland, von November bis Dezember 2001 gezeigt. Die revidierte Audiofassung wird als 30-cm-Vinyl-LP bei Bottrop Boy in Deutschland erscheinen.

to flesh out the actual details, and finally the presentation is a hybrid state of audio, text, collage, and imagination that is computer, fantasy, real life, and a total lie, like any contemporary tale ought to be.

Revisionland and its related audio work Scotch Monsters

The Revisionland project is layered with several ideas that push and pull at each other. The first idea was of the full size English Garden in the gallery, with mushroom shaped speakers buried in the dirt playing a multi-channel audio work that would blend the reality and fantasy of the site. Next came the revision of the audio piece so it could go out into other listening spaces instead of keeping it tied to the garden. With the slow addition of web specific words and images, as well as future plans to reconstruct the garden, this piece is growing up and out.

The full installation was located in the Changing Room, in Scotland from November to December 2001. The revised audio work will be released as a 12" vinyl record on Bottrop Boy of Germany.

Aeron Bergman (USA), born 1971. He studied Art History, Art Theory and Fine Art at Michigan State University, The University of Toronto and New York University. **Alejandra Salinas (E),** born in 1977, studied Fine Arts at The Ontario College of Art and Design (Toronto), The School of Visual Arts (NYC) and London Guildhall University (London). They have been running the Lucky Kitchen label since December, 1996. **Aeron Bergman (USA)** geboren 1971, studierte Kunstgeschichte, Kunsttheorie und Bildende Kunst an der Michigan State University, der University of Toronto und der New York University. **Alejandra Salinas (E),** geboren 1977, studierte Bildende Kunst am Ontario College of Art and Design (Toronto), der School of Visual Arts (New York) und der London Guildhall University (London). Die beiden betreiben das Lucky Kitchen Label seit Dezember 1996.

Point, Line, Cloud
Curtis Roads

Curtis Roads studied music composition at California Institute of the Arts, the University of California, San Diego (B. A. Summa Cum Laude), and the University of Paris VIII (Ph.D). From 1980 to 1987 he was a researcher in computer music at at the Massachusetts Institute of Technology. He then taught at the University of Naples "Federico II," Harvard University, Oberlin Conservatory, Les Ateliers UPIC (Paris), and the University of Paris VIII.

Roads' Award of Distinction winning composition *Point, Line, Cloud* features granular and pulsar synthesis, methods he developed for generating sound from acoustical particles. These microsonic particles, pinpoints of sound, remained invisible for centuries, like the quantum world of the quarks, leptons, hadrons, gluons, and bosons. Recent technological advances let composers manipulate this domain.

Point, Line, Cloud is divided into four parts: *Half-Life*, *Tenth Vortex*, *Eleventh Vortex*, and *Sculptor*. *Half-Life* (1999) explores the birth, replication, mutation, and decay of sound particles. The composition is the fruit of a long period of experimentation with microsound. The piece is divided into two sections: Sonal atoms and Granules. The first version was premiered in May 1998 in the large hall of the Australian National Academy of Music, Melbourne, with sound projection over 28 loudspeakers.

Half-life is dedicated to the memory of composer Ivan Tcherepnin. The source material for *Tenth Vortex* (2000) and *Eleventh Vortex* (2001) were created on the same evening. These consisted of granulations of a single sound file: a train of electronic impulses emitted by the Pulsar Generator program.

Curtis Roads: "I divided the *Tenth Vortex* into nine sections, tuning and editing on a micro time scale. The work proceeded rapidly. I linked the sections into the final version on Christmas Eve

Curtis Roads studierte Komposition am California Institute of the Arts, der University of California, San Diego (B.A. Summa Cum Laude), und an der Universität Paris VIII (Ph.D.). 1980 bis 1987 war er als Forscher für Computermusik am Massachusetts Institute of Technology tätig, danach lehrte er an der Universität Federico II in Neapel, an der Harvard University, am Oberlin Conservatory, an Les Ateliers UPIC (Paris) und an der Universität Paris VIII.

Roads' mit einer Auszeichnung bedachte Komposition *Point, Line, Cloud* umfasst granuläre und pulsierende Synthese, Methoden, die er selbst zur Generierung von Klang aus akustischen Partikeln entwickelt hat. Diese Mikro-Klangpartikel, sozusagen die feinsten Nadelspitzen des Klangs, waren Jahrhunderte lang unsichtbar geblieben, ähnlich der Quantenwelt der Quarks mit ihren Leptonen, Hadronen, Gluonen und Bosonen. Die jüngsten technologischen Fortschritte erlauben es den Komponisten, auch diesen Bereich zu manipulieren.

Point, Line, Cloud besteht aus vier Teilen: *Half Life*, *Tenth Vortex*, *Eleventh Vortex* und *Sculptor*. *Half Life* (1999) untersucht die Geburt, Vermehrung, Mutation und den Verfall von Klangpartikeln. Die Komposition ist das Ergebnis langjährigen Experimentierens mit Mikroklängen. Das Stück zerfällt wiederum in zwei Abschnitte über klangliche Atome und Granuli. Die erste Version wurde im Mai 1988 im großen Saal der Staatlichen Australischen Musikakademie in Melbourne mit einer Klangprojektion über 28 Lautsprecher uraufgeführt.

Half Life ist dem Gedenken an den Komponisten Ivan Tcherepnin gewidmet. Das Ausgangsmaterial für *Tenth Vortex* (2000) und *Eleventh Vortex* (2001) wurde am selben Abend geschaffen. Hier handelt es sich um Granulationen einer einzigen Klangdatei – einem Strom elektronischer Impulse, ausgesendet vom Pulsar-Generator-Programm.

Curtis Roads: „Ich habe *Tenth Vortex* in neun Abschnitte unterteilt und auf einer Mikro-Zeitskala gestimmt und editiert. Die Arbeit ging schnell voran, die einzelnen

Abschnitte wurden am Heiligabend 2000 in die end-gültige Version gelinkt. *Eleventh Vortex* verlangte in seiner Makrostruktur nach stärkerer Nicht-Linearität. Ich habe es in über 80 Fragmente zerteilt, was zu einem wesentlich komplizierteren kompositorischen Puzzle führte, dessen Zusammensetzung Monate gedauert hat. *Eleventh Vortex* hat eine stärker idiosyn-kratische Struktur, die zwischen Zusammenschluss und Desintegration hin- und herschwankt."

Der Schlussteil von *Point, Line, Cloud* ist *Sculptor*. Curtis Roads: „Das Quellenmaterial für *Sculptor* war eine Mono-Perkussionsaufnahme der Gruppe Tortoise, die mir John McEntire zur Bearbeitung sandte. Ich habe das Material gefiltert und granuliert, wodurch das Schlagen der Drums in einen Wildbach aus Klang-partikeln über die gesamte Breite des Stereofeldes aufgelöst wurde. Diesen Fluss der Partikeldichte habe ich geformt, die Amplituden einzelner Partikel und Partikelwolken gedrückt und gezogen, verbundene und getrennte Frequenzzonen herausgeschält und das räumliche Fließen in eine passende Form gedreht."

2000. The *Eleventh Vortex* called for more non-linearity in the macrostructure. I divided it into over 80 fragments, which resulted in a more complicated compositional puzzle that took months to assemble. The *Eleventh Vortex* has a more idiosyncratic structure, alternating between coalescence and disintegration."

The final part of *Point, Line, Cloud* is *Sculptor*. Curtis Roads: "The source material of *Sculptor* was a monaural percussion track by the group Tortoise, sent to me for processing by John McEntire. I granulated and filtered this material, which disintegrated the beating drums into a torrent of sound particles scattered across the stereo field. I shaped the river of particle densi-ties, squeezed and stretched the amplitudes of individual particles and particle clouds, carved connected and disconnected frequency zones, and twisted the spatial flow."

A composer, researcher and professor, **Curtis Roads (USA)** teaches electronic music composition at the University of California, Santa Barbara. His synthesis program Cloud Generator is widely distributed. Together with Alberto de Campo, he recently developed a new program for particle synthesis called PulsarGenerator. They also developed the Creatovox, a new digital synthesizer for expressive performance of particle synthesis. His music appears on CDs produced by the MIT Media Lab, OR, WDR, Mode, and Wergo. Curtis Roads served as Editor of the Computer Music Journal from 1978 to 1989, and Associate Editor 1990-2000. A co-founder of the International Computer Music Association in 1979, Roads' writings include over a hundred monographs, research articles, reports, and reviews. **Curtis Roads (USA)**, Komponist und Forscher, unterrichtet elektronische Komposition an der University of California in Santa Barbara. Sein Synthese-Programm „Cloud Generator" ist weit verbreitet. Gemeinsam mit Alberto de Campo hat er jüngst „PulsarGenerator", ein neues Programm zur Partikel-Synthese, entwickelt. Die beiden haben auch den „Creatovox" entwickelt, einen neuen digitalen Synthesizer für expressive Performance mit Partikelsynthese. Seine Musik ist auf CDs erschienen, die vom MIT Media Lab, OR, WDR, Mode und Wergo produziert wurden. Curtis Roads war 1978 bis 1989 Heraus-geber des *Computer Music Journal* und dessen stellvertretender Leiter (1990–2000). Die Schriften des Mitbegründers der Inter-national Computer Music Association (1979) umfassen über hundert Monografien, Forschungsberichte, Aufsätze und Kritiken.

We Ain't Fessin'

Anticon

Through off-kilter samples culled from classical and film soundtracks to early electronic music and spoken word recordings laid over loping bass lines, Anticon has produced a remarkable, psychedelic and classically beatnik sounding collection of peculiar formations.

Later recordings confirmed suspicions that Anticon had stumbled upon previously unexplored terrain of ambient sound art much as they had the idea of being an "anti-corporate" enterprise with an ant as an icon. Producer Jel's *10 Seconds* finds him looping samples on an SP-1200 into dustily sharp bursts of music, some too jagged and discordant to be interpreted as mere "beats." The *Giga Single* collection is noteworthy for the way the members' voices become separate instruments speeding along in different cadences, resonating as richly as producer Mayonnaise's double-time, hi-hat inflected track on *We Ain't Fessin'*.

However, it is cLOUDDEAD, a project begun between Dose One, Why?, and producer Odd Nosdam, that have brought Anticon's vision to its apotheosis. What unites these dissidents is their deliberately low-fi approach and use of vocals as oral intonations. These disparate elements, densely layered using analog equipment and computers, are used to construct a highly emotional portrait of inner discontent that is vivid and surreal, whimsical and heartbreaking. *(Mosi Reeves)*

Durch ungeordnete Samples, zusammengetragen aus Klassik, Film-Soundtracks und früher elektronischer Musik, sowie durch Sprechaufnahmen, die über Bass-Schleifen gelegt werden, hat *Anticon* eine bemerkenswerte, psychedelisch nach klassischem Beatnik klingende Sammlung ganz eigentümlicher Formationen produziert.

Spätere Aufnahmen bestätigen den Verdacht, dass Anticon tatsächlich auf bisher unerforschtes Terrain im Bereich der Umwelt-Klangkunst gestolpert war, ganz wie es sich als „anti-gemeinschaftliches" Unternehmen versteht, das eine Ameise („ant") als Symbol („icon") führt. In *10 Seconds* formt Produzent Jel Samples auf einer SP-1200 in Schleifen zu staubkornscharfen Ausbrüchen von Musik, manche davon zu rau und diskordant, um noch als „Beats" durchzugehen. Die Giga-Single-Sammlung ist bekannt für die Stimmen der Mitglieder, die zu separaten Instrumenten werden, in unterschiedlichen Kadenzen dahineilen und genauso satt nachhallen wie der Double-Time Hi-Hat-Track des Producers Mayonnaise auf *We Ain't Fessin'*.

Aber erst das Projekt cLOUDDEAD, von Dose One, Why? und dem Produzenten Odd Nosdam eingeleitet, hat Anticons Vision zu einer Apotheose gebracht. Was diese Dissidenten vereint, ist ihr bewusster Lo-Fi-Ansatz und die Verwendung von Vokalstimmen als Intonationsmittel. Diese disparaten Elemente, dicht überlagert mit Hilfe von analogem Equipment und Computern, konstruieren ein stark emotionales Porträt innerer Unzufriedenheit, das lebhaft und surreal, launig und herzzerreißend ist. *(Mosi Reeves)*

"Fuck jobs, that's what **Anticon** is all about," jokes Dose One, although he might not be joking. "Fuck jobs, get a 4-track or cheap computer, drop out of college, do what you gotta do, be a human being. There's so much crap out there and none of it's worth it. But we're all believers. That's why we're all nuts and alone in where we once were. Because we're believers in something that is not where we were standing." „Fuck jobs - darum geht's bei **Anticon**", scherzt Dose One, obwohl er vielleicht doch nicht wirklich scherzt. „Fuck jobs, such dir eine Vierspurmaschine oder einen billigen Computer, flieg von der Schule, tu, was du tun musst, sei ein menschliches Wesen. Es gibt da draußen so viel Mist, und nichts davon ist was wert. Aber wir sind noch immer alle Gläubige, und deswegen sind wir alle verrückt und alleine bei dem, wo wir einst waren. Weil wir an etwas glauben, was nicht dort ist, wo wir standen."

Oiseaux Célestes II
Iancu Dumitrescu
Traces, Sillons, Sillages II
Ana-Maria Avram

Iancu Dumitrescu ist eine der führenden Gestalten der rumänischen Musikszene und beschäftigt sich mit Komposition ebenso wie mit Interpretation und Musikkritik. Nach seiner Begegnung mit Sergiu Celibidache – jener titanengleichen Persönlichkeit, die ihm großzügig Unterricht erteilt hat –, hat er seine Heimat in der Phänomenologie gefunden. Seine Kompositionen basieren auf einer akusmatischen Ästhetik, in welcher der Klang Analysen und Dissoziationen (harmonischen Multiklängen oder Diagonal-Klängen) unterzogen wird, die diesem eine genuine Überzeugungskraft und Eindringlichkeit verleihen.

Seine Musik wird bei internationalen Musikfestivals aufgeführt, etwa in Paris (Radio France), Orléans, Rotterdam, Utrecht, London, Assisi, Perugia, Wien, Bourges, Mailand, Brüssel, Rom, Köln, Amsterdam, New York, Boston und Bukarest. Gemeinsam mit Ana-Maria Avram hat er 1990 das Label *edition modern* gegründet.

Seit 1988 arbeitet Avram eng mit Dumitrescu zusammen, aber sie schmiedet weiterhin ihre eigene Richtung in der Musik. Sie wird zu den wichtigsten rumänischen Komponistinnen ihrer Generation gerechnet. Ihr Werk ähnelt äußerlich einer klanglichen Abstraktion, die ihre volle Entfaltung in der Synthese aus elektroakustischen und instrumentalen Quellen erreicht – eine herausragende Position im Bereich der spektralen Musik.

Sie hat Auftragskompositionen für so berühmte Ensembles wie das Kronos Quartett geschrieben, das Ensemble des 20. Jahrhunderts (Wien), für Solisten des Orchestre National de France, für Orchester wie die Bukarester Philharmonie, das Rumänische Nationalorchester, das Kammerorchester des Rumänischen Rundfunks, das Orchestre de Chambre de Roumanie und viele andere.

Iancu Dumitrescu is one of the leading personalities of Romanian music, embracing both composition, interpretation and musical criticism. After his encounter with Sergiu Celibidache—the titanic personality who gave him generous lessons, he found his reason in phenomenology. His compositions are based on an acousmatic aesthetics by virtue of which the sound is subjected to analyses and dissociations (harmonical multisounds—diagonal sounds) which confer it a genuine force of suggestion and penetration.

His music is played in international musical festivals in Paris (Radio France), Orleans, Rotterdam, Utrecht, London, Assisi, Perugia, Vienna, Bourges, Milan, Brussels, Rome, Köln, Amsterdam, New York, Boston, Bucharest. With Ana-Maria Avram, he set up the *edition modern* record label in 1990.

Since 1988, Avram has mantained a close collaboration with Iancu Dumitrescu, but she has also continued to forge her own direction in music. She is considered to be one of the most important Romanian composers of her generation. Her work incorporates the outward semblences of sonic abstraction reaching its full development in the synthesis of electroacoustic and instrumental sources—an outstanding position in spectral music.

Her works has been commissioned by prestigious ensembles such as Kronos Quartet, "20. Jahrhundert" from Vienna, soloists from l'Orchestre National de France, orchestras as Bucharest Philharmonic Orchestra, Romanian National Orchestra, Romanian Radio Chamber Orchestra, L'Orchestre de Chambre de Roumanie, etc.

Iancu Dumitrescu (RO) is the author of numerous works, which have been performed all over Europe. Noted for his raw, cut-up assemblages, spectral works, and acousmatic compositions, Dumitrescu founded the avant-garde chamber music ensemble Hyperion in 1976. Conductor and pianist **Ana-Maria Avram (RO)** is considered one of the most important composers of her generation. A graduate of the National Conservatory of Music in Bucharest and the Sorbonne, Avram's work is noted for its synthesis of electroacoustic and instrumental sources. She was awarded the Grand Prize in composition from the Rumanian Academy in 1994. **Iancu Dumitrescu (RO)** ist Autor zahlreicher Werke, die in ganz Europa aufgeführt wurden. Der für seine rohen, fast zerschnittenen Assemblagen, seine spektralen Werke und akusmatischen Kompositionen bekannte Dumitrescu ist Gründer des Avantgarde-Kammermusik-Ensembles Hyperion (1976). Die Dirigentin und Komponistin **Ana-Maria Avram (RO)** wird als eine der wichtigsten Komponistinnen ihrer Generation geschätzt. Die Werke der Absolventin des Staatlichen Musikkonservatoriums Bukarest und der Sorbonne sind bekannt für ihre Synthese aus elektroakustischen und instrumentalen Klangquellen. Avram ist Trägerin des Großen Preises für Komposition 1994 der rumänischen Musikakademie.

while(p){print"."," "x$p++}
PXP

```
 lable: wavetrap
 serial: wav [04]
artista: pxp
 titolo: while(p){print"."," "x$p++}
```

the department for penetration and perversion (pxp), an fm subunit
located at [http://wrzk.web.fm/], manages to transmit across viscous
to impermeable dimensions a piece of raw waveform, strong DC offsets and
polyrythmic acrobatics aligned between, along and on the peripheries of
diverse areas such as
+++spam filtering

```
[
  ADV
  [A-Z][A-Z][A-Z]* [A-Z][A-Z][A-Z]*
  .*(asset|background|mortgage|trillion|investigation
  software|double.*speed|E-Mail Marketing|adult|amateur|\
  pharmacy.*medical|repair.*credit|los[se].*pound|viagra|double.*money|\
  for.*[0-9]+\$|for.*\$[0-9]+|breast en(hance|large)|attract.*women|opt-in|\
  unlimited.*domain|be your own.*(admin)|refinance|winner
  confirm|pheromone|\ winner confirm|this is the finest|legal
  help|underground mailing service|\ email confirmation).*
  mortgage .*(animal.*(action|love)|fun.*farm|unhuman perver|gov
  grants|debt.*cash|love like no other|make.*money)
  .*easily lose.*.*((anti|fight).*aging|job search).*
  .*(clear|boost) cell phone.*investment tip
  (start.*earn.*money|riesen.*titten|find out anything about anyone|Body
  Fat Loss|read this.*mail|increase.*bust.*size|\
  boost.*reliability.*windows|mortgage rate|mortgage|incest porn|attract
  member.*opposite.*sex|you've been selected|underground mailing
  service|double whack)
]
```

+++packetsniffing

```
[
  11:44:32.761393 193.154.188.3.57408 > 62.116.9.40.53: . ack 16 win 17506 (DF)
  11:44:32.761984 193.154.188.3.57409 > 62.116.9.40.53: . ack 1 win 17520 (DF)
  11:44:32.762995 80.128.168.113 > 62.116.9.40: icmp: echo request (DF)
  11:44:32.763080 62.116.9.40 > 80.128.168.113: icmp: echo reply
  11:44:32.772681 193.154.188.3.57409 > 62.116.9.40.53: P 1:141(140) ack 1 win 17520 (DF)
  11:44:32.772755 62.116.9.40.53 > 193.154.188.3.57409: . ack 141 win 6432 (DF)
  11:44:32.772998 62.116.9.40.53 > 193.154.188.3.57409: P 1:15(14) ack 141 win 6432 (DF)
  11:44:32.873626 193.154.188.3.57409 > 62.116.9.40.53: F 141:141(0) ack 15 win 17506 (DF)
]
```

+++tilting and declowning the axis of "its not generative", cruising the
life and times of hans aiberg, mustafa hawking, both on the fringe of
making origami ducks out of their lives

```
[
  1-)
  ---muirad: do u know hans aiberg?
  ---hawking:
  IM MRS.CP
  UR M†SS.CCP
  VR 10SCE

  2-)
  ---muirad: r u a HANIF?or muslim?
  ---hawking:
  L= (.) Vowels (/)
  ..//./h/../.h
]
```

+++participants in the configuration war, engaging in actions against
your ideas of sticky identity, NExTranScienCenTerminal,
KaiMaqam*Tayy-uz-Zeman*Tayy-ul-Meckan, yours or mine or the same? and
WHY ZIGZAG?

and who is juan chanson or even x75?

```
 x75: "My computer typed this for me while I slept."
juan: "ob er überhaupt eine aufrechte Aufenthaltsberechtigung hat?"
 she: is a messenger ..
```

back to the content of this package:

first a WARNING:

* IT may generally contain impure-data (as referenced above)

second

* IT contains these items (right->left,top->down)

```
    0 0 0 0 0 0 0 0 0 0 0 0 0 0 0 0 0
    1 1 1 1 1 1 1 1 0 0 0 0 0 0 0 0 0
    8 7 6 5 4 3 2 1 9 8 7 6 5 4 3 2 1
    . . . . . _ _ _ _ _ _ _ . . . . _
    0 0 0 0 0 n 0 0 0 0 0 0 0 0 0 0 0
    1 1 1 1 1 e 7 6 1 5 8 1 0 0 0 0 5
    4 6 5 7 8 w . . . . . . 2 5 4 3 .
    _ _ _ _ _ l a a a a a 7 _ _ _ _ a
    m m m m l i _ _ _ _ _ - a 0 1 0 _
    e e e e l f W W W W W 8 _ 4 2 6 W
    t t t t . e T T T T T . W . . . T
    a a a a a . _ - - - - w T a a a -
    _ _ _ _ _ i f r Z s a a - _ _ _ s
    U U U U W i r e P e s v 4 W W W e
    S S S S T . a c - i _   p T T T i
    . . . . r 3 g 3 5 n x   r - - _ n
    0 0 0 0 e . - - , - 1   l b s X -
    1 3 2 4 c w 0 5 6 a .   - o l Z b
    . . . . _ a l b b . w   9 b u T 1
    w w w w G v . . . w a   . b r 8 .
    a a a a . l w w a v     4 l p 6 w
    v v v v w . a a v       . e . H a
            A   W v v       W . w . v
            V   A           A l a w
            V               V . v a
                            W   V
                            a
                            v
```

third:

* YOU may call it EITHER: while(p){print"."," "x$p++}
 OR:

```
. .   .     .       .         .           .             .
.
        .           .           .                 . .
              .                       .               .   .
                        .           .                   . .
                              .
.                   .                   .
              .                       .                   .
                    .                 .                     .
.
              .
.                   .                   .
                    .                 .                     .
.                   .                   .                   .
              .
                          .             .
                    .           .
                                  .
```

file under: extreme computer music

end of all efforts starts here.

wav.post-pop.org
http://wrzk.web.fm
http://barely.a.live.fm/d/
buy it at mdos

Narc Beacon
Goodiepal

Kristian Vester grew up in a Danish suburb spending school years trading computers and electronic devices as well as doing home puzzles! Over the last ten years he has been working as a programmer and inventor for various companies with clients such as Hitachi, Lego, Warner and Columbia Pictures.

The Goodiepal also works in some unknown capacity for several large corporations including Lego and Nokia. In fact he makes sound for them. In fact, he just composed the theme song for the new Nokia advertising campaign. Then, without their knowlege, he remixed his own corporate theme song into a fragile and stupid little mess and released it onto this 7" single complete with the new Nokia logo, all before Nokia had a chance to release it for real themselves.

Nokia of course got really upset. In a way he acted like a mad scientist cartoon spy, stealing silly sounds and silly colorful blobs from their top secret laboratory, then smuggling them out to his small but growing public. Nobody blinks an eye? Was this a critique? Was this sabotage? Was this a way to take back something that he did not want to get away? Was it just a theatrical gesture?

Goodiepal's music has a fundamental music ideology that can be traced back to Danish outsiders like Rude Langaard and Niels Viggo Gade. Over the last three years Kristian Vester has been touring the world extensively. As the Goodiepal is now busy working on a new language which will not be presented until 2003, until then Mainpal is awake, alive and very active with releases and playing live.

The Mainpal rules. He has self awareness, he knows when he has done something questionable. He can seriously double check, and laugh about anything.

Kristian Vester wuchs in einem dänischen Vorort auf und verbrachte seine Schulzeit damit, mit Computern und elektronischen Geräten zu handeln und Rätsel zu lösen. In den letzten zehn Jahren hat er als Programmierer und Erfinder für diverse Unternehmen mit Kunden wie Hitachi, Lego, Warner und Columbia Pictures gearbeitet.

Der Goodiepal arbeitet auch in einer unbekannten Funktion für diverse große Firmen wie Lego und Nokia. Er macht tatsächlich den Klang für sie. Er hat tatsächlich gerade den Titelsong für die neue Werbekampagne von Nokia komponiert. Und ohne ihr Wissen hat er daraufhin auch noch seine eigene Firmenmelodie in ein fragiles und dummes Durcheinander gemixt und das Ganze auf dieser 7"-Single gemeinsam mit dem neuen Nokia-Logo herausgebracht, und zwar noch bevor Nokia die Chance hatte, das Original selbst zu veröffentlichen.

Natürlich war Nokia richtig sauer. Irgendwie hat er sich ja verhalten wie ein verrückter Zeichentrick-Spion, dumme Sounds und dumme Farbflecken aus ihrem ganz geheimen Laboratorium gestohlen, und all das hinausgeschmuggelt für sein kleines, aber wachsendes Publikum. Kein Augenzwinkern? War das eine Kritik? War das Sabotage? War das ein Weg zurückzukommen, was er nicht einfach auslassen wollte? War das einfach nur eine theatralische Geste?

Hinter Goodiepals Musik steht eine Musikideologie, die sich bis zu dänischen Außenseitern wie Rude Langaard und Niels Viggo Gade zurückverfolgen lässt. In den letzten drei Jahren hat Kristian Vester die Welt ausgiebig bereist. Als Goodiepal arbeitet er an einer neuen Sprache, die nicht vor 2003 präsentiert wird, und bis dahin ist Mainpal wach, lebendig und sehr aktiv mit neuen Releases und Live-Auftritten.

The Mainpal rules. Er hat Selbstbewusstsein, er weiß, wenn er etwas Fragwürdiges getan hat. Er kann ernsthaft nochmals kontrollieren – und über alles lachen.

Goodiepal / Mainpal Inv. (DK) is one of the most interesting musicians coming out of modern Scandanavia. Currently living in London and closely linked to British bright light music manipulators V/Vm, Goodiepal has a fundamental music ideology that can be traced back to Danish outsiders like Rude Langaard and Niels Viggo Gade. **Goodiepal / Mainpal Inv. (DK)** gehört zu den interessantesten Musikern des modernen Skandinaviens. Er lebt derzeit in London und ist eng verbunden mit den britischen Bright Light Music-Manipulatoren V/Vm. Goodiepal folgt einer grundlegenden Musikideologie, die auf dänische Außenseiter wie Rude Langaard und Niel Viggo Gade zurückgeht.

Live Salvage: 1997–2001
Russell Haswell

Das sagen einige Kritiker und Kommentatoren zu Russel Haswells CD *Live Salvage: 1997–2001*:

„Es erinnert uns an den Tod. Aber der Tod verkauft sich!"
(*Muzik*)

„Das ist feine Granulationsarbeit. Ich werde es für meine Studenten in meinen Vorlesungen über 'Geräusch-ressourcen in der elektronischen Musik' abspielen."
(Curtis Roads)

This is what some critics and commentators had to say about Russell Haswell's *Live Salvage: 1997–2001* CD:

"It reminds us of death. But death sells!"
(*Muzik*)

„This is fine granulation work. I will play it for my classes in my lectures on 'Noise Resources in Electronic Music.'"
(Curtis Roads)

Russell Haswell (UK) born 1970, is an multidisciplinary Artist living and working in Coventry, England. Recent concerts include the Sonic Youth curated "All Tomorrow's Parties', at UCLA, Los Angeles & solo performance at the opening of "FREQUENCIES [Hz]" exhibition in the Schirn Kunsthalle, Frankfurt. He has exhibited visual work at galleries all over the world. He has also worked as a curator at P.S.1/MOMA, Contemporary Art Centre, New York, and Kunstwerke, Berlin. **Russell Haswell (UK)**, geb. 1970, ist ein multidisziplinärer Künstler. Zu seinen jüngsten Konzerten zählen u. a. das von Sonic Youth kuratierte „All Tomorrow's Parties" an der UCLA, Los Angeles, und eine Solo-Performance aus Anlass der Eröff-nung von „FREQUENCIES [Hz]" in der Schirn Kunsthalle Frankfurt. Er hat visuelle Arbeiten in Galerien auf der ganzen Welt ausgestellt und war als Kurator unter anderem bei P.S.1/MOMA, Contemporary Art Centre New York und Kunstwerke in Berlin tätig.

Buildings [New York]
Francisco López

Buildings [New York] is a work featuring sound environments from the Costa Rican jungle. Non-processed, not mixed environmental sound matter from a certain "reality'. An appraisal of the richness and essential qualities of the original sonic material. A non-referential intention. An extreme phenomenological immersion led by anti-rationality and anti-purposefulness. A world devoid of human presence. A passion for drones and their inner universe; that perceptually „invisible" matrix of broadband noise that is constantly flowing around us, both in nature and in man-made environments. A *tour de force* of profound listening in which every listener has to face their own freedom and thus create.

Buildings are sophisticated hyper-bodies we build around ourselves. Their physiology is controlled by metabolites and fluids such as electricity, air, water and gas. Wires, cables, gears, pipes, air ducts, boilers, clocks, LEDs, thermostats, computers, video cameras... work inter-connectedly to make up sensory, muscular, digestive, nervous systems that we set in motion, with a high degree of autonomy and self-regulation, in the service of our hyper-physiology. As a multitude of fragmented robots that communicate to each other at our command. A community of machines that breathe, roar, hum, rattle, beep, crackle ... compartmentalized and separated from us, working constantly, while we sleep, when we are working, making love, cooking, listening to the radio. A city from the inside, an unconscious futurist paradise.

Buildings [New York] was commissioned and presented by Creative Time for Massless Medium: Explorations in Sensory Immersion as part of Art in the Anchorage 2001, Brooklyn Bridge Anchorage, Brooklyn. Edited and mastered at mobile messor during the spring of 2001.

Buildings [New York] ist eine Arbeit mit Klangumgebungen aus dem Dschungel von Costa Rica. Unbearbeitetes und ungeschnittenes Material aus Umweltklängen einer bestimmten „Wirklichkeit". Eine Hommage an den Reichtum und die essenziellen Qualitäten des ursprünglichen Klangmaterials. Eine nicht-bezügliche Intention. Eine extreme phänomenologische Immersion, geleitet von Anti-Rationalität und Zweckfreiheit. Eine Welt frei von menschlicher Präsenz. Eine Leidenschaft für das Dröhnen und sein inneres Universum; jene für die Wahrnehmung „unsichtbare" Matrix von Breitband-Geräuschen, die ständig um uns fließen – sowohl in der Natur als auch in vom Menschen geschaffenen Umgebungen. Eine Tour de Force des intensiven Zuhörens, bei der jeder Hörer seiner eigenen Freiheit gegenübertreten und so selbst kreativ werden muss.

Gebäude sind ausgefeilte Hyperkörper, die wir um uns herum bauen. Ihre Physiologie wird gesteuert von Stoffwechselprodukten und Flüssigkeiten wie Elektrizität, Luft, Wasser, Gas. Drähte, Kabel, Zahnräder, Rohre, Luftschächte, Boiler, Uhren, LEDs, Thermostate, Computer, Videokameras ... arbeiten miteinander verzahnt, um Muskel-, Verdauungs-, Sinnes- und Nervensysteme zu bilden, die wir mit einem hohen Grad an Autonomie und Selbststeuerung in Bewegung setzen und die unserer Hyperphysiologie dienen, als eine Vielzahl von verteilten Robotern, die auf unser Kommando miteinander kommunizieren. Eine Community aus Maschinen, die atmen, brüllen, summen, rasseln, piepen, knacken ... aufgeteilt in Abteilungen, getrennt von uns, die ständig arbeiten, während wir schlafen, während wir arbeiten, lieben, kochen, Radio hören. Eine Stadt aus dem Inneren, ein unbewusstes futuristisches Paradies.

Buildings [New York] ist ein Auftragswerk von „Creative Time for Massless Medium: Explorations in Sensory Immersions" und wurde als Teil der Ausstellung „Art in the Anchorage 2001", Brooklyn Bridge Anchorage, Brooklyn, präsentiert. Editiert und gemastert in Mobile Messor im Frühling 2001.

Francisco López (USA) has—over the last twenty years—been developing a powerful and consistent world of minimal electroacoustic soundscapes, trying to reach an ideal of absolute concrete music. To date, his prolific catalog comprises more than 120 sound works. He has toured extensively throughout Western and Eastern Europe, North, Central and South America, Japan and Australia doing acousmatic performances, and he has received commissions from a number of renowned institutions. **Francisco López (USA)** entwickelt seit zwanzig Jahren eine kraftvolle und konsistente Welt minimaler elektroakustischer Klanglandschaften und strebt das Ideal einer absoluten konkreten Musik an. Bis heute umfasst sein umfangreicher Opuskatalog über 120 Klangarbeiten. Er hat ausgedehnte Tourneen durch West- und Osteuropa, Nord-, Mittel- und Südamerika, Japan und Australien gemacht, wo er mit akusmatischen Performances aufgetreten ist, und hat Auftragswerke für zahlreiche renommierte Institutionen verfasst.

Soldier of Midian
Raz Mesinai

Das Ende August 2001 als viertes Badawi-Album fertig-gestellte Projekt ist nach einem mythischen Krieger benannt, der sich niemals vom Menschen untertan machen ließ. Der Großteil des Werks wurde von folgendem Textauszug inspiriert:

„Und sie sprachen zu ihm: ‚Komm und folge uns und kämpfe für unseren Gott.' ‚Ich kann nicht', antwortete er, ‚denn ihr seid es, die mich kämpfen machen wollen, nicht unser Gott.' Er senkte sein Schwert und sie hoben die ihren. ‚Wenn nicht für deinen Gott, dann für dein Volk.' ‚Wie kann ich?' antwortete er, ‚Nicht es hat mir aufgetragen zu kämpfen, nur ihr wart es.' Sie wurden ärgerlich, schlugen aber nicht zu. ‚Wenn du uns nicht beistehst, so wirst du das Los unserer Feinde teilen.' Der Wind wurde stärker, und er antwortete: ‚Wie kann ich zu eurer Armee stoßen, wenn ich nur euer Wort habe? Ich kann nicht den Menschen verehren, nur das Leben des Menschen. Wenn Krieg sein soll, so lasst die Pferde entscheiden, wer siegen wird. Und selbst wenn ein Weg gepflastert worden ist, selbst dann … Ich werde nur dem Sturm folgen."

Die Aufnahme ist überwiegend im 3/4-Takt komponiert und besteht hauptsächlich aus Perkussion und Flöte, gespielt von Raz, sowie einem Bass, gespielt von Shahzad Ismaily, und einem Dulcimer, gespielt von Carolyn „HoneyChild" Coleman. Die Instrumente wurden anschließend gesamplet, rekonstruiert und elektronisch neu gemixt.

Completed late August of 2001 as the fourth Badawi album, *Soldier of Midian* was titled after a sacred warrior who could never be owned by man. The majority of the record was inspired by the following excerpt:

"... And they said to him, 'come join us and fight for our God.'" "I cannot," he replied, "for it is you who wants me to fight, not our God." He lowered his sword and they raised theirs. "If not for your God then for your people." "How can I?" He replied, "for they have not told me to fight, only you have." They became angry but did not strike. "If you do not join us then you will join the fate of our enemies." The winds grew stronger and he replied, "How can I join your army when all I have is your word? I cannot worship the man, only the life of the man, If there is to be war let the horses decide who will be victorious. And even after a path has been paved, even then ...I will only follow the storm."

The recording is composed mostly in 3/4 and consists mainly of percussion and flute which are played by Raz as well as bass played by Shahzad Ismaily, and a dulcimer played by Carolyn "Honey-Child" Coleman. The instruments were then sampled, reconstructed, and remixed electronically.

Raz Mesinai (USA). As a percussionist, composer, improviser and producer, Raz Mesinai has been on the forefront of the New York underground music scene since 1992. Mesinai is well known for his recordings with Sub Dub, and for his Badawi identity, as well as several works under his own name including *The Unspeakable*, (BSI) and *Before the Law* (Tzadik) inspired by the stories of Franz Kafka. Als Perkussionist, Komponist, Improvisator und Produzent steht **Raz Mesinai (USA)** seit 1992 an vorderster Front der New Yorker Underground-Musikszene. Mesinai ist bekannt für seine Aufnahmen mit Sub Dub und für seine Zweitidentität Badawi, ebenso auch für zahlreiche Werke unter seinem eigenen Namen, darunter *The Unspeakable* (BSI) und *Before the Law* (Tzadik) inspiriert von den Werken Franz Kafkas.

Brownout
Phoenecia

The duo released their first album, *Tone Capsule*, under the name Soul Oddity on Astralwerks in 1996. The major label flavor did not prove appealing for them and so they formed The Schematic Music Company as a sort of artist's forum where vigorous originality and endemic aural identity could flourish. After several solo releases on Schematic, the pair released *Randa Roomet* on Warp in 1997, their first published recording as Phoenecia. *Brownout*, their most recent album represents a more organic, sublime approach. Del Castillo and Kay always seem to find themselves lodged in the proverbial cracks. In ever-progressive flux, their constructs veer from brutal street urbanity to subtle internalized musicality. With their first releases mirroring the thick groove of Miami bass, the boys recorded sound has evolved with mindfulgrace into a wholly cerebral labyrinth of space and vision. Yet when seen live, Phoenecia brazenly injects whatever of their myriad palette suits the mood. This, after all, is the same formula for all of the music they have chosen to unleash upon the world.

Das Duo brachte 1996 sein erstes Album *Tone Capsule* unter dem Namen „Soul Oddity" bei Astralwerks heraus. Der Geschmack eines großen Labels lag den beiden aber nicht so richtig, deshalb gründeten sie "The Schematic Music Company" als eine Art Künstlerforum, in dem kraftvolle Originalität und endemische auditive Identität aufblühen konnten. Nach diversen Solo-Einspielungen auf Schematic brachte das Paar 1997 *Randa Roomet* auf Warp als erste Scheibe unter dem Namen „Phoenecia" heraus. *Brownout*, ihr neuestes Album, stellt einen etwas organischeren und feineren Ansatz dar. Del Castillo und Kay scheinen sich immer irgendwie in den sprichwörtlichen Nischen niederzulassen. In stets vorwärtsdrängendem Fluss schwanken ihre Konstrukte zwischen brutaler Straßen-Urbanität und subtiler verinnerlichter Musikalität. Während ihre ersten Aufnahmen den fetten Groove des Miami-Bass widerspiegelten, hat sich der aufgezeichnete Sound der Boys mit Intelligenz und Grazie in ein völlig zerebrales Labyrinth aus Raum und Vision entwickelt. Und dennoch: Wenn man sie live hört, dann werfen die beiden von Phoenecia alles hinein, was aus ihrer riesigen Palette gerade zur Stimmung passt. Und das ist letztlich doch die gleiche Formel wie bei all der Musik, die sie auf die Welt loszulassen beschlossen haben.

Phoenecia's Romulo Del Castillo and Joshua Kay (USA) met in a sound recording class session at a college and quickly found common ground through their mutual affinity for Herbie Hancock, and hand percussionists such as Glen Velez and Zakir Hussain. After recording several solo releases on their own Schematic label, the band issued their first official Phoenecia recording, *Randa Roomet*, on Warp in 1997. **Romulo Del Castillo und Joshua Kay von Phoenicia (USA)** begegneten einander erstmals bei einem Tonaufnahme-Kurs an einem College und fanden schnell einen gemeinsamen Nenner: ihre Verehrung für Herbie Hancock und Hand-Perkussionisten wie Glen Velez und Zakir Hussain. Nach mehreren Solo-Releases auf ihrem eigenen Label „Schematic" hat die Band 1997 ihre erste offizielle Aufnahme als „Phoenecia" unter dem Titel *Randa Roomet* bei Warp herausgebracht.

Delusional Situation
Marina Rosenfeld

Rosenfelds Surround-Sound-Installation *Delusional Situation* wurde für die Ausgabe 2002 der Biennial Exhibition des Whitney Museums, New York, geschaffen und dort auch erstmalig ausgestellt. Sie beschreibt die DVD-A, eine 9-minütige Surround-Sound 5.1-Arbeit, als einen Bezug auf das Gedicht *Ich kenne dich* von Paul Celan, in dem folgende Textzeile vorkommt: „Du – ganz, ganz wirklich. Ich – ganz Wahn".

„Abgesehen davon, dass es ein Liebesgedicht ist, scheint mir *Ich kenne dich* auch auf eine schöne Weise die problematische ‚Situation' einer Person zwischen innerem und äußerem Bewusstsein, zwischen Innenwelt und Außenwelt zu beschreiben. Wo ist die ‚wahre' Wirklichkeit? Dringt sie von außen in uns ein? Fließt sie aus unserem Inneren hinaus? In *Delusional Situation* habe ich versucht, dieses ‚Problem' in eine Klangidee umzusetzen: Der Hörer ist in einer ‚realen' Welt aus Klängen, er beobachtet sie zunächst aus der Mitte, dann plötzlich von der Peripherie, dann wieder von einem neuen Mittelpunkt aus und so weiter. Die Klänge aus Gitarrenfragmenten (gespielt von vielen Freiwilligen des Sheer Frost Orchestra), die ich zunächst auf Vinyl neu gemischt und anschließend in Pro Tools auseinandergenommen und wieder zusammengesetzt habe, beschreiben nicht eine Innenwelt, sondern eine äußere Welt, die nur unvollkommen hereingefiltert wird. In dieser Welt ist die Position des Hörers nicht festgelegt, genauso wenig wie die Bedeutung der ‚Kommunikation' klar ist, die man hört."

Seit der ersten Aufführung der Komposition 1994 ist dieses Projekt von vielen verschiedenen Ensembles aufgeführt worden, die auf die von Rosenfeld erfundenen Gitarrenimprovisationstechniken trainiert sind; es wurde 2001 auf der CD *The Sheer Frost Orchestra – Drop, Hop, Drone, Scratch, Slide & A For Anything* dokumentiert (Wien: Charhizma, 2001).

Rosenfeld's surround-sound installation *Delusional Situation* was created for and first exhibited at the Whitney Museum's 2002 Biennial Exhibition, in New York. She describes the DVD-A, 9-minute Surround-Sound 5.1 work's name as a reference to the poem *Ich kenne dich* by Paul Celan containing the lines: *You all, all real, I all delusion.*

"As well as being a love poem, *Ich kenne dich* ... seems to me to formulate in a beautiful way a person's problematic 'situation' between inner and outer consciousnesses, or inner and outer worlds. Where is the 'real' reality? Outside of ourselves coming in? Inside ourselves and flowing out? In *Delusional Situation* I attempted to translate this 'problem' into a sonic idea: the listener is in a 'real' world, made of sounds. The listener is observing from the centre and then suddenly from the periphery, and then to a new centre, and on and on. The sounds from guitar fragments (performed by many sheer frost orchestra volunteers) that I then remixed on vinyl and finally dismantled and reassembled again in Pro Tools, describe not an inner world, but an outer world imperfectly filtering in. The listener's location is not fixed in this world, nor are the meanings of the "communications" s/he is hearing clear."

Since the first performance of the composition in 1994, this project has been performed by many different ensembles trained to perform Rosenfeld's invented electric-guitar-improvising technique; it was documented in 2001 on the CD the sheer frost orchestra—drop, hop, drone, scratch, slide & A for anything
(Vienna: Charhizma, 2001).

Marina Rosenfeld (USA), born 1968. Her sound compositions, live performances and installations have been presented internationally, by the Whitney Museum of American Art, the New Museum, the Kitchen, the Knitting Factory, Tonic, Artists Space, Greene Naftali Gallery, Curt Marcus Gallery, Murray Guy Gallery in New York, to name but a few; Resistance Fluctuations Festival and LACE (Los Angeles); at the Ars Electronica festival (Linz); Musikprotokoll festival (Graz); Pro Musica Nova festival (Bremen); STEIM (Amsterdam); Echoraum (Vienna); and many others. **Marina Rosenfeld (USA)**, geb. 1968. Ihre Klangkompositionen, Live-Performances und Installationen wurden international präsentiert, etwa am Whitney Museum of American Art, am New Museum, bei The Kitchen, The Knitting Factory, Tonic, Artists Space, Greene Naftali Gallery, Curt Marcus Gallery, Murray Guy Gallery in New York; am Yerba Buena Center for the Arts, am CCAC Institute und Mills College (San Francisco); beim Resistance Fluctuations Festival und LACE (Los Angeles); bei der Ars Electronica (Linz); beim Musikprotokoll Graz; Pro Musica Nova Bremen; am STEIM (Amsterdam); Echoraum (Wien) und vielen anderen.

Fysikaalinen rengas
Mika Taanila / ø

Fysikaalinen rengas ("A Physical Ring") is a found-footage film. It's based on raw material from an anonymous Finnish physical test that took place in the 1940's. The original purpose of the test remains unknown today. By careful editing techniques, inanimate research footage is assembled to a piece of kinetic fantasy. An integral part of the piece is the specially commissioned, haunting soundtrack by Ø (Mika Vainio of Pan Sonic).

Fysikaalinen rengas („Ein physikalischer Ring") ist ein Film aus Fundmaterial. Er basiert auf dem Rohmaterial eines anonymen physikalischen Versuchs, der in den 1940er-Jahren stattgefunden hat und dessen ursprünglicher Zweck unbekannt ist. Durch sorgfältige Schnitttechnik wird ein unbelebter Forschungsfilm in ein Stück kinetischer Fantasie verwandelt. Integrierter Bestandteil des Stücks ist der als Auftragswerk entstandene geisterhafte Soundtrack von Ø (Mika Vainio von Pan Sonic).

Als Muybridge oder Marey ihre ersten wissenschaftlichen Filme produzierten, erfanden sie nicht nur die Technik des Kinos, sondern schufen gleichzeitig auch seine reinste Ästhetik. Dies ist das Wunder des wissenschaftlichen Films, sein niemals versagendes Paradoxon. Nur am extremen Ende der profitorientierten zweckgebundenen Forschung, wenn ästhetische Zwecke als solche aufs Heftigste abgelehnt werden, folgt daraus kinematografische Schönheit mit übernatürlicher Grazie."
(André Bazin „The Beauty of Chance", in Écran Français, 21.10.1947)

„Als Künstler, Filmemacher und Dokumentarfilmer sprengt Mika Taanila die Schubladeneinteilung der zeitgenössischen Kunst. Seine Filme, Videoclips und Installationen sind nach den Prinzipien von Verbindung, Interaktion und Kollaboration aufgebaut. Mit Klang und Bild, mit der allerneuesten elektronischen Kultur und den technologischen Hoffnungen der 1960erJahre, mit Fiktion und Realität arbeitet Taanila einen neuen, proteushaften Ansatz für die Darstellung unserer Moderne und unseres Fortschritts in seinen futuristischen Techno-Utopien aus (etwa in den Filmen *Futuro* und *RoboCup 99*). Diese Projekte haben fast immer auch etwas mit Projektion zu tun (in beiden Sinnen des Wortes), mit Maschinen und ihrer Autonomie oder ihrer erträumten Menschlichkeit (der künstlichen Intelligenz des Roboters) und mit Zeit – und damit auch ihrer Wiederholung."
(*Stéphanie Moisdon Trembley*)

Fysikaalinen rengas gibt es in zwei unterschiedlichen Formaten: als traditionellen 35mm-Film und als ortsspezifisches Installationsstück.

Finanzielle Unterstützung: Veli Granö / AVEK, The Promotion Centre for Audiovisual Culture, Finnland.

"When Muybridge or Marey produced their first scientific films, they not only invented the technique of cinema but also created the purest aesthetics of it. This is the miracle of scientific film, its unfailing paradox. Only at the extreme end of profit-seeking utilitarian research, when aesthetic purposes as such are most sternly rejected, will cinematic beauty follow with supernatural grace."
(André Bazin, "The Beauty of Chance", *Ecran Français*, 21. 10. 1947)

"An artist, filmmaker and documentarist, Mika Taanila integrates and goes beyond the different registers of contemporary art. His films, video clips and installations are built according to the principles of connection, interaction and collaboration. Between sound and image, the newest electronic culture and the technological aspirations of the 1960s, between documentary film and advanced experiment, between fiction and reality, Taanila is working out a novel and protean approach to our representations of modernity and progress through his futuristic techno-utopias (the films *Futuro* and *RoboCup 99*). These projects nearly always have something to do with projection (in both senses of the term), with machines and their autonomy or dreamed-of humanity (the artificial intelligence of the robot) and with time – including, therefore, its repetition."
(*Stéphanie Moisdon Trembley*)

Fysikaalinen rengas exists in two different formats: as a traditional 35 mm film print and as a site-specific installation piece.

Financial support: Veli Granö / AVEK, The Promotion Centre for Audiovisual Culture in Finland.

Mika Taanila (SF), born 1965, is an artist working fluently in the fields of documentary filmmaking, music videos and visual arts. His documentary films deal with the the significant and alarming issues of human engineering and urban artificial surroundings. Taanila specializes on in the futuristic ideas and Utopias of contemporary science. **Mika Taanila (SF)**, geb. 1965, ist ein Künstler, der den Dokumentarfilm ebenso fließend beherrscht wie Musikvideos und visuelle Kunst. Seine Dokumentarstreifen behandeln signifikante und beunruhigende Fragen im Zusammenhang mit dem Menschen als „Ingenieur" und mit künstlichen urbanen Umgebungen. Taanila hat sich auf futuristische Ideen und Utopien der zeitgenössischen Wissenschaft spezialisiert.

A Lecture on Disturbances in Architecture

Carl Michael von Hausswolff

Carl Michael von Hausswolff's position is hard to force into any conventional category, be it composer, producer, editor, curator or installation artist. Clearly he has been all of these things, and it would seem that this ambiguous identity has made his work even more attractive to the art world of the last half decade, which also saw the start of the eternal project *The Kingdoms of Elgaland-Vargaland*, a conceptual piece including establishing a new country that was initiated together with colleague Leif Elggren. During the ten years that this state has functioned 650 citizens are bearers of passport and constitution and approximately 20 embassies and consulates have been inaugurated in many worldwide cities. From 1996 until now von Hausswolff has composed several pieces not using the usual installation as a source. Instead he has developed a personal technique based upon a combination of concept, intuition showing an aesthetical surface free from ornamental unnecessities. During the nineties he also developed a concept based on the discoveries by Swedish EVP researcher Friedrich Jürgenson. Here von Hausswolff established an audiovisual form that enables the audience to discover if there were life forms within the frameworks of the electrical systems in various buildings.

The seven sound pieces of *A Lecture on Disturbances in Architecture* are all based upon various sonic problems occurring when dealing with daily life in the realms of a domestic household. It seems like there is a vast ignorance within the construction of a living place. Architects seem to have neglected that area within a space that has to do with sonic vibrations. There is simply not enough interest and development from builders of houses concerning frequency problems in these living spaces.

Egal ob als Komponist, Produzent, Herausgeber, Kurator oder Installationskünstler, Carl Michael von Hausswolff ist schwer in irgendeine konventionelle Kategorie einzuordnen. Sicherlich ist er all dies gewesen, und es scheint, dass diese unklare Identität sein Werk für die Kunstwelt noch interessanter gemacht hat, jedenfalls in der zweiten Hälfte jenes Jahrzehnts, das seit dem Beginn seines Dauerprojekts *The Kingdoms of Elgaland-Vargaland* vergangen ist. Gemeinsam mit seinem Kollegen Leif Elggren hat er in diesem konzeptuellen Werk ein neues Land gegründet. In den zehn Jahren des Bestehens haben 650 Bürger Pass und Verfassung des Landes mitgetragen, und etwa 20 Botschaften und Konsulate wurden in zahlreichen Städten auf der ganzen Welt eingerichtet. 1995 wurde die erste, einstündige Fassung der Nationalhymne von Carl und Leif bei Ash International (RIP) in London herausgebracht. Seit 1996 hat Hausswolff zahlreiche Stücke komponiert, die nicht die übliche Installation als Quelle verwenden, stattdessen hat er eine persönliche Technik entwickelt, die auf einer Kombination aus Konzept und Intuition basiert und eine ästhetische Oberfläche bar jeder ornamentalen Nutzlosigkeit zeigt. Im Lauf der 90er-Jahre entwickelte er ein Konzept basierend auf den Entdeckungen des schwedischen EVP-Forschers Friedrich Jürgenson. Hier hat von Hausswolff eine audiovisuelle Form etabliert, die dem Publikum erlaubt, Lebensformen innerhalb des Gitterwerks der elektrischen Systeme in zahlreichen Gebäuden zu entdecken.

Die sieben Klangstücke von *A Lecture on Disturbances in Architecture* basieren alle auf diversen klanglichen Problemen, die im Alltagsleben in einem privaten Haushalt auftreten. Es scheint, dass bei der Konstruktion eines Wohn- oder Lebensraums große Ignoranz herrscht – die Architekten haben scheinbar nicht beachtet, dass Fläche innerhalb eines geschlossenen Raums auch mit Klangvibrationen zu tun hat. Bei der Errichtung von Gebäuden wird Fragen der Frequenz einfach nicht genug Aufmerksamkeit geschenkt.

Carl Michael von Hausswolff (S), born 1956. Operating mainly through his companies Radium 226.05 and Anckarström, he has composed music and executed live-installations and performance art during the eighties together with filmmaker Erik Pauser under the group name Phauss and has also completed solo projects. In the beginning of the nineties he collaborated with Andrew McKenzie and shortly joined The Hafler Trio on their European tour in 1994. **Carl Michael von Hausswolff (S)**, geb. 1956, ist vor allem über seine Firmen Radium 226.05 und Anckarström mit musikalischen Kompositionen und der Ausführung von Live-Installationen und Performances (teils solo, teils gemeinsam mit dem Filmemacher Erik Pauser unter dem Gruppennamen Phauss) in den 80er-Jahren hervorgetreten. Anfang der 90er-Jahre arbeitete er mit Andrew McKenzie zusammen und trat kurzfristig dem Hafler-Trio bei dessen Europa-Tournee 1994 bei.

Streams
Stephan Wittwer

Elf Jahre nach *World of Strings* lässt Stephan Wittwer seine zweite Solo-Einspielung *Streams* folgen. Während *World of Strings* eine Live-Aufnahme – oder wenn man so will, eine nackte Gitarren-Scheibe – war, präsentiert sich *Streams* als vielschichtiges, komplexes, aber durchaus hörbares Texturgefüge. Es reflektiert Wittwers Arbeit mit Live-Elektronik, die zu einer überraschenden, aber absolut logischen Symbiose geführt hat. Was Gitarre ist und was digital verarbeitet wurde, was live gespielt und was später synthetisiert wurde – all das lässt sich nicht länger klar auseinanderhalten.

Jeder Track hat seine eigene Herkunfts- und Entwicklungsgeschichte. Allen gemeinsam ist jedoch, dass sie auf Aufnahmen einer E-Gitarre beruhen und häufig ungewöhnliche Spieltechniken, manuelle Gesten und mechanische Präparierung oder Installation einschließen. Bisweilen waren weder Verstärker noch Lautsprecher beteiligt (sehr leise), manchmal gab es zahlreiche davon (sehr laut). In vielen Fällen waren in den Lauf des elektrischen Signals analoge Prozessoren eingeschaltet – Geräte für Ringmodulation, spannungsgesteuerte Filter, Valve-Distortion, dynamische Kompression, Resonanz und dergleichen. Die Post-Produktion erfolgte digital, festplattengestützt, ähnlich einem virtuellen Studio, aber auch unter Verwendung von digitalen Nicht-Echtzeittools wie Spectral Mutation, Granularsynthese, Convolution, Modulationssysnthese, Wave-Shaping, und dazu etwas Real-Time-Action mit Plug-Ins der üblichen wie auch exotischen Sorte, dann wieder primitive „Stomp-Boxes" im Signalweg, physisches Fader-Riding, Switching, Veränderung und Verschlechterung des Ausgangsmaterials ... Es gibt Einiges an herausragen- dem Sequencing, aber auch häufige räumliche und/ oder elektronische Rückkoppelungen. Meistens wurde die Linearität der ursprünglichen Improvisation in dem Prozess unberührt gelassen, die gestische Information schimmert durch oder ist sogar offensichtlich.

Jeder Track besteht nur aus dem Material der jeweils zugehörigen Aufnahmesituation (sei es Mikrofon, Linein oder beides) – hier wird kein „gefundenes" oder „konkretes" Material beigemischt – alles war schon da, aber möglicherweise auf einem subliminalen Niveau versteckt.

Eleven years after *World of Strings*, *Streams* is the second solo record from Stephan Wittwer. If *World of Strings* was a live recording, or, if you wish, naked guitar record, then *Streams* presents itself as multi-layered, complex but thoroughly listenable textures. It reflects Wittwer's work with live electronics, which has led into a surprising, yet absolutely logical symbiosis. What is guitar and what is digitally processed, what is played live in real time and what was synthesized later— all this is no longer clearly recognizable.

Each track has its own history of origin and development. What all of them do have in common is that they are based on recordings of an electric guitar, with often quite unusual playing techniques, manual gestures and mechanical preparations/ installations. Sometimes there was no amplifier nor loudspeaker involved (very quiet),sometimes there were several of them (very loud). In many cases there were analogue processors in the chain of the electrical signal—devices for ring modulation, voltage controlled filtering, valve distortion, dynamic compression, resonance, phasing and such.

Post-production was 'digital', hard disk—based, virtual studio-like, but also utilizing non-real-time computer music tools like spectral mutation, granular synthesis, convolution, modulation synthesis, wave shaping—plus some real-time-action with plug-ins of both pedestrian and exotic origin, primitive 'stomp-boxes' in the signal path again, physical fader riding, layering, switching, alteration and degradation of the basic sonic material...there is some exceptional sequencing, but frequent spatial and/or electronic feedback. Most often the linearity of the underlying improvisation was left intact in the process, the gestural information shines through or is obvious.

Each track consists only of material of the corresponding recording situation (be it microphone, line-in, or both)—there is no addition of "found" or "concrete" material—everything was already there, but possibly hidden in a subliminal area.

Stephan Wittwer (CH) born 1953. Instruments: guitar, devices, studio, computer. As a child piano lessons, autodidact in electric guitar. Four years of college formation (drop out). Workshop in Heidelberg with Paul Lovens, Evan Parker, Alexander v. Schlippenbach, Peter Kowald, Karl Berger. Music Academy and Conservatory in Zurich. Teaching diploma in classical guitar. Studio for electronic music in Basel. **Stephan Wittwer (CH)**, geb. 1953. Instrumente: Gitarre, Geräte, Studio, Computer. Als Kind Klavierstunden, dann Autodidakt auf der E-Gitarre. Vier Jahre Studium, dann Abbruch. Workshop in Heidelberg bei Paul Lovens, Evan Parker, Alexander v. Schlippenbach, Peter Kowald, Karl Berger. Musikakademie und Konservatorium in Zürich. Musiklehrerdiplom für klassische Gitarre. Studio für elektronische Musik in Basel.

CYBERGENERATION
u19 freestyle computing

A Question of Expectations or of Just Growing Up?
Erwartungshaltungen oder „Just Growing Up"?

Hans Wu

What do grown-ups actually expect from young people? For a jury which has to evaluate four to nineteen-year-olds, this question should indeed be asked. This is especially true when the average age of the jury is way past nineteen. So how does an adult jury want to go about evaluating the work of a young entrant? Does it try to evaluate how near the youngster is to becoming an adult? Or does it deliberately search for those qualities which an adolescent will lose when he or she reaches adulthood?

A competition for the up-and-coming generation—and the u19 category of the Prix Ars Electronica must be seen as such—mainly takes the adult world as a standard of comparison. Moreover, to what extent adults view young people as the "professionals" of tomorrow can be seen in the growing number of e-business competitions for young talents. Even classic innovation contests judge young people's works primarily by their ability to "pay-off" in the adult world.

Over the years, u19 juries have shown great appreciation of works which exhibit a professional working knowledge of technology; yet, in the end, final decisions have been determined by the search for what is described in the competition subheading: "Freestyle Computing". It is matter of a working knowledge of technology that does not necessarily meet adult demands: experiments resulting from the pure instinct to play and solutions arrived at without pre-planning. Last year's jury statement reflected such expectations: "If one wants to be pessimistic, one can interpret this technical obsession among such young people as a lack of imagination—without meaning to mourn the loss of an idealized potential of young people to be creative, cheeky and naive at the same time." Of course, these too are expectations—expectations which seek those potentials in young people which adults may have lost long ago.

These two kinds of "grown-up" expectations—both those on the lookout for a young and yet already adult professionalism and for a cheeky, naive and creative potential—have been consciously avoided by the jury. Just the same, precisely these expectations were more than satisfied this year.

After a preliminary examination of the entries it was clear that the quality of this year's submissions would cause no problems with regard to selecting the twelve Honorary Mentions. And ultimately the jury awarded these to:

Was erwarten Erwachsene von Heranwachsenden? Bei einer Jury, die Werke von Vier- bis 19-Jährigen beurteilen muss, sollte diese Frage einmal gestellt werden. Erst recht, wenn das Durchschnittsalter der Beurteilenden weit über 19 Jahre liegt. Wie also will eine erwachsene Jury das Werk eines heranwachsenden Einsenders beurteilen? Wird beurteilt, wie sehr er zum Erwachsenen herangewachsen ist? Oder wird bewusst nach dem gesucht, was den Heranwachsenden als Erwachsenen verloren gehen wird?

Nachwuchswettbewerbe – und auch die u19-Kategorie des Prix Ars Electronica ist hierzu zu rechnen – nehmen zumeist die Erwachsenenwelt zum Vergleich. Wie sehr die Erwachsenen Jugendliche als zukünftige „Professionals" sehen, zeigt sich ganz extrem in der wachsenden Anzahl von E-Business-Wettbewerben für Jugendliche. Aber auch die klassischen Innovationswettbewerbe beurteilen Arbeiten von Jugendlichen zumeist nach „Pay-off"-Qualitäten in der Erwachsenenwelt.

Die u19-Jury hat Projekte, die von professionellem Umgang mit Technologie zeugen, immer hoch bewertet, aber der endgültige Entscheid war doch auch immer von der Suche nach dem geprägt, was der Untertitel des Bewerbs umschreibt: „Freestyle Computing". Es geht dabei um einen Umgang mit Technologie, der nicht unbedingt den Anforderungen von Erwachsenen entspricht: Experimente aus reinem Spieltrieb und Lösungen abseits vorgegebener Blaupausen. Das Jury-Statement des Vorjahres spiegelt diese Erwartungshaltung wider: „Will man pessimistisch sein, kann man diese technische Besessenheit bei so jungen Menschen als Fantasielosigkeit interpretieren – ohne damit den Verlust des so idealisierten Potenzials der Jugend, kreativ, frech und naiv zugleich zu sein, beklagen zu wollen." Natürlich ist auch dies eine Erwartungshaltung – eine, die Potenziale, die Erwachsene möglicherweise längst eingebüßt haben, bei den Heranwachsenden sucht.

Diese beiden „erwachsenen" Erwartungshaltungen, sowohl die Erwartung, ein junges und schon erwachsenes professionelles Projekt zu finden, als auch die, ein freches, naives, kreatives Potenzial zu entdecken, wurden in der Jury bewusst vermieden. Sie wurden dieses Jahr trotzdem mehr als befriedigt.

Nach der ersten Durchsicht der Einsendungen war klar, dass die diesjährige Qualität der Einsendungen keine Probleme bei der Vergabe der zwölf Anerkennungen bereiten würde. Der Jury traf schließlich folgende Wahl:

Die Geschwister Schweinöster (Jahrgang 96 und 92) mit ihren ersten Gehversuchen, die ein Konvolut an unbeschwerten digitalen „Malereien" hervorbrachten.

Marian Kogler (Jahrgang 91), der aus Neugier das Programm „Topix" machte, das Bilder in Töne umwandelt.

René Weirather (Jahrgang 91) mit seinen vielen kleinen Programmen; besonders begeistert hat jenes, das sinnlosen Text ausgibt.

Martin Kucera (Jahrgang 86), der seine Begeisterung für Film in einer sehr professionellen Web-Community umsetzte.

Dominik Jais (Jahrgang 86) mit seinen 3D-Grafiken und seinen interaktiven Lösungen zur Erstellung von Berufsbekleidung.

Die Schüler des BG XIX Wien, die sich in einem animierten Film mit SMS-Textlichkeit auseinandersetzen.

Lucas Reeh alias DJ Sky (Jahrgang 86) mit seiner Idee, eine Schulhausübung akustisch umzusetzen: Aus den Geräuschen, die sein Drucker beim Ausdrucken des Deutschaufsatzes machte, wurde ein Musikstück arrangiert.

Die Website *www.herein.at* vom „Projekt Dezentrale Medien", die die Lebenswelten junger Neo-Österreicher der zweiten Generation im Netz darstellt.

Georg Gruber (Jahrgang 84) und Stephan Hamberger (Jahrgang 87) mit ihren persönlichen Websites, die eine besondere Auseinandersetzung mit Web-Interfaces zeigen.

Raphael Murr (Jahrgang 87) und sein Computerspiel *Overcast*, für dessen Erstellung er im Netz eine Arbeitsgruppe zusammensuchte.

Manuel Fallmann (Jahrgang 85) mit seinem Flashfilm *o Fortuna*, der vor allem durch Schnitt und Dramaturgie bestach.

The Schweinöster sisters (born 1996 and 1992) for their first explorative attempts on a computer and the huge amount of *Digital Paintings* they unabashedly produced.

Marian Kogler (born 1991) who out of curiosity created *Topix*, a program which converts images into sounds.

René Weirather (born 1991) for his many little programs—we were particularly taken by the one producing nonsense texts.

Martin Kucera (born 1988) whose enthusiasm for film led him to implement a very professional web community.

Dominik Jais (born 1986) for his 3D graphics and his interactive solution for designing work clothes.

The pupils of the college preparatory school BG XIX in Vienna who explored the textual qualities of SMS messages in an animated film.

Lucas Reeh alias DJ Sky (born 1986) for his idea to render his homework assignment acoustically: he arranged the sounds made by his printer when it printed out an essay for German class into a piece of music.

The web site *www.herein.at* by "Projekt Dezentrale Medien" for their online presentation of the worlds in which young second generation Austrians live.

Georg Gruber and Stephan Hamberger (born 1984 and 1987) for their personal web sites which are testimony of their special exploration of web interfaces.

Raphael Murr (born 1987) for his computer game *Overcast* and the fact that he went online to put together a team to create it.

Manuel Fallmann (born 1985) for his Flash film *o Fortuna*, his outstanding editing and dramaturgy particularly impressed the jury.

The Awards of Distinction

The two Awards of Distinction differ from each other mainly in how they were made: while the Flash animation *minials* was a group effort, the animated film *Arena* exemplifies a solo "bedroom production".

In *minials*, sofa23 (a group including Milo Tesselaar, Markus Murschitz, Ulrich Reiterer und Jona Hoier), Mathias Scherz and Stefan Bermann displayed a refreshing approach to linking music and visuals interactively. As a consequence, the user's camera perspective can be augmented by and combined with figures and the respective sound patterns. The jury found the idea, the design as well as its implementation convincing. It also appreciated how the combined effort of the group could be felt in the work or, to put it more simply, it could feel how much fun they had had.

Whereas sofa23 produced the greater part of their work outdoors in a park, Philipp Luftensteiner took an entirely different course. Once he had decided he wanted to make a 3D film on his own, he had to master the technology: "So that was how I came to spend the loveliest days of the year (the summer holidays) in my room, intensively studying manuals and tutorials", as he himself put it in his project description. The outcome of these summer holidays spent in his room is the short 3D film *Arena*, and it is remarkably well crafted. Philipp Luftensteiner recounts the story of two fighting robots. Through an unexpected turn of events, this so popular computer-game theme is satirized.

The Golden Nica

This year's Golden Nica goes to a work that astonished the jury more than any other and lived up to the title "Freestyle Computing" best of all. Yet the idea of actually awarding the main prize to this work was much disputed. Karola Hummer made drawings on a standard school pocket calculator using means which were not actually conceived for doing so. It took her up to 200 hours per drawing. Essentially, a wonderfully "useless" activity which completely captivated the entire jury. The jurors unanimously felt that her unusual approach and "misuse" of technology should be rated highly. Yet the images themselves fell short of the aesthetic demands of some of the jurors, especially in comparison with the visually impressive works that ultimately received Awards of Distinction. But then in her description of her

Die Auszeichnungen

Die beiden Auszeichnungen unterscheiden sich vor allem in ihrer Entstehungsweise: Während die Flash-Animation *minials* das Ergebnis einer Gruppe ist, ist der Animationsfilm *Arena* ein Beispiel für eine solistische „Bedroom Production".

Die Gruppe sofa23 (bestehend aus Milo Tesselaar, Markus Murschitz, Ulrich Reiterer und Jona Hoier), Mathias Scherz und Stefan Bergmann, zeigen in *minials* einen erfrischenden Ansatz, wie Musik und Visuals interaktiv verbunden werden können. Als Ergebnis kann eine Kameraperspektive vom User durch Figuren und dazugehörende Soundpattern ergänzt und rekombiniert werden. Die Idee, das Design und die Umsetzung überzeugte. Es gefiel der Jury auch, wie im Werk die Kooperation der Gruppe spürbar ist, oder, einfacher gesagt, man sieht, welchen Spaß sie an der Sache gehabt haben.

Während sofa23 ihr Werk hauptsächlich in einem Park in der freien Natur erstellte, ging Philipp Luftensteiner ganz andere Wege. Als er alleine einen 3D-Film produzieren wollte, ging es erst einmal darum, die Technologie zu beherrschen: „So kam es dazu, dass ich die schönste Zeit des Jahres (Sommerferien) mit dem Auswendiglernen von Manuals und Tutorials in meinem Zimmer verbrachte", erzählt er selbst in seiner Projektbeschreibung. Das Ergebnis der im Zimmer verbrachten Sommerferien ist der 3D-Kurzfilm *Arena*, der sich durch hohe handwerkliche Qualität auszeichnet. Philipp Luftensteiner erzählt die Geschichte von zwei Kampfrobotern. Durch eine überraschende Wendung in der Geschichte wird aber das bekannte Computerspielthema persifliert.

Die Goldene Nica

Die Goldene Nica geht an eine Arbeit, die die Jury am meisten überraschte und am ehesten dem Titel „Freestyle Computing" gerecht wurde. Trotzdem wurde über die Vergabe des Hauptpreises lange diskutiert. Karola Hummer erstellte auf einem schulüblichen Taschenrechner Bilder mit Mitteln, die dafür nicht geeignet sind. Bis zu 200 Arbeitsstunden wendete sie pro Grafik auf. Im Grunde eine wunderbar „nutzlose" Arbeit, die die ganze Jury begeisterte. Einig war sich die Jury über eine hohe Bewertung des ungewöhnlichen Ansatzes und des „Missbrauchs" von Technologie. Es waren aber die Bilder selber, die gewissen ästhetischen Anforderungen mancher Jurymitglieder nicht ganz genügten, vor allem im Vergleich mit den visuell starken Werken, die letztendlich mit Auszeichnungen bedacht wurden. Es war aber die „Künstlerin" selber, die in der mitgesendeten Projektbeschreibung den Augenmerk stärker auf den Gesamtprozess als lediglich auf den

Output lenkte: „Selbstverständlich fühle ich mich nicht als Künstlerin, im Gegenteil, eher als 'Anti-Künstlerin' im heutigen Sinn: Ich provoziere nicht, ich schockiere nicht und gehe insofern einen der modernen Kunst diametral entgegengesetzten Weg, als ich keine Abstraktion suche. Mir ist von der Technik her die Abstraktion vorgegeben (ein Screen mit etwa 23000 Punkten), und ich strebe mit meinen bescheidenen Mitteln maximale Realität an. Wenn Kunst Idee und Technik verbindet, dann sind meine Bilder zumindest eine bescheidene künstlerische Äußerung."

Es gefiel der bewusste Einsatz beschränkter Möglichkeiten, auch wenn es einfachere Wege gegeben hätte, Grafiken am Taschenrechner zu erstellen, denn, so die Preisträgerin selber: „Ich zeichne mit mathematischen Funktionen aus der analytischen Geometrie. Ich verwende *niemals* den Cursor (im Original wirklich hervorgehoben, Anm.), sondern berechne jede Linie, gebe die Funktion am y-Editor des TI-92 ein und lasse sie am Graphic-Bildschirm zeichnen."

Die endgültige Juryentscheidung wurde von einem Mitglied so zusammen gefasst: „Bei jedem anderen Jugendwettbewerb wäre Karola wegen der scheinbaren Nutzlosigkeit ihrer Arbeit gar nicht so weit gekommen. Nur beim Prix Ars Electronica werden auch andere Qualitäten gewürdigt." Was die Jury zum Zeitpunkt der Entscheidung nicht wissen konnte: In einem Radiointerview verriet Karola Hummer, die jahrelang Hunderte mathematische Funktionen für ihre Passion erstellte, dass sie eigentlich eine Wiederholungsprüfung in Mathematik hatte. Aber dies ist eine andere Frage der Erwartungshaltung.

project, the "artist" directed the jury's attention more toward the process as a whole than toward just the output: "It goes without saying that I don't consider myself an artist, on the contrary, in contemporary terms, I see myself as an 'anti-artist': I don't aim at provoking or shocking and have taken a route diametrically opposed to modern art, for I don't seek abstraction. The abstraction which occurs is preconditioned by the technology I use (a screen with about 23000 dots), and I strive for maximum reality with my modest means. If art links ideas and technology, then my pictures are, at least, modest artistic expression."

The jury greatly enjoyed the contestant's deliberate use of limited possibilities despite the fact that there would have been easier ways to create drawings on a pocket calculator. As the prize-winner herself put it: "I draw using mathematical functions from analytical geometry. I *never* use the cursor, but instead calculate each line, enter the function in the Y-Editor of my TI-92 calculator and then let it be graphed on the screen."

A jury member summed up the final decision as follows: "At any other competition for young people, Karola would not have made it as far as she did because of the apparent uselessness of her work. Only at Prix Ars Electronica are other qualities like these acknowledged." What the jury could not have known when they made their decision: in a radio interview, Karola Hummer, who had spent years creating hundreds of mathematical functions for her passion, revealed that she was going to have to repeat her math exams. But then that is a question of entirely different expectations.

TI-92
Karola Hummer

TI - 92 DIA - SHOW

| I<< | << ZURÜCK | | VOR >> | >>I |

☑ Beschreibung

Entstehungszeitraum: Jänner bis März 2002

RIO --- etwa 200 Netto - Arbeitsstunden. ca. 1000 Funktionen. Hauptschwierigkeit: Übergänge 'positiv' - 'negativ'. Grauwerte finden nur mit weiß und schwarz. Bearbeiten eines Bildes auf 10 unterschiedlichen Displays. Einem Photo nachempfunden. Suche von Realitätstreue bei hoher Pixelbeschränkung.

Ich zeichne mit mathematischen Funktionen aus der analytischen Geometrie. Ich verwende *niemals* den Cursor, sondern berechne jede Linie, gebe die Funktion am y-Editor des TI-92 ein und lasse sie am Graphic-Bildschirm zeichnen.

Die Idee dazu kam mir, als ich am Ende der 6. Klasse meinen TI-92 zur Hand nahm und meinen Mathematik-lehrer zeichnen wollte. Ich musste allerdings wochen-lang mit dem Graphic-Programm experimentieren, bevor der „Homo mathematicus" entstand. Ich finde, dass gerade die Grobkörnigkeit den Bildern einen ganz eigenen Reiz verleiht und die Pixel-Beschränkung auch für mich eine besondere Herausforderung darstellt. Genauso beschränkte ich mich bei meinen ersten Bildern bewusst auf einen einzigen y-Editor und einen Screen. In diesem Sinne verzichtete ich auch auf Verbesserun-gen, die ich an meinen Bildern gerne noch angebracht hätte. Jedenfalls musste ich Funktionen „sparen" und die jeweils mathematisch am besten geeignete Funk-tion wählen, um bestimmte Kurven wiederzugeben. Ich verwendete hauptsächlich Teile von Geraden, Kreisen, Ellipsen, Parabeln und trigonometrischen Funktionen. Beim Doppelporträt meiner Eltern überlagerte ich erstmals drei Screens (ca. 260 Funktionen). In *Rio* trieb ich diese Arbeitsweise auf die Spitze und an die Grenze der Speicherkapazität meines TI-92: Etwa 980 Funktionen auf zehn übereinandergelagerten Screens. Bei diesen übereinandergelagerten Bildern kam es mir weniger auf mathematische Tüfteleien als vielmehr auf grafische Experimente an.

Selbstverständlich fühle ich mich nicht als Künstlerin, im Gegenteil, eher als „Anti-Künstlerin" im heutigen Sinn: Ich provoziere nicht, ich schockiere nicht und gehe insofern einen der modernen Kunst diametral entgegen-gesetzten Weg, als ich keine Abstraktion suche. Mir ist von der Technik her die Abstraktion vorgegeben (ein Screen mit etwa 23000 Punkten), und ich strebe mit meinen bescheidenen Mitteln maximale Realität an. Wenn Kunst Idee und Technik verbindet, dann sind meine Bilder zumindest eine bescheidene künstlerische Äußerung.

I draw using mathematical functions from analytical geometry. I *never* use the cursor, but instead calculate each line, enter the function in the Y-Editor of my TI-92 calculator and then let it be graphed on the screen.

I first hit upon the idea at the end of my sixth year of college preparatory school, when I took my TI-92 and decided to draw my math teacher. Although it still took weeks of experimenting around with the graphic program before my "Homo mathematicus" emerged. I think the very coarseness of the pictures gives them their special appeal and the limited number of pixels poses a particular challenge to me. In my first pictures, I restricted myself to using just one y-editor and one screen. In this way I had to make do without improvements I would have liked to have made on my pictures. In any case, I had to be "sparing" with functions and choose the most suitable mathematical function for depicting a specific curve. I mainly used parts of straight lines, circles, ellipses, and trigonometric functions. For the double portrait of my parents, I superimposed three screens (approx. 260 functions) for the first time. In *Rio* I carried this method to extremes and the limits of my TI-92's memory capacity: about 980 functions superimposed on ten screens. For me, with these pictures, it was less a matter of wracking my brains mathematically than it was a question of experimenting with the graphics.

It goes without saying that I don't consider myself an artist, on the contrary, in contemporary terms, I see myself as an "anti-artist": I don't aim at provoking or shocking and have taken a route diametrically opposed to modern art, for I don't seek abstraction. The abstraction which occurs is preconditioned by the technology I use (a screen with about 23000 dots), and I strive for maximum reality with my modest means. If art links ideas and technology, then my pictures are, at least, modest artistic expression.

Karola Hummer (born 1983) lives in Mieders / Tyrol. After graduating from the Akademisches Gymnasium, a college preparatory school, she began studying law and political science in Innsbruck. Besides being interested in sports, music, film and her friends, she enjoys experimenting on her TI-92. **Karola Hummer** (geb. 1983) lebt in Mieders / Tirol. Nach ihrer Matura am Akademischen Gymnasium studiert sie in Innsbruck Jus und Politikwissenschaften. Zu ihren Interessen zählt neben Sport, Musik, Film und Freunden die Auseinander-setzung mit ihrem TI-92.

Arena
Philipp Luftensteiner

Sometime at the beginning of last summer, I was suddenly overcome by the urgent desire to make a film: one with at least 20-meter-tall robots and tons of destruction. I had already made films with a great deal of blood and chases—and this had been relatively easy.

From the very start, there was no question, I would use a computer. Probably it would have been easier to make the film in 2D, but I couldn't resist the temptation: it had to be 3D.

So that was how I came to spend the loveliest days of the year (the summer holidays) in my room, intensively studying manuals and tutorials.

When the new school year began, I hadn't gotten very far. And if I hadn't been able to

Ungefähr zu Beginn des letzten Sommers verspürte ich das dringende Bedürfnis, einen Film zu machen: einen mit mindestens 20 Meter hohen Robotern und viel Zerstörung. Ich hatte vorher schon Filme mit viel Blut und Verfolgung gemacht. Das war noch verhältnismäßig einfach gewesen. Von Anfang an kam nur der Computer für die Umsetzung in Frage. In 2D wäre er wahrscheinlich einfacher gewesen, aber ich konnte der Versuchung nicht widerstehen: Es musste 3D sein.

So kam es, dass ich die schönste Zeit des Jahres (die Sommerferien) mit dem Auswendiglernen von Manuals und Tutorials in meinem Zimmer verbrachte.

Als das Schuljahr begann, war ich noch nicht sehr weit gekommen, und wenn es mir nicht möglich gewesen wäre, im Rahmen des Maturaprojektes während der

Schulzeit daheim weiter daran zu arbeiten, hätte ich meinen Film wohl nie fertiggekriegt.

Der Film ist ca. 8,5 Minuten lang, vollständig 3D animiert und wurde im nachhinein geschnitten und vertont.

Die Handlung spielt im Jahr 3000. Die gesamte Menschheit ist von Robotern versklavt worden (das kennen wir doch von irgendwo her ...). Um die Menschen bei Laune zu halten, werden Robotergladiatorenkämpfe abgehalten.

Zwei dieser Kampfroboter spielen die Hauptrollen in meinem Film. Durch einen Defekt in seinem Elektronengehirn verliert einer der beiden seine Aggressivität und Mordlust, die ihn antreiben, und verliebt sich in den anderen.

continue working on it on school days at home, in conjunction with a graduation project, I never would have gotten my film done.

The film is about 8.5 minutes long, and completely 3D animated. I edited it afterwards, and then added the soundtrack.

The story takes place in the year 3000. All humankind has been enslaved by robots (we've heard of something like this somewhere before ...).

To keep humans happy, robot gladiator fights are held.

Two of these fighting robots star in my film. Due to a defect in its electronic brain, one of the two robots loses its aggressive drive and killer instinct, and falls in love with the other robot.

Philipp Luftensteiner (born 1982) lives in Aschach / D. He graduated in creative design from the HBLA, a secondary school, in 2002. His pastimes are movies, instruction manuals, CG and photography. **Philipp Luftensteiner** (geb. 1982) lebt in Aschach / D. Er maturierte 2002 an der HBLA für künstlerische Gestaltung. Die Freizeit verbringt er mit Kino, Betriebsanleitungen, CG und Fotografie.

minials
sofa 23

Macromedia Flash Player 6

Datei Ansicht Steuerung Hilfe

Der Titel *minials* setzt sich aus „mini" und „visuals" zusammen. Er steht für viele kleine Segmente, die in die Video- bzw. Audiospuren einfließen.

Unser Projekt ist eine Flash-Animation, die Video mit Audio kombiniert. Es gibt acht Buttons, denen jeweils eine Tonebene plus eine Bildebene zugewiesen ist. Jeder Track und jeder Videoloop sind von uns eigens dafür produziert. Beim Anklicken eines Buttons werden beide Ebenen – Video- und Audio-Spur – aktiviert. Die einzelnen Buttons können nebeneinander aktiv sein, was dem Benützer ermöglicht, einen eigenen Musiktrack zu kreieren.

Das Video besteht aus nur einer Perspektive und nur einem Bild, wobei verschiedene Szenen in dieses Bild eingespielt werden.

Das Ziel ist es, dem Benutzer die Möglichkeit zu bieten, den Track und das Video wenigstens teilweise individuell zu gestalten und somit Freude daran zu entwickeln, sich mit den Medien Ton und Film zu beschäftigen.

The title *minials* was created from the words „mini" und „visuals". It stands for the many small segments that flow into video or audio tracks.

Our project is a Flash animation, combining video and audio tracks. There are eight buttons and each of them has been assigned an audio level and a video level. Each track and video loop was specially produced by us. By clicking on a button, the two levels—video track and audio track—are activated. Individual buttons can be active simultaneously, enabling the user to create his own music track.

The video consists of a single perspective and frame, although different scenes can be played into this frame.

The goal is to give users the chance to design their tracks and videos at least in part individually and so to discover the fun involved in working with the media of sound and film.

sofa23 is a group of young people who are practically exploring the fields of video/film, multimedia and photography. "sofa23" is a team of four—Ulrich Reiterer, Jona Hoier, Markus Murschitz and Milo Tesselaar; they all live, work and study in Graz. In its

present form, the team has existed since spring 2001 and has been called "sofa23" ever since. Further collaborators to the project are Mathias Scherz and Stefan Bermann. **sofa23** ist eine Gruppe von jungen Menschen, die sich mit den Bereichen Video / Film, Multimedia und Fotografie praktisch auseinandersetzen. „sofa23" besteht aus vier Personen – Ulrich Reiterer, Jona Hoier, Markus Murschitz und Milo Tesselaar -, die in Graz leben, arbeiten und studieren. Die Formation, wie sie heute ist, wurde im Frühling 2001 gegründet und trägt seither den Namen „sofa23". . Weiter Mitwirkende am Projekte sind Mathias Scherz und Stefan Bermann.

www.herein.at

Projekt „Dezentrale Medien",
Semen Aklan, Gülcan Ates, Nerdjivane Brahimi, Flamur Kryezi, Franz Fiser, Asif Mohamed Naseri, Jean Paul Nduwayezu, Ferda Özel, Ruwani Rosa, Reza Soltani und Sezer Üzum

In spring 2001, at the invitation of the "Initiative Minorities" [Minorities Initiative], a four-month project was launched with 13 adolescents who were at the time attending the final course of secondary modern school at the BFI Gudrunstraße. We were interested in developing and designing a project with them that would deal with topics of importance to them. Priority was given to vocational training, jobs, their living situations, personal stories and life in Vienna. The group had in common that Vienna was a place of immigration for them.
As it turned out, the original topics were expanded by their "furnishing" a place of their own. We built a virtual house that was to accommodate all the participants' wishes and ideas. In the process, we discussed their different plans for life, and began conceiving and designing a homepage together.
In November *www.herein.at* went online and our work was presented at the „Depot" (a space for art and discussion) in Vienna and at the MAIZ club (Autonomous Integration Center for and by Migrants) in Linz. At the same time, *www.herein.at* came out on CD-ROM.

Im Frühjahr 2001 begann auf Einladung der „Initiative Minderheiten" eine viermonatige Zusammenarbeit mit 13 Jugendlichen, die zu dieser Zeit einen Hauptschul-Abschlusskurs am BFI Gudrunstraße besuchten.
Unser Interesse lag in der gemeinsamen Entwicklung und Gestaltung eines Projekts und in der Auseinandersetzung mit Themen, die die Jugendlichen beschäftigten. Ausbildung, Beruf, Wohnsituation, die eigene Geschichte und das Leben in Wien standen im Vordergrund. Eine Gemeinsamkeit der Gruppe war das Begreifen von Wien als Ort der Einwanderung.
Das „Einrichten" eines eigenen Raumes wurde zur Weiterentwicklung des ursprünglichen Themas. Wir bauten ein virtuelles Wohnhaus, das den Wünschen und Vorstellungen aller TeilnehmerInnen entsprechen sollte. Dabei wurden die unterschiedlichen Lebensentwürfe diskutiert und mit der Konzeption und Gestaltung einer gemeinsamen Homepage begonnen.
Im November wurde *www.herein.at* ins Netz gestellt und unsere Arbeit im „Depot" (Raum für Kunst und Diskussion) in Wien und im Verein MAIZ (Autonomes Integrationszentrum von und für MigrantInnen) in Linz präsentiert. Gleichzeitig wurde *www.herein.at* auch als CD-Rom veröffentlicht.

www.herein.at is a project of "Dezentrale Medien", an initiative under the direction of Eva Dertschei, Petja Dimitrova, Carlos Toledo and Boriana Ventzislavova. The contributors were: Semen Aklan, Gülcan Ates, Nerdjivane Brahimi, Flamur Kryezi, Franz Fiser, Asif Mohamed Naseri, Jean Paul Nduwayezu, Ferda Özel, Ruwani Rosa, Reza Soltani and Sezer Üzum. *www.herein.at* ist ein Projekt der Initiative „Dezentrale Medien" unter der Leitung von Eva Dertschei, Petja Dimitrova, Carlos Toledo und Boriana Ventzislavova. Teilnehmer waren: Semen Aklan, Gülcan Ates, Nerdjivane Brahimi, Flamur Kryezi, Franz Fiser, Asif Mohamed Naseri, Jean Paul Nduwayezu, Ferda Özel, Ruwani Rosa, Reza Soltani und Sezer Üzum.

Flash Animation
BG XIX

In einem Workshop im Sommersemester mit Stefan Sonvilla-Weiss lernten die Schüler der 5a Flash-Animationen zu erstellen. Flash ist ein vektororientiertes Computerprogramm, das die Möglichkeit bietet, sehr kleine Bilddateien zu erstellen, die ins „Netz" gestellt werden können.

Alles muss schnell gehen: das Laden von Bildern im Netz, die Nachrichtenübermittlung. Kommunikation verändert sich. SMS-Bildsymbole gibt es im Netz und auf unserem Handy. Wir können mit den Zeichen der Tastatur einfache Bilder erzeugen. Die Flash-Animationen, deren Anwendung im Netz zur Gewohnheit des Users geworden ist, wird hier im experimentellen Kurzfilm zu einer humorvollen Collage von gewohnten Bildbotschaften.

Der Ton setzt sich aus dadaistischer Lautmalerei und Computersprache zusammen.

In a workshop during the summer semester with their teacher Stefan Sonvilla-Weiss, the pupils of class 5a learned how to produce Flash animations. Flash is a vector-based computer program which enables users to produce very small image files and these can be loaded onto the web.

Everything has to go quickly: the loading of images onto the web and the transmission of messages. Communication is changing. There are SMS pictures on the web and on our mobile phones. We can produce simple pictures using the characters on the keys. In an experimental short film, Flash animations—whose use has become customary on the web—turn into a humorous collage of familiar picture messages. The sound is a mixture of Dadaist onomatopoeia and computer language.

The following pupils – mostly in their fifth year—participated in this project at the Bundesgymnasiums XIX, a college preparatory school: Bernhard Kreuzer, Magdalena Auff, Lisa Lederer, Tobias Bernecker, Sophie Brockmann, Theresa Freissmuth, Gisela Kristopheritsch, Florian Kuderna, Mathias Meiller, Miriam Reischauer, Benjamin Schuster, Martin Wurzer, Moritz Gottsauner-Wolf, Christoph Prager, Clara Preiser, Susanne Reich Rohrwig, Franziska Steinbichler, Peter Magpantay, Daniela Klima, Clemens Vichityl, David Kellner. Project leader: Petra Suko; project supervisor, Flash: Stefan Sonvilla-Weiss; film editor: Renate Holubek. An dem

Projekt des Bundesgymnasiums XIX nahmen folgende Schüler – hauptsächlich aus 5. Klassen – teil: Bernhard Kreuzer, Magdalena Auff, Lisa Lederer, Tobias Bernecker, Sophie Brockmann, Theresa Freissmuth, Gisela Kristopheritsch, Florian Kuderna, Mathias Meiller, Miriam Reischauer, Benjamin Schuster, Martin Wurzer, Moritz Gottsauner-Wolf, Christoph Prager, Clara Preiser, Susanne Reich Rohrwig, Franziska Steinbichler, Peter Magpantay, Daniela Klima, Clemens Vichityl, David Kellner. Projektleitung: Mag. Petra Suko, Projektbetreuung, Flash: Mag. Stefan Sonvilla-Weiss, Filmschnitt: Mag. Renate Holubek.

o fortuna
Manuel Fallmann

The animated work *o fortuna* was originally based on Carl Orff's music for the text *O Fortuna* from *Carmina Burana* – which explains the name. The plot of my work more or less relates to the text of the same name: a vanquished figure once again takes heart and so triumphs in the end. All luck has deserted the figure who was previously so superior.

In my original version of *o fortuna*, I used Carl Orff's composition as background music, as major component of this animated work.

Yet, unfortunately, in order to comply with the entry regulations, I had to replace the composition by sounds distorted or modified on the computer, sounds which I thought fit this animation, this duel.

Ursprünglich basiert die Animation *o fortuna* auf Carl Orffs Vertonung des Textes *O Fortuna* aus den *Carmina Burana* – deswegen der Name. Die „Handlung" meiner Animation bezieht sich – mehr oder weniger – auf den gleichnamigen Text: Der einst Besiegte richtet sich von Neuem auf, um schlussendlich doch zu triumphieren. Der vormals Überlegene jedoch wird von seinem Glück verlassen.

In meiner ursprünglichen Version von *o fortuna* habe ich Carl Orffs Musikstück als Hintergrundmusik verwendet, als tragendes Element dieser Animation.

Um den Einreichbedingungen gerecht zu werden, musste ich das Musikstück leider durch am Computer verzerrte bzw. überarbeitete Geräusche ersetzen, von denen ich dachte, dass sie zu dieser Animation, diesem Duell, passen.

Manuel Fallmann (born 1985) is in his seventh year of college preparatory school at the Gymnasium der Englischen Fräulein in St. Pölten. His hobbies are drawing, listening to music, going out and computers (both games and diverse programs, especially Flash 5). **Manuel Fallmann** (geb. 1985) besucht die 7. Klasse des Gymnasiums der Englischen Fräulein in St. Pölten. Seine Hobbys sind Zeichnen, Musikhören, Fortgehen und Computer (sowohl Spiele als auch diverse Programme, vor allem Flash 5).

Die Technik nicht als Ausgangspunkt, sondern vielmehr als Werkzeug, um das Konzept einer experimentellen und interaktiven Selbstvorstellung zu realisieren: Das ist der Ansatz von *www.inflex.org*.

Die größtenteils in Flash umgesetzte Website hat den Charakter einer digitalen Spielwiese und präsentiert auch ein Portfolio mit Arbeiten aus den Bereichen Animation und Design. Sowohl Intro als auch Navigation bieten hierbei eine klare Struktur und wirken durch ihre schlichte Erscheinung.

Technology, not as a point of departure, but as a tool for implementing the concept of an experimental and interactive self-presentation: this is *www.inflex.org*'s approach.

Mostly made with Flash, this web site has the character of a digital playground, and presents a portfolio of works from the fields of animation and design. Both the intro and the navigation exhibit a clear structure and are compelling in the simplicity of their appearance.

Georg Gruber (born 1984) lives in Inzing in Tyrol; since 1998 he has been attending a technical secondary school, the HTL for Graphics and Communications Design in Innsbruck. His interests and hobbies include: art and design, film and cinema, music, football and snowboarding. **Georg Gruber** (geb. 1984) wohnt in Inzing in Tirol und besucht seit 1998 die HTL für Grafik und Kommunikationsdesign in Innsbruck. Interessen und Hobbys: Kunst und Design, Film und Kino, Musik, Football, Snowboarden.

My homepage provides information about myself, my classmates and the web sites I have made so far.

The section called "about" gives you personal details about me and my hobbies.

Under "other" you can find links to interesting Internet addresses, my visitors' book, a password area for my schoolmates, a photo album of my class, games I have created, and a school section where I am compiling my projects and a portfolio for different school subjects.

The section "my sites" contains all the homepages I have made so far.

After creating web sites for the Galerie Puchheim Schloss, the youth center and the secondary modern school in Attnang, and winning the first prize with my sports site *4F* at the competition "www.ebbewerb" held by the federal province of Upper Austria, I decided to program a page for my own use, one which would allow my schoolmates to download different works from it.

What is more, I enjoy using everything I have recently learned about Flash 5 and Dreamweaver 4.

Meine Homepage liefert Informationen über mich, meine Klassenkameraden und meine bisher erstellten Websites.

Der Bereich „About" informiert über meine persönlichen Daten und Hobbys.

Unter „Other" findet man Links zu interessanten Internetadressen, ein Gästebuch, einen Passwortbereich für meine Schulkollegen, ein Fotoalbum von meiner Klasse, von mir selbst erstellte Spiele und den Schulbereich, wo ich meine Projekte und Portfolioarbeiten in den verschiedenen Unterrichtsgegenständen sammle.

„My Sites" beinhaltet alle von mir bisher erstellten Homepages.

Nachdem ich für die Galerie Schloss Puchheim, für das Jugendzentrum und für die Hauptschule Attnang Websites erstellt hatte und mit meiner Sportsite *4F* den ersten Preis beim „www.ebbewerb" des Landes Oberösterreich gewonnen hatte, wollte ich eine Seite für meinen persönlichen Gebrauch programmieren, die es meinen Schulkollegen ermöglicht, diverse Arbeiten von meiner Seite herunterzuladen.

Außerdem macht es mir Spaß, die verschiedenen neu erworbenen Kenntnisse über Flash 5 und Dreamweaver 4 zu nutzen.

Stephan Hamberger (born 1987) lives in Attnang-Puchheim. Since 1998 he has been attending the BRG Schloss Wagrain Vöcklabruck, a college preparatory school. He has created web pages for the Galerie in Schloss Puchheim, the "Nang-Pu" youth center and the Hauptschule Attnang, a secondary modern school. His personal sports homepage won first place in the competition "www.ebbewerb" held by the federal province of Upper Austria.

Stephan Hamberger (geb. 1987) wohnt in Attnang-Puchheim. Seit 1998 besucht er das BRG Schloss Wagrain Vöcklabruck. Er hat Webpages für die Galerie Schloss Puchheim, das Jugendzentrum „Nang-Pu" und für die Hauptschule Attnang erstellt. Seine persönliche Sporthomepage gewann den ersten Platz beim „www.ebbewerb" des Landes Oberösterreich.

Berufsbekleidungsprogramm / Work Clothes Program
Dominik Jais

Unser Berufsbekleidungslieferant wollte vor einiger Zeit ein Programm, mit dem man die verschiedenen Kleidungsstücke nach Belieben färben und zusammenstellen kann. Die zuständige Webdesign-Firma wollte sich aber nicht über dieses Projekt wagen. Über Vermittlung meines Vaters wurde ich gefragt, ob ich nicht versuchen könnte, ein Programm in dieser Richtung zu erstellen. Natürlich stimmte ich zu, da es für mich eine neue Herausforderung war. Somit verbrachte ich die gesamten Osterferien damit, die Kleidungsstücke auf dem Computer nachzuzeichnen und das Programm samt den Funktionen zu erstellen.

Das Programm dient dazu, dem Kunden einen optischen Eindruck seiner Vorstellungen in Bezug auf die gewünschte Berufsbekleidung zu vermitteln.

Im Programm wird das Kleidungsstück in zwei Fenstern (vorne / hinten) dargestellt. Durch Anklicken eines Segmentes, z. B. der Brusttasche, und anschließendes Auswählen einer Farbe aus der Farbpalette wird dieser Teil gefärbt. In einer Tabelle rechts unten wird dann zu diesem Segment der Farbcode aufgelistet. Mit Hilfe der Menüleiste kann man unter „Modelle" zwischen Overalls, Jacken, Latzhosen usw. in verschiedenen Ausführungen wählen.

Wenn das Kleidungsstück fertig modelliert ist, können über die Menüleiste Angaben zum Kunden eingeben werden. Diese Informationen werden an das Werk gesendet, wo die Kleidung nach dieser Vorlage produziert wird.

Our work clothes supplier had for some time wanted a program with which one could "dye" and combine different articles of clothing however one liked. The web design firm he had been working with did not, however, want to risk an attempt. Through my father, I was asked if I would try to design a program in this direction. Of course, I accepted, because for me it meant a new challenge. I spent all of the Easter holidays copying the clothing into my computer and constructing the program with all its functions.

The program helps customers to get a visual impression of their ideas for the work clothes they want.

In the program, an article of clothing is depicted in two windows (front / back). By clicking on a part, e.g. the breast pocket, and then choosing a color from the range of colors offered, the part is "dyed". The color code for this part then appears listed in a chart at the bottom right. With the help of the menu bar, one can select under "models" between diverse overalls, jackets, dungarees, and so on.

When an article of clothing has been completed, the customer can submit his information via the menu bar. These details are then sent on to the factory where the clothes are produced according to these instructions.

Dominik Jais (born 1986) currently attends the HAK Innsbruck, a commercial secondary school. His father has a company for municipal technology and work clothes. His first professional job was to design the company's homepage. He was then entrusted with designing a "work clothes program". Dominik Jais is especially skilled in Flash, 3-D modeling and HTML. Dominik Jais (geb. 1986) besucht die HAK Innsbruck. Sein Vater betreibt eine Firma für Kommunaltechnik und Berufsbekleidung. Die Erstellung der Firmenhomepage war seine erste professionelle Arbeit, der dann der Auftrag „Berufsbekleidungsprogramm" folgte. Besondere Kenntnisse besitzt Dominik Jais im Umgang mit Flash, 3D-Modellierung und HTML.

Topix
Marian Kogler

I had long been looking for a way to play notes back one at a time. After DirectX 8 came out, I had the chance to make my "dreams" (and more) come true. When I realized that many players allow one to convert notes into images as they are played, I decided I wanted to make the reverse happen for once. In October 2001, I did the groundwork for the program: I "decoded" the DirectX 8 documentation and laid the foundations for the program. In autumn and winter I evolved the special tools and the program design. In early 2002, I expanded the program by including some examples and adding new features: a paint program and an audio recorder. Afterwards, I beta-tested it on members of my family and got rid of a few flaws.

Ich suchte schon lange eine Möglichkeit, einzelne Musik-noten abzuspielen. Nach dem Erscheinen von DirectX 8 bekam ich die Möglichkeit, meine „Träume" (und noch mehr) zu verwirklichen. Nachdem ich merkte, dass viele Player die Umwandlung abgespielter Töne in Bilder er-lauben, wollte ich auch einmal das Gegenteil ermög-lichen. Im Oktober 2001 leistete ich erste Vorarbeiten für das Programm: Ich „entschlüsselte" die DirectX-8-Dokumentation und legte den Grundbaustein für das Programm. Im Herbst und Winter erstellte ich die Spezialinstrumente und das Design des Programms. Anfang 2002 erweiterte ich das Programm um Beispiele und fügte als zusätzliche Features Malprogramm und Audiorecorder hinzu. Dann ließ ich es von meiner Familie beta-testen und entfernte noch einige Fehler.

Marian Kogler (born 1991) has been interested in computers since he was two. At age four he developed his first computer program. In primary school he completed the third and fourth grades in one year, and attended math, physics and chemistry classes at a college preparatory school. In 1999 he created his first assembler program. Since 2001, he has attended GRG Albertgasse in Vienna, a college preparatory school and is taking upper form classes in computer-aided geometry and computer science. He also goes to a seminar for experimental physics at the University of Vienna, and trains weekly in track and field with SVS Schwechat, a sports club. In 2001, he received an Honorary Mention in u19 Freestyle Computing. **Marian Kogler** (geb. 1991) beschäftigt sich seit seinem zweiten Lebensjahr mit dem Computer. Mit vier: erstes Computerprogramm. Volksschule: 3. und 4. Klasse gleichzeitig absolviert. Außerdem Mathematik, Physik und Chemie im Gymnasium. 1999: erstes Assembler-Programm. Seit 2001 am GRG Albertgasse/Wien. Zusätzlich „Computergestützte Geometrie" und „Informatik" in höheren Klassen. Außerhalb der Schule Seminar am Institut für Experimental-physik der Universität Wien und einmal wöchentlich Leichtathletik-Aufbautraining des SVS Schwechat. 2001: Anerkennung bei u19 Freestyle Computing.

www.filmemacher.at
Martin Kucera

www.filmemacher.at bietet jungen Filmemachern eine Community, um sich über das Thema Film auszutauschen zu können. Nach einer Gratis-Anmeldung hat der User dann die Möglichkeit, sich einzuloggen und alle Vorteile von www.filmemacher.at (kurz FMR.at) zu benutzen. Einmal eingeloggt, hat der User in verschiedenen Areas unterschiedliche Möglichkeiten, sich weiterzubilden oder sich mit anderen auszutauschen oder Promotion für sich als User auf der Homepage zu machen. Die Idee zum Projekt besteht seit etwa Frühling 2001, weil es keine ähnliche Homepage gibt, die Österreichs jugendliche Filmemacher ansprechen will und in einem solchen Umfang Dinge zum Thema Film gratis anbietet. Im November 2001 wurde das Projekts überarbeitet, ein neues Design erstellt und ab Dezember 2001 programmiert. Erstellt wurde das Projekt alleine von Martin Kucera. Gearbeitet wurde außer mit HTML und Java-Script auch mit Flash sowie PHP und MySQL, um eine laufende und einfache Aktualisierung der Homepage vorzunehmen zu können.

www.filmemacher.at offers young filmmakers a community in which they can exchange ideas on film. After registering free of charge, the user may log in and use all the benefits of www.filmemacher.at (short form: FMR.at).
Once users have logged in, they have many possibilities of learning more, and exchanging views and experiences with others about different areas or of promoting themselves on the homepage.
The idea for the project was born in 2001, because at the time there was no homepage like it on the web—no page that aimed at reaching Austria's young filmmakers and at offering so much about film free of charge.
In November 2001, the project was revised, redesigned and then reprogrammed as of December 2001. The entire project was conceived and constructed by Martin Kucera. Besides working with HTML and JavaScript, he used Flash, PHP and MySQL. These programs enable him to constantly update the homepage without difficulty.

Martin Jan Georg Kucera (born 1988) lives in Faistenau (Salzburg). He is currently in his fourth year of secondary modern school there. He has special skills in EDV (HTML, XHTML, CSS, Java, Java Script, PHP, PERL, CGI...) as well as in web design; he is also experienced in writing screenplays and filmmaking (he was awarded a grant by the youth jury at the „Klappe Jugend Film und Video Festival" 2/01 in Salzburg). **Martin Jan Georg Kucera** (geb. 1988) lebt in Faistenau (Salzburg). Er besucht dort derzeit die 4. Klasse der Hauptschule.Er verfügt über EDV-Kenntnisse (HTML, XHTML, CSS, Java, Java Script, PHP, PERL, CGI ...), Kenntnisse im Webdesign und hat Erfahrung im Bereich des Drehbuchschreibens und Filmens (Auszeichnung mit Förderung der Jugendjury beim "Klappe Jugend Film und Video Festival" 2/01 in Salzburg).

Overcast
Raphael Murr

Overcast is a computer game like *Bomberman*. My friend Alex (who I've never actually met because he lives in Germany) and I have been working on this game for some months now—it is our very first.

The idea was mine and I was looking for people who would want to help me, when suddenly Alex (who knew nothing of my plans) got in touch and asked me if I wanted to join the team he had just formed. Because I had known him for so long, I immediately agreed. We named our team "Metrax", and Overcast—our first game—was in the making.

After a few weeks, we were suddenly informed that the name Metrax was already taken and so we renamed ourselves "fallenstudios" and immediately secured *www.fallenstudios.de*.

Soon we faced other problems: none of us knew how to do modeling or how to do the textures for the characters. We got really close to giving up, but then we found two modelers who were happy to do the characters for us and so we could continue.

Overcast is still in the demo stage and it might be a while till it is really finished.

Overcast ist ein Computerspiel in *Bomberman*-Art. Mein Freund Alex, den ich noch nie gesehen habe, da er in Deutschland lebt, und ich arbeiten schon seit einigen Monaten an diesem Spiel, es ist auch unser erstes.

Die Idee kam von mir, und ich war auf der Suche nach Leuten, die mir helfen wollten, und plötzlich meldete sich Alex bei mir (der nichts davon wusste) und fragte mich, ob ich in seinem neu gegründeten Team mitmachen wollte. Da ich ihn schon lange kannte, war ich sofort dabei. Unser Teamname war „Metrax" und unser erstes Spiel Overcast war schon in Arbeit.

Nach einigen Wochen kam plötzlich die Meldung, dass der Name „Metrax" schon vergeben war, und so benannten wir uns in „fallenstudios" um und sicherten uns sofort *www.fallenstudios.de*.

Bald stießen wir auf weitere Probleme: Keiner von uns konnte modeln, und niemand konnte Texturen für Models machen. Wir waren nahe daran aufzugeben, doch wir fanden zwei Modeller, die uns gerne Models machten, und so konnten wir weitermachen.

Overcast befindet sich zur Zeit noch im Demostatus, und es kann noch etwas dauern, bis es wirklich fertig ist.

Raphael Murr is currently attending a technical secondary school, the HTL in Ybbs. His hobbies are computer games (extremely important for the job he wants: a computer-game developer) and constructing homepages. He taught himself all he knows about EDP. **Alex Schomacker** lives in Münster (D). **Raphael Murr** besucht zur Zeit die HTL in Ybbs. Seine Hobbys sind Computerspiele spielen (sehr wichtig für den Job, den er anstrebt: Computerspielentwickler), Homepages basteln. Seine EDV-Kenntnisse hat er sich selber beigebracht. **Alex Schomacker** wohnt in Münster (D).

DJ_Sky feat. HP - Deskjet 695c

Lucas Reeh

"Making of HP DJ 695c Song"

Drucker

Micro

(c) by DJ_Sky

Thanks to Sonic Foundry and Hewlett Packard for support

Wie vielleicht bekannt, besuche ich eine Computer-HTL, und so redet man auch mit seinen Freunden in der Freizeit über Computer und auch über Drucker. Dabei habe ich anbringen müssen, dass mein Drucker diese komischen Geräusche macht.

Natürlich hat es nicht lange gedauert, bis die Idee da war, einen „Sound" damit zu schneiden. Gesagt, getan. Hin zum Computer. Das erste Problem war der Hintergrundsound, die Drums. Ein paar Stunden am Programm „DTd Drumstation", und das war auch schon der Background.

Jetzt noch irgendein Dokument ausdrucken und das Micro laufen lassen. Nichts leichter als das. Dann noch die passenden Stücke rauskopieren und dann nach Gefühl zusammenbasteln. Ein bisschen von den Drums drunter und passt.

Dann ist meine Mutter auch schon gleich zur Tür reinspaziert, hat das gehört und wieder wie letztes Mal gesagt, ich soll's bei u19 einschicken.

As you may already know, I am attending a technical secondary school, an HTL with an emphasis on computers. So also in my spare time I talk with my friends about computers, and sometimes printers, too. One day I just had to remark that my printer made such funny noises.

It wasn't long till I had the idea to record the sound. No sooner said than done.

I went over to my computer. The first problem was a track for the background, the drums. A few hours fiddling with "DTd Drum Station" and I had the background.

Then I had to print out some document and leave the mike on. Nothing easier than that. Afterwards, I picked out and copied the right parts and put them together, intuitively. I mixed in a bit of drums and everything fit.

Just then my mother walked into the room, heard it and said—like last time—I should send it in to u19.

Lucas Reeh (born 1986) lives in Lassnitzhöhe / Styria. He is currently attending the department for EDP and organization at the HTBLA Kaindorf, a technical secondary school. He is also studying Spanish, is well-versed in Pascal/Delphi programming language and knows the rudiments of C. In addition, his pastimes are music, fantasy adventures and sports. **Lucas Reeh** (geb. 1986) lebt in Lassnitzhöhe / Steiermark. Er besucht die HTBLA Kaindorf, Abt. EDV und Organisation. Daneben lernt er Spanisch, beherrscht die Programmiersprache Pascal/Delphi und verfügt über Grundbegriffe in C. Außerdem beschäftigt er sich mit Musik, Fantasy Adventures und Sport.

Digitale Malereien / Digital Paintings
Iris und Silvia Schweinöster

Iris and Silvia became interested in computer painting about three years ago because their parents bought two Apple Power Books G3 on which Claris Works, a writing, drawing and painting program, was installed. Iris began first, nearly three years ago, and mainly painted pictures for her relatives' birthdays; they were sometimes representational, though mostly abstract. Silvia, who wanted to be her sister's equal, began painting at the computer when she was three. Because she couldn't read yet, her father showed her how to open the painting program. Both girls learned to use the program on their own by playing with it. They paint whenever they feel like it and whatever comes into their heads. Their works almost never have titles. Iris mainly paints pictures for special occasions, while Silvia asks several times a week: "Can I paint on the computer?"

Aufs Computer-Malen kamen Iris und Silvia, weil ihre Eltern vor drei Jahren zwei Apple Power Books G3 gekauft haben, auf denen auch Claris Works, ein Schreib-, Zeichen- und Malprogramm, installiert ist. Vor nicht ganz drei Jahren hat zunächst Iris vorwiegend für Geburtstage von Verwandten Bilder zu malen begonnen, manchmal gegenständlich, meist aber abstrakt. Silvia wollte ihr nicht nachstehen, und sie begann mit drei Jahren mit dem Malen am Computer. Da sie noch nicht lesen kann, hat ihr ihr Vater gezeigt, wie sie das Malprogramm öffnen kann. Den Umgang mit dem Malprogramm haben sich die beiden durch Probieren spielerisch selbst beigebracht. Beide Töchter malen nach Lust und Laune, was ihnen gerade einfällt. Die Arbeiten haben fast nie Titel. Iris malt meist zu besonderen Anlässen ein Bild, bei Silvia heißt es mehrmals in der Woche „Kann ich Computer malen?"

Iris Schweinöster (born 1992) is currently attending the fourth grade of primary school in Salzburg-Gnigl; in fall she will attend the HIB Saalfelden. Silvia Schweinöster (born 1996) has been going to kindergarten in Salzburg-Gnigl for two years now; she will begin primary school in St. Martin near Lofer in fall. **Iris Schweinöster** (geb. 1992) geht derzeit in die 4. Klasse Volksschule in Salzburg-Gnigl, sie kommt ab Herbst in die HIB Saalfelden. Silvia Schweinöster (geb. 1996) besucht seit zwei Jahren den Kindergarten in Salzburg-Gnigl, sie kommt im Herbst in die erste Klasse der Volksschule in St. Martin bei Lofer.

Seit ein paar Monaten kenne ich Visual Basic. (Das Programm bekam ich von einer Informatik-Professorin geschenkt.) Ich finde es besser als Flash.
Ich verbringe eigentlich jeden Tag mindestens zwei bis drei Stunden mit Visual Basic. Ich bin begeistert.
Ich versuche, nützliche kleine Programme zu schreiben. Auf CD habe ich einige abgespeichert, und auf meiner Homepage habe ich ein paar als Download platziert. Super wäre es, wenn es mir irgendwann einmal gelingt, ein Programm zu schreiben, das alle Leute brauchen können. Am stolzesten bin ich auf mein Englisch-Programm.

I have known Visual Basic for a few months now. (A computer science teacher gave it to me as a present.) I think it is better than Flash.
In fact I spend at least two to three hours a day on Visual Basic. I'm very enthusiastic about it.
I try to write useful little programs. I have saved some on CD and put a few on my homepage so they can be downloaded. It would be great if one day I could succeed in writing a program which everyone would be able to use. I'm proudest of my English program.

René Weirather (born 1991) attends college preparatory school in Reutte / Tyrol. He devotes much time to different programming languages and the Internet. His other hobbies include: his budgies and his dog, nature, going on outings and inviting a friend over every day. **René Weirather** (geb. 1991) besucht das Gymnasium in Reutte (Tirol). Er beschäftigt sich mit verschiedenen Programmiersprachen und dem Internet. Weiter Hobbies sind: seine Wellensittiche und sein Hund, die Natur, Ausflüge machen und jeden Tag einen Freund einladen.